Exhibiting Patriotism

Exhibiting Patriotism

Creating and Contesting Interpretations of American Historic Sites

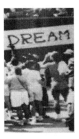

Teresa Bergman

Routledge
Taylor & Francis Group
LONDON AND NEW YORK

First published 2013 by Left Coast Press, Inc.

Published 2016 by Routledge
2 Park Square, Milton Park, Abingdon, Oxon OX14 4RN
711 Third Avenue, New York, NY 10017, USA

Routledge is an imprint of the Taylor & Francis Group, an informa business

Library of Congress Cataloging-in-Publication Data:

Bergman, Teresa.
Exhibiting patriotism : creating and contesting interpretations of American historic sites / Teresa Bergman.
 p. cm.
 Includes bibliographical references and index.
 ISBN 978-1-59874-596-2 (hardback : alk. paper) — ISBN 978-1-59874-597-9 (pbk. : alk. paper) — ISBN 978-1-61132-679-6 (consumer eBook) — ISBN 978-1-61132-782-3 (institutional eBook)
1. Historic sites—Interpretive programs—United States. 2. Visitors' centers—United States. 3. Historiography—Social aspects—United States. 4. USS Arizona Memorial (Hawaii) 5. California State Railroad Museum. 6. Alamo (San Antonio, Tex.) 7. Lincoln Memorial (Washington, D.C.) 8. Mount Rushmore National Memorial (S.D.) I. Title.
 E159.B45 2013
 973--dc23
 2012032797

Cover design by Piper Wallis

ISBN 978-1-59874-597-9 paperback
ISBN 978-1-59874-596-2 hardcover

Contents

List of Illustrations 7

Acknowledgments 11

Introduction: Necessary Tensions 15

1 Submerged Patriotism: Evolving Representation at the U.S.S. 31
 Arizona Memorial Visitor Center

2 Getting the Chinese on Board at the California State 59
 Railroad Museum

3 The Day the Plaster Fell: Museological Change Comes 89
 to the Alamo

4 Sex and Gender in the Lincoln Memorial: The Politics of 117
 Interpreting Lincoln's Legacy

5 Patriotism Carved in Stone: Mt. Rushmore's Evolution 143
 as National Symbol

Conclusion: Necessary Changes 173

Notes 185

Bibliography 231

Index 241

About the Author 253

Illustrations

Figure I.1	National Park Service ranger with Native American at Mount Rushmore National Memorial, ca. 1950s	17
Figure I.2	One of the first signs visitors encounter when attending the U.S.S. *Arizona* Memorial	18
Figure I.3	Image of theology students joining civil rights protests from the *Lincoln's Legacy* exhibit, ca. 1960s	20
Figure I.4	Hispanic railroad worker mannequins in the California State Railroad Museum, ca. 1980s	22
Figure I.5	The Alamo chapel, 2006	23
Figure I.6	Construction of the U.S.S. *Arizona* Memorial, ca. 1961	28
Figure I.7	Construction of the Lincoln Memorial, ca. 1914	29
Figure 1.1	U.S.S. *Arizona* National Memorial, 2005	32
Figure 1.2	Bombing of the U.S.S. *Arizona* Battleship, December 7, 1941	33
Figure 1.3	World War II Valor in the Pacific National Monument entrance sign, 2011	34
Figure 1.4	Lei floating above U.S.S. *Arizona*, 1962	37
Figure 1.5	Navy platform above U.S.S. *Arizona*, 1950	38
Figure 1.6	Aerial view of the 1980–2010 U.S.S. *Arizona* visitor center	40
Figure 1.7	U.S.S. *Arizona* Memorial Shrine Room	44
Figure 1.8	World War II Valor in the Pacific National Monument visitor center, 2011	48

Figure 1.9 Alfred Preis's "Tree of Life" replica from the U.S.S. 50
 Arizona Memorial, World War II Valor in the
 Pacific National Monument visitor center, 2011

Figure 1.10 Torpedoes located at the U.S.S. *Bowfin* 51
 entrance, 2011

Figure 2.1 California State Railroad Museum exterior, 2011 60

Figure 2.2 Old Sacramento, 2011 63

Figure 2.3 Locomotives exhibit in the California State 65
 Railroad Museum, ca. 1980

Figure 2.4 *Gov. Stanford* locomotive, 2011 66

Figure 2.5 Railroad station mannequin in the California 67
 State Railroad Museum, 2011

Figure 2.6 Hispanic mannequins in the California State 68
 Railroad Museum, 2011

Figure 2.7 Pullman porter mannequin in the California 69
 State Railroad Museum, 2011

Figure 2.8 Virginia & Truckee Railroad No. 13 *Empire* in the 70
 California State Railroad Museum, 2011

Figure 2.9 "People Gallery" exhibit in the California State 71
 Railroad Museum, ca. 1980s

Figure 2.10 Chinese Railroad worker mannequin in the 74
 California State Railroad Museum, ca. 1980s

Figure 2.11 Sierra Nevada mural behind Chinese railroad 75
 worker exhibit in the California State Railroad
 Museum, 2011

Figure 2.12 Chinese railroad workers' artifacts exhibit in 76
 the California State Railroad Museum, 2011

Figure 2.13 Female railroad engineer mannequin in the 83
 California State Railroad Museum, ca. 1980s

Figure 3.1 Alamo chapel, 2011 90

Figure 3.2 Interior of the Alamo chapel, 2011 91

Figure 3.3 Mission San José, San Antonio, 2011 93

Figure 3.4 Mission Concepción, San Antonio, 2011 93

Figure 3.5 Mission San Juan, San Antonio, 2011 94

Figure 3.6 Mission Espada, San Antonio, 2011 94

Figure 3.7 U.S. Army horse-drawn wagons enter the Alamo 95
 chapel when the location served as the quartermaster
 depot between 1848 and 1878

Figure 3.8 Downtown San Antonio buildings surround the 96
 Alamo grounds, 2006

Figure 3.9 Stones in the commercial center sidewalk across 102
 the street from the Alamo complex demarcate
 the Alamo's original borders, 2006

Figure 3.10 Alamo gift shop, 2011 104

Figure 3.11 Long Barrack in the Alamo complex, 2011 111

Figure 4.1 Lincoln Memorial, ca. 1920s 118

Figure 4.2 Civil rights marchers at the Lincoln memorial, 1963 119

Figure 4.3 *Lincoln's Legacy* exhibit sign outside the Lincoln 120
 Memorial, 2011

Figure 4.4 Lincoln Memorial construction, ca. 1914 123

Figure 4.5 Lincoln Memorial before construction of the 123
 reflecting pool, ca. 1920

Figure 4.6 Daniel Chester French, sculptor of the Lincoln 127
 Memorial statue, in his studio, ca. 1920s

Figure 4.7 Royal Cortissoz's quote inscribed on the wall 128
 behind the statue of Abraham Lincoln in the
 Lincoln Memorial, 2011

Figure 4.8 Jules Guerin's mural in the Lincoln Memorial 129

Figure 4.9 Dr. Robert R. Moton, president of the 131
 Tuskegee Institute, at the Lincoln Memorial's
 dedication, 1922

Figure 4.10 Marian Anderson singing at the Lincoln 132
 Memorial, 1939

Figure 4.11 *Lincoln's Legacy* exhibit containing the 134
 Lincoln's Living Legacy film, basement
 of the Lincoln Memorial, 2011

Figure 5.1 View of Mount Rushmore National Memorial 144
 from the Peter Norbeck Scenic Byway, 2011

Figure 5.2 Gutzon Borglum, sculptor of Mount Rushmore, 147
 working on model, ca. 1920s

Figure 5.3 The Mount Rushmore Washington carving 148
 extends to his chest, ca. 1930s

Figure 5.4 Gutzon Borglum's plan for a carved entablature 149
 next to the four presidents

Figure 5.5 Mount Rushmore before the carvings 153

Figure 5.6 Visiting family with National Park Service personnel 154
and Native American at Mount Rushmore National
Memorial, ca.1950s

Figure 5.7 Workers preparing dynamite for Mount Rushmore 164
carving, ca. 1930s

Figure 5.8 Dynamite exhibit in Mount Rushmore National 167
Memorial's visitor center, 2011

Figure 5.9 Mount Rushmore National Memorial's Heritage 169
Village, ca. 2008

Figure 5.10 Mount Rushmore National Memorial entrance, 2011 171

Figure C.1 "If You Had Been on Oa'hu" display, World War II 177
Valor in the Pacific National Monument, 2011

Figure C.2 Chinese railroad worker exhibit with Sierra Nevada 179
background mural, 2011

Figure C.3 Alamo chapel, 2011 180

Figure C.4 Image of rally at the Lincoln Memorial, *Lincoln's* 182
Legacy exhibit, ca. 1970s

Figure C.5 Aerial view of Mount Rushmore National 183
Monument under construction, ca. 1930s

Acknowledgments

*Dedicated to my mother and to the memory of my father
and to everyone who ever entered a historical site
and wanted to change something*

I have been thinking about and writing parts of this book for a very, very long time. This book would not exist without the support and insights of many scholars, colleagues, and friends. Without the careful and thoughtful observations of those who have studied and written about sites of public memory, I could not have built on their insights and valuable contributions. And without the patience and encouragement of colleagues and friends, I could not have completed this research.

From my first tentative move from writing about documentaries to studying sites of public memory, Carole Blair has been incredibly supportive and has provided a brilliant path into thinking about and understanding how locations communicate. Communication professors Barbara Biesecker, Mary Kahl, Heather Hundley, Janellen Hill, Greg Dickinson, Brian Ott, and Janis Edwards have all provided steady support, encouragement, and intelligent and canny observations. My friends and colleagues Paul Turpin and Jon Schamber are genuinely interested in my research and provide smart insights on just about everything on a very regular basis.

I want to acknowledge and thank all the National Park Service personnel and administrators of public history sites who shared with me their thoughts and insights on the rewards and challenges of administrating sites of public memory. Their work to preserve, interpret, and enrich these sites to the best of their abilities during times of shrinking budgets is inspirational. Many of these individuals perform their work not only because it is their job but also because it is their sense of duty and responsibility to

make sure that these sites are interpreted in such a manner that contemporary audiences will continue to understand and appreciate their heritage. During my first research trip to the U.S.S. *Arizona*, historian Daniel Martinez was gracious and informative even though I took an inordinate amount of his time in trying to understand the evolution of interpretation of the site. By the time of my return trip, the site had become part of the World War II Valor in the Pacific National Monument, and Scott Pawlowski, Chief of Cultural and Natural Resources, and Stan Melman, his assistant, worked diligently to provide me with all the information I could use in order to understand the creation of the new (and improved) interpretive exhibits.

Ellen Halteman, the Director of Collections at the California State Railroad Museum, met with me multiple times and was always helpful and efficient in getting me the right documents. Her love of railroads was infectious. Philip P. Choy was very gracious with his time and provided me with a wealth of information on the history of the addition of the Chinese exhibit to the California State Railroad Museum.

I have many people to acknowledge and thank who helped me to understand the Alamo and its evolution. Alamo historian Bruce Winders and his assistant, Ernesto Rodriguez III, provided me with tremendous resources and were very generous with their time and insights into the Alamo's administration and Texas history. Rudi Rodriguez, founder of Tejano, Inc., was gracious to meet with me and share his enthusiasm concerning the addition of Tejano contributions to Texas history. Harry Haines, Larry Frey, and Tracey Christeson all made my time in San Antonio insightful and more fun than I ever thought possible. My colleague and friend Jon Schamber contributed key insights and brilliant observations on the Alamo's changing orientation films.

Research at the Lincoln Memorial proved extremely challenging because I conducted part of my research during the fight to change the orientation film and the ensuing freedom of information act (FOIA) court cases to release documentation concerning the requested changes. My good friend, Larry Shapiro, Associate Director for Program Development at the Rockefeller Family Fund, alerted me to the escalating controversy, and Jeff Ruch, Director of Public Employees for Environmental Responsibility, was extremely helpful by providing me with all the documentation that was eventually released because of the FOIA case. Eric Epstein and Tim and Jane Radford of the Harpers Ferry Center were all very friendly and generous with their time in helping me to find the materials and background information on all the interpretive materials in the Lincoln Memorial. Robert Stanton, former Director of the National Park Service, provided important insights and perspectives on the role of the NPS in its contribution to public history. Suzy Taraba, Head of Special

Collections at Wesleyan Olin Library, made my research on Henry Bacon both rewarding and a pleasure.

At Mount Rushmore National Memorial I was lucky to work with Museum Specialist Zane Martin and Historian Amy Bracewell. Both women went out of their way to provide me with information and insights into the changing nature of interpretation at the site. Jim Popovich, former Superintendent for Mount Rushmore, was very helpful in sharing his time and thoughts about the memorial and its administration. Gerard Baker, also a former Superintendent for Mount Rushmore, was enormously helpful and eloquent in his discussion about his time at Mount Rushmore and the implications of his stewardship.

I am extremely grateful to the University of the Pacific for its support of this project and for its ongoing support of my research agenda. At Left Coast Press, I was so lucky to have Jennifer Collier's unwavering support and editorial expertise, which helped shape my idea into a much better book. And the one person who read every chapter, edited every page, and always worked through every idea with me was Phil Garone. As a scholar and environmental history professor, he brought his expertise and thoughtful analysis to each discussion whether it was first thing in the morning or at the end of a very long day of teaching. I am deeply grateful for all of his support and belief in my ideas and patience with my grammar. He has been my best friend for such a long time that I cannot imagine life without him.

Teresa Bergman
December 2012

Necessary Tensions

How we remember the past has long been contested terrain. Questions regarding which events receive commemoration, the contents of the depictions, and who makes these decisions are central issues in the development and maintenance of memory sites. These choices have never been easy, and in the twentieth century these questions became significantly more demanding. Displays implying Japanese American sedition, neglecting Chinese contributions to the California section of the transcontinental railroad, omitting Tejanos from the battle for Texas liberation, removing gay and women's rights from the Lincoln Memorial, and eliding Native American presence at Mt. Rushmore have initiated controversies at U.S. historic sites even as they strive to repre-

Exhibiting Patriotism: Creating and Contesting Interpretations of American Historic Sites by Teresa Bergman, 15–29 © 2013 Taylor & Francis. All rights reserved.

sent the past. The U.S.S. *Arizona*, the California State Railroad Museum, the Alamo, the Lincoln Memorial, and the Mount Rushmore National Memorial have all experienced significant controversy concerning some elements of their interpretive materials.[1] These five U.S. historic sites have been locations where cultural views clashed over the choices of artifacts, orientation films, historic images, or interpretive exhibits. Each of these sites has been the location for strident disagreements over how the past should be remembered. For these reasons, I have chosen to examine these particular sites and the conditions that contributed to the disputes as well as the resolutions.

Museums, historical sites, and memorials have long served as locations where citizens could voluntarily learn about a nation's significant events, outstanding individuals, and constituent communities. The act of visiting a museum, memorial, or historic site constitutes a performance of citizenship that families, school children, and young and old seek out on a regular basis. Museums have been recognized and organized as locations where "virtues of citizenship are acquired," and such acquisition offers particular definitions of citizenship.[2] Sites of public memory have also been recognized as performing a central role in providing evidence—as well as justification—for contemporary "attitudes and actions."[3] These justifying messages deserve critical attention, because the ideals of U.S. citizenship, patriotism, and nationalism are fluid in nature, and their evolving messages can be found at historic locations. Historians constantly engage in research and apply new theoretical approaches to significant events in order to provide more nuanced understandings of the past with an eye to providing insights into the dynamics of the present. Museum and historical site visitors encounter compelling narratives explaining a country's past that work to compose a national identity. Museums have become "places for defining who people are and how they should act and as places for challenging those definitions."[4] The flare up of conflict at these locations in the late twentieth and early twenty-first centuries raises a host of issues for the sites' administrators concerning who is included in the historical narratives, which historical episodes are displayed, how causality is depicted, and how these decisions are made.

This book investigates these questions by addressing several significant suppositions concerning representation at each of the five historic sites. One of the most important presumptions has been that the politics of commemoration and museum exhibits should be the province of a relatively small number of government officials, museum administrators, and professional designers; however, the increasing number of communities demanding that museums and memorials respond to their concerns has significantly affected both the contents of exhibits as well as the decision-making processes that lie behind them. With a reconfiguration of those involved in the politics of commemoration and museum exhibits come consequential challenges to traditional definitions of patriotism,

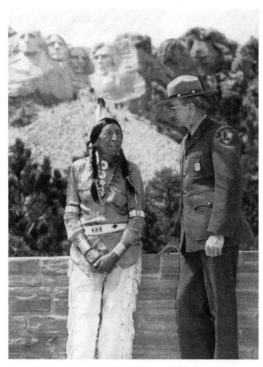

Figure I.1 National Park Service ranger with Native American at Mount Rushmore National Memorial, ca. 1950s (courtesy of Bonita Cockran, Mount Rushmore National Memorial Archives, Mount Rushmore, SD)

nationalism, and citizenship—three interrelated concepts that are at the core of my analysis. For the purposes of this book, I am concerned with a definition of patriotism that encompasses representations depicting those involved in the creation and maintenance of the United States. In terms of nationalism, my interest lies in those interpretive materials that both recognize and celebrate the United States and the ideals on which it was founded. The issues of citizenship with which I am concerned revolve around who receives representation and the content of those depictions.

The need to interrogate the representations of nationalism, patriotism, and citizenship at these sites arises from their "official" designations. This supposedly unbiased "official" read of these sites originates primarily from governmental association, funding, and administration. Furthermore, the locations themselves enhance their "official" association with structures of power. The fact that these interpretive materials are located in museums, actual historic sites, and the Washington, D.C., mall adds considerably to their reception as authoritative. Yet these sites are of course not free from

the presence of bias; however, the dimensions and implications of this bias provide insight into the evolution of the messages at each of these sites. And the evolution of those messages reveals perhaps the least recognized supposition, that the meanings of these sites are contested.

By the end of the twentieth century, museum studies researchers recognized that the historic cultural role that museums performed was changing and that multiple publics were demanding inclusion and representation. The combination of increasing incidents involving high-profile challenges to interpretive materials, plus a steady decrease in revenues, contributed to what is now referred to as a museological paradigm shift.[5] Many museum researchers recognized the need to move away from "collection-driven institutions to visitor-centered museums," where visitor concerns and demands would be addressed.[6] Former Smithsonian Institution deputy director and scholar Stephen Weil described the need for a museum to "shift its focus outward to concentrate on providing primarily educational services to the public," instead of focusing primarily inward on the "growth, care, and study of its collection."[7] It is hard to overstate the enormity of the implications of such a shift in philosophy and attitude. Many academic disciplines experienced their own paradigm shifts in the twentieth century, and these shifts have been referred to variously as the cultural turn, poststructuralism, and postmodernism. For museums, this paradigm shift also reignited a long-simmering tension between the material limitations in the practice of interpretation and the theoretical and representational concerns of scholars and the multiple publics that compose a museum or historical site's constituents.

Similar tensions between theory and practice exist in the academic disciplines of film studies and history in which theoretical goals and

Figure I.2 One of the first signs visitors encounter when attending the U.S.S. *Arizona* Memorial at the World War II Valor in the Pacific National Monument (photograph by the author, 2011)

desires come up against physical limitations. These tensions are a result of the inherent challenges involved in representing complicated topics within the material limitations of film and interpretive displays, as well as the limitations of visitors' attention spans. In December 2011, this tension flared in a heated discussion concerning the New York Historical Society's installation on the Atlantic slave trade, entitled "Revolution! The Atlantic World Reborn." History professor Alan Singer criticized the exhibit for containing panels that "offered very broad simplifications that present platitudes about the past two hundred years rather than an accurate account or historical analysis."[8] One unfortunate response to Singer's critique called for "a law that keeps historians away from history exhibits," because academic historians "know too much about a subject to be able to distill what they know into comprehensible exhibit formats."[9] Although historians and museum personnel encounter different sets of challenges in their work, a conversation between the two is warranted.

The apparent intractability of this debate can be misleading; museum interpretive exhibits benefit from criticism as much as historical scholarship benefits from evaluation. These dual endeavors proceed in different time scales, with unequal funding, and with changing personnel. Each of these factors produces its own sets of tensions, and neither discipline is free from the influence of contemporary political exigencies.

The need to engage contemporary audiences with meaningful interpretive exhibits is another tension-producing component, largely because of museums' increasing reliance on visitation in terms of both absolute numbers and revenue generation. Professor George Hein's research on learning in museums finds that the most successful exhibits are those that enable visitors to connect the new exhibit information with "what they already know, understand, and acknowledge."[10] And museum studies researcher John Falk observes that museum visitors "have come to equate that which is attended to and remembered with the idea of meaningfulness."[11] The production of meaningful exhibits that incorporate recent scholarship is no small task during times of reduced revenues and shifting museological priorities.

The tensions that result from creating museological exhibits that are meaningful as well as historically accurate are not easily resolved and arguably are inherent to the enterprise. The main stakeholders in museological representation fall roughly into three categories—visitors, museum personnel, and historians and academics—all of whom have evolving experiences, needs, and desires. This museological triangle is unlike the iron triangle of political economy, which are the "closed, mutually supportive relationships" of "entrenched interest groups, bureaucrats, and politicians" who can dominate "a particular functional area of government policy" to serve their own interests.[12] Members of an iron triangle work

to close off or limit options in order to meet their own institutionally defined needs and desires. In contrast, the museological triangle consists of groups whose interests are continuously shifting and incorporating new concerns and issues. The research of historians and other academics into significant U.S. events provides new information and interpretations that define and offer more nuanced insights into the country's heritage, and museum studies researchers' findings on visitor learning continue to provide guidance in producing effective exhibits. For museum visitors, their knowledge and experience with particular museological exhibits changes drastically on account of age, education, ethnicity, gender, and economic class. Many communities throughout the U.S. have demanded inclusion in the official spaces of memory; however, this demand for inclusion is not simply a response to absence. In many cases, the demands for changes in museological representation concern the desire for positive associations with U.S. history. These requests for inclusion speak to the powerful allure of iconic American historical narratives of success and liberation. The founding myths of the United States are extremely charismatic, and several of the groups studied in this book sought positive association with these historical narratives.

For museum personnel, priorities have shifted primarily because of reduced government funding and the need to justify expenses by

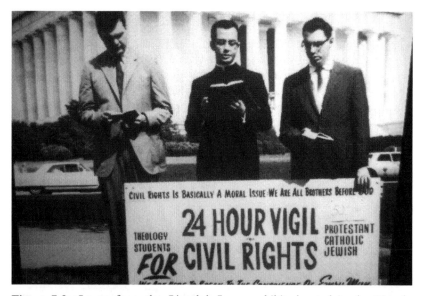

Figure I.3 Image from the *Lincoln's Legacy* exhibit, located in the Lincoln Memorial basement, of theology students joining civil rights protests at the Lincoln Memorial ca. 1960s (courtesy of the National Park Service, 2011)

increasing their visitation numbers. At the same time, a significant body of research on the museum visitor experience has provided insight into how to sustain visitor interest, provide learning environments, and build museum audiences.[13] The confluence of shrinking resources, new research on improving museum experiences, and the need to increase visitation numbers has contributed to this museological shift to a visitor-centric paradigm. Museum personnel and museum studies researchers both acknowledge that a profound change has taken place in the overall function and operation of U.S. museums. Museum consultant Gail Anderson observes that "the paradigm shift from collection-driven institutions to visitor-centered museums has really taken hold."[14] For the purposes of this book, I am particularly interested in the visitor-centered change that has taken place regarding shared historical authority in the development of exhibitions and displays. Sharing historical authority at sites of public memory can take place on several levels. One level is to involve visitors in the creation and revision of exhibits, and another level is in the creation of exhibits with open-ended narratives that encourage visitors to create their own stories and interpretations. The case studies in this book primarily concern the first level of visitor-centrism in terms of analyzing how visitors were involved in the development and revision of exhibits.

The consequences of moving away from exclusively privileging curatorial knowledge to incorporating visitor priorities are significant and by no means uniform. One of the outcomes of this shift is the recognition of museums' multiple publics and the attendant need to both evaluate and incorporate their views into exhibits and interpretative materials. With this shift in focus, museum studies research has provided strategies and insights into achieving success in this new paradigm. To attract and retain visitors "The museum should seek connections between the museum experience and the visitor's life outside the museum."[15] One consequence of interpretive exhibits providing connections for contemporary visitors is that museum personnel need to be aware of their multiple publics when developing displays. A second outcome is that multiple publics expect museum responsiveness to their requests. Museums' response and service to their constituencies can be challenging. Museum constituencies can be local, regional, national, and international, with a web of interconnections—not all of which are necessarily harmonious. In addition to a shrinking financial base and the resulting increased need to rely on visitation for funding, the expressions of the museological paradigm shift are as varied as each museum's location and history. I use the term *museological* in reference to exhibits and displays with interpretive materials primarily concerned with the specific site. The content that I refer to as museological includes the historic sites' visitor centers, audio tours, films, and the physical locations.

Scholars of public memory look to locations and texts in order to understand how past events are constructed and which messages are privileged and communicated to contemporary audiences. The research in memory studies is particularly appropriate at sites of public memory where representation is determined not only by physical space, funding, and visitor interest, but also by a wide variety of representational choices. Memory studies scholars Greg Dickinson, Carole Blair, and Brian Ott note that memory sites' meanings are produced using "specific rhetorical means."[16] These rhetorical constructions begin with the choice of who and what has been found to merit representation and continue through how the memory sites convey their history. For example, not every elected government official has a monument, and not every cause of a particular war is depicted. The variety of influences that affect these choices range from politicization on account of current affairs, to limited museum personnel, and budgets. Examination of the myriad choices and influences at work in sites of public memory produces a more nuanced and complex understanding of how and what memory sites communicate and, in some cases, why some stories persist while others languish. Approaching a memory site as a rhetorical situation moves the analysis away from examining

Figure I.4 Hispanic railroad worker mannequins in the California State Railroad Museum, ca. 1980s (courtesy of the California State Railroad Museum Archives, Sacramento, CA)

what is remembered and what is forgotten toward a discussion of why particular representations exist and which influences privileged those representations while diminishing others.[17] The advantage of this approach is that it illuminates the relations of power at work from the time of the sites' creation through any changes that have taken place. Often, changes in representation are tied to changes in relationships of power.

Many sites of public memory have been locations where the tensions surrounding changes in power have become apparent. It should not be unexpected that "official" sites of U.S. public memory would serve as the locus for various communities' discontent, because these sites have provided visitors with material depictions of those events, people, and items deemed necessary for remembrance and commemoration. Each of the five historic sites studied in this book is significant in U.S. history for its role in constructing and defining a national identity, each has experienced controversy over some element of its interpretive materials, and each possesses adequate resources to replace its interpretive materials. Although each of the case studies addresses the challenges of incorporating historical accuracy into their interpretive materials, this book is about more than correcting the historical record. This book not only examines five locations where historical accuracy was an issue but also considers how stereotypes and racism functioned in maintaining or changing representations. One of the objectives of this book is to recognize that interpretations at historical locations do change over time and that these interpretive materials reflect changing ideologies.

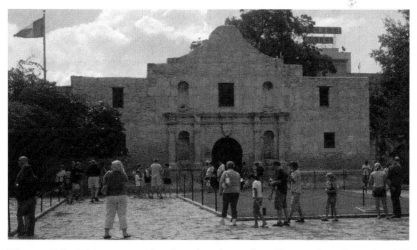

Figure I.5 Visitors outside the chapel at the Alamo, San Antonio, TX (photograph by the author, 2006)

Sites of public memory have been critiqued for relying on celebratory and nostalgic narratives of U.S. history that often ignore the attending social and cultural declension.[18] For several locations in the U.S. this tendency became most apparent in the sites' orientation films. The fact that these films became the focus of particularly vituperative controversies owes to several factors involving both their form and their content. Unlike static interpretive exhibits, an orientation film's goal is to provide an overarching narrative and explanation for the site's significance. Orientation films generally employ a documentary film format to organize the narrative and most use an expository style to convey the information.[19] Thanks to its well-recognized and familiar form, it is not surprising that an orientation film at a national monument or memorial would employ an expository documentary format. The expository format is the "closest to the classic expository essay or report and it has continued to be the primary means of relaying information and persuasively making a case since at least the 1920s."[20] The documentary expository mode gathers a large measure of its authority from theories of Cartesian modernism where a stable subject can observe a stable object and report its results "objectively."[21] While all forms of documentary invoke the camera's historic presumption of "seeing is believing," expository film also incorporates the notion that its representational apparatus is value-free.[22] Orientation films at sites of public memory position audiences to accept their depictions as truthful and as objective explanations for the sites' significance. In terms of content, audiences can readily perceive "the values emphasized in different orientation films that an institution is asking them to accept."[23] Orientation films at historic sites direct its visitors' attention on how to interpret the location's significance *before* the visitors experience the site themselves and develop their own interpretations.

In addition to the orientation films, the multiplicity of interpretive messages offered at these public memory sites are examined and contextualized by attending to the history that led to the creation of each site. Each chapter analyzes the visitor center's holdings, and the museum exhibits, as well as the interpretive materials that sparked controversy and the resulting consequences. For the purposes of this book, I have defined controversy as the appearance of organized demands to change an element of the public memory site's interpretive materials. National historic sites receive abundant communication with suggestions and complaints about their exhibits on a daily basis; however, I am principally interested in those sites where criticisms involved community groups, or regional or national organizations. For each of these case studies, I was motivated by the observation of former Director of the National Park Service (NPS), Robert Stanton, that painful events in U.S. history are places of learning and inspiration.[24] Painful periods in U.S. history are one of the significant

elements that contributed to the paradigm shift of sharing interpretive authority with visitors in the development and changing of interpretive materials at each of the sites studied in this book.[25]

The U.S.S. *Arizona* Memorial experienced controversy primarily when the site replaced its previous orientation film in 1992. The new film included problematic representations that were both historically inaccurate and racist. This film contained a sequence implying that Hawai'ians of Japanese descent had been spies for Japan during World War II. Japanese Americans in Hawai'i organized to demand removal of this depiction, because it was not factual and because the representation perpetuated animosity against Japanese Americans and denied Japanese Americans' claims to U.S. patriotism. Chapter 1 explores how the controversy resulted in the U.S.S. *Arizona* Memorial personnel reediting the orientation film and the addition of multiple exhibits in the visitor center (opened in 2010) depicting Hawai'ians of Japanese ancestry as loyal U.S. patriots.

The California State Railroad Museum (CSRM), which opened in 1980 in Sacramento, the state's capital, encountered contention soon after its opening. Many Chinese Americans were upset by the absence of Chinese in both the museum's exhibits and in the orientation film. It seems counterintuitive that the missing representation in the CSRM was not due to oversight or lack of sensitivity to Chinese contributions in building the California section of the railroad. California State Railroad Museum personnel had attempted to include Chinese in their depictions of California railroad history; however, during the museum's planning stages in the 1970s, the Chinese American societies of the area did not want reference to their roles as coolies in the museum. It was not until the 1990s that a new generation of Chinese Americans would demand inclusion and representation of their difficult history in California and with the railroad. Chapter 2 explores the complex issues for Chinese Americans in their California history as well as the CSRM's evolving response to Chinese American demands for inclusion and persistent reluctance to represent the railroad's social injustices.

The arrival of the paradigm shift to share historical authority at the Alamo brought changes in the site's interpretive materials as well as in its administration. In 2011, the Texas State legislature voted to remove the Daughters of the Republic of Texas (DRT) from their sole custodianship of the Alamo. As of 2012, the Texas State General Land Office has direct responsibility for the operations of the wildly popular historic site, and the DRT must work under its supervision. There were long simmering tensions between the DRT and the Mexican American population of San Antonio as well as with many other Alamo publics. The DRT's lack of transparency as an organization and extremely slow response to community concerns were additional elements that contributed to their removal.

The DRT also had resisted interpreting the Alamo in terms other than the thirteen-day battle in 1836, and the Tejano contribution in this battle for Texas' liberation was mostly absent. In the 1990s, interpretive materials did begin to include Tejano depictions in the fight for Texas liberation along with exhibits locating the Alamo within the broader contexts of U.S. and Mexican history; however, it was too little, too late. The Texas legislature decided that the DRT must be under state control to ensure transparency and responsiveness to its publics. Chapter 3 explores the tensions that led to this shift, the changing interpretive exhibits, and the potential future of interpretation at the Alamo under the new regime.

The Lincoln Memorial is a site where visitor-centric interpretation arrived much earlier than the other sites. African American organizers for civil rights specifically chose the Lincoln Memorial as the location for many of their key rallies and events. A redefinition of the Lincoln Memorial arguably began in 1939 with Marian Anderson's performance on the memorial steps and continued through Martin Luther King's 1963 "I Have a Dream" speech, also delivered on the memorial's steps. Interpretive materials installed in the memorial's basement in 1994 extended the Lincoln Memorial's interpretation as one of emancipation in the form of civil rights not only for African Americans but also for gays and women. In 2003, national leaders called for the removal of the representation that included gays and women. To contextualize this controversy, Chapter 4 examines the original debates that began in 1867 surrounding President Abraham Lincoln's commemoration. The initial disputes concerned Lincoln's legacy as emancipator or as savior of the nation with the resulting memorial embodying both ideals. The civil rights marches of the twentieth century served to change the site's interpretation to one primarily of emancipation. The 2003 controversy rekindled a version of the initial debate concerning how to commemorate President Lincoln. This chapter argues that one segment of the memorial's publics initiated an interpretive shift at the Lincoln Memorial, which took place during the civil rights era and that the controversy surrounding the interpretive materials in 2003 was actually an endorsement of that earlier shift. Although powerful national political forces called for the removal of the images depicting gay and women's rights demonstrations from the orientation film, no calls were made to remove the African American civil rights images; additional national groups organized to challenge those demands, and the film was not changed.

The Mt. Rushmore National Memorial is the site that has had the most substantial changes in its interpretive materials, and it is also the site that most directly represents definitions of U.S. patriotism, citizenship, and nationalism. Chapter 5 is the longest, because the site has had three different orientation films and two different visitor centers and

because the interpretation of Mt. Rushmore's meaning has evolved to the point of complete redefinition. Through all of its changing interpretations, one element that continued to be absent was any reference to Native Americans' claim to the Black Hills and the relationship of Native Americans to Mt. Rushmore. Native Americans have long defined their identity by their geographic location, and for many Americans, the West and its magnificent landscapes have come to define U.S. nationality, especially in opposition to Europeans who look to their historic culture for a definition of their nationality and citizenship. To exclude the Lakota, Nakota, and Dakota Sioux from representation at Mt. Rushmore confiscates part of their heritage.[26] With the hiring of the first Native American superintendent, Gerard Baker, at this national park in 2004, the interpretive paradigm shifted.[27] During his tenure, several exhibits were installed depicting Native Americans; however, the challenge for Mt. Rushmore is whether these exhibits will continue to coexist when there is no longer a Native American superintendent.

The goal of this book is to assist curators, administrators, scholars, tourists, and local communities in recognizing that there are necessary tensions in the interpretations and depictions of history in public memory sites. These tensions reflect changing ideologies and new historical research, as well as various publics' desire for both inclusion and association with U.S. historical liberation narratives and exceptionalism. Additionally, these changes were the result of local, regional, or national publics organizing to demand change in the sites' interpretive materials. Each of the case studies in this book provides an example of how communities had to challenge the institutional structure of a public memory site in order to gain, maintain, or correct their representation in U.S. history. This process is neither easy nor fast. The work of public memory construction is tedious, contentious, and never complete. The tensions that inhabit the relationships of the museological triangle are necessary and unavoidable. In the worst case, these controversies result in disenfranchisement for those publics that have felt like outsiders in the United States, even though their ancestry would dictate otherwise. In the best case, these controversies provide opportunities for those same groups to develop local, regional, and in some cases national organizations that can address their long overlooked and devalued contributions to U.S. history.

The results of the controversies discussed in this book are commendable because they serve as exemplars of how a multiracial country can include difficult narratives of its past in the composition of an inspirational nationalism. The lessons from these case studies are numerous, but the one overwhelmingly salient feature in each site's history is that the demands for change were met with resistance. Yet, change of representation and interpretation does occur at official sites of memory. Further unifying

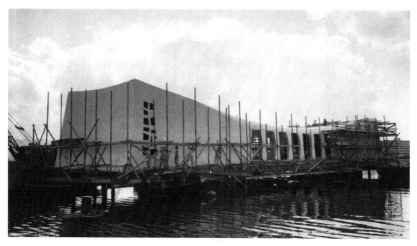

Figure I.6 Construction of the U.S.S. *Arizona* Memorial, ca. 1961 (courtesy of World War II Valor in the Pacific National Monument Archives, Honolulu, HI)

elements for these sites were that the requests for change were grounded in historical accuracy and that the origin of the controversies can be traced to initial discussions surrounding each site's creation. Another theme that emerges is the differential set of challenges between state and federally administered sites. There are certainly institutional limits in a site's ability to respond to its publics; however, the issues in each of these case studies are cultural concerns that affect all sites of public memory regardless of the institution's access to resources. It is not possible for an orientation film, exhibit, or even an entire museum to convey the complete history of an event or site, but interpretive materials can provide visitors with enough information to stimulate their imaginations and encourage them to learn more about the depicted events. Inciting the desire to read additional books, and to see additional films, as well as providing meaningful access, are powerful achievements at sites of public memory. The controversies and demands for change at these five sites demonstrate how patriotism is not carved in stone and that its interpretation is malleable, evolving, and subject to contemporary political considerations. As always, it is up to multiple publics to evaluate the definitions offered. If they are problematic, then we must organize to change them; if they are suitable, then we must stay involved to maintain them. This book is my contribution to this ongoing discussion in the hope of sparking similar conversations in public memory sites around the country.

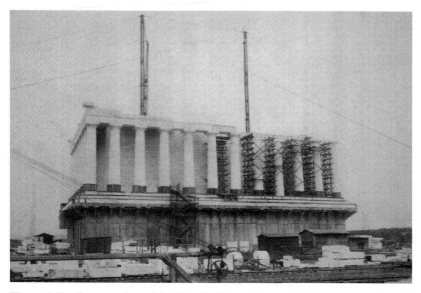

Figure I.7 Construction of the Lincoln Memorial, ca. 1914 (courtesy of Special Collections and Archives, Henry Bacon Papers, Wesleyan University Library, Middletown, CT)

Submerged Patriotism: Evolving Representation at the U.S.S. *Arizona* Memorial Visitor Center

History and memory shape perceptions of the landscape, and the U.S.S. *Arizona* Memorial is one such site where history and memory suffuse every aspect of the landscape. There is no escaping the emotional impact of standing on top of this sunken battleship, watching its slow leak of oil and realizing that this submerged ship is also a gravesite. Given the intensity of this landscape, the stories portrayed here take on additional

Exhibiting Patriotism: Creating and Contesting Interpretations of American Historic Sites by Teresa Bergman, 31–58 © 2013 Taylor & Francis. All rights reserved.

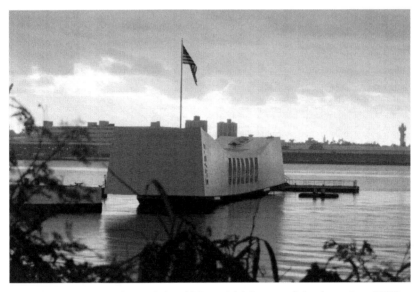

Figure 1.1 U.S.S. *Arizona* National Memorial (photograph by the author, 2005)

weight, and the memories that are constructed during a visit to this site are particularly consequential in the construction of a U.S. national identity.

The location as well as the representation of iconic national historic events can have a deeply personal effect. Architectural historian Edwin Heathcote observes that "memorials to the dead co-exist with the wandering figures of the relatives and the curious; it is at once cathartic and the deepest engagements with the history."[1] This deep engagement with a memorial and its representation can work rhetorically to "activate deep structures of belief that guide social interaction and civic judgment."[2] This powerful mixture at the U.S.S. *Arizona* Memorial and its visitor center activates definitions of U.S. citizenship and patriotism within its representation of events surrounding the bombing of Pearl Harbor. The U.S.S. *Arizona* Memorial is an exceptional case study because its exhibits represent an explicit definition of U.S. citizenship, which includes specific acts that denote patriotism and nationalism.

The site's emotional wallop and its stimulation of civic judgment contribute to producing a historic site with many active and vocal stakeholders. The management and response to this large audience result in a perpetual tension concerning the development of its interpretive materials. An additional element in the creation of its visitor center concerned how to represent the U.S.S. *Arizona* within the vast World War II narrative. On account of the immense scope and consequential nature of these two matters in developing a new visitor center for

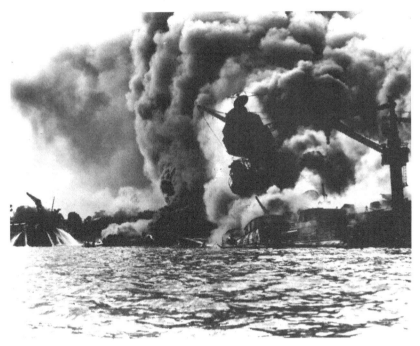

Figure 1.2 Iconic image of the bombing of the U.S.S. *Arizona* Battleship, December 7, 1941 (courtesy of the World War II Valor in the Pacific National Monument Archives, Honolulu, HI)

the U.S.S. *Arizona*, the National Park Service staff began its planning in 2004 with the goal of a 2010 completion date.[3] The previous visitor center was much smaller in narrative scope and in physical size; the vision for the new center was to be both larger and more inclusive of the World War II Pacific theater. The NPS established several goals for its new visitor center, which included—in addition to portraying the events of December 7, 1941—expanding the historical narrative of the U.S.S. *Arizona*, and making this site relevant to contemporary audiences.[4] The U.S.S. *Arizona* Memorial personnel were rightly concerned that changes needed to take place in the interpretive materials in order for contemporary audiences to have a meaningful experience at the site. For the U.S.S. *Arizona* Memorial's interpretive materials to connect with contemporary visitors' lives, its long-established historical narratives needed to be revisited. The diverse publics that visit this site include those who are younger each year and have no personal connection to the site, as well as those visitors whose histories have never been included in the U.S.S. *Arizona* Memorial's narrative on-site.

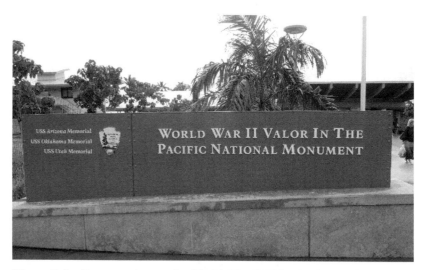

Figure 1.3 Entrance sign to the World War II Valor in the Pacific National Monument (photograph by the author, 2011)

National and international historians continue to research and document historical experiences of those who have been underrepresented, misrepresented, or omitted from historical texts, and this is particularly relevant for World War II narratives. This chapter analyzes the controversy concerning the U.S.S. *Arizona* Memorial's 1980 orientation film and the objections of local audiences to its representation of Hawai'ians of Japanese descent as spies. Additionally, this chapter examines the changes between the 1980 and the 2010 visitor centers, the NPS response to the controversy, and whether the visitor center exhibits provide enough historical context to provide connections to their diverse publics' outside lives.

National commemorative and historic sites provide their audiences with an opportunity to reflect on events, and they provide a touchstone or basis for present and future actions for individuals and for countries. For many, the act of attending a national historic site is, in itself, a performance of citizenship and patriotism. The steady increase in historical tourism attests to its role in the performance of civic virtue, as well as the "worldwide upsurge in memory."[5] In 2002, historian Pierre Nora observed that "every country, every social, ethnic or family group has undergone a profound change in the relationship it traditionally enjoyed with the past."[6] With this upsurge, questions emerged regarding how civic virtue would be defined and how multiethnic histories would be incorporated into historical narratives. For memory studies scholars, these questions demand attention because the content as well as the form of these

narratives contributes to producing messages that "stick" with visitors.[7] That is, the construction of public memory and its "stickiness" or effectiveness depends on "particular audiences in particular situations."[8]

The changes that have taken place at the U.S.S. *Arizona*'s visitor center offer insights into why and how this upsurge in memory contributed to revisions of their interpretive materials. The U.S.S. *Arizona* Memorial *did* include representations of its multiethnic population; however, its representation was a direct challenge to Japanese Americans' patriotism and nationalism. Local groups of Hawai'ians of Japanese descent argued for historical accuracy in a manner that both added complexity to the traditional historical narrative and "rehabilitat[ed] their past [which] is part and parcel of reaffirming their identity."[9] The controversy regarding the depiction of Hawai'ian Japanese Americans at the U.S.S. *Arizona* Memorial raised a dimension of the visitor-centric exhibition shift that extended Robert Archibald's concerns with authenticity and core values. Archibald argues for the need to balance historical evidence and a site's core values in response to a public's demand for change in the interpretive materials.[10] In this particular debate, both sides could demonstrate authenticity and an adherence to core values in the interpretive materials. To meet the demands of the Hawai'ian Japanese Americans, the traditional historical narrative for the U.S.S. *Arizona* Memorial had to be reimagined.

The National Park Service staff at the U.S.S. *Arizona* Memorial is acutely aware that visitors to their sites expect accuracy and elements of authenticity, as well as a narrative of the site's historic events. The controversy at this site concerned the accuracy and lingering racism in the Pearl Harbor attack narrative in the NPS's 1992 orientation film. Local groups were particularly upset with the film's implication that Hawai'ian Japanese Americans functioned as spies for Japan and demanded that the film be changed. To help readers to understand this controversy and its outcome, the next section examines the history of commemoration for the U.S.S. *Arizona*, the development of its first visitor center, the controversy over the NPS's orientation film, its resolution, and the development of the second visitor center. I conclude with a discussion of the lasting vicissitudes of the controversy in the 2010 visitor center and discuss how this case study can serve as an exemplar of diverse publics successfully engaging with a public history site in order to change traditional historiography to produce effective (sticky) historical narratives.

U.S.S. *Arizona* Memorial Background

Recently the U.S.S. *Arizona* Memorial was incorporated into a much larger monument by congressional proclamation. On December 5, 2008, Congress created the World War II Valor in the Pacific National

Monument, with its official dedication on December 7, 2010. This site now includes nine historic sites representing various aspects of World War II history in the Pacific. In addition to the U.S.S. *Arizona*, the monument includes the U.S.S. *Utah* Memorial, the U.S.S. *Oklahoma* Memorial, four mooring quays that constituted part of battleship row, six chief petty officer bungalows on Ford Island, and three sites in Alaska's Aleutian Islands, which include the crash site of a consolidated B-24 Liberator bomber on Atka Island, the Kiska Island site of Japan's occupation that began in June 1942, and Attu Island, the site of the only land battle fought in North America during World War II. The last of the nine designations is the Tule Lake Segregation Center National Historic landmark and nearby Camp Tule Lake in California—both of which housed Japanese Americans relocated from the West Coast of the United States. The monument occupies a total of 6,295 acres, all of which are federal land.[11] This analysis focuses on the U.S.S. *Arizona* Memorial, its visitor center, and the changes that have taken place at this public memory site. The planning and development for the U.S.S. *Arizona* Memorial's 2010 visitor center took place separately from the memorial's incorporation into the World War II Valor in the Pacific Monument.

The U.S.S. *Arizona* Memorial was dedicated on May 30, 1962. The architect was Alfred Preis, an Austrian American, who was living and working in Honolulu at the time and who had fled Nazi Germany in 1939. During World War II, he and his wife were interned for four months on Sand Island in Hawai'i as suspected enemy aliens.[12] Also interned on Sand Island were "naturalized citizens, Italians, Germans, Norwegians, Swedes, Finns, and Hungarians. Next to them, separated by a twenty-foot fence, was the Japanese camp."[13] The implementation of Japanese American internment was handled differently in Hawai'i than in the U.S. mainland, and this situation was due primarily to the large population of Hawai'ian Japanese Americans. "The number of Japanese in Hawai'i who were detained was small relative to the total Japanese population here: less than 1 percent.[14] Preis's experience in the camp may have influenced his decision to create a hopeful design for the U.S.S. *Arizona* Memorial that included a tree of life. Even though initially the memorial was criticized for resembling a "squashed milk carton,"[15] the memorial design went on to receive wide praise and has been described as "majestic" and as a "fitting shrine."[16] Preis explained his meaning of the design as one that "sags in the center but stands strong and vigorous at the ends, [which] expresses initial defeat and ultimate victory."[17] The memorial was listed on the National Register of Historic Places on October 15, 1966.

Several forms of commemoration for the U.S.S. *Arizona* battleship had begun soon after the attack, one of which included military personnel saluting

as they passed the sunken ship off Ford Island. In 1946, when Tucker Gratz, naval officer and Chair of the Pacific War Memorial Commission, "placed a lei" over the shattered warship, where he "found the wilted remains of the lei he [had] placed the year before."[18] In fact, wreath-laying over the sunken battleship became so popular, that in 1957 the *Tuscaloosa News* declared: "Wreaths from each of the forty-eight states will be placed aboard the bomb-gutted sunken battleship U.S.S. *Arizona.* . . . It will be the first time in the sixteen years since the Japanese sneak attack that representatives from all forty-eight states have participated in such a ceremony."[19]

In 1950, the Navy erected a temporary wooden platform with a flag[20] over the ship, and this platform is currently in storage on Ford Island.[21] Subsequently, the Navy constructed the first permanent memorial in Pearl Harbor on December 7, 1955, which consisted of a ten-feet-high basalt stone with a dedication plaque that was placed over the mid-ship deckhouse on the battleship.[22] Plans for a larger memorial began in 1956, but there were substantial difficulties in raising funds for its construction. Creative fundraising for the memorial included a performance by Elvis Presley; all the proceeds went to the memorial's construction in 1961.[23] Initially, plans for this memorial were under the auspices of the Pacific War Memorial Commission, the group that oversaw the development and construction of war memorials throughout the area.[24] Concurrently, the Navy operated the site in order to preserve its control over the battleship's commemoration. However, the Navy soon realized that the site's popularity was rapidly increasing. In 1962, the visitor total was just over 122,000 and by 1973, the number of visitors was over a half million. Since 1990, the site has received

Figure 1.4 Lei floating above U.S.S. *Arizona*, May 30, 1962 (courtesy of the World War II Valor in the Pacific National Monument Archives, Honolulu, HI)

approximately 1.5 million visitors annually, making it one of the most popular visitor destinations in O'ahu.[25] The Navy recognized this long-term upward trend and also understood that it was not prepared to handle the increasing number of tourists. Former Congressional Hawai'ian Representative Spark M. Matsunaga "pointed out that visitors to the Arizona Memorial now must stand at an uncovered boat dock to await transportation" and that "visitors facilities are urgently needed."[26] Although the Navy did not want to give up complete control of the site, on October 10, 1980, the Navy agreed to jointly operate the site with the National Park Service. The terms of this agreement included the Navy retaining control of the boats taking tourists from the visitor center out to the memorial, while the NPS developed and operated the visitor center as well as any other interpretive material on the grounds. This operational agreement existed as of 2012.

The first visitor center for the U.S.S. *Arizona* was completed in 1980, and it was replaced with a new visitor center that was dedicated on December 7,

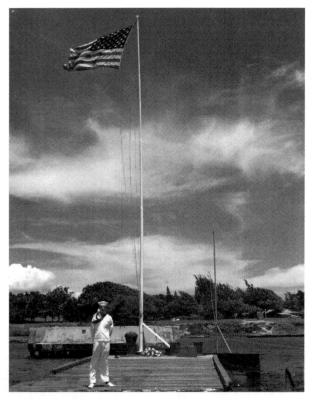

Figure 1.5 Navy platform above U.S.S. *Arizona*, 1950 (courtesy of the World War II Valor in the Pacific National Monument Archives, Honolulu, HI)

2010. There was dire need to create a new visitor center on account of the literal sinking of the buildings. The original visitor center buildings were designed to settle up to twelve inches because the buildings were knowingly built on landfill; however, the first center's buildings had sunk over thirty inches. Ironically, the 1980 visitor center won a design award because of its engineering excellence that allowed "the building to be lifted hydraulically and re-leveled from time to time as . . . settlement occurs."[27] In addition to the challenges of building on landfill, the development of the first memorial and visitor center evinced competing visions of the memorial's contents.

Ideological concerns regarding what was to be commemorated at this site started in 1957 when John Burns, Hawai'i's single delegate to the U.S. Congress (who did not have a vote, because Hawai'i did not become a state until 1959), introduced legislation to create a memorial for the U.S.S. *Arizona*.[28] Burns was well aware of the competing views of how to commemorate the U.S.S. *Arizona* and the Pearl Harbor attack. The range of views included that of Tucker Gratz, who saw it as "a fitting tribute to the personnel of the U.S.S. *Arizona* who gave their lives . . . and whose remains have not been and cannot be recovered."[29] The Chief of Naval Operations, Admiral Burke "thought of it as commemorating all American servicemen who lost their lives in the Pacific during World War II, and it will remind the people of the free world that they must never allow an attack such as that which sank the *Arizona* to occur."[30] Admiral Nimitz wrote at the time that "I have always regretted that we memorialize Pearl Harbor Day—which was a great defeat for us."[31] Federal funding and approval of construction of the memorial eventually came in 1961 from Senator Daniel Inouye's HR 44, which also provided the first "official" definition of the memorial's purpose, which was "to be maintained in honor and commemoration of the members of the Armed Forces of the United States who gave their lives to their country during the attack on Pearl Harbor, Hawai'i, on December 7, 1941."[32] Similar to the development of other national memorials, the development of U.S.S. *Arizona* Memorial had many stakeholders. In addition to a tremendously diverse tourist public, and the extremely vocal and active participation of the survivors and their families, there was also the ongoing pressure to take into account the United States' changing role in international relations and, in particular, to address the issue of a former enemy becoming an ally.

1980 Visitor Center

The first visitor center was diminutive when compared to the 2010 visitor center, but, in 1980, the new buildings were a vast improvement to the uncovered Navy dock where tourists would stand, sometimes for hours, waiting for the boat ride out to the memorial. In addition to

Figure 1.6 U.S.S. *Arizona* visitor center 1980–2010 (courtesy of the World War II Valor in the Pacific National Monument Archives, Honolulu, HI)

standing in the rain or the Hawai'ian sun for "three hours or more,"[33] "visitors learn[ed] nothing about the Dec. 7 story,"[34] according to a local newspaper report. The Navy provided a brief oral orientation for visitors on the boat ride to the memorial and also offered a tugboat tour of Pearl Harbor.[35] The NPS designed the 1980 visitor center to include two orientation film screening rooms, a bookstore, and a small space for interpretive exhibits. The NPS, in consultation with the Navy, developed the interpretive area, which contained four permanent exhibits and one changing exhibit structure.[36] The four permanent exhibits that composed the interpretive section were "Paxton Carter" (the U.S.S. *Arizona*'s acting pay clerk), a "1941 and 1987 model of the U.S.S. *Arizona*, Pre-War Navy and World Situation, and the Japanese View of the Attack."[37] The 1980 visitor center covered neither Japanese internment and incarceration camps nor Hiroshima and Nagasaki.[38] According to Daniel Martinez, historian for the memorial, the NPS limited interpretation at the site to the attack on Pearl Harbor and to the memorial. Although Martinez found this limitation "horrifying" because it ran counter to providing visitors with a complete story of the site,[39] the 1980 visitor center was well received and described as richly supplementing the boat ride to the memorial[40] and as a "gem."[41]

The development and implementation of the themes and narratives for the first exhibits were to include "heavy 'personalization' of the Pearl Harbor story."[42] Early NPS memos state that the guidelines for putting together the collections for the visitor center should include: "Oral history—collecting oral history from ex-service men, civilians, Japanese American residents of Hawai'i, and Japanese airmen and sailors (who participated in the attack). This is probably where most of our efforts should go."[43] In fact, the collection of oral histories continues to be a major interpretive theme in the 2010 visitor center. One of the ongoing problems for the U.S.S. *Arizona* administrators has been how to manage the collections, because they are inundated with donations of World War II artifacts. The size of the collections for the 1980 visitor center exhibits was limited primarily because of space. Former site Superintendent Gary Cummins addressed the interpretive limitations that resulted from such a small amount of interpretive materials and collections by using a twenty-minute orientation film. He described the centrality of the orientation film in this small visitor center where, "Much of the interpretive burden is taken off of the staff by the movie . . . It constitutes the heart of the interpretive program."[44] The U.S.S. *Arizona*'s orientation film plays a prominent role in every visitor's experience at the memorial because of the overall design of the 1980 visitor center. Visitors could choose to bypass the four interpretive exhibits and bookstore, but if they wanted to board a boat to the memorial, they were required to view the orientation film,

because the entrance to the boarding docks was accessible only through the theaters.

The first orientation film was commissioned by the Navy and began showing at the memorial in 1980. This film was twenty-two minutes long and served as the basis for the second orientation film, which the NPS commissioned and began showing on site in 1992. The Navy film employed a documentary expository format that included a male narrator (Robert Stack), sound effects, and background music. The images included graphics, animation, newsreel images, Hollywood film clips, historic photographs, and contemporary images of the U.S.S. *Arizona*. The Navy film had no interviews, titles, or screen credits. The expository format combined with the lack of screen credits and its location in the visitor center all contributed to the film's reception as the site's authoritative narrative. The film begins with forty seconds of "eerie sounds"[45] over contemporary images of the sunken U.S.S. *Arizona* while voices whisper the names of the dead soldiers, followed by approximately two minutes on the history of the battleship before Pearl Harbor, approximately six minutes describing events leading up to the attack, approximately five minutes depicting the attack, and approximately seven minutes explaining the aftermath. Lyle Nelson, the military writer for the *Honolulu Star Bulletin*, quickly criticized the film's factual errors in describing the Japanese invasion of the Marshall Islands; it was "an impossibility since the Japanese received the Marshalls by mandate at Versailles in 1919." Furthermore, it was "unclear that the capture of Singapore, the smashing of American aircraft at Clark Field, the Battle of Java, and the invasion of Guam all occurred after Pearl Harbor."[46] Several of these errors were corrected by 1981, and Nelson praised the corrections even though the film had "to show the fall of Singapore before the climax of the film, the attack on Pearl Harbor. Historically they were in reverse order."[47]

Criticism of the Navy orientation film was not limited to factual errors. There were also complaints regarding the descriptions of the Japanese military and comments that the film was "too soft on the Japanese."[48] Former Park Supervisor Don Magee observed that the Navy film described Admiral Yamamoto as "a brilliant strategist" and that this was "too much for some people."[49] In a letter to the producers who were creating the replacement orientation film for the NPS, Magee wrote that describing Admiral Yamamoto as brilliant was a "controversial statement" and need "not be repeated" in the new NPS film. Even though Magee insisted that the "subject matter be treated with sensitivity," the 1992 NPS orientation film became controversial for very different reasons.[50] Although the NPS wanted to create an entirely new film and was "deliberately crafting something original without reference to the film it replaced,"[51] the new

NPS orientation film did borrow from the Navy's orientation film. The 1992 NPS film incorporated images from the Navy film; however, there was no indication which images were created for the film and which images were culled from newsreel footage. It was this borrowing that ushered in the paradigm shift at the U.S.S. *Arizona* Memorial, where both the content and the process concerning exhibition creation became much more visitor-centric.

How Shall We Remember Them

The NPS orientation film, *How Shall We Remember Them*, began screening in the visitor center in 1992 and, with a few changes, was still showing in 2012. The film begins with contemporary underwater images of the U.S.S. *Arizona*, and then a camera pans across the marble-engraved names in the Memorial's shrine room (echoing the Navy film's whispering the names of the dead), followed by approximately eight minutes on the history of events leading up to the war, approximately eight minutes describing the attack, and approximately five minutes on the aftermath and its lessons. Lance Bird, the producer of the 1992 NPS orientation film, was clearly aware that many publics continuously scrutinized the U.S.S. *Arizona* Memorial's interpretive materials when he wrote: "This site generates more letters to Congressmen and Park Service executives than any other site in America."[52] The Honolulu local paper described that for some World War II veterans, criticizing the U.S.S. *Arizona* Memorial is "almost a way of life."[53] There were several themes in the continual feedback that the NPS staff took into consideration while creating the 1992 film. One theme regarded a steady set of criticisms from veterans who thought the Navy film was not adequately critical of the Japanese. Their critique placed blame for the film's depictions with the NPS, apparently unaware that the Navy had produced the first orientation film: "Veterans groups, blaming the Park Service for the original film, had regularly demanded that the visitor center be taken away from the Park Service and operated by the Navy."[54] Consequently, the NPS was extremely sensitive to the survivors' critique of the interpretive materials appearing too lenient in their depictions of the Japanese.

The second change that the NPS staff wanted for the new orientation film concerned the film's tone. Previously, NPS personnel had observed that visitors would "come out a lot more aggressive" after viewing the Navy's orientation film.[55] The ending of the Navy's orientation film included the U.S.'s road to triumph (in particular, the Navy's role) in World War II, rather than concluding on a more somber commemorative note. The final narration of the Navy film states: "If we ever forget December 7, 1941; if we ever forget over 1,000 men still entombed

Figure 1.7 U.S.S. *Arizona* Memorial Shrine Room (photograph by the author, 2011)

aboard the USS *Arizona*; if we ever forget that a nation unprepared will sacrifice many of her finest men and women, then we would forget what American stands for and that is why we must remember Pearl Harbor. Home Port still, for one of the world's most powerful Naval forces, the United States Pacific Fleet."[56] This desire to change the film's tone echoes the initial discussions surrounding the memorial's creation and whether the memorial should be interpreted as a shrine to those who died or as a reminder for constant vigilance against future attacks. The NPS chose to invoke the shrine interpretation and replaced the Navy's orientation film with little fanfare as reported in the *Honolulu Star Bulletin*: "The National Park Service quietly switched films yesterday at the *Arizona* Memorial Visitor Center hoping to end a controversy that has simmered since the museum opened in 1980."[57] NPS staff believed that the new film would satisfy the veterans' concerns as well as make visitors' attitudes more reflective and commemorative at the memorial. With so much attention focused on addressing the survivors' concerns and changing the film's tone, the NPS did not anticipate the new set of criticisms related to the film's representation of Hawai'ian Japanese Americans.

James and Yoshi Tanabe wrote the NPS in 1998 complaining that the orientation film implied that Hawai'ian Japanese Americans functioned as spies supplying vital information to Japan concerning the Pacific Naval Fleet in order to aid their attack on Pearl Harbor. In retrospect, it is fitting

that the Tanabes were the ones to call attention to the problematic message and to become the driving force demanding its change. Many members in the Tanabe family had served in the U.S. military. Two of Mrs. Tanabe's brothers served in World War II in the 442nd Regimental Combat Team, and one served through Korea and Vietnam, while another of her brothers and James Tanabe served in the Military Intelligence Service.[58] The surprising aspect about the Tanabes' critique is that it did not take place until 1998. The Tanabes stated that even though they both first saw the film in 1992, it was only "after seeing the film several times with visiting friends and relatives [that] they decided to do something about it."[59] The visitor-centric paradigm shift to share historical authority had finally reached Hawai'i and the U.S.S. *Arizona* Memorial.

The problematic film sequence for the Tanabes included three scenes beginning with an image of an Asian-looking sugarcane cutter who looks out to Pearl Harbor and the Pacific Fleet from the field where he works. This scene is followed by two different crowd shots of Asian-looking people walking in downtown Honolulu. The narration that accompanies this three-scene sequence states: "General Short believed, however, that the great danger was not air attack but saboteurs, hidden amid Hawai'i's large Japanese population."[60] The choice of the first image for this sequence has a provocative history. The sugarcane cutter footage was also used in the Navy's orientation film, and it is a recreation that was made for the 1943 documentary, *December 7th*. John Ford (then Lieutenant Commander) and Greg Toland (then Lieutenant) made this film as part of the U.S. War Department's morale film series.[61] *December 7th* contained actual historical footage as well as historical recreation, but there is no indication identifying which footage is a recreation and which is not. The sugarcane cutter image was taken from a six-minute sequence that depicted how easy it was for Hawai'ian Japanese Americans to function as spies. This inflammatory sequence is also accompanied by tense music, and includes scenes focusing on the casual conversations between unsuspecting U.S. citizens (portrayed by those who do not look Asian), and the many Japanese Americans doing their jobs (barbers, maids, dancers, taxi drivers, and even children playing). The sequence implied that Japan received its intelligence concerning the Pacific Fleet's movements from Hawai'ian Japanese Americans through their daily conversations with U.S. military personnel and through their ability to see Pearl Harbor military ship movements from their homes.

December 7th won the academy award for best short documentary in 1944; however, 2012 audiences would be hesitant to classify this film as a documentary because there is so much historic recreation, including scripted performances by Walter Huston and Dana Andrews and many others. Although the film contains a large amount of actual footage

from the attack on Pearl Harbor, contemporary audiences would be more inclined to call this form of film a docudrama.[62] *December 7th* was extremely biased in its depictions of Hawai'ians of Japanese descent, and the use of its staged footage within an expository documentary format that is shown at the U.S.S. *Arizona* Memorial compounds its reception as definitive and accurate.

World War II historical research confirmed that there were no acts of sabotage by the local Hawai'ian Japanese American population, and the Tanabes wanted the statement of Robert Shiver, the former chief of the FBI's antisabotage unit in Hawai'i, added to the orientation film: "There has been no proven case of espionage or sabotage by any resident of Japanese ancestry in Hawai'i either before, during or after the war."[63] The NPS film's portrayal conflated U.S. military fears of Hawai'ians of Japanese ancestry functioning as spies with the fact that Japanese nationals did conduct espionage in Hawai'i. Historian Gordon Prange describes one Japanese national in particular, Takeo Yoshikawa, who worked in the Japanese consulate and would "dress in laborer's garb and hide among the cane," because the sugarcane fields gave him "the best view of the Pacific Fleet in Pearl Harbor."[64]

There were two other events that could only loosely be construed as Hawai'ian Japanese Americans aiding Japan, but even these two are questionable. Historian Geoffrey White explains that the one "example of support for the Japanese military occurred in the Island of Ni'ihau, when Yoshio Harada, a California Japanese American, attempted to aid the escape of a downed Japanese aviator," which also could be interpreted as a humanitarian act. White declares that "The only documented case of a Hawai'ian Japanese American assisting [a] Japanese [national] spying on Pearl Harbor is that of John Mikuma, who regularly acted as a taxi driver for military attaches gathering intelligence."[65] Mikuma drove Yoshikawa (the real spy) to various spots in Hawai'i, including scenic overlooks and the infamous sugarcane fields, but there is no historical documentation that he did anything other than his job as a taxi driver by driving Yoshikawa where he wanted to go.

The U.S.S. *Arizona* Memorial historian, Daniel Martinez, initially answered the Tanabes' criticism by citing three different sources and eight citations to document the military's suspicions of local sabotage, which included Gordon Prange, *Shipmate Magazine*, and quotations from the Hearings before the Joint Committee on the Investigation of the Pearl Harbor Attack.[66] In response, the Tanabes enlisted the support of politicians and several community groups including the Japanese American Citizens League (JACL), the 442 Veterans club, the Americans of Japanese Ancestry Veterans Council, and U.S. Senator Richard Lugar from Indiana. The Honolulu chapter of the JACL conducted screenings

of the NPS orientation film for its members, collected feedback, and wrote to the U.S.S. *Arizona* Superintendent demanding that the NPS eliminate "any implication that Americans of Japanese ancestry were engaged in espionage or sabotage before the Pearl Harbor attack" and "delete any race based images . . . specifically JAPS BOMB PEARL HARBOR."[67] The JACL also enlisted the support of Senators Daniel Inouye and Akaka, as well as Congressional Representatives Neil Abercrombie and Patsy Mink.[68] Moreover, the Tanabes made the strategically savvy move of contacting the Pearl Harbor Survivors Association (PHSA) in order to gain their support in demanding that the NPS change their orientation film. Both the JACL and the PHSA agreed with the Tanabes' assessment that the film implied that Hawai'ians of Japanese descent functioned as spies. Robert Kinzler, the president of the PHSA, stated that "When I heard about their concerns and they explained it to us, it was OK," because it "doesn't rewrite history."[69]

As demands to change the NPS orientation film grew louder, Kathleen Billings, then Superintendent of the U.S.S. *Arizona* Memorial, sought outside opinions on the film's depiction of Hawai'ians of Japanese descent. She contacted University of California Berkeley Professor Ronald Takaki, Tufts University Professor Roger Daniels, and University of Washington Professor Gail Lee Dubrow. All three professors supported the Tanabes' interpretation of the sequence, and all three went further in their critique of the NPS orientation film. Professor Takaki wished that "the narrator had described, even briefly, the fervently loyal responses of Japanese Americans in Hawai'i during and shortly after the attack."[70] Professor Daniels noted that the majority of Hawai'ians in 1941 were Asian Americans and that "the film clips used to show America fighting back and winning only show white Americans."[71] Sending the longest reply, Professor Dubrow was highly critical of the film as a whole: "It is entirely unbalanced in its treatment of Japanese vs. American colonialism, imperialism and aggression in the Pacific during the first half of the twentieth century," and "the most disturbing and misleading aspect of the video is its failure to address the American governments [*sic*] response to the Japanese bombing of Pearl Harbor, in terms of domestic policy." Professor Dubrow also commented on the film's problematic representation of women: "Might women appear in the film other than as hula girls?"[72] Superintendent Billings probably received more criticism of the film than she had initially sought, but these responses, combined with the Tanabes' organizing of community groups and elected officials, finally brought the NPS into negotiations to change the film.

This time when the NPS staff at the U.S.S. *Arizona* Memorial responded to the Tanabes' demand for changing the film, it was in terms

Figure 1.8 World War II Valor in the Pacific National Monument visitor center (photograph by the author, 2011)

of budget constraints. The NPS staff no longer argued for their previous claims of historical accuracy but instead negotiated for changes that would incur minimal costs while satisfying the Tanabes. After a series of meetings, they reached a compromise that consisted of digitally removing the sugarcane cutter image from the film and editing the narration. The narration, which stated "General Short believed, however, that the great danger was not air attack but saboteurs, hidden amid Hawai'i's large Japanese population," was changed by eliminating the words "hidden among Hawai'i's large Japanese population." The resulting scene is of a sugarcane field with battleships in Pearl Harbor in the far distance and no sugarcane cutter. The Tanabes had also wanted the NPS to insert a five-second disclaimer into the new sugarcane scene (with the cane cutter absent), which would have read: "NO SABOTAGE WAS COMMITTED BY JAPANESE RESIDENTS IN THE U.S."[73] However, this disclaimer was not added. James Tanabe stated that he understood that he compromised, but he was pleased that the NPS "removed the offensive footage of implied disloyalty."[74] Yoshi Tanabe was satisfied with the compromise as well and told the local newspaper that this is "what our country is all about . . . you're going to correct it when it's wrong and support it when it's right."[75] This version of the orientation film, with three additional minor narration edits, was still showing on site in 2012 with no immediate plans for its replacement.[76]

Historian Geoffrey White has written on the use of the sugarcane cutter scene and the problems it engendered in terms of how the memories created by the U.S.S. *Arizona*'s orientation films changed from depictions heightened by the "emotions of war" to representations "advancing public

education for global audiences."[77] These edits do move the film away from illustrating emotions of war and more toward advancing public education. The Tanabes' demand for change also coincided with the broader movement of national museums responding to their community's concerns about their interpretive exhibits. Former museum curator Robert Archibald observed that "previously suppressed voices now successfully demand to be heard."[78] And in this particular case study, the previously suppressed voices *were* heard, and the consequences reverberated beyond the orientation film. During the negotiations to change the orientation film, the Park Superintendent as well as the Tanabes floated ideas of expanding the visitor center's interpretive exhibits as another path toward inclusiveness and clarifying the patriotic contributions of Hawai'ians of Japanese ancestry during World War II. The timing for these suggestions was fortuitous, because the U.S.S. *Arizona* Memorial was beginning its plans to replace its visitor center.

2010 Visitor Center

The NPS visitor center opened in February 2010 and was dedicated on December 7, 2010. This configuration doubled the exhibit space from approximately 3,500 square feet to 7,000 square feet, added six acres to the entire site for a total of 17.4 acres, and cost approximately $58 million.[79] Instead of grouping the buildings together into a large rectangle (similar to the previous visitor center), the new complex of buildings formed more of a long L shape connected by wide outdoor walkways with ample overhangs that provide much needed shade. The buildings are divided into several areas, which include ticket sales, an education and research center, two sets of greatly expanded restrooms, a substantially larger bookstore, a snack shop, two history exhibit halls, two theaters (the only buildings remaining from the previous visitor center), and an interpretive trail that runs along the harbor coastline from the boat dock to the U.S.S. *Bowfin*. There is no obvious separation between the two sites, even though a private nonprofit group, the USS [*sic*] *Bowfin* Submarine Museum & Park, operates the U.S.S. *Bowfin* site, and the NPS operates the U.S.S. *Arizona* Memorial. One of the unanticipated results of physically connecting the two sites concerns the iconic outdoor elements at either end of the broad center walkway. On the U.S.S. *Arizona* side stands a large white replica of Alfred Preis's "Tree of Life" from the memorial's shrine, and on the U.S.S. *Bowfin* side stand extremely large black and red painted torpedoes. Although not planned, the connection of these two elements embodies the initial ideological debate over whether the U.S.S. *Arizona* Memorial should stand for peace or for preparedness against future

attacks. The interpretive trail that runs between the two historic sites along the harbor includes a remembrance circle, the U.S.S. *Arizona*'s anchor, and a series of explanatory signs depicting Pearl Harbor as it was during the December 7, 1941, attack. The new visitor center resembles more contemporary history museums by incorporating interactive exhibits and more opportunities for shopping and food. In fact, one columnist wrote that the new visitor center reminded him of a "really nice elementary school."[80]

In addition to greatly enhanced visitor facilities (that is, larger and more bathrooms, food availability, ADA compliance, shaded outdoor seating areas), the interpretive exhibits inhabit two buildings entitled "The Road to War" and "The Attack." The doubling of the interpretive space accomplishes many goals including shifting the visitor center away from functioning primarily as a shrine to those who lost their lives in

Figure 1.9 Replica of Alfred Preis's "Tree of Life" from the U.S.S. *Arizona* Memorial located in the 2010 World War II Valor in the Pacific National Monument visitor center (photograph by the author, 2011)

the December 7th attack and toward providing contextual information about World War II. With almost twice the amount of interpretive space, the site now offers much more background on events leading up to the attack on Pearl Harbor as well as additional information on its aftermath. The two new interpretive exhibit halls strive to provide content in multiple formats, including video monitors, artifacts, and exhibits with hands-on elements. (Visitors can turn dials and press buttons to activate audio-visual elements.) Museum Studies professors John Falk and Lynn Dierking argue that, for learning to take place in a museum, it is helpful to employ "multisensory and multimedia techniques, which aids audiences in acquiring information through visual, aural, and tactile means."[81] In addition to incorporating twenty-first century museum studies research into the form of the new interpretive material, the content of the new interpretive exhibits integrates elements of the visitor-centric paradigm shift of sharing historical authority that was initiated by the Tanabes.

Figure 1.10 The torpedoes that stand in front of the U.S.S. *Bowfin* entrance are located opposite of Alfred Preis's "Tree of Life," both of which are part of the World War II Valor in the Pacific National Monument (photograph by the author, 2011)

From the beginning of the planning and design for the 1980 and 2010 interpretive exhibits, the U.S.S. *Arizona* Memorial staff consulted with the public; however, not all their publics were treated equally. The one public to which the Memorial administration was most responsive was the Pearl Harbor Survivors Association. As late as 1997, Geoffrey White observed that there was a "general cognizance that veterans are a primary constituency for the memorial and its film—a cognizance that shapes the context within which representation of Pearl Harbor history are produced at the memorial."[82] The U.S.S. *Arizona* Memorial's move to value the Hawai'ians of Japanese ancestry public as much as the Pearl Harbor survivors' public was momentous, and the consequences of this shift rippled through the planning and development of the memorial's 2010 visitor center. During the initial planning stages for the new visitor center, the U.S.S. *Arizona* staff conducted an extraordinary outreach effort for comments on each element of the new interpretive exhibits. The U.S.S. *Arizona* administrative staff contacted ten historians, six military reviewers, six educators, four Pearl Harbor Historic Partners, seventeen stakeholders, the NPS Harpers Ferry Center, and eight Pearl Harbor survivors.[83] Site historian Daniel Martinez, who participated in the development of both visitor centers, knows of only one other NPS site—Custer's Battlefield—that had so many stakeholders involved in its development.[84]

One challenging consequence of involving so many publics in the design process was that the project became much more difficult to manage. Aldrich Pears Associates, the design group that won the design contract for the new NPS visitor center, received voluminous amounts of comments from the reviewers who provided feedback on everything from historical accuracy to suggestions to widen the World War II Pacific War's historiography. Military historian Mike Wenger wrote a fifteen-page, single-spaced response stating that the NPS needs to do some "MAJOR fact checking and sweeping up behind Aldrich-Pears," so that the "NPS does not get a black eye here."[85] John W. Roberts, the senior archivist at the NPS Washington Support Office stated that his "biggest concerns are that the exhibit fails to address (and debunk) the Pearl Harbor conspiracy theories."[86] Professor Tetsuden Kashinma cited the need to clarify the differences between internment and incarceration, because not making "clear the difference between the two processes and terms leads to a misunderstanding of the mass incarceration of Japanese Americans on the mainland."[87] Professor Laura Hein commented that "the perspective of Asians other than Japanese is completely missing from this exhibit" and that "World War II in the Pacific includes more than just the USA and Japan."[88] Ultimately, the U.S.S. *Arizona* Memorial staff needed to hire additional personnel and brought in the NPS Harpers Ferry Center in order to bring the project to fruition.

With the increased participation in the 2010 planning process and a heightened sensitivity to a wider array of the memorial's publics, the ramifications of its paradigm shift into incorporating multiple publics' participation into exhibition design can be found throughout the interpretive exhibits in new visitor center. Most notably is the manner in which the exhibits interpret the issue of spying in O'ahu. In the 2010 interpretive exhibits, there are twelve different displays that address this issue as well as Japanese American loyalty to the United States during World War II. This topic begins in the "Road to War" building with the "Japanese Information Gathering" panels that describe Takeo Yoshikawa, a Japanese national, and his documented espionage work for Japan before the attack on Pearl Harbor. Next to this display is a hands-on exhibit that provides a magnifying glass for visitors to use on a photo to identify the U.S. battleships in Pearl Harbor. This exhibit communicates the ease with which Yoshikawa collected vital information on the U.S. Pacific Fleet's schedules in and out of Pearl Harbor. The depictions of Lieutenant General Short's suspicions are located in two displays; one is at the end of a two-paragraph biography stating that "he considered potential sabotage by local Japanese a realistic and serious threat."[89] The second reference is in the exhibit entitled "Defending O'ahu," under the "Cracks in the Citadel" subheading; the description reads, "Short focused on preparing to repel beach assaults and foiling sabotage."[90] Instead of committing the same mistake as in the first version of the NPS orientation film, the new interpretive exhibits respond repeatedly to Short's suspicions. The "Fear of Sabotage" exhibit rebuts Short's suspicions in the first sentence of text: "Military commanders in Hawai'i and Washington viewed with great but unwarranted suspicion Hawai'i's large number of people of Japanese descent." And farther along in the "Road to War" building, the exhibit with a "Japanese Map of O'ahu" points out how easy it was to gather information on the Pacific Fleet: "Besides using standard navigational charts, the Japanese also used publicly available charts in planning and carrying out their attacks."[91] In the "Eve of War" display, located toward the end of the "Road to War" building, there is the subheading "Suspicions about Loyalty." This rhetorical statement is countered with the text "Hawai'i's large community of people of Japanese descent had much to lose—and much to fear—from war with Japan." Furthermore, "many Japanese Americans belonged to the Emergency Services Committee, which worked as a liaison between military authorities and the civilian community to relieve tensions and misunderstandings."[92] This display acknowledges the suspicions and provides visitors with concrete examples of Japanese Americans' loyalty during the war and also implies that the suspicions were unfounded.

Additional effects of the memorial's paradigm shift into sharing historical authority are also visible in the second building, with interpretive

materials entitled "The Attack." Inside this building, the "Acts of Valor" exhibit includes biographies of Naval and Air Force award winners and of Harry Tuck Lee Pang, a firefighter with the Honolulu Fire Department. Pang responded to the fire at Hickam Air Force Base with twenty-one other firefighters and was killed by Japanese machine gun fire. In 1984 he became the first civilian to receive a Purple Heart.[93] The addition of Pang to this display broadens to definition of acts of valor during wartime to include those outside the military and, important to note, Hawai'ian Asian Americans. The "Hawai'i at War" exhibit highlights Hawai'ian Asian American experiences during World War II, with Violet Lai attesting to how fearful it was for children to live in O'ahu under martial law. Another panel describes how "Richard Chun and his classmates picked fruit after their elementary school was converted into a hospital," and, continuing in Chun's words: "'Everyone goes into the pineapple field, and you get graded, too, because theres [sic] teachers in the pineapple field.'"[94] The postwar suspicions of Hawai'ians of Japanese ancestry are again addressed in this building's "Loyalty Questioned" exhibit. Painted on the wall is a startling quote from Harry Goda, identified as a Japanese American teacher at a Japanese-Learning school on Maui, which reads: "You are not an American citizen. You are a Jap. That word I cannot forget [during] my lifetime, you know. You are not a citizen, although you were born in Hawai'i. You're a Jap."[95]

The 1980 visitor center had no exhibits concerning internment and incarceration of people of Japanese ancestry. The only reference to their presence in the war was one temporary exhibit on the 442nd regiment, which had "generated a fair amount of complaints."[96] Representation of the 442nd regimental combat team is in a permanent exhibit in the 2010 visitor center, and it is located in the "Loyalty Questioned" exhibit in the "Attack" building. This exhibit also includes descriptions of interment as well as the first section of the internment proclamation, explaining that President Roosevelt signed Executive Order 9066 owing to "widespread fears of sabotage and espionage." This statement is immediately followed by a quotation from Japanese historian Shigeo Yoshida stating that "those fears were 'the least of the things they could have been concerned about, because during the War, there was not a single case of confirmed sabotage concerning the Japanese population.'"[97] A second exhibit on internment, entitled "In Hawai'i Disrupted Lives," describes how Executive Order 9066 was carried out in Hawai'i: "The nearly 150,000 people of Japanese ancestry living in Hawai'i were spared mass internment, but their lives changed forever. About 5,000 were detained under martial law. Many of those were incarcerated at internment camps."[98]

The additional exhibits on the interment and incarceration of people of Japanese ancestry also coincide with larger cultural changes that have

taken place since the creation of the 1980 visitor center. During this time, the Congress and President Reagan approved the Civil Liberties Act of 1988 apologizing for Executive Order 9066, built the Japanese American Memorial to Patriotism During World War II in Washington, D.C. (2000), completed the NPS Manzanar National Historic Site (2004), and included the Tule Lake Basin (location of Japanese Americans' incarceration) in the creation of the World War II Valor in the Pacific National Monument (2008). The shift to visitor-centrism in exhibition development at the U.S.S. *Arizona* Memorial "parallel[ed] actual social change"[99] and was also part of a successful nationwide movement to publicly define Japanese Americans' longtime patriotism and loyalty to the United States.

Additional fingerprints of the U.S.S. *Arizona* Memorial's exhibition development shift are evident in two other new exhibits. One exhibit, entitled "State of Mind: Japan," depicts Japanese events during the 1930s and 1940s, and the other exhibit portrays the local Hawai'ian population in 1941 in the "O'ahu Court." The "State of Mind: Japan" exhibit is particularly evocative, owing to its placement directly next to the "State of Mind: America" exhibit. These two exhibits cherry-pick popular culture artifacts to create an impression of day-to-day life in both countries. The American side has images of the Great Depression's unemployment lines, newspaper boys, jitterbugging couples, and protesting isolationists interspersed with political commentary from President Roosevelt, Charles Lindbergh, and Joseph P. Kennedy. The Japanese side of the exhibit includes an image of Babe Ruth with teenage Japanese baseball players, kimono-wearing women playing badminton, posters from the Greater Asia Co-Prosperity project, the Great Depression's effects on Japan, a student's observations at the time—"I believed that Japan was liberating Asia"—children's school songs, and another Japanese elementary student reminiscing about Japanese racism—"My friends would talk of nothing but the brave Japanese and the cowardly Chinks."[100] Historian Saburō Ienaga's political commentary is peppered throughout the exhibit: for example, "Negotiations were broken off with America in order to protect the Empire's position as the stabilizing force of Asia" and there was "a national consensus of an imperialistic policy towards China, but there were sharp disagreements and differing emphasis over implementation." The placement of the two exhibits back to back combined with the overall concept of depicting 1941 daily life in both countries has the effect of humanizing a former enemy by providing context for how both countries' populations experienced events leading up to the attack.

The O'ahu courtyard, located between the "Road to War" and the "The Attack" buildings, is another exhibit that incorporated concerns generated by the memorial's shift to sharing historical authority. The courtyard emphasizes Hawai'i's multiethnic population with large black

and white documentary photographs of local citizens and their brief biographies located below the photos. This exhibit further contextualizes how Hawai'ians of Japanese ancestry contributed to Hawai'i's historic diversity. One of the displays in this courtyard entitled "Home to Many Peoples" states: "By 1941 Hawai'i was ethnically and racially diverse. Chinese had begun to immigrate in the mid-1800s to work in the sugar industry. Portuguese, Germans, Japanese, and Puerto Ricans followed in the late 1800s. Filipinos and Koreans arrived in the twentieth century. By 1941 about 460,000 people lived in Hawai'i. More than a third were of Japanese ancestry."[101] The combination of the O'ahu courtyard with the exhibits depicting U.S. and Japanese states of mind during the 1930s and 1940s enacts the memorial's exhibition production paradigm shift by providing additional context that corrects the historical record concerning the patriotism and loyalty of people with Japanese ancestry during World War II in Hawai'i and in the U.S. mainland. Although the 2010 visitor center has made tremendous strides in recreating itself into a location that more closely resembles a history museum instead of a shrine to those who died on the U.S.S. *Arizona*, there are glaring absences regarding the history of events that led to the attack on Pearl Harbor.

The Tanabes' demand that the memorial change its representation of people of Japanese ancestry also touched on another public that historically has not been well represented in the memorial's visitor center exhibits. The previous visitor center's depiction of Hawa'iian history was absent, and Hawai'ian citizens were primarily depicted as female hula dancers in the orientation films (as noted by Professor Gail Lee Dubrow). Hawai'ians' participation in the Pearl Harbor attack in the 1980 visitor center was relegated to the 442nd temporary display.

The 2010 visitor center begins to address this absence with the story of Harry Tuck Lee Pang, the Honolulu Fire Department firefighters, and the O'ahu Court's Hawai'ian immigration descriptions; however, the exhibits still elide significant questions concerning Hawaii's history. One missing component concerns the Pacific Fleet and how it came to be stationed in Pearl Harbor when Hawai'i was only a U.S. territory. The 2010 interpretive exhibit states that Roosevelt moved the fleet to "deter Japanese Aggression;"[102] however, the U.S. presence in Hawai'i raises larger international questions. In her reviewer comments, historian Laura Hein points out the consequences of moving the Pacific Fleet to Honolulu: "This is the perfect opportunity to explain that the U.S. saw this specific act as deterrence and Japanese saw it as aggressive action. While it made sense militarily, the U.S. was not sending the message it intended to send."[103] Hein's critique points to the continued absence of U.S. expansionist history in the Pacific. Although the visitor center provides enlarged coverage of Japan's history of aggression and imperialism

in the Pacific, there is scant coverage of U.S. Pacific history in terms of the United States' seizure of the Philippines, acquisition of Guam, and annexation of Hawai'i. In his reviewer capacity, historian Ed Linenthal noted that "the text reads America 'obtains' the Philippines. . . . Well yes, but this is really a sanitized term to use. . . . If you are going to raise the vexing issue of America's so-called benevolent colonialism in the Pacific, then address it head on."[104]

Linenthal's critique is not the first time that the issue of incorporating U.S. imperialism into the memorial's narrative had been noted. In 1998, Geoffrey White observed that one of the key missing themes in the visitor center is any discussion of "the colonial history that first established Pearl Harbor as a U.S. Military base."[105] Hawai'i's history and its response to U.S. annexation could be addressed easily. A comparison of U.S. expansionism and imperialism as well as a discussion of Europe's role in Pacific expansionism and imperialism could provide a broader interpretation of the *world's* role and perceptions of events that led up to the attack on Pearl Harbor, which is a perspective that is sorely needed.

Architect Heathcote observes that a memorial "contains within it not only the superficial gesture towards remembrance and the dead but a wealth of information about the priorities, politics and sensibilities of those who built it."[106] The 2010 visitor center announces that suspicions concerning people of Japanese ancestry's loyalty were unfounded during World War II and that they were demonstrably patriotic to the United States. As this memory site looks to the future, the question remains whether it will be able to incorporate additional publics into its extremely consequential narrative. Falk and Dierking's observation on how museums need to make connections with visitors' lives outside the museum in order for learning to take place is the central issue for this memory site. Can only so much change happen at once in the retelling of the Pearl Harbor attack narrative? What will it take to add discussion of the history of U.S. Pacific expansionism?

As mentioned at the beginning of this chapter, no memory site is ever complete. The paradigm shift that incorporated multiple publics into exhibition design engendered questions concerning whose histories are represented, whose are left out, and how those decisions are made. Commemoration is a notoriously difficult terrain to navigate. There are a variety of stakeholders and competing claims to historical accuracy, combined with limited spaces and shrinking budgets. As a case study in the visitor-centric paradigm shift in exhibition development, the U.S.S. *Arizona* Memorial is a site that illustrates some of the challenges as well as the benefits of responding to its publics' concerns. The evolution of the NPS visitor center demonstrates how historic representations are incomplete, how its exhibits are not static, and how there is no one fixed

definition of a site's meaning. This site exemplifies how local Hawai'ians of Japanese ancestry were able to defend their patriotism, nationalism, and their U.S. citizenship without diminishing the memory of the attack. One hopes that the public memory work at the U.S.S. *Arizona* Memorial is not finished; that its 2010 visitor center brings into stark relief important historical absences that still need to be addressed. The U.S.S. *Arizona* Memorial, and now the World War II Valor in the Pacific National Monument, stands as a case in point of the tremendously consequential and fluid nature of public historic sites and an exemplar of a local community's ability to affect change in the construction of public memory.

Getting the Chinese on Board
at the California State Railroad Museum

Many people throughout California and the nation eagerly anticipated the opening of the California State Railroad Museum (CSRM) in 1981. Railroad enthusiasts had worked for over thirty years in the planning and development for this new museum. The Pacific Coast chapter of the Railway & Locomotive Historical Society, which formed (and began collecting) in 1937, provided the initial historic locomotives and railcars for the CSRM.[1] The creation of the CSRM would fulfill the increasingly urgent need to properly store its aging rail collection and would make

Exhibiting Patriotism: Creating and Contesting Interpretations of American Historic Sites by Teresa Bergman, 59–88 © 2013 Taylor & Francis. All rights reserved.

Sacramento a national destination for railroad history. The CSRM is widely lauded for its commitment to providing a cultural as well as a technological history of railroads in California. Few railroad museums include larger historical curatorial representation, and most rely solely on explanations of the technological aspects of railroads. John R. White, former curator of transportation for the National Museum of American History, regards the CSRM as one of the preeminent railroad museums and as an exemplar for other technology museums: "We now have a railway museum that can serve as a model for what can and should be done elsewhere in the nation."[2] Museum critic Joseph Corn writes that the CSRM is not "dominated by interpretation" of its technological artifacts and that it is "keyed to the personal dimension of railroading."[3] Corn notes that technology museums generally interpret only the technology and not the social and cultural implications of their exhibits; he cites the CSRM as one of the few technology museums in the United States that incorporates representation of social effects. The *Locomotive & Railway Preservation* magazine notes that the CSRM is taking railroad representation to a new level: "By far one of the biggest reasons for CSRM's success, though, has been a shared sense of purpose . . . we decided that the emphasis should not be on the history or technology of railroads per se, but on the railroads' effect on the course of California and western history."[4] The CSRM's approach to California railroad history has also been well received by the community; its yearly attendance figures average 300,000.[5]

One of the noteworthy aspects of this approach to the development of the CSRM is the level of support and the ideological fervor that

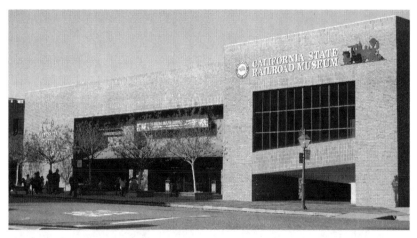

Figure 2.1 California State Railroad Museum exterior (photograph by the author, 2011)

the museum engendered. Preserving historic rolling stock was, from its inception, more than mere warehousing. A 1972 recommendation for its planning and development proclaims that the CSRM will "honor the indomitable spirit of our forebears . . . [and] perpetuate the memory of those whose sagacity, enterprise, and love of independence induced them to settle in the wilderness and become the germ of a new state."[6] In the planning stages for the CSRM, railroads were repeatedly conflated with success and progress, which suffuses all the planning documents for the CSRM. It was such a persuasive vision of California history that not only railroad enthusiasts but also politicians and the Sacramento community offered strong support for its development. Questions regarding whose success and whose progress did not emerge until after the museum's opening in 1981.

The CSRM is a particularly valuable case study in rhetoric's materiality and the ways in which a museum negotiates with its publics when there is conflict regarding its representation. The CSRM is a state run site of public memory that attracts national and international audiences. Unlike the sites run by the NPS, which has a longer institutional experience with visitor complaints and demands for change, the CSRM had less institutional resources available for its transition into the visitor-centric paradigm when developing its exhibits. The CSRM was conceived during one paradigm regarding their role and function and then opened into the new paradigm. The CSRM was able to successfully negotiate the demands it encountered concerning its representation of the Chinese contribution to the railroad in California. This chapter examines the primary factors that enabled its relatively smooth transition through the museum's response to Chinese Americans' request for inclusion. However, the shift into a visitor-centric paradigm concerning exhibits was limited to Chinese inclusion, and the CSRM did not change its depictions of other minority groups whose histories do not conform to a progressive or celebratory trajectory.

The shift in orientation in museum curatorial practices was a challenge for the CSRM for multiple reasons. The move from an object-centric to a visitor-centric orientation meant that the museum needed to consider how to be more "customer" friendly in an environment defined by its rolling stock collection. Its collection connoted knowledge, achievement, and respect. The factors that contributed to the CSRM's ability to change its representation included those involved in the planning of the CSRM and the time period during which these negotiations took place. There was strong political support for a *railroad* museum, a knowledgeable museum staff, available state funding, and perhaps most important, the fact that the missed representation was of Chinese laborers and not of another ethnic minority. This particular combination of factors makes the CSRM an informative example of the intersection of the rhetoric of

location, multiculturalism in U.S. history, the visitor-centric paradigm shift in exhibitions, and the reasons why some transitions are limited in scope. The following analysis of the museum's planning documents, exhibits, and orientation films provides background of the CSRM's initial ideological orientation and its execution. Reasons for why the CSRM left out representation of the Chinese contribution to California railroad history can be found in how the museum was initially conceived and who was involved in its original conception. This analysis begins with an overview of the CSRM's history, interpretive exhibits, and orientation films from the opening through 2012.

The California State Railroad Museum and Old Sacramento

Although many compelling reasons are now offered for the appropriateness of locating the CSRM in Old Sacramento, that was not the case initially. One of the first suggestions for a railroad museum's creation and location came in 1957 from Dr. Aubrey Neasham, historian for the Division of Beaches and Parks, who proposed locating a railroad museum in San Francisco's Maritime Park as part of the San Francisco State Historical Monument Project.[7] When it became clear that the San Francisco location was not a possibility, the focus turned to Sacramento and a timely offer from the Safeway grocery stores to house the rail stock. With a time limit on the Safeway offer for storage, pressure mounted to find a permanent home for the rail cars. Although redevelopment plans for Old Sacramento had been previously submitted to the state of California, they did not include a railroad museum. The initial planning document, which added the railroad museum to the redevelopment plans also included the restoration of several historical buildings associated with the railroad's founders, a riverfront park, and the efforts to recreate a 1849 scene.[8] Although the historic documents do not show any opposition to locating the railroad museum in Old Sacramento, there is one section that is notable if only for one of the very few cautionary remarks. Original development plans for Old Sacramento described the need for "stringent controls as to historic authenticity and period," with language expressly prohibiting "merry-go-rounds, Ferris-wheels, and 'midway' type activities." Appropriate recreations would include "buggy and hack rentals; saddle horse rentals (that could use developed trails to the Discovery Park area); river rides on re-created steamers, sailing hay scows, and other appropriate vessels; and stagecoaches and freight wagons."[9] This desired adherence to historical accuracy for the entire district of Old Sacramento speaks to the conviction that this authenticity would be read as "a monument to the past set in the heart of a city that looks to the future, insuring its destiny by honoring its past."[10] This proposal for

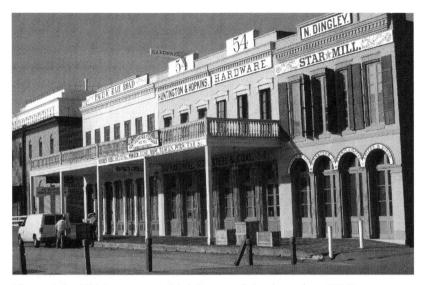

Figure 2.2 Old Sacramento, CA (photograph by the author, 2011)

locating a railroad museum in Old Sacramento gathered support quickly from many Sacramento publics.

Notably, the Sacramento Trust for Historic Preservation developed and submitted its proposal for a railroad museum in Sacramento. The board members of this group included many prominent Sacramento residents and members of the Pacific Chapter of the Railway and Locomotive Historical Society.[11] Although no members from the Chinese American community were board members, Thomas Chinn, a former City Council and School Board member, served as the liaison to the development of the CSRM. According to Philip Choy, architect, historian and former director of the Chinese Historical Society, Chinn was quite pleased to be included in such an important group.[12] The Trust's report, "Recommendations for Planning and Development," served as the basis for the CSRM, and it is effusive in its description of the importance and need for a railroad museum. The stated goal of the museum is to chronicle "the railroads' effect on the course of history"[13] and establish "the finest location for a State railroad museum . . . in Old Sacramento at the site where the transcontinental railroad began."[14] There is no mention in this report that the proposed location of the CSRM would abut Sacramento's historic Chinatown.[15]

Railroad as Nation Builder

Early planning documents for the CSRM make clear that the interpretive direction is not limited to defining California's experience with railroads;

instead, its interpretive focus is national in scope. Barry Howard &
Associates Inc., the museum's planning and design team, succinctly cap-
tures the museum's goals in the section appropriately titled "Symbolism:
The Engine as Symbol—The locomotive as symbol of efficiency."
The planners then extend their definition of the railroad's symbolism:
"The locomotive as incarnation of progress. The engine as means of
wanderlust and escape. The locomotive as iron horse of productivity. The
engine as bringer of national unity. The locomotive as symbol of indus-
trial power."[16] Reference to the railroad as nation builder is one that is
prevalent throughout the museum in its exhibits, films, and collection of
rail cars. When visitors enter the CSRM, if they follow the intended route,
they walk up a ramp to the mezzanine, which consists primarily of U.S.
cinematic references to railroads in video installations, movie posters, and
railroad film props. From the mezzanine visitors enter the theater to see
the orientation film (the contents of which will be discussed in the later
part of this chapter). After audiences view the film, the film screen lifts to
reveal the *Gov. Stanford* locomotive in the museum, and visitors exit the
theater directly into the museum exhibits through a set of doors that are
opposite from where they entered the theater. It is an impressive entrance
into the museum's collections, because the last frame of the orientation
film is of the *Gov. Stanford* locomotive, which creates the impression that
visitors walk right into the movie screen. The beautifully preserved No. 1
Gov. Stanford locomotive engine is impressive in size and in its pristine
condition. This engine was retrieved from Stanford University and is one
of the premiere pieces of rail stock in the museum.

To the left of the *Gov. Stanford* locomotive engine are eight small
glass-enclosed cases that set out some of the themes of the museum. The
first, "Manifest Destiny," contains a reprint from an 1869 newspaper, the
San Francisco Daily Alta California, which states that "the U.S. are [*sic*]
bound finally to absorb all the world and the rest of mankind, every well-
regulated American mind is prepared to admit." This version of manifest
destiny belies its more problematic meanings, which includes Robert C.
Winthrop's 1845 declaration that Providence had given the United States
the divine right to expand territorially, along with the ensuing racist impli-
cations.[17] The remaining displays consist of text explaining Pacific Railroad
fever—the outpouring of national desire to build the railroad to fulfill
manifest destiny—Theodore Judah's history, President Lincoln's role,
and the Big Four's significance, as well as images of the building of the
railroad through the Sierra Nevada mountain range.[18] The display cases
end with a scene of an early surveyor mannequin working for the railroad
in his camp in the Sierras. Although visitors encounter the CSRM's major
theme of representing the railroad as nation builder, as well as the accom-
panying themes of resourcefulness, imagination, capitalism, hard work,

Figure 2.3 Interior California State Railroad Museum, ca. 1980 (courtesy of California State Railroad Museum Archives, Sacramento, CA)

and conquering nature, there is no question that the rail cars themselves are intended to provide the main interpretive messages.

As visitors move past the *Gov. Stanford* locomotive, they encounter several exhibits on the construction of the railroad as well as additional antique rail cars assembled in various interpretive settings. There is a re-created rail station with station agent and a rail car into which visitors can peer. Further into the museum, visitors encounter an elegantly furnished rail car, the "Gold Coast," which they can peek into through the windows (but not enter) to glimpse the lavish interiors depicting how the rich traveled and dined. Directly behind this display is the refrigerator rail car that visitors can walk through to see Hispanic mannequins loading produce. In 2011, the space next to the refrigerator car contained two temporary exhibits—one on the history of railroad nurses and another on the history of railroad musical bands. The back third of the main floor is filled with six antique rail cars, three of which visitors can enter.

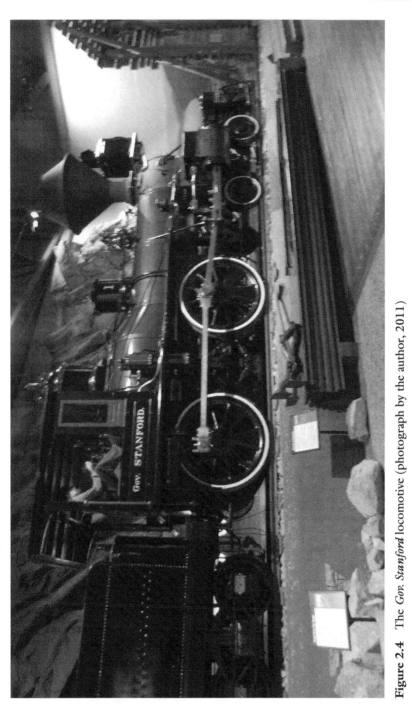

Figure 2.4 The *Gov. Stanford* locomotive (photograph by the author, 2011)

Figure 2.5 Re-created railroad station in the California State Railroad Museum (photograph by the author, 2011)

The dining car, the sleeping car, and the post office car are open to walk through, and each provides a somatic experience of "what it must have felt like" to ride a railcar while it was in use. The dining and sleeping cars are particularly impressive, with the Pullman porter mannequins appearing to offer assistance and food preparation, while the displays of the different eras of china created for each rail line remind visitors that at one time rail travel was for the wealthy. The post office car is remarkable for its orderliness and efficiency in using extremely simple technology for delivering transcontinental mail (replacing the short-lived Pony Express of 1860–1861). In each of these railcars there are volunteers, dressed appropriately as nineteenth-century rail workers, who are available to answer questions.[19]

As visitors wind back toward the front of the museum, they encounter two more splendid examples of well-preserved rail stock, which include the *C. P. Huntington* and the *Empire* locomotives. Both railcars are awe-inspiring in their massive size, and the *Empire* locomotive is surrounded by mirrors and lit in a dazzling manner. The presentation of these two rail cars confirms the museum's message that its meaning is in its collections. The last two exhibits are *The Last Spike* painting by Thomas Hill

Figure 2.6 Hispanic mannequins loading produce onto railcars in the California State Railroad Museum (photograph by the author, 2011)

and the famous A. J. Russell photograph taken at Promontory, Utah, commemorating the completion of the transcontinental railroad on May 10, 1869. The Hill painting is a creative rendition of the completion of the transcontinental railroad that includes many people who were not present but played roles in the railroad's completion.[20] Also in this corner is a glass case containing "The Lost Spike," which was unknown until research revealed that San Francisco contractor and friend of Leland Stanford, David Hewes, had an additional gold spike cast for the transcontinental railroad's completion. This gold spike was acquired by the CSRM in 2005.[21]

To exit the museum, visitors return to the entrance and can leave either through turnstiles or through the gift shop. The gift shop is notable for its large array of railroad memorabilia, books, and a miniature railroad track hung from the ceiling with a constantly running toy train. The playfulness of the toy train caps a CSRM visit by reminding visitors that trains are not only fun but also a key to California's history of successful economic and technological development. This incredibly positive representation of the railroad as the definition of progress and prosperity was

Figure 2.7 Pullman porter mannequin in the California State Railroad Museum (photograph by the author, 2011)

one that was not lost on the Chinese Americans. In 1982, one year after the CSRM's opening, several prominent Chinese Americans wanted to know why they had been left out of this history and demanded inclusion.

Missing Chinese

In 1982, Philip Choy was on a tour of the newly opened CSRM, and he was impressed with the "People Gallery" exhibit, which included life-size mannequins of a variety of people working on the railroad. The "People Gallery" included a "railroad shop worker 1943–1946, Station Agent 1910, Amtrak Conductor 1975–1981, Locomotive Engineer 1955, Waiter 1955, Conductor 1950–1971, and Pullman Porter 1935."[22] Choy remembers that "what annoyed me at the time was you got all of these life size mannequins and everybody was represented, but where's the Chinese?"[23] Dr. Wesley Yee, a CSRM board member in 2011, remembered that the "Chinese insisted that they needed the human story of

Figure 2.8 The Virginia & Truckee Railroad No. 13 *Empire* located in the California State Railroad Museum (photograph by the author, 2011)

how it was built."[24] To account for this glaring absence, Choy observed that a profound generational shift had taken place in Chinese Americans' participation in U.S. culture, even though Thomas Chinn had served as the liaison to the CSRM during its development. Choy describes Thomas Chinn, the former director of the Chinese Historical Society of America, as "from a generation that I call earning the goodwill. He had to behave himself. We don't rock the boat."[25] Choy's description of Chinn's behavior recalls the "model minority" stereotype, which has been used to describe Asian Americans since the 1960s and has implied their successful assimilation into U.S. culture particularly in terms of their achievements under American capitalism.[26] Asian American scholar Keith Osajima notes that one result of the "model minority" stereotype is defining success in "narrow, materialistic terms."[27] This analysis is not lost on Philip Choy, who in 1969, as one of the founding members of San Francisco State's Asian American Studies department, observed that it took until the third generation and beyond for Chinese Americans to assimilate in U.S. culture without rejecting their Chinese culture.[28]

Despite their notable absence in the CSRM's initial planning document, plans to include an exhibit portraying Chinese laborers building the railroad in California did appear in the CSRM's 1976 and 1977 master

Figure 2.9 "People Gallery" exhibit in the California State Railroad Museum, ca. 1980s (courtesy of California State Railroad Museum Archives, Sacramento, CA)

plans. The description of the "worker" scene was to include exhibits of "the methods employed to bring Chinese laborers to California and speak to the life which the Chinese faced in the incredibly difficult task of cutting through the great Sierra range."[29] At this point in the planning process for the museum—the middle 1970s—CSRM archivist Marilyn Somerdorf recalled approaching some of the "Chinese societies" for input regarding the worker exhibit. Somerdorf remembered that she did not realize that "there were different schools of thought in the Chinese community," and "at first there wasn't a lot of interest in having something about the railroad workers . . . one school didn't want to have the Chinese workers represented, they were the doctors and lawyers."[30] Choy explained that some of the "Chinese were embarrassed" at that time by their U.S. history, because Chinese "involvement in the history of the United States" was as "second-class citizens."[31] Despite having plans for Chinese mannequins in the worker exhibit, Somerdorf remembered that eventually there was not enough money to "flesh out" this exhibit, and instead this section of the museum opened with a "generic last minute mural; most of it was kind of bare, with a non-Sierra mural painted around the snow shed."[32] The resulting mural was, in fact, a very sparse depiction of the Sierra Nevada mountain range with little detail, and it was not site specific.

It is difficult to assess which event was most responsible for the Chinese worker mannequins not coming to fruition for the opening of the museum. The museum archivist perceived a lack of interest from the Chinese American community, there were dwindling funds to finish all the exhibits, and there is no record of Thomas Chinn, the Chinese American liaison to the CSRM foundation board, lodging any objection to the omission of the mannequins. But by1982, one year after the CSRM's grand opening, there had been a shift in the Chinese American community, and the Chinese absence was now a problem.

The legacy of the U.S. civil rights movement was most likely also a factor in the change of positions and new requests for inclusion of the Chinese. Professor Michael Schudson observes that "the rights-conscious world that the sixties revolution began . . . did so by appealing to common American traditions of equality and liberty, in many cases from the point of view of the people who had been left out."[33] The Chinese in America are certainly one of the groups that had been left out because they had experienced discrimination in the form of exclusion laws aimed at preventing Chinese immigration, antimiscegenation laws, the prohibition of Chinese testimony against white citizens, and discrimination in housing and employment. Philip Choy recognized that the history of U.S. assimilation and acculturation for the Chinese was not well known, and, as president of the Chinese Historical Society of America, he made

it his mission "to put the Chinese role and participation in the railroad building on the map after 100 years because we were well aware that 100 years ago they were totally ignored."[34]

A direct result of Choy's complaint about the missing Chinese mannequins was that former San Francisco Assemblyman Art Agnos procured $100,000 in state funds to remedy the "worker" exhibit, and Agnos enlisted Choy to develop this project. The Chinese railroad-worker mannequins were eventually added to this scene in the mid-1990s. By 2011, the redesigned "worker" exhibit was referred to as the Chinese exhibit, and it included five interpretive text placards describing the number of Chinese who worked on the railroad, the difficulty of the work, their legacies, their work with dynamite to blast through the Sierra Nevada mountains, and a description of Chinese life in a hostile California. There are three Chinese worker mannequins as well as historically accurate mining tools, and the background includes similarly dressed Chinese railroad workers in a beautifully painted Sierra Nevada mountain mural. A realistically constructed railroad snow shed borders the right side of the exhibit. This exhibit is a stunning improvement over its previous iteration as only a nondescript mural of the Sierra Nevada mountain range. The glass case in front of the exhibit contains artifacts from the nineteenth-century Chinese workers, including dishes, money, and vases. There are two text displays that describe life after work in camp, and another entitled "Fidelity and Industry" includes Charles Crocker's description of the Chinese railroad workers: "I wish to call to your minds that the early completion of this railroad that we have built has been in large measure due to that poor, despised class of laborers called the Chinese—to the fidelity and industry that they have shown."[35] To the left is one more glass case with photographs of Chinese railroad workers and a description of their labor on the railroad. In 2011, museum staff expressed satisfaction with the Chinese exhibit, and Choy concurred: "I think in terms of the overall exhibit, the Chinese are well represented in the exhibit itself."[36] Drs. Wesley and Herbert Yee, CSRM foundation board members in 2011, both expressed admiration and uncritical support of the CSRM and its representation of the Chinese.[37]

The CSRM's initial exclusion and then addition of the Chinese mannequins reflected a legitimate response to one of its publics. The request for inclusion paralleled a shift in identity that took place among Chinese Americans. By the 1980s, many Chinese Americans' definition of themselves as Americans had evolved to a point of embracing their ethnicity, economic class, and history of oppression. Choy's request regarding the missing representation of Chinese also brought substantial changes to the CSRM's orientation film.

Figure 2.10 Chinese Railroad worker exhibit without Sierra Nevada background mural in the California State Railroad Museum, ca. 1980s (courtesy of California State Railroad Museum Archives, Sacramento, CA)

1981 *Orientation Program*

The CSRM was again reminded that it had opened into a visitor-centric museological paradigm when it encountered criticism of its first orientation film. Choy simply described the film as "terrible," and that it was "basically the progress and advancement of white civilization."[38] The 1981 film, entitled *Orientation Program*, began preproduction while plans for the CSRM were being developed concurrently with the redevelopment of the Old Sacramento State Historical Park. There was concern regarding the creation of compatible interpretative histories. In the late 1970s and

Figure 2.11 Painted mural of the Sierra Nevada behind Chinese railroad worker exhibit in the California State Railroad Museum (photograph by the author, 2011)

early 1980s, the emphasis in U.S. historical and technology museums was on easy access and understanding where "the larger message could not help being celebratory," and the "sense of the past . . . was fundamentally nostalgic."[39] There is a congruence and compatibility between the philosophies guiding the general development of technology museums

Figure 2.12 Exhibit case of Chinese railroad workers' artifacts in the California State Railroad Museum (photograph by the author, 2011)

with the Old Sacramento State Historical Park, the redevelopment of Old Sacramento, and the creation of the CSRM and its first orientation film. The CSRM's 1972 Overview stated that the purpose and goal of the *Orientation Program* is to provide "satisfying, stimulating, evocative and/or provocative content as a learning experience and/or entertainment for all age levels."[40]

The *Orientation Program* is twelve and a half minutes long and was written, produced, and directed by the Peterson Company. The format consists of ten vignettes, of which nine are historic recreations and the last uses actual location footage: (1) circa 1920s, a young boy sleeping, awakened to ride in a model "T" Ford with his family to the railroad station to receive a package; (2) circa 1870s, blonde immigrants looking lost riding the train to California; (3) circa 1920s, a telegraph operator handing off a message to an oncoming train; (4) circa 1930s, the rich and the hobos riding trains; (5) circa 1940s, "Rosie the Riveter" women looking for railroad work; (6) a WWII soldier saying goodbye to his mother and boarding the train; (7) circa 1950s, a politician campaigning at a whistle stop rally; (8) 1950s–1960s, a Hollywood starlet entering a train station amid reporters; (9) railroad crewmen coupling and uncoupling railcars; and (10) contemporary footage of the Sierra Nevada mountains with a narrator describing the difficulties and ultimate triumph of the railroad tunnel connecting California to the transcontinental railroad. Before this tenth and final vignette, there is a montage of earlier scenes serving as a "reprise" of the history of California railroads.[41] The final scene in the tenth vignette lingers on a Donner Lake railroad scene as the actual

film screen lifts revealing the same scene recreated as an exhibit in the museum with doors opening to let visitors access this exhibit and the museum.

The Peterson Company describes the organizing narrative of the *Orientation Program* as a "tone poem," which looks to achieve the CSRM's stated goals of integrating education and entertainment: "This format helps the viewer concentrate on the material being presented, and thereby aids the Museum by increasing the amount of information transferred to the viewer."[42] However, the vignette format and tone of this film received a substantial critique from John R. White, curator for the National Museum of American History, who describes the film as "present minded, lacking in historical context, and sentimental, as well as fragmented and disjointed."[43] His critique of the film is particularly stinging because he was an early and enthusiastic supporter of the CSRM and his letter served as a formidable endorsement for the creation of the museum.[44]

In addition to problems with the film's format, White's critique concerning the film's content as "sentimental" reveals an ideology that conflates the technology and nostalgia of railroads. This particular nostalgia reflects the ongoing struggle in the United States between embracing and celebrating technology while holding onto romantic notions of life in the United States before the industrial age.[45] A nostalgic interpretation of railroad history works to flatten and simplify the extremely complex social and cultural effects associated with the railroad and technology in general. This nostalgic interpretive lens whitewashes or omits incongruities associated with economic class, race, and gender in favor of a triumphalist narrative in the form of railroad technology. In terms of the museological paradigm shift, nostalgia as an interpretive approach inhabits earlier understandings of museums that were "more about [us] than our ancestors, more about our own values and concepts than those of the culture they profess to portray."[46] Even while museums turned outward toward more diverse publics and away from an inward privileged focus, the CSRM's *Orientation Program* displays an ideological stance rooted in the previous paradigm. The film represented railroad history in a manner that ignored its racist and economic challenges. The first orientation film's ideology depicts a romanticized memory of California railroad history—one that diminishes economic hardship, omits reference to the dangers of railroad work, and ignores the Chinese contribution to building the railroad.

This triumphalist view of the railroad, where human costs and economic inequality are glossed over in favor of a celebration of the technology are most clearly represented in the hobo vignette, the dangers encountered by rail workers vignette, and in the complete absence of the Chinese workers' participation. The hobo vignette in the 1981 *Orientation*

Program is particularly illustrative of the nostalgic interpretive method employed throughout the film. The sequence begins in a luxurious dining car with an African American porter serving a white couple. Immediately following is a scene of a younger white couple eating in a mid-level dining car (no wait staff in sight), followed by a scene of a hobo sitting in a moving railcar staring out to the scenery, his face impassive, bordering on melancholy. During this sequence, the narrator states: "The rich and poor, they all fell on hard times during the Great Depression. The homeless hobo riding the rails. An empty boxcar his shelter. The train's haunting whistle always reminding him of his loneliness."[47]

It is not clear in the film how the rich are falling on hard times, but the hobo's clothes, lack of hygiene, and inability to buy a ticket certainly depict hard times. The revealing choice here is that this scene visually suggests a positive read of the hobo, because he travels through a beautiful stretch of countryside. This romanticized version of a hobo's life as the rugged individual who is free from life's material obligations contains no reference to the fact that the hobo is poor, out of work, and without family. There is evidence that this idealistic interpretation was problematic for the Peterson Company and the CSRM. There are ten drafts of the screenplay for the *Orientation Program*, and this scene was rewritten six times, which is many more than any of the other vignettes.[48] The hobo scene is dropped completely from the first treatment for this film, but reappears and receives substantial revisions.[49] In earlier drafts of this scene, it is evident why this sequence could be read so appealingly. The first film treatment describes a scene where a hobo eats "his meager lunch" intercut with a rich man eating in a high-end private railcar in "all its splendor." In the screenplay, the hobo mocks the wealthy man's table manners while the narrator states, "The hobo smiles in the knowledge that *his* train is more important than the other's."[50] By the fourth script rewrite, the hobo is not on the train but is seen hiding in the bushes trying to hop a train, accompanied by the following lines of narration: "I think hobos would be surprised to see themselves glorified today. I guess that's because people want to forget the grim reality."[51] The final version of the hobo scene appears in the sixth script rewrite and stays fairly unchanged until the eighth and final rewrite. This version attempts to straddle a midpoint between representing a hobo's grim reality and that of representing his life as more important than that of the rich. Ideologically, this scene indicates an adherence to a sanitized version of the railroad's social history and does not embrace the railroad's messy social history.

The vignette concerning the dangers that rail workers encountered illustrates another aspect of this film's selective memory or affect. Communication Professor Lawrence Grossberg points out the consequential nature of this aspect of memory production in which "affect

always demands that ideology legitimate that fact that these differences and not others matter, and that within such differences a particular term becomes the site of our investment."[52] The depiction of rail workers' safety is an example of presenting only one side of the story for the visitors' ideological investment. There are many rewrites of this scene suggesting there were differences in the scene's primary message. In the sequence concerning rail workers' lives, a telegraph operator rapidly translates a message, then delivers the message via a wooden hoop to an oncoming train with the following narration: "It's past midnight. Suddenly, the telegraph office comes alive with new orders for an approaching train. Seconds count. The skilled telegrapher quickly translates the dots and dashes into a train order that must be handed up to the train crew as the engine thunders by." The train engineer responds: "Looks like a red order board ahead. I think they've got orders for us at Carson Tank."[53] The close timing in receiving and translating and the awkwardness of using a wooden hoop to hand off important information to an oncoming train compose the sequence's drama. In earlier drafts of this sequence, the telegrapher translates the message and hands it off to the train, but a switchman farther down the line does not get out of the way in time for the oncoming train. The screenplay sequence ends on a tombstone from Pioneer Cemetery with the narrator stating that "life was dangerous but wasn't always tragic in those days, however."[54] The funereal depiction of the dangers of railroad work remains in the first three drafts of the script, but by the fourth draft it was eliminated and never reappeared.

With the elimination of the rail worker's implied death, the narration also scales back the description of the dangers of railroad work. The fourth script states that "railroading was considered a dangerous job around the turn of the century. . . . in the early days it seemed that men were easier to replace than trains."[55] By the final script rewrite, there is no mention of the dangers facing crewmen, and the emphasis is on efficiency and ingenuity. The choice to omit the deadly risks elides the real dangers of railroad work, and this choice devalues those who lost their lives through their employment. The resulting message is that the loss of workers' lives is an acceptable price to pay in order to usher in technological advance. The insistence on depicting railroad history as a uniformly positive chapter in U.S. history sets the stage for why the Chinese were left out of this orientation film.

The Chinese contribution to building the California railroad is completely absent in the *Orientation Program*. The only reference made to the Chinese in building the railroads comes in the first draft of the script, and this reference is at best oblique: "In the foreground we see parts of a Chinese work camp, adjacent to a large busy station. We hear Chinese spoken by silhouetted figures, as our view moves past the camp,

and toward the station," at which point the narrator further intones that "people came from all over the world to create our railroads and to settle the West."⁵⁶ The missing representation of Chinese, as well as any people of color who labored on the railroad, were elements that the CSRM added to the 1991 orientation film and are discussed shortly.

Philip Choy's call for inclusion of the Chinese in the worker exhibit also led to the creation of a new orientation film for the CSRM. Former CSRM Director Stephen Drew wrote that the "Chinese Community was successful in securing funding to develop an expanded exhibit in the Museum. This heightened interest plus new historical documentation helped support a more expanded role of the contributions of the Chinese to building the Central Pacific Railroad."⁵⁷ The fact that the Chinese American community had to pay for representation in the CSRM was never contested, and from 1981 to 1991 the CSRM screened the nostalgic *Orientation Program* in a museum that represented California railroads as the proudest advancements and best progress that technology had to offer. In a departure from an earlier stance, by 1982 Chinese Americans wanted to be clearly associated with this museological experience. The worker exhibit benefited from their fundraising efforts in the form of additional Chinese mannequins plus interpretive displays that explain the challenges as well as the successes of the Chinese in California. The new orientation film follows a different path in its move to correct the glaring absence of leaving out the Chinese contribution to the California railroads. Instead of offering a balanced representation of the lives that the Chinese experienced in their work on the railroad, as was accomplished in the Chinese exhibit, the new orientation film continues to rely on a nostalgic and sanitizing interpretive lens.

1991 Orientation Film: *Evidence of a Dream*

The differences between the two orientation films are striking. The second film, *Evidence of a Dream*, is twenty minutes long; the overall production quality is much higher than the first film, the transitions between scenes are smoother, there are contemporary interviews and historical film footage, and many ethnic minorities are depicted in their contribution to the railroad.⁵⁸ The production of *Evidence of a Dream* appears to respond to John White's criticism of the first *Orientation Program* as lacking in historical context and being sentimental and disjointed, and he does so primarily by addressing the fragmented nature of the film. On closer inspection, I found that the two films had a great deal in common ideologically in that both films depict railroads as the apex of technological progress and as having an unqualified positive impact culturally and socially even with the addition of ethnic minorities' contributions to the California railroad.

One explanation for this continued nostalgic representation may be the location of the railroad in the cultural landscape, one that combines technological prowess and romantic fantasy: "Like Jules Verne's ships and submarines, it [the railroad] combines dreams with technology."[59] In fact, both orientation films draw on a poetic interpretation of the railroad's impact in the U.S., and Walt Whitman is quoted at length in several early drafts for the second orientation film, invoking his vision of an ideal marriage between man and technology.[60] Although both of the CSRM's orientation films share Whitman's lofty goals regarding the effects of technology on the population, there is a difference between holding that view in the nineteenth century and in representing that view in the late twentieth century. The former is prediction while the latter is nostalgia; both gather momentum in their reliance on the desire to simplify difficult cultural issues.

Format Changes

The CSRM's Request for Proposals for the 1991 film reflects some dissatisfaction with the *Orientation Program* and calls for a "more structured introduction to the Museum of Railroad History."[61] The new production company, Intrepid Productions, addresses the *Orientation Program*'s structural problems in terms of how the film "seems to leap, without appropriate segue, from era to era."[62] Even though both Intrepid Productions and the CSRM indicate that they want a more seamless orientation film, *Evidence of a Dream* also uses a vignette format. There are stylistic format changes in *Evidence of a Dream*; only eight of fifteen vignettes use historic reenactment (instead of nine out of ten in the *Orientation Program*), and historic photography and contemporary interviews are incorporated.[63] The following is a brief description of *Evidence of a Dream*'s vignettes: (1) an American Indian on horseback in a desert location looking at railroad tracks; (2) in 1825 Great Britain, George Stephanson explaining the steam locomotive; (3) a series of historic black and white photographs depicting the evolution of the locomotive; (4) a narrator reading a John Godfrey Saxe poem during an European immigrant scene in Strasbourg; (5) an American Indian on horseback paralleling the railroad tracks in Missouri while watching a family in a covered wagon; (6) a train whistle echoing through the snow-covered Sierra Nevada mountains; (7) the Big Four meeting with Theodore Judah; (8) Chinese laborers working on the railroad; (9) workers completing the railroad at Promontory Utah; (10) the narrator defining American character over a montage of locomotives; (11) a train delivering a Victrola record player, fresh fruits, and vegetables, intercut with ethnic farm workers in California; (12) a telegraph operator working a telegraph and receiving a newspaper by train; (13) a montage of historic photographs of various railcars carrying passengers,

freight, and rail workers (including Pullman Porters); (14) an interview
with railroad workers Leslie Selby and Bill Tatem; (15) a final montage
including locomotives, rail workers, the Sierras, and a Christmas window
with a toy American Indian on a horse next to a train set in a replica of
the Sierra Nevada mountain range. While the last scene lingers, the screen
rises to reveal an exhibit of the same final scene that visitors can access
from inside the theater.

One reason for some of the changes in the format is that in 1981,
the CSRM had specifically prohibited the use of historic film footage for
the first film but allowed its use in the new film.[64] *Evidence of a Dream*
contains three sequences using historic black and white photographs and
film, and this photographic representation of historic actuality addresses
one aspect of missing historical context, as critiqued by John White.
Additionally, the photographic images work to offset some of the senti-
mentality that attends historical reenactment. Although all photography
serves an interpretive function, inserting these three sequences between
eight historic reenactments incorporates contemporary documentary
approaches to representing history.

One of the most notable format changes in *Evidence of a Dream* is the
use of interviews. These interviews also address the missing historical con-
text of the first film and anchor its narrative in a more modern context.
Although Intrepid Productions states that it wants to "avoid the 'talking
head' approach,"[65] inclusion of the interviews places this film more firmly
in the late twentieth century documentary film form.[66] The two inter-
views are of Leslie Selby, identified as the Road foreman of Engineers,
and Bill Tatem, identified as working forty-four years on rail engines.
Selby attests to her lifelong dream "to become a locomotive engineer,"
and Tatem describes the changes that he has seen during his career,
including "the transition from steam to diesel" and "women working for
the railroad." Their sequence ends by describing the railroad profession
as "one happy family."[67] In addition to modernizing the film's format,
Selby's interview works to replace the "Rosie the Riveter" vignette in the
Orientation Program, whereas Tatem's family remark reinforces romantic
notions of the railroad as outside the business-as-usual sphere. The use
of interviews incorporates both a historical context and a contemporary
referent to the documentary film form. Overall, the format changes in
Evidence of a Dream work to better secure this film to current notions of
the documentary film form and historical referents.

Content Changes

With *Evidence of a Dream* utilizing elements from a more contempo-
rary documentary film form, the next change is the inclusion of ethnic

Figure 2.13 Female railroad engineer mannequin in the California State Railroad Museum, ca. 1980s (courtesy of California State Railroad Museum Archives, Sacramento, CA)

minorities' contributions to California railroad history. Even though Chinese, African Americans, Mexican Americans, and Native Americans all receive mention in *Evidence of a Dream*, both orientation films insist on minimizing the effects of the railroads in terms of economic class and ethnicity. In *Evidence of a Dream*, the Chinese railroad laborer vignette uses historic recreation to portray several Chinese men at work in and outside of a railroad tunnel. The narration is essentially self-referential by pointing to this topic's absence in the previous film: "Now it's true that 2,000 laborers, mostly Irish, composed the army of men needed to start work on the Central Pacific, but the skill, resourcefulness and courage mustered to complete the job was irrefutably Chinese. . . . Failure to make fair mention of the formidable Chinese contribution is conspicuous."[68] With the addition of minority participation in railroad history, the issue of racism enters this historical narrative. Racism was easily elided in the 1981 *Orientation Program* because the historical representation focused exclusively on a white history. Incorporating the racial and ethnic contributions to U.S. history complicates the representation, but not in ways that conform to the CSRM's desire for entertaining interpretive material. One of the rhetorical problems with simply layering racial representation into a nostalgic framework is the sacrifice of a complex social and cultural history and its attendant consequences. Elision of the railroads' negative racial or economic implications creates

an unbalanced representation at best, and at worst creates a public
memory so one-sided as to deny significant portions of its citizens access
to their heritage.

The history of racism that attended minority participation in build-
ing the railroads was not only a state issue; its roots were in national law.
Federal law in 1790 severely restricted immigrants' ability to become U.S.
citizens.[69] By the mid-nineteenth century, thousands of Chinese men had
worked in the California mining industry before moving into the railroad
industry, and their cultural and legal status was fiercely debated. The cli-
mactic resolution to these debates was the 1870 Naturalization Act that
specifically "excluded Asians" from becoming U.S. citizens.[70] Chinese
railroad workers were also paid less than their Irish-American counter-
parts; the Chinese "wage scale was substantially lower than that of com-
mon laborers in the mines or in the cities," and the "labor cost for white
workers was 64–90 percent higher than that of Chinese."[71] Chinese men
were also subjected to some of the worst working conditions in railroad
construction: in addition to their availability and cheapness, the Chinese
workers were well adjusted to "teamwork"—"sometimes 20 teams and
250 crammed upon a space within 250 feet caused admiration and dis-
belief, especially among people who had experience with the disciplinary
problems of white workers in early California."[72] One of the Big Four,
Charles Crocker, hired Chinese men "mainly for the purpose of fright-
ening his white workers, who had threatened a strike. The results were
so gratifying to Crocker that he sent out a general call to recruit more
Chinese rail laborers."[73] In addition to exploitation from the owners,
there was division among railroad workers during the 1869–1871 Miners'
Strike that called for the "exclusion of Chinese mining laborers" as one of
the Anglo miners' demands.[74] Even with mounting local and national rac-
ist sentiments and the consequent exclusionary laws, Chinese immigrant
labor roles grew and followed the same path of many first generation
immigrants to the United States. The work available to the Chinese con-
sisted primarily of "unskilled menial, or otherwise undesirable tasks, the
performance of which would enhance the job opportunity and earning
capacity of non-Chinese workers. On the railroads especially, this arrange-
ment turned out to be extraordinarily enduring."[75] *Evidence of a Dream*'s
sequence of happy Chinese workers stands in stark contrast to the reality
of their working conditions. In contrast, the Chinese museum exhibit
mannequins and the images of Chinese railroad workers painted on the
mural behind them are not smiling.

African American laborers also receive representation in *Evidence of
a Dream* through several black and white historic photographs of African
American Pullman porters with the accompanying narration: "As many
as three generations of Black-Americans worked on the railroads and

encouraged their children to do the same."[76] African Americans were not granted U.S. citizenship until the ratification of the fifteenth amendment of the Constitution in 1870, just one year after the transcontinental tracks reached completion.[77] African Americans gained limited employment in the railroad industry, primarily as porters for George Pullman, because all four major railroad labor unions that organized between 1860 and 1893 "had 'White Only' exclusion clauses in their union's constitution."[78] On the heels of the Civil War, non-agricultural employment for African Americans was difficult to find, and George Pullman exploited that opportunity. In addition to suffering from racism, African American Pullman porters were not unionized at the time and did not receive a regular wage. Joseph F. Wilson notes that African American men "were willing by force of circumstance to work without wages and for tips only." Wilson goes on to describe Pullman porters' work as "virtual bondage until 1934, when the Railway Labor Act of 1926 was amended to include the porters under its protective statutes."[79] Previously, porters "were not considered to be railroad employees, despite the fact that some trains were made up entirely of Pullman cars."[80] Brailsford Reese Brazeal identifies three major factors that contributed to African Americans' filling the porter jobs on railroads. First, African Americans offered a large and inexpensive labor pool. Second, the "societal caste distinctions between Negro and white people created 'social distance,' which had become an accepted fact in the mores of American society." Third, "Negroes were known to possess a servile attitude, which qualified them for the tasks of serving passengers."[81] The addition of African Americans in *Evidence of a Dream* is laudable when considering their previous absence, but this representation is so unbalanced that one of the major achievements for African Americans, the creation of the Pullman Porters' Union, goes unmentioned.

The two vignettes that include Native American representation both position Native Americans as a necessary casualty in the name of progress. In the opening vignette, the Native American character is described as a "mixture of gravity and expectation."[82] The fifth vignette includes a Native American on horseback trying to keep up with a locomotive. Given the "social reading" of this scene, the use of Native Americans in this manner is acquiescence to a vanishing time and culture.[83] This scene suggests that another facet of U.S. and California citizenship is one that accepts the elimination of Native Americans as the price that has to be paid in order to build railroads, which ensures progress.

Mexican American laborers' appearance in *Evidence of a Dream* is a view of working conditions that belies difficulties in favor of a simplistic positive depiction. The Mexican American scene is couched within a discussion stating that the dangerous nature of railroad work fosters familial

relations: "In the early days it was considered six times more dangerous being a workman than a passenger, but it has somehow remained a family affair . . . a time-honored tradition. In California, Mexican American families have lived near the railroads for decades, supplying generation after generation of Gandy Dancers, men who had the muscle and the grit to maintain roadbeds, align rails, and generally keep the dream on the road."[84] Defining the dream of railroad history is certainly the goal of *Evidence of a Dream*; however, this representation avoids the realities of Mexican American rail laborers who lived in "old tie bunkhouses, with dirt roofs."[85] The Southern Pacific Company newsletter reports that until 1913, the children of Mexican American rail workers could not attend school because "there were no schoolhouses on many of the sections. . . . It was not possible to send children away to other towns to school" because so few people lived in the area. The Southern Pacific Company announced that they now provide "either bunkhouses or dismantled car bodies for schoolhouse purposes."[86] *Evidence of a Dream*'s declaration that Mexican American families have a "time-honored tradition" of working for railroads ignores their harsh living conditions as the price they had to pay for railroad work.

Evidence of a Dream's representation of the Chinese, African Americans, Native Americans, and Mexican Americans raises issues as to whether "museums have a fundamental obligation to take sides in the struggle over identity."[87] The CSRM's entry into the visitor-centric exhibition paradigm achieved success in its exhibit of the Chinese railroad workers' difficult lives; however, *Evidence of a Dream* resorts to a laundry-list-like effort to include all the minorities who worked on the railroads. Instead of using the experience with Chinese Americans to inform their depictions of the hardships and racism that many immigrants endured during their time working on the California railroad, this film offers the railroad industry's work ethic as a model for U.S. and California identity: "When it came to the steam locomotive . . . a technology would replace inequity by serving people of every origin. Qualities associated with the railroad like respect for authority, conformity to routine and pride in technical skill . . . would be assimilated into the notion of a national character, and there was plenty of room for character! A schedule had to be kept!"[88] This description of railroads performs two ideological functions. First, it positions railroads as the answer to systemic racial discrimination. *Evidence of a Dream* represents the railroad as the technological entity that marks as well as promotes the power relationship in which racial inequality is solved by an adherence to the values of "respecting authority, conforming to routine, and [taking] pride in technical skill." Railroads represent a mythic leveler of the playing field that enables meritocracy. The second function of this scene is that it reproduces traditional relations of power that work "perpetually to

reinscribe this relation through a form of unspoken warfare; to reinscribe it in social institutions, in economic inequalities, in language, in the bodies of each and every one of us."[89] *Evidence of a Dream* reinscribes immigrants' power through assimilation into the form of one national character that is the railroad. Overall, *Evidence of a Dream* functions to orient and position audiences to accept unquestioningly that the railroad was a racial equalizer and that there were no negative cultural or economic events associated with railroads.

Conclusion

The CSRM experience with the shift into a visitor-centric paradigm that shared historical authority in its exhibition development was one initiated by a request for Chinese representation. This request came *after* the Chinese American community had asked not to be represented during the CSRM's initial planning stages. Significant changes concerning identity had taken place within the Chinese American community since the 1970s. With changing self-perceptions and increasing interest in claiming their overlooked role in U.S. history, concerns about the absence of Chinese in the CSRM were voiced. The differences between the redesigned "worker" exhibit and the replaced orientation film are illustrative of how the one request for inclusion resulted in widely varying outcomes. In the Chinese exhibit, the CSRM staff created a balanced representation of the Chinese experience working on the railroads that included the immense difficulties they endured while living in California and in the U.S. The replaced orientation film, *Evidence of a Dream*, added the Chinese contribution to its narrative, but the film does not include any of the difficulties that the Chinese or the other ethnic minorities encountered in their labor for the railroad.

Change has come to the CSRM since 1981, and when visitors attend, they now learn that the Chinese and many ethnic minorities participated in the building and development of the railroad in California. The quality of the information regarding these pieces of history varies tremendously from the exhibit to the orientation film. Although no one exhibit or film could provide the complex social and cultural history of the Chinese and all the ethnic minorities' contributions to the railroads in California, the Chinese exhibit displays qualities of balancing between the need for brevity, recognition of their involvement, and inclusion of the challenges they endured while living in California during this time period. This exhibit resists the traditional interpretive route of technology museums to represent their collections in a unidirectional celebratory narrative. The CSRM moved beyond a strictly technological historical representation to include both the positive and negative social and cultural effects of railroad

technology, which met their community's desire for learning their history. The *Evidence of a Dream* orientation film, by failing to adequately represent the hardships faced by Chinese laborers, serves as an example of a museum's limitations in responding to their public's request for change in representation. The inclusion of multiculturalism into public history sites' interpretive materials requires more than a nostalgic and triumphalist lens if the goal is to provide all members of its community access to their histories. Often, a great tragedy or injustice has served as the catalyst for social reform.

What are the lessons to be learned from this case study of one museum's experience with moving into a visitor-centric paradigm in the development of its exhibits? A museum's response to its community for changes in representation can be an opportunity to improve its interpretive material. The success that Chinese Americans experienced at the CSRM is exemplary for other groups who have been left out of historical narratives at official sites of public memory. The evolution of the Chinese exhibit serves as an exemplar of how to achieve recognition of their accomplishments while balancing the presentation with the social ills of the time. Incorporating a more complex representation of minority participation into mainstream U.S. history more completely explains the genealogy and current state of cultural and social relations.

A responsive staff, public funding, the ongoing appeal of railroads, and publicly active Chinese Americans eased the CSRM's move into the new visitor-centric exhibition paradigm. Several Chinese Americans in Northern California recognized that the Chinese were long overdue for adequate representation in U.S. history in general, and at this museum in particular. This combination of events is not easily replicable, but the changes in Chinese representation at the CSRM underscore that none of it would have been possible without the initial request for inclusion. This case study also reveals the limitations of this shift throughout the museum on account of its reliance on a triumphalist narrative. As an institution that is run by the state, the CSRM certainly has fewer resources to undertake large-scale revisions of its exhibits and orientation film. Unfortunately for the museum's multiple publics, lessons from the museum's experience with the Chinese exhibit have yet to be applied to other minority groups' depictions. As we will see in the following chapters, requesting inclusion by no means guarantees an institutional response, much less the quality of that response.

The Day the Plaster Fell:
Museological Change Comes to the Alamo

On May 29, 2011, the Texas state legislature voted to remove the Daughters of the Republic of Texas (DRT) from the custodianship of the Alamo. This historic change came about because of the passage of House Bill 3726, authored by Senator Leticia Van de Putte, which took effect on September 1, 2011. Since 1905, the DRT had been "granted the custody and care" of the Alamo according to the General Laws of Texas,[1] but in the wake of the new law, the DRT agreed to serve, beginning January 1, 2012, "as a contractor for the Texas General Land Office," which became

Exhibiting Patriotism: Creating and Contesting Interpretations of American Historic Sites by Teresa Bergman, 89–115 © 2013 Taylor & Francis. All rights reserved.

the custodian of the Alamo.[2] Given the DRT's entrenchment in Texas politics and culture, such an outcome was previously thought to be impossible.

It is difficult to overstate the significance of this legislation and its implications for the Alamo, the DRT, the state of Texas, and historical tourism. During the DRT's 106-year custodianship the Alamo became one of the top U.S. historical destinations, attracting over four million visitors each year.[3] Senator Van de Putte, whose district encompasses the site, readily acknowledges the financial importance of the Alamo: "The Alamo is a huge economic generator for my community."[4]

This latest controversy in the Alamo's administration is but one of many significant clashes concerning the DRT's management of the Alamo, which have ranged from financial disputes, to problematic site expansion plans, to competing ideological uses of the location, to a series of internal organizational disputes. However, unlike the U.S.S. *Arizona* Memorial, the California State Railroad Museum, the Lincoln Memorial, and the Mt. Rushmore Memorial, the demand for change at the Alamo did not specifically concern its representation of a minority group. At least, that was not the public argument made that led to the removal of the DRT. The public argument to remove the DRT from their traditional role with the Alamo rested on the accusation that they had neglected their primary role as preservationists to the point of plaster falling from the roof inside the Alamo chapel. A 2010 *New York Times* article stated that "the roof has

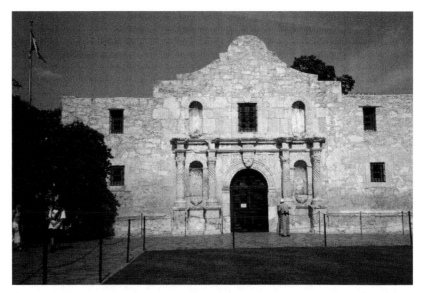

Figure 3.1 Exterior of the Alamo chapel (photograph by the author, 2011)

become the focus for those calling for new management . . . complaints reached a peak last February when a patch of plaster fell from the ceiling and forced the closing of two rooms in the church."[5] The Texas state legislature's response to remove the DRT from their historic role would appear overzealous and certainly hints at larger issues driving this historic change. This chapter looks at how the removal of the DRT from its direct custodianship of the Alamo is also a consequence of the visitor-centric paradigm shift in sharing historical authority.

The relatively late appearance of this paradigm shift at the Alamo is indicative of a set of issues that are particular to the Alamo and its administration. As is the case for many controversies concerning historical interpretation, the context for this shift at the Alamo has deep roots, and in this situation the issues evolved from four main tensions. One involved the lack of representing the Alamo within Mexico's national history. A second tension has been the lack of Tejano representation in

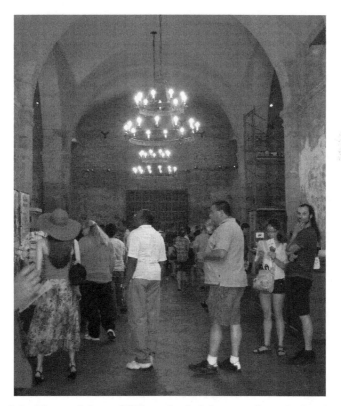

Figure 3.2 The roof plaster fell from the far left corner from the interior of the Alamo chapel (photograph by the author, 2011)

the 1836 battle, and the third tension was the absence of information concerning the site's history before 1836. The fourth tension is actually a set of problems revolving around the DRT's long-standing lack of organizational transparency as well as its extremely slow response to community concerns. This chapter addresses these tensions with a description of the history of the Alamo site, followed by an examination of the DRT's relationship with the Alamo and their decision to define the Alamo's historical significance primarily as a thirteen-day battle in 1836. This discussion is followed by an analysis of the controversies involving the Alamo site itself and the expanded interpretive exhibits in the Long Barrack that opened in 2005. The chapter concludes with a discussion of the implications of the Alamo's visitor-centric paradigm shift that included both removing the DRT from their direct custodianship of the Alamo and the appearance of relatively recent interpretive materials, which define the Alamo's significance within the broader perspective of U.S. and Mexican history.

The Alamo before 1836

The buildings that are now called the Alamo were built initially as part of Spain's efforts at colonization in Northern Mexico (now the southwest United States). Eighteenth-century Franciscan friars built a series of missions along the San Antonio River, the first of which became known as the Alamo. The Alamo's original name was the Mission San Antonio de Valero; the mission was established in San Antonio in 1718 as "part of the official Spanish plan to Christianize Native Americans and colonize northern New Spain."[6] This particular mission moved three times before occupying its current site in San Antonio.[7] During the next thirteen years, the Friars built or moved four additional missions to the nearby San Antonio River: Mission San José (1720), Mission Concepción (1731), Mission San Juan (1731, moved from East Texas), and Mission Espada (1731, moved from East Texas).[8] All five missions lie within six miles of each other. The Spanish friars eventually abandoned the Mission San Antonio de Valero after sixty-nine years, resulting in its land and church falling into a variety of uses over the years. The remaining four San Antonio missions were "secularized—the lands were redistributed among the inhabitants, and the churches were transferred to the secular clergy." Ultimately, these four missions, which did not include the Alamo, became part of the National Park Service in 1978 under a cooperative agreement with the Archdiocese of San Antonio where the "churches remain active centers of worship."[9] The history of the Alamo followed a different trajectory.

After the Spanish friars abandoned Mission San Antonio de Valero, the Spanish military force, under the name of Segunda Compañía Volante de San Carlos de Parras, continued efforts to keep the region under Spanish

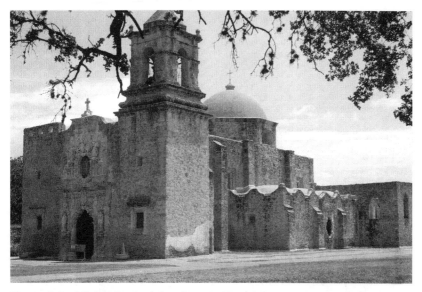

Figure 3.3 Mission San José, San Antonio, Texas (photograph by the author, 2011)

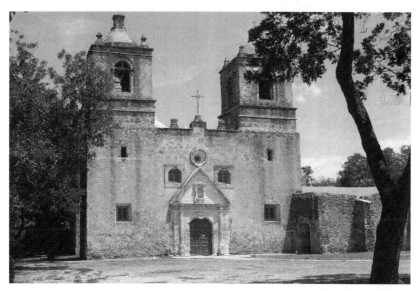

Figure 3.4 Mission Concepción, San Antonio, Texas (photograph by the author, 2011)

rule. The mission became known as Alamo de Parras, apparently in reference to the *alamos*, the Spanish word for the cottonwoods that grew on the site.[10] The Spanish continued their utilization of the location as a fortress

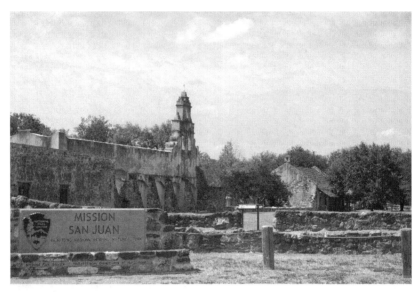

Figure 3.5 Mission San Juan, San Antonio, Texas (photograph by the author, 2011)

Figure 3.6 Mission Espada, San Antonio, Texas (photograph by the author, 2011)

until the revolution in 1821, when Mexico achieved its independence from Spain. The fortress "became an integral part of the frontier forces of the new Mexican Republic" that would "promote Mexican expansion and

check illegal immigration and smuggling."[11] It is noteworthy that illegal immigration at this time in history meant controlling illegal U.S. immigration into Mexico. After the Mexican revolution, a significant number of U.S. citizens immigrated into northern Mexico, known as Cohuila y Tejas, and by 1835 Mexican citizens there numbered 7,800 compared to 30,000 Anglo-Americans.[12] Even with the large influx of Anglo-American immigrants into Cohuila y Tejas, the battle at the Alamo was not simply divided along the lines of Mexicans versus Anglo-Americans. Of the 187 men who fought inside the Alamo, "thirteen were native born Texans . . . eleven of whom were of Mexican descent . . . forty-one were born in Europe, two were Jews, two were Blacks, and the remainder were Americans from other states in the United States."[13] The thirteen-day battle at the Alamo is discussed in more detail in the next section concerning the DRT.

After the battle for Texas independence from Mexico and once Texas became the twenty-eighth state in 1846, the Alamo was leased to the U.S. Army, and both the U.S. and the Confederate armies used the Alamo as a quartermaster depot. By 1876, all property was sold, except the church, for commercial use. The city of San Antonio took over the former battlegrounds.[14] Unlike the other four San Antonio missions whose original property footprints remain largely intact, the Alamo's original mission site was significantly encroached on by the city of San Antonio's commercial developments.

The purchase of the Alamo buildings by the State of Texas took place in 1905, organized by Adina de Zavala, one of the original

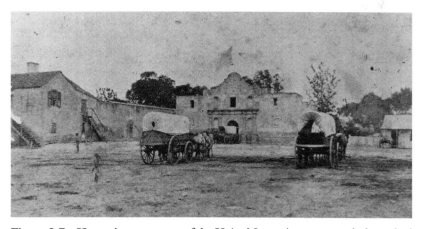

Figure 3.7 Horse-drawn wagons of the United States Army approach the arched door of the Alamo chapel when the location served as the quartermaster depot between 1848 and 1878 (courtesy of Daughters of the Republic of Texas Library, San Antonio, Texas)

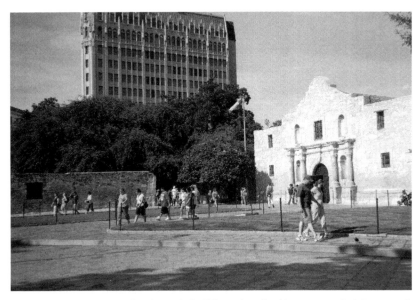

Figure 3.8 Downtown San Antonio buildings abut the Alamo grounds (photograph by the author, 2006)

founders of the DRT and the "granddaughter of Lorenzo de Zavala, a Mexican statesman who also became the first Vice-President of the Republic of Texas."[15] On January 10, 1905, the state of Texas passed S.H.B. No. 1, in which Texas purchased the Alamo chapel, the Long Barrack (formerly owned by Hugo and Schmeltzer Co.), and the property "bounded on the north by Houston Street, and on the east by the Alamo Ditch, and on the south by the Alamo and the Alamo Plaza and on the west by the Alamo Plaza."[16] The Alamo is actually a complex of buildings of which the chapel is the most familiar element. The Alamo site also includes the "Long Barrack Museum, DRT Library, Sales Museum, Alamo Hall, Cavalry and Convento Courtyards, Acequia (the waterway that marks the remains of the irrigation system that served the Spanish communities along the San Antonio river), Stone Walls and Arcade, and the Wall of History."[17] The 1905 Texas law also directed the Governor to deliver all of the Alamo property "to the custody and care of the Daughters of the Republic of Texas, to be maintained by them in good order and repair, without charge to the State, as a sacred memorial."[18] For 106 years the DRT ran the Alamo complex, which included the development of all of its interpretive materials as well as maintenance and expansion of the buildings and grounds. The Alamo's lush gardens are another visual difference from the NPS's four San Antonio missions. The DRT has put tremendous

effort into transforming the mostly barren site into one that now boasts verdant gardens with impressive specimens.

Daughters of the Republic of Texas

Until recently, the Alamo was the only site studied in this book that had not been administered by a public agency. Even though the state of Texas handed the DRT the Alamo's custodianship, the DRT was never a public organization. The DRT is a private, nonprofit organization founded in 1891. The DRT's nonpublic structure contributed to the types of problems and limitations of having a private organization administer an historical site of national and international interest.

To be a member of the DRT, applicants must prove either direct lineage (or descent through marriage) to those who were involved in Texas's fight for independence from Mexico. To qualify for membership, the DRT Constitution and By-Laws state that: "Any woman may be eligible for membership who is of the age eighteen years, and whose ancestors were of the *Old Three Hundred*, or were soldiers, seamen or civil officers of the State of Coahuila and Texas, who aided in establishing the independence of Texas, or served the Republic of Texas in maintaining its independence up to its annexation to the United States, February 19th, 1846. Widows and wives of men who rendered such services are also eligible for membership."[19]

The DRT stated their purposes in their 1892 Constitution as follows: "(1) To perpetuate the memory and spirit of the men and women who achieved and maintained the independence of Texas. (2) To encourage historical research into the earliest records of Texas, especially those relating to the revolution of 1835 and the events which followed; to foster the preservation of documents and relics; and to encourage publication of records of individual service of soldiers and patriots of the Republic. (3) To promote the celebration of March 2d (Independence Day), and April 21st (San Jacinto Day); to secure and hallow historic spots, by erecting monuments thereon; and to cherish and preserve the unity of Texas, as achieved and established by the fathers and mothers of the Texas revolution."[20]

There are approximately 8,000 DRT members, and there have been 24,000 daughters since 1891.[21] In addition to running and maintaining the Alamo, the French Legation, the DRT Library, the DRT Headquarters and Museum, and the Cradle (the building in Galveston, Texas, where the idea for creating the DRT took place), the DRT provides printed materials for the Texas public schools' Texas history courses. The Texas Education Agency requires sections on Texas history be taught in the fourth and seventh grades in all public schools in Texas. Additionally,

from 1905 through January 1, 2012, the DRT vetted and made all the final determinations on anything that was built, removed, sold, or distributed in the Alamo complex. There is no entrance fee to the Alamo; the DRT used a combination of gift shop sales, contributions, and grants to support the site's operation.[22]

The DRT are part of a long tradition in the United States of women's participation in historic preservation. This practice of preservation was particularly significant during times when women's public participation was severely limited: "While improving the world around them, they also learned . . . to acknowledge their own worth as individuals in a society that tried to keep them at home."[23] The DRT formed around the same time as the Daughters of the American Revolution and the Colonial Dames of America, and all three based their membership on patriotic heritage and their missions included historic preservation.[24] Although the DRT has been one of the nation's most successful women's historical preservation groups, their tenure has been marked by controversy. In addition to the initial internal divisions that pitted DRT founders Adina de Zavala against Clara Driscoll,[25] the DRT's stewardship of the Alamo has repeatedly been criticized for its "fervently Anglo account of Texas history."[26] Although the Alamo was built in 1718, the DRT concentrated its interpretive materials on the site's significance in terms of the thirteen-day battle in 1836. Madge Roberts, former DRT Alamo Committee Chair, declared that the DRT are telling "the correct history of Texas."[27] Alamo historian Bruce Winders has defended the DRT's long-standing interpretation of the Alamo in terms of this one battle as a result of the 1905 enabling legislation that required the site to be maintained "as a sacred memorial to the heroes who immolated themselves upon that hallowed ground."[28] However, this same piece of legislation also proclaimed "the great importance to the people of Texas of conserving the existing monuments of heroism of their fore-fathers."[29] This law that enabled the DRT's stewardship at the Alamo could be interpreted narrowly to cover only the 1836 battle, or this law could be interpreted more broadly to include all of Texas history that led up to the battle and its implications. Until 1997, the DRT had chosen the less inclusive interpretive approach, which was one that did not include situating the Alamo as part of the Spanish Friars' founding of the five missions along the San Antonio river, or representing the Alamo within Mexico's battle for independence from Spain, or acknowledging its strategic role in Mexico's development as an independent nation.

The Mythic Narrative of Texas Independence

The "traditional"[30] story of the Alamo is a mythic narrative of battle where "the death of the Alamo defenders is a strategic and well-executed military

move; as a successful sacrifice, the Alamo story ends with victory rather than defeat."[31] Holly Benchley Brear's description of the traditional story nicely captures the mythic and religious qualities of this particular narrative. The U.S.-appointed Alamo commander was William Barrett Travis, whose "decision to stay appears as a redeemed investment rather than a needless waste of human lives, the inception of a painful birth rather than death. Within the mythology, the Alamo harbors the metaphorical altar on which the Alamo defenders—led by the trinity of Travis, [James] Bowie, and [David] Crockett—offer their lives to allow this birth of Texas liberty. The old mission itself becomes a part of the birthing process as it is reborn as a Texas chapel . . . the Alamo was baptized in the fire of battle and the blood of heroes." The traditional story depicts General Antonio Lopez de Santa Anna as "a self-styled Napoleon of the West," and, "if not the most brilliant of military strategists in history, Santa Anna was perhaps the most vain. . . . By Santa Anna's command, the Alamo heroes received no Christian burial. Their bodies were stacked between layers of wood and burned. . . . Santa Anna's cruelty at the Alamo and Goliad spawned a reign of terror, and whipped across the young republic."[32]

The traditional Alamo story relies on the archetypal myth format where "the pure gesture which separates Good from Evil . . . [that] unveils the form of Justice . . . is at last intelligible."[33] In the Alamo's traditional story, the form of justice that becomes intelligible is that those who fought for Texas independence were uniformly good and those aligned with Santa Anna were unrelentingly evil. Popular historian Lon Tinkle describes the Texan white male heroes as independent thinkers and supporters of democracy while depicting the Mexicans as members of a "master-slave society" with Santa Anna as their fascist leader.[34] This traditional story has proven to be extremely popular, and the DRT is keenly aware that the Alamo "has become a symbolic element of the memorial heritage" not only for Texas but for the United States and many international visitors as well.[35] In the Convento Courtyard stands a stone memorial commemorating the similarities between the battle of the Alamo and the Japanese 1577 Battle of Nagashino. This memorial was donated to the Alamo in 1914 by Japanese professor Shigetaka Shiga.[36] In 1980, "Alamo fanatics . . . traveled from all over the United States and Europe for the first convention of the Alamo Lore and Myth organization—ALAMO."[37]

The story of a small band of men fighting for liberation against much larger numbers of men intent on taking away their freedom is a broadly embraced narrative, and it is one that the DRT portrayed narrowly on site despite the Alamo's more complex history. "The most frequent challenges to the DRT's authority at the Alamo come, not surprisingly, from Hispanics in San Antonio."[38] Rudi Rodriguez, founder of the Hispanic Heritage Center, observed that Tejanos were "written

about as witnesses but not as heroes" at the Alamo.[39] Broadening the Alamo's narrative to include Tejano heroics was only one of the challenges for the DRT's administration of the Alamo. Developing a coherent narrative on-site through its interpretive materials has proven to be surprisingly difficult.

Alamo Interpretive Materials

Until the late 1990s, there was relatively little interpretive material on the Alamo grounds, and those items were frequently critiqued for their lack of relevance. Bruce Winders noted that over the years the Alamo had not received many artifacts, which is unlike other history museums that have warehouses full of donated objects and memorabilia pertaining to the depicted time and events.[40] Winders posited that one of the main reasons for the lack of authentic Alamo artifacts is on account of the Alamo's burning after the 1836 battle. Until the 1990s, the site's interpretive materials consisted of changing display cases in the chapel and in the Long Barrack, an orientation film, and a very large bookstore. Until 1997, a visitor's experience at the Alamo consisted of finding the chapel, walking around the relatively small grounds, and ending in the sizeable bookstore.

The entire Alamo site is generally depicted as the Alamo chapel. Brochures printed by the DRT contain an image of the iconic chapel (Shrine)[41] on the front cover; the printed guide for the audio tour contains the same picture (in color), and websites promoting San Antonio tourism usually contain a similar photo of the chapel.[42] This visual representation is further supported by the layout of the grounds. The Alamo chapel is the most visible element of the site because of its gate-free west-facing location and its clear visibility from Alamo Street. No other building in the site is as visible from the street as the chapel. The eastern, southern, and northern sides of the site are lined with foliage-covered stone walls, which contain several additional entrances into the site that lead visitors to the gardens behind the chapel. Most visitors find the chapel relatively quickly, and this becomes their first encounter with the Alamo.[43] During the day, and especially during the high tourist season summer months, there are long lines flowing out of the chapel into the Alamo plaza, which again marks the chapel as the "entrance" to the site. At night, the chapel's dramatic lighting makes the yellow sandstone-building stand out starkly against a black nighttime sky.

Once visitors are inside the chapel, Alamo staff members ask males to remove their hats and all visitors to lower their voices. These admonitions remind visitors of the building's religious history and reinforce its meaning as sacred.[44] The inside of the chapel is cool, and visitors generally use

hushed voices as they make their way through the relatively brief circuit of the interior. About halfway up the chapel's nave, visitors encounter an information desk run by the DRT, which is the DRT's only paid position.[45] In 2000, the DRT began a series of extensive renovations on the chapel's interior, which revealed frescoes "likely painted in the 1700s" in the sacristy. Only one of the other four San Antonio missions has "remnants of interior decorations," which resemble fresco-painting methods that were likely inspired "by a friar as early as 1525."[46] The sacristy previously held the flags of all the home states and nations of the Alamo independence fighters; they had been moved into the chapel's interior during this renovation. This is the same renovation that ultimately led to the infamous falling ceiling plaster incident.

The inside of the chapel is sparsely decorated with very few historical artifacts or detailed descriptions of the battle. There are four permanent display cases, which include a John Gadsby Chapman painting of Davey Crockett, Crockett's beaded buckskin vest, Gregg Dimmick's "Sea of Mud" artifacts (items recovered from the Mexican military as they retreated in the mud during the 1836 battle), a Dickertt rifle, a Crockett rifle, a Searles Bowie knife, and powder horns.[47] There are also temporary exhibits that rotate through the chapel.[48] Over the years there have been complaints that a visit to the Alamo is disappointing, and one survey found that the Alamo was ranked "third among 10 most disappointing tourist destinations in North America (Gatlinburg, Tennessee, and Disneyland, California, ranked first and second)."[49] From discussions with Alamo staff and historic newspaper coverage, this disappointment appears to have come from three sources: the small size of the location, San Antonio's downtown commercial encroachment onto the historic site, and the lack of interpretive materials. In 1973, a *Houston Post* reporter blamed his disappointing Alamo visit on the "lack of historical continuity," the "thin trickle of exhibits," and the lack of "a model that allows him to orient himself."[50] Most visitors of historical sites are accustomed to achieving a level of imagination sufficient to orient themselves physically in order to understand and envision a site's historic events. This ability is significantly challenged at the Alamo, where the site is surrounded on all four sides by multistoried urban corridors that make it particularly difficult to visualize the initial layout of the Alamo as a mission. The original boundaries cross over into the neighboring streets and into the surrounding commercial storefronts. Astute visitors can find evidence of the original mission's perimeters in the sidewalks that contain inlaid stones delineating the mission's borders, which would have encompassed the chapel, the Long Barrack, and three additional acres.[51]

In addition to the difficulties visitors encounter when trying to envision the mission boundaries of 1718, until recently the Alamo's exhibits

Figure 3.9 Stones in the sidewalk of the commercial center across the street from the Alamo demarcate its original borders as a mission and a fort (photograph by the author, 2006)

have not provided the voluntary learning ("free choice learning") experience that many history tourists seek.[52] In fact, the interpretive materials have been described as a "hodgepodge" with items "crammed . . . into exhibition cases wherever there is room."[53] Over the years, the Alamo exhibits appeared to contain any item that had something to do with the thirteen-day battle, which included everything from a single rifle that *may* have been used in the battle, a child's small ring perhaps from Travis, a rusted knife blade, silverware, lace handkerchiefs, Sam Houston's walking stick, and publicity photographs of John Wayne and Richard Widmark.[54] In 1964, a newspaper columnist described the new Alamo exhibits where "one large glass case affords a copy of the original Texas declaration of independence," and also in the case were pictures of five early Texas capitol buildings, an old blacksmith shop at Washington-on-the Brazos, a farmhouse at Columbus, and a frame building at Houston. Another case contained documents pertaining to San Antonio's early history and mementos of everyday life of the Texas colonists, which included

homespun trousers, silver-rimmed spectacles, an old bedspread, and a country doctor's medicine bag. The DRT acquired a 400-year-old brass bell in 1963 that "conforms in its style to that of the ancient Spanish tradition associated with the Alamo."[55] In 1963 the Alamo's exhibits included "a Sam Houston corner furnished with a chair which belonged to the General, an authentic desk and the Treasury chest used during the Republic of Texas," and a "daguerreotype of Robert H. Dunham, two civil war cannonballs, an original land grant signed by Stephen F. Austin, an original report from General Thomas J. Rusk, chief of staff at the Battle of San Jacinto, and a replica of the auxiliary sail-propelled prairie wagon invented by Gail Borden."[56] In 1964, a cardboard model of the Alamo battle with scores of miniature figures was added to the site.[57] The collection of Alamo artifacts was, in fact, eclectic and somewhat random.

The DRT's elaborate gift shop, built by the Works Progress Administration (WPA) in 1937 to resemble the chapel, is one of the few historic site bookstores that include museum exhibit cases, and these are located in the middle of the store's themed mementos, trinkets, books, and films. Given the historic paucity of coherent interpretive materials at the Alamo, it is significant that these display cases even exist on site. The bookstore exhibit cases contain a diorama of the 1836 battle of the Alamo and archeological artifacts uncovered during onsite digs over the years. The diverse and apparent arbitrary nature of artifacts exhibited at the Alamo bookstore include a brown clay pot for hot chocolate, beads, buttons and one bottle, spoon, metal fragments, Texas newspapers from the 1830s reporting on battle and revolution, and the coonskin cap and the director's award from the 1960 movie *The Alamo*.[58] The only location on this site where visitors could find a historical narrative of the Alamo was in the Long Barrack, in the orientation film.

The Long Barrack sits on the west side of the site and, along with the chapel, is one of the only two original buildings remaining from the Alamo as a mission. The first room on the far left of the Long Barrack is used to screen an orientation film that runs every twenty minutes throughout the day. The orientation film offers an excellent window into understanding the production, reproduction, and endurance of the traditional story at the Alamo, and for many tourists it is their first encounter with a sustained narrative of the Alamo.

The Alamo's Current and Former Orientation Films

The DRT produced two orientation films for the Alamo. The first film, *1836 Battle of the Alamo* (1982), briefly reviews the early history of Texas beginning with its colonization by the Spanish and then tells the story of the famed battle of Texan resistance against Santa Anna's forces.[59] This

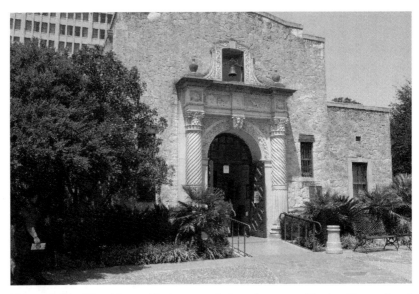

Figure 3.10 The Alamo gift shop was designed to resemble the Alamo chapel (photograph by the author, 2011)

film was shown to Alamo visitors for thirteen years, from 1982 to 1995, until the second film made its début in the public theater in the Long Barrack. The second film, *The Alamo* (1995), focuses on the 1836 battle at the historic site, the battle's aftermath, and the DRT's efforts from the 1890s to the present at preserving the site. This film was still screening in 2012. Although the second film is an "update" and is visually much different from the first videotaped slide show film, the traditional story remains largely intact in both films.

Most orientation films at national historic sites are from ten to twenty minutes long and simply do not have the time to present a complicated and nuanced historical depiction; however, the Alamo's continued use of the "traditional story" is surprising on account of the local tensions surrounding representation at the Alamo. San Antonio is home to a substantial Mexican-American community, which comprises just over 63% of the city's population.[60] Despite repeated calls to include more positive representations of Mexican Americans, Tejanos, and the role of the Alamo in Mexico's historical development, the Alamo's narrative of Texas history in its orientation films has not much changed to reflect these concerns.[61] Historian Michael Wallace notes that the desire for representation derives from "people [who] are clearly interested in the past, but when they seek understanding they are confronted with institutions (of which the museums are only one) that tend to diminish their capacity to situate

themselves in time."[62] Richard Flores further argues that the story of the Alamo "elides the real conditions of history for constructed notions of the nation."[63] Various historical elisions that persisted in both of the orientation films constitute three of the four tensions that contributed to the visitor-centric paradigm shift in historical authority at the Alamo.

The DRT's films about the Alamo rely on the strategies of marginalization, division, and vilification, which ultimately construct knowledge and a way of interpreting the world that privileges one select group and rejects others. For tourists visiting the Alamo, both films present a story with a narrator telling the audience what happened at the Alamo from the DRT's perspective. This point of view rests on a representation of Texas history that glorifies the white heroes of the Alamo, marginalizes the contributions of Native American Indians and Tejanos, and demonizes the Mexican dictator Santa Anna and his army, dividing and separating the white defenders of the Alamo from others who were involved in the history of the mission and reinforcing an ethnocentric mythology of Texas history.

Both of the DRT's orientation films invite the Alamo visitor to view the Alamo as a symbol of liberation. The first orientation film retells the traditional story of the battle at the historic site and reminds the audience that when General Sam Houston and his army defeated Santa Anna's forces at the battle of San Jacinto, the Texans of Houston's army shouted with one voice, "Remember the Alamo!"[64] The DRT's second orientation film also frames the Alamo experience as one of liberation. The film begins with the narrator telling the Alamo visitors that they are at "an historic shrine," the "site of one of the most famous battles of American history," the place where "the story of the Texans' courageous stand for freedom in the face of such overwhelming odds is so powerful that it has transcended the pages of history."[65] Hence, both films frame the Alamo experience as a place of liberation, where brave men died to defeat the dark forces of oppression. The films position the Alamo visitors to identify with this place, viewing it as a symbolic manifestation of the human quest for freedom.

Central to revealing the message of both orientation films is an understanding of the exclusive and inclusive appeals used to construct the historic roles of the actors who are part of the Alamo story. In the DRT's first film, an exclusive appeal is developed about the role of the Native American Indians in the founding of San Antonio and the Alamo. The film presents a sanitized view of American history about what the narrator identifies as the Spanish decision "to civilize and Christianize the province of Texas." The film fails to mention the tribal name of the indigenous Indians from San Antonio but depicts them as living an idyllic life under the spiritual guidance and supervision of Spanish monks after the mission

was founded in 1718.[66] According to the film's narrator, the Indians of the Alamo "were instructed in crafts and manners by the friars" and "worked the fields surrounding the enclosure and guarded the livestock," and "when not working, they attended religious services and many were converted to Christianity." A more candid representation of life at the Alamo at this point in time is contained in the film's admission that "Life was hard for both the Indians and friars, and by 1778 a series of epidemics had depopulated the mission." The DRT's second orientation film nearly excises the indigenous Indians of San Antonio from the history of the Alamo with the exception of one reference to Spanish "missionaries" "convert[ing] local Indians to Catholicism and teach[ing] them Spanish culture." Both films emphasize the Spanish as the principal actors in early history of the Alamo and the local native Indian tribes are marginalized in their role in the history of the Alamo. The film presents an exclusive appeal dividing the indigenous Indians from the Christian Spaniards who sought to "civilize" this far-flung outpost of the Spanish empire.

Tejanos are treated differently in each of the DRT's films. Visitors of the Alamo who watched the first orientation film would have left the theater completely unaware of the role played by Tejanos in the founding of San Antonio and the defense of the Alamo. In the second film, this crucial historical omission is corrected by the DRT: Tejanos are identified by the narrator of the film as actively allied with the white settlers of San Antonio in the "mounting civil unrest" against the despotic rule of the Mexican dictator Santa Anna. However, the major characters that defend the Alamo as told in the DRT's second film are all white. Indeed, nearly three minutes of the film are devoted to telling the Alamo visitor about the historical and mythical contributions of James Bowie, William Barrett Travis, David Crockett, and James Walker Fannin, while only eighteen seconds of the film are allotted to Gregorio Esparza, a defender of the mission "from the oldest Tejano families in Bexar" and the only Tejano specifically identified by name in the entire film. This treatment of Esparza and his unnamed Tejano comrades who defended the Alamo against the assault of Santa Anna's army, as contrasted to the attention given to Bowie, Travis, Crockett, and Fannin, divides Tejanos from whites, devaluing and rejecting their historical stake in the liberation of Texas. Other than identifying Esparza as a Tejano, the DRT's second orientation film mentions only the fact that his body was recovered and buried by "his brother, a Mexican soldier," unlike the other Alamo defenders, whose bodies were "piled together and burned in large fires." By implication, Esparza, the Tejano, is divided from the white martyrs of the Alamo; his ethnic identity is transformed from a Tejano into a Mexican because his body was symbolically reclaimed by the Mexicans as one of their own. Moreover, the telling of this minor detail about the burial of Esparza's body, especially

in the absence of information about his role in the defense of the Alamo, diminishes the results of the DRT's effort in the second film to present a more inclusive story about the role of Tejanos as heroes of the Alamo.

Significantly, neither orientation film produced by the DRT helps the Alamo visitor to understand the many causal factors that contributed to the birth of the Republic of Texas. The first orientation film fails to mention why Santa Anna inflicted repressive policies on the colonists of this Mexican province. In fact, the story told by the narrator of this film jumps from the depopulation of the mission in San Antonio in 1778 to General Cos's defeat at the Alamo in 1835. In the second film, "the story begins in 1835," when the Texans rebelled against the Mexican government's imposition of "new taxes," the attempts "to halt further immigration from the United States," and the abolition of the "federal constitution of 1824" that "guaranteed the colonists' rights as Mexican citizens." Although the telling of these facts helps the visitor to learn why the colonists revolted, the film does not mention the reasons that Santa Anna initiated these policies in the first place. Moreover, the delineation between the white defenders, Tejanos, and Mexicans is further complicated by the fact that many of the Alamo defenders were actually Mexican citizens at the time of the battle. In the years between 1820 and 1830, at Mexico's invitation, about 20,000 Americans with approximately 2,000 slaves settled in Texas as part of Mexico's effort to colonize the area and remove the Indians.[67] To legally immigrate into Mexico, migrants had to be "of good moral character, . . . profess Roman Catholic religion, and . . . abide by Mexican law."[68] Not only were the U.S. immigrants outnumbering the Mexicans by nine to one in 1828, but also these colonizers were not inclined to integrate into Mexican society.[69]

A point of contention for the American colonizers concerned the new Mexican law prohibiting slavery. Historian Will Fowler notes that the "abolition of slavery in Texas remains one of the main, yet often downplayed, reasons why the Texans rise up in arms."[70] One of the achievements of Mexico winning its independence from Spain in 1821 was a "promised equality among all Mexicans regardless of their caste."[71] Neither film explains that many of the Americans who settled in Texas and fought at the Alamo wanted to establish a plantation economy complete with slaves, despite Mexico's prohibition on slavery.[72] This law was flagrantly violated in Texas, and in "1829 the Mexican government passed an emancipation proclamation outlawing slavery . . . that was aimed at curbing the number of U.S. citizens moving into the Mexican provinces."[73] Given that the Alamo defenders are uniformly represented as liberators and fighting oppression, their support of slavery would seriously complicate the site's representation of good and evil. Depicting the story of Texas independence within the U.S. fight regarding slavery would disrupt the traditional

narrative and offer visitors a representation of Mexico as not uniformly evil and the defenders as not uniformly good.

Regardless of which orientation film a visitor to Alamo may have viewed, it is evident that the DRT wanted to ensure that visitors to this historic site see the traditional story of the Alamo. Richard Flores observes that the Alamo's traditional story is disconnected from the actual events of Texas history and serves to erase the actual participants and their identities and replaces them with a new definition of nationalism and patriotism.[74] Holly Beachley Brear comments that "most Hispanic community members and visitors to the Alamo have expressed frustration with this focus, for they feel their cultural ancestry has been greatly diminished at the site."[75] The two orientation films' characterization of nationalism and patriotism excludes many of the very people who fought for the Alamo and instead offers a depiction that is the exclusive province of white male heroes. One implication of this representation has been the disenfranchisement of current populations who have legitimate historic claims to the story of Texas liberation.

Tejano Claims on Alamo Memory

The lack of representation of Tejanos as heroes at the Alamo battle of 1836 is a distinct tension that contributed to the Alamo's paradigm shift into a more visitor-centric approach to exhibition development. Efforts to incorporate Tejano participation into the Alamo's historical narrative were slow to take root despite repeated calls to include more positive representations of Mexican Americans, Tejanos, and the Alamo's role in Mexico's history.[76] Indications of an increasing desire for inclusion in the Alamo liberation narrative can be seen in Lieutenant Commander David Nava's letter in which he writes that "Texans also died in the Alamo and that most of these were of Mexican descent. Not all Mexicans at the Alamo were enemies."[77] Beachley Brear observed that the DRT's resistance to changing "their narrow, ethnocentric interpretation of the site" is a tension that has been somewhat ameliorated but that has not disappeared.[78] In 1996, the DRT hired professional historian Bruce Winders, who among his many projects, oversaw the installation of the *Wall of History* in 1997, which is located just west of the Alamo bookstore in the Convento Courtyard. This outdoor exhibit is forty-eight feet long and consists of six "porcelain-coated panels display[ing] timelines, illustrations, photographs, maps, and text that tell the story of the Alamo's nearly three-hundred-year long history."[79] This installation was the DRT's first on-site interpretive exhibit that provided a comprehensive explanation of the Alamo's history but that did not privilege the thirteen-day battle. The 1836 Alamo battle occupies just under two panels. Although

the *Wall of History* references Jose Antonio Navarro and Jose Francisco Ruiz as the "only native-born Texians to sign the Texas Declaration of Independence," as well as Juan Sequin and Enrique Esparza (Mexicans who fought for Texas liberation), there continued to be lingering concern that Tejanos were not receiving their rightful place as heroes in the Alamo historical narrative.

This tension crystallized with the efforts of businessman Rudi Rodriguez, who created the Hispanic Heritage Center of Texas. Rodriguez's stated goal was to remedy the absence of Tejano participation in Texas history: "The Tejano history of Texas has not been told. The omission of various tales of those who were not Anglo have led many ethnic groups in early Texas to not being included in textbooks, academic curriculum, or even Texas myth."[80] His desire to change Texas mythology reflects his understanding that the deeply held narratives of Texas history are not necessarily historically accurate, as well as the practical observation that "most Hispanics in San Antonio don't know their history."[81] As a result, since 2002 Rodriguez's group has published books, created documentaries and travelling exhibits, and launched a website that are all dedicated to "bringing awareness and education about the true lives and stories of early Tejano pioneers."[82] Peppered throughout Rodriguez's work in educating Texans about Tejanos in Texas history is his desire for Tejanos to be associated with the story of Texas liberation and in particular the Alamo story. Expressing his frustration with the DRT's tenure at the Alamo, Rodriguez comments that "I can't help but believe any organizational structure birthed by the Land Office has got to be better than what currently exists."[83] Even though the DRT is largely responsible for the promotion of the Alamo as a symbol of emancipation, Rodriguez strongly supported Senator Van de Putte's bill to remove the DRT as the Alamo's custodians.

Tejanos were not the only group seeking association with the Alamo's story of liberation. Although the DRT maintained a primarily Anglo version of the battle, the story of a small band of men fighting overwhelming numbers of those opposed to individual freedom is a tremendously appealing narrative, and the site has thus served as a symbol that defines the United States. In his book on U.S. holidays, Walter Rundell claims that Alamo Day is a holiday that all Americans should celebrate: "Like Lexington and Concord, it is a spot where heroes stood and died for freedom—where men were willing to give their lives so that others could be free to govern themselves."[84] The Alamo's appeal has resulted in the site's use for a surprising array of contradictory political causes. In 1965, the local newspaper described how the Alamo was the location for a progovernment and pro-Vietnam War rally: "In a day of draft-card [*sic*] burning and violent demonstrations, it was heartwarming to

see Americans rally 'round to show their support of flag and country,"
because this was "where 188 men sacrificed their lives in the cause of
liberty and freedom."[85] The Alamo was again the setting for another pro-
Vietnam war rally in 1969 that included "mainly high school and college
age persons [who] shouted patriotic slogans" with signs that read "'God
Bless America, Down With Protestors, and Better Dead Than Red.'"[86]
The local newspaper also wrote about those *opposed* to the Vietnam War
who chose the Alamo for their demonstrations in 1971: "The dem-
onstrators sought to link the battle of the Alamo [to] the bombing of
Hiroshima and the Vietnam war as symbols of 'American militarism' and
'American imperialism.'"[87] In 1985, two Vietnam veterans picked the
Alamo as the site to commemorate the over 2,000 military personnel
still missing in action, because "the Alamo symbolize[s] that Vietnam
soldiers were fighting a losing cause but continued to fight out of a sense
of duty."[88] The Alamo's attraction extended to ethnic pride as well, with
Irish Americans celebrating their claim to the Alamo's heroic legacy on
St. Patrick's day when the "Harp and Shamrock Society of Texas honor[s]
the 188 Texans who died defending the Alamo, and especially the 33 of
Irish descent."[89] And even the Knights Templar "have attempted to verify
the Masonic membership of the Alamo heroes" and dedicated a bronze
plaque "to the memory of the unidentified Masons who gave their lives in
the battle of the Alamo."[90] The symbolic meaning of the Alamo site is one
that has been and continues to be appropriated across the political and
demographic spectrum, with each group claiming its messages of heroism
in the fight for liberty.

The success of defining the Alamo as an international symbol of lib-
erty and struggle against oppression is one of the main tensions that con-
tributed to the paradigm shift of sharing historical authority at the Alamo.
With the annual attendance rivaling top NPS historic sites, the DRT, simi-
lar the NPS and the California State Railroad Museum staffs, needed to
respond to their publics. The installation of the *Wall of History*, which
was followed by the updated interpretive exhibits in the Long Barrack in
2005, marked the DRT's understanding of the need to interpret the site
as more than the thirteen-day battle in 1836.

Long Barrack Exhibit

"'We wanted to give something back to the citizens of Texas and San
Antonio. We're thanking them for allowing us to be custodians,' said
Virginia Van Cleave, DRT Alamo chairwoman, on the opening of the 2005
Long Barrack exhibit."[91] Ms. Van Cleave's statement spoke to the pride the
DRT took in the new interpretive exhibit as well as to their understanding
that they needed to shore up public support. The *Southwestern Historical*

Quarterly offered high praise for the new 178-feet-long exhibit: "For the first time at the Long Barrack Museum the public gets a comprehensive picture of the role that the battle of the Alamo had upon the histories of the United States and of Mexico." Furthermore, the exhibit "has an important myth-breaking story to tell."[92]

The exhibit contains five sections, which include the Mission/ Presidio Period, Mexican Independence from Spain, Colonization, Texas Revolution, and Remembering the Alamo.[93] The overall design concept to interpret the Alamo's history via these five periods gives visitors the opportunity to experience a coherent chronological narrative that provides the voluntary learning that so many seek at historic sites. Even though the 1836 battle is the largest of the five sections, the additional historical information is a significant change of representation for the site that builds on the *Wall of History*'s contributions. In particular, there are multiple panels depicting the Native American tribes' experiences in the

Figure 3.11 The Long Barrack in the Alamo is one of the only two original buildings that remain from the 1718 Alamo mission (photograph by the author, 2011)

area and not just in terms of their decimation: "Treaties with the Apaches in 1749 and with the Comanches in 1785 brought members of both groups to town regularly to trade. . . . Some San Antonio families developed special relationships with Native American families, exchanging hospitality and providing valuable channels of communication."[94] Another substantial addition is the entire section describing the revolution in Mexico as similar to the U.S. revolution, because they sought independence from foreign domination and modeled their first independent government on the U.S. Declaration of Independence. This section addresses one of the long-standing critiques of the DRT's refusal to interpret events at the Alamo in terms of Mexican history and Mexico's struggles with independence and governance after winning its independence from Spain.

The topics of slavery and Tejanos both appear in the 2005 Long Barrack museum in the Colonization section. Slavery is first mentioned in the description of the Anglo immigrants into Mexico: "Many settlers from the United States were from the South, a number of whom brought African American slaves with them." The issue appears one other time within the context of Mexico trying to slow U.S. immigration into Mexico, "[Mexico] established several new forts in Texas to strengthen its presence [and] prohibited importation of slaves."[95] There is no mention of the Alamo heroes' slave ownership, which was a violation of Mexican law, or of the long fight to preserve the institution of slavery in the State of Texas.[96] The lack of even a few more sentences explaining the role of slavery in Texas history and at the Alamo is disappointing; the incorporation of Tejanos into this historical narrative is much more successful.

Tejano representation can be found throughout the Long Barrack exhibit. Tejanos are first referenced in the Mission/Presidio period under a picture depicting "Tejano Scouts" with a picture of Jose Francisco Ruiz, who is described as "a soldier and statesman . . . [who] supported the revolution of 1813 and 1835. He signed the Texas Declaration of Independence in 1836."[97] The next two references are in the Colonization section: "Many Tejanos lived on ranches and raised cattle. Commerce was restricted under [a] tightly controlled trade system inherited from the Spanish, although many *Tejanos* engaged in illegal trade across the border with Louisiana." Within this section there is an entire panel entitled "Anglo Tejano Interdependence," which reads: "Most of the new colonists settled to the east of San Antonio de Bexar. . . . Some, however, joined the *Tejano* community in San Antonio de Bexar. *Tejanos* saw their own economic prosperity tied to the newcomers, who planned to transplant American-style agriculture and industry to Texas. *Tejanos* lobbied on behalf of the colonists in the state legislature of Coahuila y Tejas."

This particular panel also includes the picture of Jose Antonio Novarro with the caption: "a native of Bexar, [he] supported both the revolts of

1813 and 1835. He befriended Stephen F. Austin, voting for the laws in the legislature of Coahuila y Tejas that benefitted the colonists. He signed the Texas Declaration of Independence in 1836, he later served in the Congress of the Republic of Texas." In the Texas Revolution section, Tejano names are listed in the following panels: "Companies Composing the Bexar Garrison," "Couriers of the Alamo," "Timetable of Travis Messages," "What Happened Later in Life," "Who Were the Survivors?" and "What Happened after the Alamo." Tejano names are engraved in the marble walls, which list all the Alamo defenders who died during the 1836 battle.

The increased presence of Tejanos as historical residents and participants in the Texas battle for independence is a consequential change. Captions for both Jose Francisco Ruiz and Antonio Novarro declare their long-standing commitment to Texas independence by noting their participation in both the revolutions in 1813 and 1835. The amount and quality of Tejano representation into multiple sections of this exhibit echo the level of Japanese American incorporation into the 2011 museum at the U.S.S. *Arizona* Memorial. The Tejano portrayals may not meet Rudi Rodriguez's demands of representing Tejano heroics in the 1836 battle, but their inclusion throughout the exhibit addresses their long absence and provides context for their presence in the overall development and drive for independence in Texas. Although the issue of slavery appears in this exhibit, the explanation of its role in the Alamo and in Texas history is too brief for even the most astute visitor to determine its impact. As a former confederate state, slavery played a key role in Texas' in fight for independence from Mexico and in its annexation to the United States as well.

Although the 2005 Long Barrack exhibit was received with generally positive reviews, it was too little, too late to save the DRT as the Alamo's sole custodians. The DRT's long-standing exclusivity and slow response to demands for change set in motion the successful drive to remove their direct custodianship, despite their additions of the *Wall of History* and the completely revamped Long Barrack museum.

The Shift

On December 16, 2011, the DRT signed "an interim agreement for management of the Alamo" with the Texas General Land Office, and so ended the DRT's 106-year tenure as sole custodians of the Alamo. Although the DRT had finally responded to local calls for the incorporation of Tejano and Mexican history into their interpretive exhibits, the final tension that contributed to their removal as sole stewards was the combination of their lack of transparency and slow response to their publics. In 2009, Jan Jarboe Russell, reporter for the *San Antonio Express-News* wrote:

"As custodians, they have resisted outsiders, rejected accurate historical representations, fired professional managers, and micromanaged[;] . . . the annual reports the DRT makes to the governor's office are sketchy at best and reviewed by no one."[98] In June 2010, the Texas state attorney's office began an investigation of the DRT that "generated 38,000 pages of documents, are said to include alleged diversion of Alamo funds to other sites, inappropriate remarks in e-mails, and an Alamo promotions contract that some fear could cost the state as much as $900,000."[99] While these accusations alone would generally not be sufficient to remove an organization from its duties, it was the multiple tensions discussed throughout this chapter that brought down the DRT. Each tension increased during their paradigm shift into sharing historical authority and using a visitor-centric approach to exhibition development, and, when taken together, they were too much for the DRT to endure. In 2011, Russell called for "steady, reliable management and a staff of historians and professionals with a solid understanding of quality museum practices" to be employed at the Alamo.[100] Also in 2011, the *San Antonio Express-News* editorial board called for the Alamo to have "better and more transparent care" and stated that "its operation should not be shrouded in secrecy."[101] The steady demands on the DRT from their publics are now codified in the pact with the Texas Land Office.

Although the oft-stated public reason for the DRT's removal was their lack of transparency, one of the provisions in their operating agreement with the state of Texas indicates concerns with their interpretive materials. Included in the agreement is the following directive: "DRT is to address the diverse, rich heritage of the Alamo; maintain the 'dignity and decorum' of the site; and provide education outreach that emphasizes historical accuracy."[102] Other requirements include that the DRT will maintain its prohibition on charging an admission fee but will receive $10,000 per month from the Texas Land Office; the Land Office may have an on-site representative and may have an employee on the DRT's Alamo Committee; the Land Office will oversee the entire Alamo staff; the DRT will administer a process approved by the Land Office for handling visitor complaints; and the Land Office may inspect the site or its records, which the DRT is to keep on file for at least seven years.[103] This contract "could be renewed for up to four five-year terms, for a total of twenty years."[104] The paradigm shift at the Alamo has moved the DRT into an organizational structure that requires attentiveness to its publics and incorporation to the Texas state government. The group's ability to operate in this new arrangement is yet to be determined.

As one of the case studies in this book, the DRT's experience with the paradigm shift into sharing historical authority is of note because the Alamo is the only site where the management not only changed but also

became part of public government. The DRT, as a private entity, lacked a structural organization that enabled response and incorporation of public concerns in a timely fashion. Although the nature of the criticisms leveled at the DRT were similar to those directed at the U.S.S. *Arizona* Memorial, Mt. Rushmore, the California Railroad Museum, and the Lincoln Memorial, each of these public history sites was able to respond swiftly, and their administrations were transparent on account of their governmental associations.

How we remember the Alamo is no longer the production of a relatively small private group. The day the ceiling plaster fell on visitors in the Alamo chapel may also become the day that secured the Alamo's move into a visitor-centric paradigm where shared historical authority is possible.

Sex and Gender in the Lincoln Memorial: The Politics of Interpreting Lincoln's Legacy

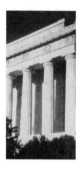

The Lincoln Memorial is one of the few U.S. historic locations where the entire site's meaning has gone through a substantial redefinition. The memorial's initial design was intended to provide a location where visitors could experience quiet reverence for the man who saved the Union, emancipated the slaves, and defended U.S. democracy. However, from Marian Anderson's performance on the Lincoln Memorial's steps in 1939[1] through the 1963 Civil Rights March on Washington, the Lincoln Memorial has become so closely aligned with the fight for African American

Exhibiting Patriotism: Creating and Contesting Interpretations of American Historic Sites by Teresa Bergman, 117–141 © 2013 Taylor & Francis. All rights reserved.

civil rights that this association is no longer questioned.[2] This change in public memory is instructive in how historic sites can be dynamic locations of contest and can also continue to inspire citizens long after the creators' original intentions. The changing perception of the Lincoln Memorial also illuminates some of the historical contests in defining citizenship, civil rights, and nationalism, all of which suffused the discussions of the memorial at its inception and continue through the twenty-first century. The twenty-first-century version of this debate involved the memorial's interpretive materials, and the vitriolic arguments that these materials engendered remind us of the contentiousness of deeply held beliefs concerning interpretations and representations of U.S. history.

In 2003, there was a demand to change the film that screens in the Lincoln Memorial's basement, which was a nearly successful attempt to eliminate representation of civil rights for women, gays, lesbians, and the transgender community. For nine years, an eight-minute film had been playing continuously in a far corner of the memorial's basement on a television monitor, which is one element of the memorial's interpretive exhibits. The film also includes images of marches at the Lincoln Memorial for the rights of workers, Russian Jews, farmworkers, and employee unions.[3] To this day, many visitors are unaware that the Lincoln Memorial has a film or any interpretive materials, because the exhibits are not well signed, they are not mentioned in the memorial's information brochure, and the National

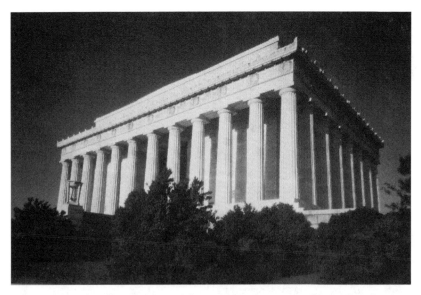

Figure 4.1 The Lincoln Memorial, ca. 1920s (courtesy of Special Collections & Archives, Henry Bacon Papers, Wesleyan University Library, Middletown, CT)

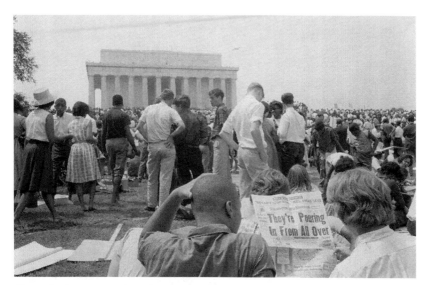

Figure 4.2 Image of Civil rights marchers at the Lincoln Memorial (Warren K. Leffler, August 28, 1963, "Civil Rights March on Washington, D.C.")

Park Service (NPS) personnel do not direct visitors to the exhibits and the film.[4] Most visitors discover this film and the accompanying *Lincoln's Legacy* exhibits when looking for the bathrooms that are located in the memorial's basement. But, in 2003, this short film gained national attention when the Reverend Louis Sheldon, the chairman and founder of the Traditional Values Coalition, declared that this orientation film was "a first class inversion, perversion of Abraham Lincoln. . . . It's political correctness par excellence."[5] The Concerned Women of America added that to "put the struggle for civil rights on the same level as that of abortion and gay rights is warping Lincoln's words."[6] Reverend Sheldon and the Concerned Women of America's criticisms did, in fact, result in the production of a new film for the Lincoln Memorial; however, the national controversy that ensued prevented the NPS from replacing the film.

Lincoln's Living Legacy, the film that touched off this controversy, began screening in 1994, and it is the only film that has been shown at the Lincoln Memorial. Its addition to the memorial came as a result of a Scottsdale, Arizona, high school's field trip in 1990, whose students "were surprised that there was no interpretation or recognition of the 1963 March on Washington and Martin Luther King's 'I Have a Dream Speech.'"[7] The students requested the installation of an exhibit that would demonstrate the Lincoln Memorial as a "living 'stage' embodying Lincoln's legacy on civil and First Amendment rights."[8] The high school

Figure 4.3 National Park Service sign for the *Lincoln's Legacy* exhibit outside the Lincoln Memorial (photograph by the author, 2011)

students and their history teacher, John Calvin, organized a successful campaign to secure funding and approval for their proposal. They worked with the Close Up Foundation[9] and the American Federation of Teachers to conduct a nationwide penny drive, which raised $62,000 of the $350,000 cost of the exhibit.[10] The students also enlisted twenty-four members of Congress, including John Lewis, Morris Udall, Ben Nighthorse Campbell, and George Miller, to sign a letter requesting the NPS to "create an exhibit which uses photographs, video presentations, and artifacts to depict the ways in which Lincoln's memory has inspired Americans to understand and use their First Amendment rights to further the case of freedom for all Americans."[11]

The balance of the exhibit's funding was supplied through a supplemental appropriation.[12] The exhibit and film opened in 1994, and the film, *Lincoln's Living Legacy*, won the 1995 National Park Foundation Partnership Leadership Award for Education and Interpretation.[13] It is not surprising that the Arizona high school students were dismayed at finding no representation concerning Martin Luther King and the civil rights movement at the Lincoln Memorial. King's association with the Lincoln Memorial is a part of U.S. civil rights history that is taught across the country, and there are many contemporary protests at the memorial that "invoke King's memory more than Lincoln's." Moreover, King's identification with the Lincoln Memorial is reenacted every year with the

ritual wreath laying on the memorial on King's birthday.[14] In 2003, an inscription was added to the memorial's steps at the precise spot where King delivered his "I have a Dream" speech.[15] For nine years the *Lincoln's Legacy* exhibit fulfilled the desires of the Arizona high school students of associating the Lincoln Memorial with modern civil rights movements.

The demand in 2003 to change the *Lincoln's Living Legacy* film raises many questions regarding historical representation and the role that historic sites and their interpretive materials perform in the formation of public memory. There is a general recognition that memorials and historic sites provide visitors with a location to contemplate the site's past, to understand its impact on the present, and to consider its implications for the future.[16] More recently, increased attention has been given to the uses of historical representation and calls to evaluate their legitimacy, ethics, and political inferences.[17] That is, the interpretation of public history can become politicized endeavors, and their results need to be evaluated as such. There is no question that the demand to remove the gay and women's rights footage from the Lincoln Memorial film was an unabashed attempt to stop the political legitimacy of representing women, gays, lesbians, and the transgender community's pleas for civil rights. The insistence on changing this film also falls within a larger context of the paradigm shift concerning sharing historical authority and visitor-centric exhibition development; for the Lincoln Memorial this shift began even earlier in 1939 with Marian Anderson's performance on its steps. The demand to remove what became known as the gay and women's rights footage illustrates a limitation of sharing historical authority, and that inclusivity is by no means guaranteed in this new paradigm.

Limits of Shared Historical Authority

Museum professionals and academics both recognize that the shift from an object-centric to a visitor-centric orientation has rhetorical and methodological implications. Professor Hilde Hein optimistically observes how museums can work to encourage visitors "to ask questions and express opinions" and that this new posture "parallels actual social change."[18] This social change is most evident in the variety of exhibits across the country that "decenter elites" and has an interest in "telling history from the 'bottom up.'"[19] Amid this democratic impulse for inclusivity in the development of museum exhibits is an attendant concern for the loss of professionalism in the interest of audience satisfaction. Historian and former museum curator Robert R. Archibald warns against conducting "audience research" at public history sites where museums relinquish authority. His concern about losing the museum curators' professionalism echoes recent research confirming the need for

museums to continue to provide "rich interpretations and fresh, accurate information."[20] The challenge for museum personnel then becomes how to balance an increasing variety of requests from multiple publics desiring museological representation.

In this new dynamic paradigm, Archibald worries that museological exhibitions could become a "free-for-all."[21] These observations on the implications of changing museological displays to more fully accommodate visitors' points of view delineate the potential and the limits of sharing historical authority. Archibald offers guidelines for interpretations that would ensure accuracy and accommodate multiple publics: "staff members [should] balance the perspectives against the historical evidence and core values."[22] Using this sensible insight and suggestion as a guide to develop and evaluate visitor-centric exhibits, this chapter explores whether the request for change in the Lincoln Memorial's interpretive material was based on historical evidence and the memorial's core values.

To answer this question, the next section begins with a discussion of the Lincoln Memorial's creation and its creators' original symbolic design intentions. An examination of the evolving values and ideologies in the development and use of the National Mall and in the Lincoln Memorial follows this discussion in order to establish a context in which core values can be identified and hence evaluated. The chapter concludes with a discussion of the implications of sharing historical authority at the Lincoln Memorial and their difficult lessons for other historical museums and memorials.

Creation of the Lincoln Memorial Space

From its inception, there is historical evidence that the Lincoln Memorial was designed to be a location that would invite visitors to actively participate in their understanding of Lincoln and his role in U.S. history. D. H. Burnham, chair of the Lincoln Memorial Commission, described the memorial's design as one that would "afford conditions of comfort and sentiment conducive to quiet contemplation and a reverential attitude of mind."[23] This early description of a performative goal for the Lincoln Memorial reflects a desire to break with memorials that served a didactic function for its visitors. Architectural and art historian Kirk Savage describes traditional memorials where there is "no attempt to represent the historical forces or ideologies that had motivated these men"— memorials that "simply glorified the individual leaders as exemplars of the nation's continuing greatness."[24] The initial plans for the Lincoln Memorial clearly describe a location where visitors could participate in comprehending Lincoln in a historical context or as a "formal analogue to democracy."[25] Savage explains how the memorial's design "opened

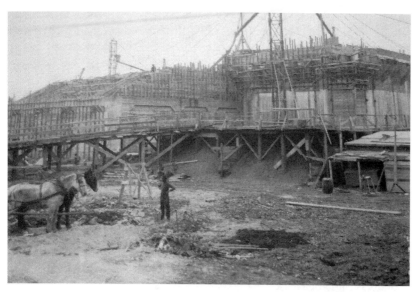

Figure 4.4 Construction of the Lincoln Memorial, ca. 1914 (courtesy of Special Collections & Archives, Henry Bacon Papers, Wesleyan University Library, Middletown, CT)

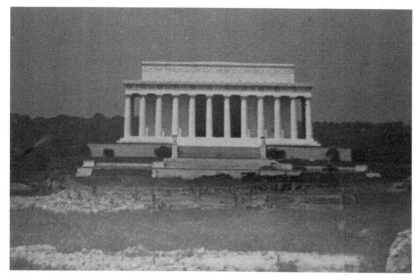

Figure 4.5 The Lincoln Memorial ca. 1920, before the completion of the Washington, D.C., capitol mall and the reflecting pool (courtesy of Special Collections & Archives, Henry Bacon Papers, Wesleyan University Library, Middletown, CT)

up a space for subjective experience, in which viewers would come to understand Lincoln's achievement."[26] Although the Lincoln Memorial was designed to and does facilitate reflection, this fact does not mean that the memorial does not have an intended rhetorical message. The contours and directions of that reflection contain the memorial's core values.

A discussion of the Lincoln Memorial's core values, or any core values associated with a historical museum or memorial, includes identifying the ideologies that informed their construction as well as discerning their evolution. In some cases, the core values of a historical site may be problematic for contemporary audiences' understandings of the particular location and for constructing a national identity. Southern monuments to the Civil War, such as Stone Mountain, continue to be fractious on account of their core values, which include racism. The point here is that the evaluation of public history sites according to standards of historical evidence and core values becomes more complicated when a site's core values challenge contemporary ideas of nation building.

Nationalist ideology was very much on the minds of the members of Congress on February 1, 1913, with the acceptance of the plans from the Lincoln Memorial Commission and the appointment of Henry Bacon as architect. On December 22, 1915, Daniel Chester French was hired to create the statue and pedestal, and in 1916, Jules Guerin was retained to produce the mural paintings located inside the memorial. Work on the memorial started on February 12, 1914; it opened to the public June 21, 1921; and the memorial was dedicated on May 30, 1922. The total cost for the project was just under $3 million.[27] Even with the memorial plans accepted and personnel hired, disagreements over the memorial's core values as a national symbol lingered.

Competing ideologies regarding Lincoln's national symbolism infused the Lincoln Memorial's planning and reception. Initially, the dispute concerned whether to frame Lincoln's memory primarily as an emancipator of slavery or as a savior of the union. The Lincoln Monument Association proposed the first bill for a memorial to Lincoln in 1867 "for the purpose of erecting a monument . . . commemorative of the great charter of emancipation and universal liberty in America."[28] Although Congress approved this proposal, it did not come to fruition. Depicting Lincoln as an emancipator was immediately challenged and gradually replaced with "a less threatening symbol," whereby Lincoln's contribution became "an instrument in the growing sense of a powerful, united American nation."[29] Vociferous debates concerning the representation of this changing national ideology took place in the Lincoln Memorial Commission.

Congress created the Lincoln Memorial Commission under the supervision of the Secretary of War on February 19, 1911, and this venue is where the memorial's design and placement were fiercely

argued.[30] Senator Shelby M. Cullom, a member of the Lincoln Memorial Commission, who also knew Lincoln personally, wrote to Bacon that "the meeting of the Commission was quite a stormy one and very unsatisfactory to me so far as the conduct of the meeting was concerned."[31] Every aspect of the memorial was debated on the Commission, from its location on the National Mall, to the choice of stone (Yule marble from Colorado) to the choice of greenery and the memorial's ideological meaning. During these discussions, Bacon was clear about his design: "The exterior of the Lincoln Memorial, as I have said before, is a symbol of the Union, and I cannot imagine a more fitting monument to the man whose paramount idea was to save the Union, and who did save it."[32] However, Bacon's overall design for the memorial takes a nuanced position on Lincoln as emancipator verses savior of the nation. Bacon states that the intended meaning of his design is found not just in the building but also in the memorial's four features—the Gettysburg Address, the Second Inaugural Address, the Lincoln statue, and Jules Guerin's allegorical murals depicting "Charity, Patience, Patriotism, Devotion to High Ideals, and Humaneness."[33] The inclusion of Lincoln's Second Inaugural Address as one of the memorial's four elements demonstrably represents an antislavery ideology in the memorial. Lincoln's address included these lines about his position on slavery: "If we shall suppose that American slavery is one of those offenses which, in the providence of God, must needs come, but which, having continued through His appointed time, He now wills to remove, and that He gives to both North and South this terrible war as the woe due to those by whom the offense came, shall we discern therein any departure from those divine attributes which the believers in a living God always ascribe to Him?" For architectural historian Kirk Savage, the presence of the Second Inaugural Address in the memorial is a "biblical message of divine retribution for the offense of 'American slavery.'"[34] This message is certainly not lost on the myriad visitors who encounter the easily visible inscription.

U.S. Senator Shelby M. Cullom was pleased with the final Bacon design declaring that: "It seems to me that your ideas are sound, and especially so in reference to not having too much jumble in connection with Lincoln in the memorial."[35] In 1921, architect Electus C. Litchfield described the Lincoln Memorial: "The way it completely fills the imagination is little short of astounding. As one stands before it, one thinks of nothing but the greatness and simplicity, which are characteristic equally of Lincoln, and this, his memorial. Nothing would one have otherwise with this monument. It reminds one of those wonderful words in Genesis—'And God saw, that it was all very good.'"[36] Royal Cortissoz, the art and literary editor for the *New York Tribune*, joined in the conversation about the Lincoln Memorial design and in particular about

Bacon's role: "If I had to characterize Bacon in two words I would call him embodied conscience."[37]

More recently, art historian Albert Boime argued that the final monument design for the memorial was extremely conservative and that it eliminated the representation of Lincoln as Emancipator: "The Lincoln of the original designers of the monument was the patriarchal Lincoln who preserved the union."[38] The memorial's symbolism is subtle by contemporary standards, but Boime's critique does not capture the memorial's ideological representation as a whole. The building does symbolize the saving of the union with its thirty-six columns representing the states in the Union at the time of Lincoln's assassination. The names of the forty-eight states are carved into the exterior attic walls, and a plaque notes the addition of Alaska and Hawaii. Boime's critique of the conservative character of the memorial *building* is accurate in that the design draws on Greek and Roman architecture's "art of shaping space around ritual" and the desire to "control and to shape their rituals."[39]

Beacon's design defines the ritual of visiting national memorials as similar to attending a Greek or Roman temple, which is certainly a conservative architectural choice, and the building *alone* does represent the preservation of the Union.[40] However, to evaluate the memorial's overall ideological message, we need to take all its main elements into consideration. In addition to the engraved Gettysburg Address and the Second Inaugural Address (with its references to God's demand for the end of slavery), there is the Lincoln statue, which is remarkable for many reasons, including its size, pose, and overall sculptural beauty. Daniel Chester French, the sculptor, described his intent for the statue: "What I wanted it to express was the strength of the man and confidence in his ability to see his job through. I think, perhaps, the hands express this as much as the face."[41] French's description of Lincoln's "job" does not differentiate between saving the union and eliminating slavery; instead, French conflates all the ideological concerns into the word "job." This description again stakes out a nuanced position in the ideological rift between Lincoln as emancipator or Union savior. The memorial's other main element that more clearly sides with Lincoln as savior of the Union is the inscription above the Lincoln statue written by Royal Cortissoz which states: "In this temple, as in the hearts of the people for whom he saved the union, the memory of Abraham Lincoln is enshrined forever."[42] During the development of this inscription, Cortissoz fought vehemently with President Taft (through Bacon) about his proposed wording. Cortissoz defended his wording in an appeal to Bacon, and in this defense Cortissoz refers to the ideological debate surrounding the memorial, "I am perfectly aware of the discussion so often started about the motivation of Lincoln's policy. The saving of the Union was his fundamental aim. That is why I avoided

any allusion to the abolition of slavery."[43] Although Cortissoz intended to avoid representing slavery in his inscription, the memorial's other elements offset his intent.

The murals by Jules Guerin are located at the top of the interior walls, above the Gettysburg Address and the Second Inaugural Address. The placement of these murals above the two carved inscriptions forces visitors to lean back and gaze upward in order to see them. Guerin described the murals' as allegorical symbols of truth, freedom, immortality, justice, intelligence, and unity.[44] Specifically, the mural above the Gettysburg Address alludes to the emancipation of slaves, whereas the mural about the Second Inaugural Address references the nation's unity.[45] The NPS brochure interprets the allegorical figures as "depicting principles evident in Lincoln's life."[46] An initial description of Guerin's intent for the murals states that they "are not intended to tell a story" and that much of the meaning is "left to the spectator's imagination."[47] Although the Guerin murals include an antislavery message, I would argue that most visitors receive the memorial's antislavery message from the Second Inaugural Address, owing to its physical accessibility (that is, it is easier to see than the murals are), and it is easier to understand, because of its lack of allegory. Guerin's murals, combined with the other memorial elements, offer an ideological message on Lincoln's legacy as one of antislavery and savior of the union, which

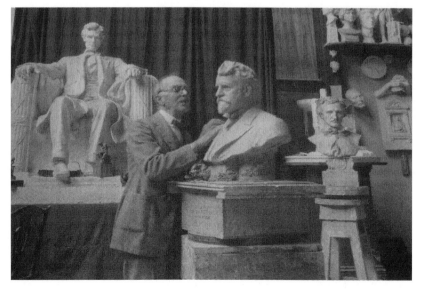

Figure 4.6 Daniel Chester French, sculptor of the Lincoln Memorial statue, in his studio (courtesy of U.S. Library of Congress, Daniel Chester French Manuscript Collection, Washington, D.C.)

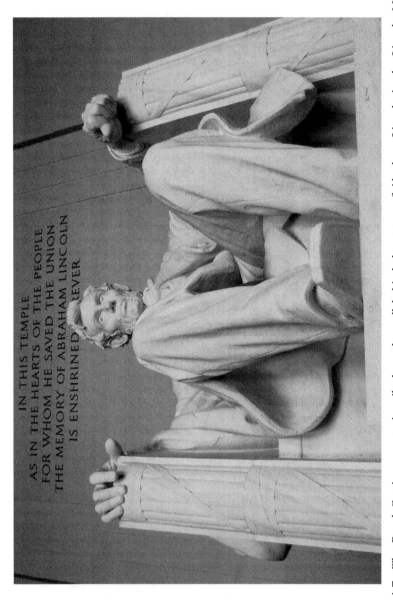

Figure 4.7 The Royal Cortissoz quote inscribed on the wall behind the statue of Abraham Lincoln in the Lincoln Memorial (photograph by the author, 2011)

nuances the dichotomy between his representation as only emancipator or only union savior. This mixed ideological message is offered in a space designed for visitors' introspective engagement with their own interpretation of the memorial's inscriptions, statue, murals, and building.

The importance of creating a less didactic memorial for Lincoln that would actively engage visitors resembles more modern understandings of memorials as locations for visitors to reflect on the past and to consider its effects on the present and the future.[48] The Lincoln Memorial ultimately does achieve its creators' goal of providing a space for a contemplative encounter with Lincoln's legacy. In his dedication address President Warren G. Harding stated: "This memorial . . . is less for Abraham Lincoln than those of us today, and for those who follow after . . . his great American heart would be aglow to note how resolutely we are going on, always on, holding to constitutional methods, amending to meet the requirements of a progressive civilization, clinging to majority rule, properly restrained, which is the only true sovereign of a free people, and working to the fulfillment of the destiny of the world's greatest republic."[49]

Charles Moore, Chairman of the National Commission of Fine Arts in 1921, echoed Taft's sentiment of the memorial serving as a site for inspiration: "The Lincoln Memorial does not exist primarily to afford an opportunity to exercise the critical faculty so dear to the American mind.

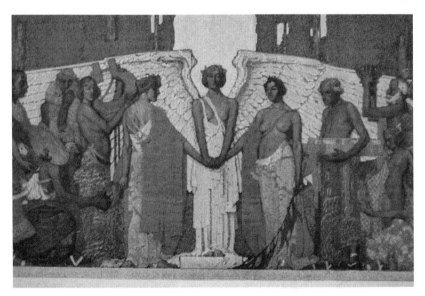

Figure 4.8 Jules Guerin's mural in the Lincoln Memorial depicting allegorical symbols of truth, freedom, immortality, justice, intelligence, and unity (courtesy of U.S. Library of Congress, Prints and Photographs Division, Washington, D.C.)

It exists to be enjoyed. It is intended to stir emotions of patriotism, of reverence for heroism and tenderness. Highest and best of all, it stands for the hope of the future . . . the Lincoln Memorial stands for beauty in life, for order in the universe, for the reward of struggle, and as the promise of the life eternal."[50]

Even though the Lincoln Memorial's creators attempted to straddle the emancipation and union savior division in the design, that ideological debate did not disappear. At the memorial's dedication in 1922, Dr. Robert R. Moton, president of the Tuskegee Institute and invited guest speaker, eloquently described Lincoln as both emancipator and symbol of national unity: "There is no question that Abraham Lincoln died to save the union. It is equally true that to the last extremity he defended the rights of the states. . . . The united voice of posterity will say: the claim of greatness for Abraham Lincoln lies in this . . . in the hour of the nation's utter peril, he put his trust in God and spoke the word that gave freedom to a race, and vindicated the honor of a nation conceived in liberty and dedicated to the proposition that all men are created equal."[51] Notwithstanding Moton's inspired rhetoric, it was delivered to a crowd in segregated seating at the memorial's dedication. The outrage generated from this event resulted in the District Branch of the N.A.A.C.P. calling for the resignation of Colonel Clarence O. Sherrill, the Superintendent of Public Buildings and Grounds, and national press coverage condemned the seating arrangements at the Lincoln Memorial dedication.[52] J. LeCount Chestnut of the *Chicago Defender* wrote that "the South was truly 'in the saddle' at the dedicatory exercises," where "a Jim Crow section of seats, directly opposite the center of the memorial was reserved for distinguished Colored ticket holders."[53] The dedication ceremony highlighted the slippage between ideals and actuality in forming a national identity and in fulfilling the goals of emancipation.

After its dedication in 1922, the memorial found that its primary function outside of tourist visitation was for "national celebrations of Lincoln's birthday and Memorial Day."[54] The ideological division that dominated the creation of the Lincoln Memorial reappeared in 1939, and this time it was not a nuanced representation. The move to associate the Lincoln Memorial with emancipation was etched into public memory with the April 9, 1939, performance of opera singer Marian Anderson. Although Anderson's performance on the Lincoln Memorial steps is popularly remembered as the first instance of African Americans using the memorial to highlight their civil rights struggles, the first use of the Lincoln Memorial specifically for African Americans was for a "mass religious service in August 1926."[55] However, Anderson's singing "America" on the memorial steps was certainly the moment that began the movement that would bind the memorial to the African American

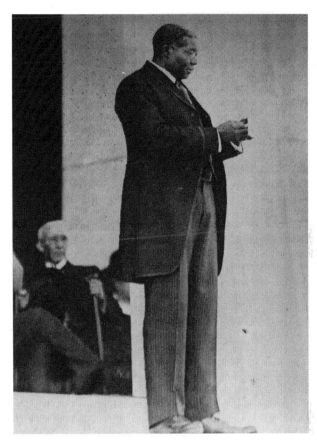

Figure 4.9 Dr. Robert R. Moton, president of the Tuskegee Institute, at the Lincoln Memorial's dedication in 1922 (courtesy of National Archives and Records Administration, Record Group 42, Washington, D.C.)

civil rights movement.[56] From 1939–1963, the memorial began to be used for a series of African American civil rights gatherings, and thereafter "the monument and that part of the mall leading to it has become a site for demonstration of diverse constituencies."[57] It is on these ideological core values of Lincoln as emancipator, which evolved from the memorial's original design, that the NPS developed the interpretive exhibits for the basement of the Lincoln Memorial.

Lincoln Memorial Basement

During the planning stages of the Lincoln Memorial, Henry Bacon opined: "It is my sincere hope that there will never be placed in the Lincoln

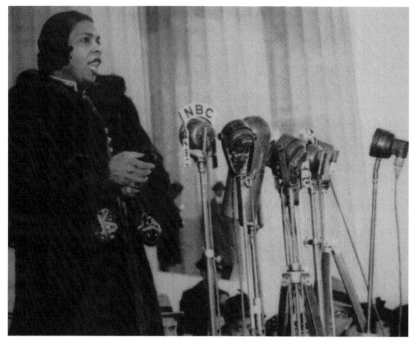

Figure 4.10 Marian Anderson singing at the Lincoln Memorial on April 9, 1939 (courtesy of U.S. Library of Congress, Prints and Photographs Division, Washington, D.C.)

Memorial anything that will give it the slightest degree the character of a museum."[58] In the early 1990s, Bacon's wishes were ignored, and the NPS erected a series of exhibits in the memorial's basement.[59] There are very few historical references to any planned use of the memorial's basement other than in terms of its existence architecturally, except for a 1918 letter asking the Lincoln Memorial Commission for the "temporary use of the space under the Lincoln Memorial for the storage of National archives . . . until the National Hall of Records is erected"—but that request was not granted.[60] Jane Radford, one of the Harpers Ferry Center (HFC) exhibit planners for the Lincoln Memorial, describes the basement in the early 1990s as "essentially empty before these exhibits were installed. . . . It was just an armpit. . . . It smelled and was a bit damp . . . painted white . . . an unused space, but it did have a window that revealed the underpinnings of the memorial."[61]

Many contemporary visitors know neither that the Lincoln Memorial has a basement nor how to enter it—even though there are two points of entry. One is through a door located on the left side of the memorial (when one is facing the memorial), which is the entrance for the

restrooms. Visitors also can gain entry to the basement via an elevator located on the left side of the memorial that operates between the basement and the main hall. The two signs outside the memorial, indicating the exhibits' location, are not prominently displayed, and both can be partially covered by bushes.

Once visitors do find the memorial's basement, they encounter the *Lincoln's Legacy* exhibits, which were created in response to high school history teacher John Calvin and his students' efforts to add information in the memorial commemorating Martin Luther King, Jr., and the civil rights movement. In 1990, this group of high school students submitted proposals for exhibits to the NPS, and, in an unprecedented arrangement and early foray into sharing historical authority, the students were able to participate directly with the NPS and the HFC and so became part of the design team.[62] Jane Radford describes her time with the students as "one of the most thrilling experiences in the park service" and as a unique experience that she believes "has never been done before or after."[63]

The resulting exhibits developed by this unusual collaboration include traditional historical site orientation information provided by governmental agencies—information on the actual building of the memorial; a display of the architect (Henry Bacon) and the sculptor (David Chester French); a description of the memorial's dedication; a row of black marble plaques highlighting events in Lincoln's presidency that are grouped under the headings of Union, Freedom & Emancipation, Equality; a display of international Lincoln stamps, and a description of the "Pennies Make a Monumental Difference Campaign," which partially funded the exhibit. In spite of Bacon's early request not to develop the memorial's basement, the exhibits were well received. *Washington Post* journalist Hank Burchard offered high praise for the finished basement exhibits: "We got a lot for the money. From 8 A.M. to midnight daily, visitors are welcomed into a clean, well-lighted place where Lincoln's living legacy and humanistic spirit are made manifest with a warmth and relevance not possible in the vast, formal—and drafty—main hall."[64] Robert Stanton, NPS Director from 1997–2001, felt that "these students' views were more visionary than any of us had considered . . . we weren't telling the story of the contemporary influence on society."[65] The Lincoln Legacy exhibits adhere to the historical accuracy and core values of both the memorial, as well as Lincoln's presidency. The part of the exhibit that expressly extends the memorial's core values to Martin Luther King and the civil rights movement is in the back corner. It is this part of the exhibit that drew the ire of Reverend Lou Sheldon of the traditional Values Coalition and the Concerned Women of America.

The Controversial Exhibit

To get to the area that contains the *Lincoln's Living Legacy* film, visitors must walk through the previously described Lincoln's Legacy exhibits. The film screens in a U-shaped exhibit room whose three walls contain captions to a variety of documentary photographs of marches and ceremonial events that have taken place at the memorial. The lighting in this particular room is lower than the others, and the grey walls provide better conditions for viewing the film and the backlit documentary photographs that are mounted above the thirty-one captions engraved in metal below.

This film was made by the NPS at their Harpers Ferry Interpretive Center (HFC) in 1994, and it continues to receive federal funding in order to run at the memorial. The film is eight minutes long, and it runs in a repeating loop in a television monitor on the wall opposite the entrance, above the documentary photographs and captions. There is no seating in this room, and to view the film, visitors have to stand and look up toward the ceiling. One consequence of this placement is that very few people stand in this uncomfortable position long enough to watch the entire film. There are no signs near the monitor with any information about the film, and there are no titles or screen credits at the beginning or end of the film.

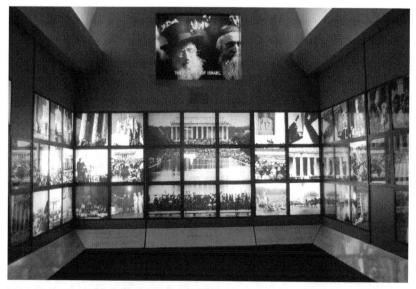

Figure 4.11 The corner display room of the *Lincoln's Legacy* exhibit houses the *Lincoln's Living Legacy* film, which is located in the basement of the Lincoln Memorial (photograph by the author, 2011)

Tim Radford, the film's director, and HFC employee, explains his role in making the film: "I'm an interpreter . . . I call myself a filmmaker, I'm making a movie, trying to draw people along."[66] Jane Radford, who worked on the Lincoln Legacy exhibits, explains why there is no identifying information in the film: "We were trained to provoke thinking as opposed to deliver information, to bring visitors to an emotional, thoughtful, and stimulating situation so people remember it."[67] Despite the lack of identifying information that usually appears in films at national historic sites, this film does provide those visitors who see it with an orienting experience; that is, the film offers a frame through which visitors can understand the Lincoln Memorial's history and its historic as well as contemporary role in culture. Regular history tourists would surely recognize this interpretive element as part of most history museums and understand its presence as an orientation film for the memorial owing to its location within the memorial. The *Washington Post*'s Hank Burchard described *Lincoln's Living Legacy* as a "stirring and well-orchestrated pastiche that portrays events at the memorial as they progressed from formal affirmations of Lincoln's place in history to passionate demands for fulfillment of the Great Emancipator's vision."[68]

The format of *Lincoln's Living Legacy* consists of a series of montages (short film sequences) that incorporate contemporary images of the memorial with historical news footage from a wide variety of historical protests and ceremonial events that have been held at the Lincoln Memorial, with particular emphasis on the 1963 March on Washington for Jobs and Freedom. The overall format of the documentary film is expository and uses a male narrator with a reassuring, trustworthy, and deeply toned voice. The text of the narration consists of the narrator reading Lincoln's quotes, which are mixed with location sound from the various historic film clips. *Lincoln's Living Legacy* combines the narration and stunning historical footage of the memorial, while Aaron Copeland's inspirational *Fanfare for the Common Man* plays in the background for most of the film.

The total running time of the film is just under eight minutes. None of the historical footage in this film is identified on screen, and there are no titles indicating when each of the depicted events took place.[69] There are over one hundred different film clips in *Lincoln's Living Legacy,* and its visuals consist primarily of historic news footage ranging from the memorial's dedication in 1922 to Presidents Roosevelt, Eisenhower, Johnson, Clinton at the memorial, to John Glenn and Russian astronauts at the memorial, to a 1920s Works Progress Administration march, to a "modern" workers' rights march.[70] With over four minutes of images depicting protests at the memorial, the clear interpretive direction of the film is to

demonstrate how the site has been the location for myriad rights and protest rallies in the twentieth century.

Intercut with the historic protest footage are numerous shots of the memorial's ceremonial use by national as well as foreign dignitaries and cultural luminaries. The film also amplifies the memorial's association with African American civil rights by using approximately two minutes of images of Martin Luther King and the 1963 March on Washington for Jobs and Freedom rally. The film unambiguously addresses the Arizona high school students' request to show the memorial's ongoing use as a location for civil rights demonstrations. Taken as a whole, *Lincoln's Living Legacy*'s message is one that extends the Lincoln as emancipator ideology into the arena of obtaining civil rights for all citizens, not just African Americans. The ideological representation of Lincoln as savior of the union takes a decidedly backseat in this film, with only two lines of narration referring to Lincoln's role as union savior: "And that government of the people, by the people and for the people, shall not perish from the earth" and "A house divided against itself cannot stand."[71] The Reverend Sheldon and the Concerned Women of America did not object to the exhibit's extension of Lincoln's emancipator legacy to contemporary African American civil rights, or worker's rights, or Soviet Jewry rights, or to any of the anti-Viet Nam war imagery. Their objection was solely to the gay and women's rights images. Images from the same gay and women's rights protests that were used in *Lincoln's Living Legacy* are also used in the orientation film, *Light of Liberty*, at the Jefferson Memorial. To date, there has been no call to remove these images from the *Light of Liberty*.

At approximately six minutes into this eight-minute film (*Lincoln's Living Legacy*), the contested images of gay and women's rights' rallies appear. The HFC shot list for the film describes the images as, "Gay rights protest, sign: 'The Lord is my Shepard and Knows I'm Gay,'" "Gay rights protestors on the steps of the Memorial," "Multiple Women's Rights protest," "sign: 'Women's Rights, Regan's [*sic*] wrong,'" "Protestors waving placards for 'Pro Choice President,'" "Crowd in front of Memorial, with 'ERA YES' signs," "Women at podium talk about sit-ins," "sign: 'Save the Lives of Black Women,'" "Women chanting in ERA march," and "Marchers with signs 'Keep Abortion Legal.'" The total time for all of these images is twenty-nine seconds.[72] By 2003, the debate concerning the Lincoln Memorial's core values had shifted to the point where the emancipator interpretation was no longer questioned. The ideological contest over how to memorialize Lincoln moved into a much narrower realm where the debate was reduced to whose civil rights should be associated with the Lincoln Memorial.

The federal government responded to the Reverend Lou Sheldon and the Concerned Women of America's demand to eliminate the

footage of gay and women's protests for civil rights from the *Lincoln's Living Legacy* film. Former U.S. Representative Todd Tiahrt (R-Kan.) carried the complaint to the White House by "contact[ing] the [Bush] administration officials" to "'begin exploring legislative options regarding the Lincoln video."[73] By March 14, 2003, the NPS began purchasing new video footage from the Associated Press Television News, ABC, and CNN for a new film for the Lincoln Memorial. The Harpers Ferry Center spent $16,413.13 on purchasing new video footage for the "Lincoln Living Legacy Video."[74] Gary Cummins, former manager of the HFC, stated that "the NPS was directed to edit the video to show examples of conservative demonstrations, or to drop interpretation of the memorial altogether and focus on interpreting Abraham Lincoln himself."[75] Tim Radford, the director of *Lincoln's Living Legacy*, was again put in charge of developing the new film for the Lincoln Memorial; however, this time he felt differently about this assignment. Even though he had worked for NPS for almost thirty years, his initial response to making these changes was, "I wasn't going to do it, my whole approach was do nothing, just be quiet . . . I went through the exercise but didn't do anything."[76] During Radford's sluggish tactical approach to re-editing the film, news of the events was leaked.

Information on this attempt to eliminate the "the gay and women's" footage was given to a group of retired NPS employees.[77] The first stories to report on the demand to excise the gay and women's rights images appeared in several independent and LBGTQ news outlets including *Red Orbit, Washington Blade Online, Gay.com,* and the *Bay Area Independent Media Center*. One story affirmed that "National Park Service officials announced last February that they would re-edit the video after conservative and religious groups complained" and that "Social conservative and religious groups including . . . the Traditional Values Coalition, have called on the National Park Service to add scenes of religious oriented rallies . . . including Promise Keepers and the March for Jesus, rallies by pro-life groups, and events by organizations supporting the right to keep and bear arms."[78] This story was then picked up by the mainstream press, including the *Washington Post, ABC News,* and *Fox News,* which in turn led to the People for the American Way (funded by Norman Lear) and the Public Employees for Environmental Responsibility (PEER) filing a freedom of information act (FOIA) request on January 19, 2005, to find out if the gay and women's scenes were actually going to be deleted.[79] The federal government fought the FOIA request for several years but eventually lost, and I was able to read their heavily redacted internal email and letters at the PEER offices in Washington, D.C. One NPS email dated January 20, 2005, instructed all Harpers Ferry Personnel to have "No Comment" if asked about the

potential changes to the film, with the comment that this "is not advice but rather a direct order."[80] By 2011, retired NPS personnel were more receptive to answering my queries about this controversy; however, some employees at the HFC would not discuss these events, because they wanted to keep their jobs.[81]

Through reading all of the material that was released on account of the FOIA ruling, I was able to ascertain that a fair amount of video footage had been purchased and that it was intended as a replacement for *Lincoln's Living Legacy*. Bob Karotko, chief of Visitor Services for the National Capital Parks Central, acknowledged that "some things were either shortened or removed while other things were added. . . . I don't know what was added or deleted."[82] Cummins confirmed that "the film underwent some editing but not enough to satisfy the conservative group."[83]

The new political direction of the film is clear from the internal NPS emails and copies of the purchase receipts for new video footage. Tim Radford asks for "sources for footage of conservative 'right wing' demonstrations" at the "lincoln memorial [*sic*]."[84] Following is an abbreviated list of the video footage that the HFC purchased for the new film: "Reagan Marks 172nd Anniversary of Lincoln's Birth"; "Inauguration Ceremonies Get Underway for President Elect George W. Bush"; "Rally in front of Lincoln Memorial/CU signs 'No More Gun Laws' and 'Ban Criminals Not Guns'"; "Pro-War Rally 4; Pro-War Rally 3; Pro-War Rally 1"—all three are described as "a rally at the Lincoln Memorial in support of GW Bush's policy of war against Iraq"; "Pro-Life Rally 1-3"; "March for Life"; "George Bush, Sr., walking down Lincoln Memorial"; "George W. Bush walking down LIME steps (inauguration)"; "'Liberate Iraq' sign."[85]

One of the implications of this video purchase list is an abandonment of Lincoln's core values either as an emancipator or a unifier. Not only do these images part with Lincoln's traditional representation as either emancipator or union savior; some of them also counter his national unifier ideology by showing support for the U.S. war in Iraq. There is little debate that Lincoln's main contributions were domestic, and using the memorial's film to support U.S. foreign wars would have been a complete break with the memorial's core values. Cummins remembered that "the requests for changes were overtly political"[86] but that "the issue finally faded away."[87]

Although this particular challenge did, in fact, bureaucratically fade away, the difficult political issues of this controversy remain and will undoubtedly reappear in another context. Radford described his experience with trying to remake *Lincoln's Living Legacy* with a right-wing or conservative focus as fruitless, because you "don't try to edit an exist-

ing film," and his resistance to creating another film was his "standing up for my work, standing up for the thoroughness of the work."[88] The most troubling aspect of this entire event was not the list of video purchases that might have become the new *Lincoln's Living Legacy* film but the demand to remove images of citizens demonstrating for their civil rights. This attempted hijack of the Lincoln Memorial's interpretive material in order to deny civil rights representation of women and the GLBTQ community was justifiably and successfully stopped.

The Lincoln Memorial is an example of the evolution of sharing historical authority in a visitor-centric designed exhibit and the challenges it engendered. The NPS and the HFC did respond to the Saguaro High School students' request to include Martin Luther King and civil rights representation at the memorial. The twist in this case study was that the Lincoln Memorial's meaning had previously undergone a shift in public memory on account of its association with African American civil rights. The Arizona high school students' request for interpretive exhibits built on this earlier interpretive change in the Lincoln Memorial's meaning. In the new visitor-centric paradigm the NPS staff shared historical authority with part of their diverse publics in the development and design of a new exhibit only to have another public (at a much later date) object to this interpretation. The Lincoln Memorial experienced a second iteration of sharing historical authority, which resulted in political objections. In many ways, the objections raised over the *Lincoln's Living Legacy* film confirmed Robert Archibald's fears that historical interpretive exhibits would be based on audience response with no relation to the site's historical accuracy or core values. When viewed in this context, NPS's initial response of agreeing to remove the gay and women's rights footage is of concern. The vicissitudes of sharing historical authority at the Lincoln Memorial illustrate the need for ongoing, if not increased, critique of visitor demands to alter public history representations.

Implications

This chapter began with the observation that the Lincoln Memorial has become so thoroughly linked with civil rights that this association is no longer questioned. The Arizona high school students, who were the genesis for the exhibits in the Lincoln Memorial's basement, were taught this understanding of the memorial, and their request to include civil rights' interpretive material clearly derives from the memorial's evolving core values. In this case, Archibald's advice is helpful in a shared historical authority paradigm for evaluating politically motivated demands for change in public history sites' interpretive materials. For the Lincoln Memorial, Archibald's evaluative standards are useful in determining

whether its interpretive exhibits were legitimate representations of its ideological core value concerning emancipation.

It should not be unexpected that the Lincoln Memorial became the site for this particular ideological battle. The memorial's creators purposely designed a location that enables visitors to contemplate their understanding of the sixteenth president with a minimal amount of didacticism. The NPS, in its administration of the memorial, adheres to U.S. Senator Shelby M. Cullom's pleasure at finding that the memorial does not have "too much jumble."[89] If anything, it could be argued that the Lincoln Memorial is under-interpreted. There is only one free NPS brochure distributed on site, and it does not allude to the historical ideological debates in representing Lincoln. Bacon's intended meanings struck a nuanced ideological position, and his designs are extremely subtle for contemporary audiences. Most visitors are not aware of the implications of the building's traditional architecture, or that Cortissoz's quote above the Lincoln statue was his attempt to skirt Lincoln's emancipator ideology. For those who do see the Guerin murals, their dated allegories are generally obscure. Contemporary visitors would benefit from additional interpretive material in order to better understand the memorial's design elements in terms of their ideological intentions and evolution. As a public history site administered by the NPS, its goal is clearly not to dictate individual interpretations; rather, it is to provide enough information to enable visitors to have a meaningful encounter with Lincoln's legacy during their time at the memorial. Additional interpretive material would help address the historical appropriateness of civil rights associations with the memorial as well as point out the basement exhibit.

In the fall of 2010, the National Park Service finished its long-awaited recommendations for the National Mall Plan, and the section with recommendations for the Lincoln Memorial states that "the Lincoln Memorial, at the western end of the National Mall, is associated not only with the contributions of our 16th president but also the rights of all citizens" and that the "exhibits will be updated."[90] As a case study in the evolution of sharing historical authority and developing visitor-centric exhibits, the Lincoln Memorial offers vital and consequential lessons in the construction of public history and memory. The struggle to define Lincoln's memory is by no means fixed, and it is as fluid today as it was during the memorial's initial conception. The addition of the *Lincoln Legacy* exhibit is a notable exemplar of the need to share historical authority in order for national monuments to provide meaningful encounters with contemporary publics. The attempt to remove the gay and women's rights footage from the *Lincoln's Living Legacy* film was a deliberate attempt to manipulate the meaning of the Lincoln Memorial;

however, the memorial's ideological history and core values were strong enough to withstand this politically motivated maneuver. The Lincoln Memorial is one location in the United States that certainly inspires "feelings of a shared identity," which are central in the construction of a national identity.[91] The Lincoln Memorial's many publics need to stay involved in the development of its interpretive materials in order to assure the continued to representation of Lincoln's ideals of emancipation and civil rights for all.

Patriotism Carved in Stone: Mt. Rushmore's Evolution as National Symbol

Mt. Rushmore National Memorial is an historic site whose meaning has been embraced, contested, and repeatedly revised since its inception. Of the five sites studied in this book, Mt. Rushmore most directly embodies notions of U.S. patriotism, nationalism, and citizenship. On account of its creation specifically to commemorate U.S. ideals, its interpretive materials are particularly revealing in their varying explanations of Mt. Rushmore's meaning and significance. Although Mt. Rushmore is frequently used as "shorthand for patriotism"[1] in political campaigns, films,

Exhibiting Patriotism: Creating and Contesting Interpretations of American Historic Sites by Teresa Bergman, 143–172 © 2013 Taylor & Francis. All rights reserved.

and marketing, a closer examination of its on-site interpretive materials indicates that the colossal mountain carving has been interpreted and reinterpreted in ways that indicate a significant evolution in its use and meaning as a U.S. patriotic icon. The combination of Mt. Rushmore's stature as a national icon and the mutability of the site's meaning have engendered multiple changes in the site's interpretive exhibits. Yet, the move into a visitor-centric paradigm concerning exhibition development did not arrive at Mt. Rushmore until 2007 when local Native American history was incorporated into its displays. Although the site's interpretive materials responded to several changing rhetorical situations over the years, reference to Native Americans' relationship to the Black Hills and Mt. Rushmore had been missing. Native Americans have long defined their identity by their geographic location, and for many Americans the West and its great landscapes have also come to define their U.S. nationality.[2] One result from the long exclusion of the Lakota, Nakota, and Dakota Sioux from representation at Mt. Rushmore has been a confiscation of their heritage.

Similar to the Lincoln Memorial, the rhetorical situations regarding Mt. Rushmore's interpretation have changed significantly from the time of its creation through the twenty-first century. And similar to the Alamo,

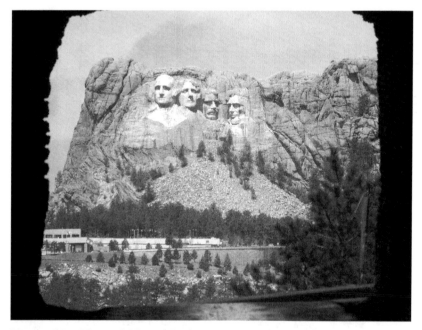

Figure 5.1 View of Mount Rushmore National Memorial from the Peter Norbeck Scenic Byway, State Highway 244, SD (photograph by the author, 2011)

the visitor-centric paradigm shift involving shared historical authority arrived fairly late at Mt. Rushmore. But unlike all of the other sites studied in this book, the circumstances concerning the paradigm shift at Mt. Rushmore include legal proceedings related to the site's ownership, and the future of this paradigm shift is the most uncertain. The incorporation of Native Americans into Mt. Rushmore's interpretive exhibits signaled the recognition of a long historical absence as well as an uneasy relationship to the present.

There has been considerable scholarly analysis in recent years regarding Mt. Rushmore as a site of national symbolism, and these interpretive challenges address some of the questions that have arisen with this national symbol.[3] One of the questions raised concerns the Lakota, Nakota, and Dakota Sioux's legal pursuit of their ownership rights to the Black Hills. Since 1868, the Lakota, Nakota, and Dakota Sioux have yet to relinquish their claims to the area. The contested nature of the land and its meaning has made Mt. Rushmore an excellent case study of shifting into a visitor-centric exhibition development paradigm, as well as the challenges national historic sites encounter when a part of their public is ignored. This chapter examines the history of interpretation at Mt. Rushmore, which began with the hagiography of Gutzon Borglum—the creator—as the definition of Mt. Rushmore. The interpretation then changed to extolling the Black Hills' natural wonders and defining the four depicted presidents when each contended with national crises. The next iteration of Mt. Rushmore's meaning proclaimed that those who worked on creating the mountain carving were the symbolic representation of Mt. Rushmore's patriotism. The interpretation changed again with the addition of Heritage Village at the foot of Mt. Rushmore and the development of an audio tour that included the Lakota language. The chapter concludes with an examination of the mutable meanings of Mt. Rushmore and the implications of sharing historical and curatorial authority, as well as their contribution to public memory.[4]

The interest in "historically oriented tourism"[5] has resulted in more than a million tourists attending this site each year since 1959, and in 2011, over two million tourists visited Mt. Rushmore. Since its opening in 1941, a staggering 102,303,551 people have visited.[6] On account of Mt. Rushmore's enduring status as a popular national icon, Mt. Rushmore's changing interpretive exhibits work rhetorically to stimulate ideals of social unity and civic loyalty. Communication scholars Robert Hariman and John Louis Lucaites note that the "visual practices in the public media . . . reflect social knowledge and dominant ideologies" at the time of their production and that an iconic patriotic image "negotiate[s] the trade-off between individual autonomy and collective action."[7] The interpretive exhibits of Mt. Rushmore have worked to naturalize "matrices

of privilege," including expansionism and imperialism, through the techniques of selectivity, manipulation, and political expediency.[8] Until 2007, with the erection of Heritage Village, Native Americans had been selected for absence because it was politically expedient to simply ignore the Native American claims to the Black Hills. Mt. Rushmore's exhibits have depicted social unity as constituted by an uncritical acceptance of past U.S. aggressions and by civic loyalty regarded as little more than an appreciation of physical might.

Not a Colossal Stunt[9]

The mutable nature, or as Cecelia Tichi puts it, the "continuous textual mediation[s]"[10] of Mt. Rushmore, began in 1956 with the NPS's observations that Mt. Rushmore required additional on-site interpretation.[11] In 1956, visitors' experience at Mt. Rushmore consisted of driving out to several overlooks for a view of the carved mountain. The only interpretive material that they would have encountered was located in the NPS Administration Building, which housed all the administrative personnel and contained three interpretive panels that were "somewhat frayed, soiled and in need of refurbishing." The panels were "devoted to the story of Borglum and the conception of the Mount Rushmore carvings, the progress of the sculpturing, and the mechanics of the mountain-carving process." The Superintendent and park historians described the panels as having "only fleeting and entirely inadequate reference to the major inspirational theme of the Memorial,"[12] and they commented that "there is overwhelming need for a visitor center where the meaning of Rushmore can be defined and emphasized in the interests of better American citizenship" and "aid the visitor in a better understanding and appreciation for the great central patriotic theme."[13] The NPS personnel appeared acutely aware that the meaning of Mt. Rushmore's patriotism was not immediately apparent. The vast majority of visitors to the area arrived by car, with Mt. Rushmore as just one stop among several. NPS staff worried that "the Black Hills are full of 'stunt' attractions such as zoos, snake pits, life-size concrete dinosaurs, highly ballyhooed caves, and synthetic frontier atmosphere. To the bewildered tourist, the Mount Rushmore figures are apt to be merely the climactic stunt, something to gape at in awe, a masterpiece of man's artistic and mechanical ingenuity."[14] Of note in the NPS request is how unreadable Mt. Rushmore became in just fifteen years since its completion.

The idea or concept of a Mt. Rushmore-like sculpture began with South Dakota's State Historian Doane Robinson in 1923.[15] In his goal to boost state tourism, he initially considered a project "commemorating some phases of American history by . . . carving massive figures on some

of the granite pinnacles in the Black Hills."[16] Robinson's original concept was to depict Western heroes with historical ties to the Black Hills, carvings that would include "notable Sioux, . . . Lewis and Clark, Frémont, Jed Smith, Bridger, Sa-kaka-wea [Sacajawea], Redcloud, . . . Cody, and the overland mail."[17] However, once the prospective mountain carving was offered to Gutzon Borglum, the concept for the tourist attraction changed from one with a local historical focus to one of a national scale, and all reference to Native Americans disappeared.[18] In 1924, *The Free Press* reported that Borglum was planning "a colossal undertaking commemorating the idea of union," and Borglum stated that "the United States is without a real memorial to our nation."[19] Robinson did not contest this change of focus, and, in fact, "Robinson's contribution to the project ended almost with its inception."[20] South Dakota's Senator Peter Norbeck stepped in, and, with Gutzon Borglum as sculptor, this mountain-carving project took on a national emphasis. Borglum led the "monumental" task of constructing Mt. Rushmore between the years 1927 and 1941, during the Great Depression. The total cost of the project amounted to just under one million dollars, and its cost proved to be the most contentious issue during the memorial's development.

The exact plan for Mt. Rushmore evolved over the course of the project and was tethered to financial and temporal constraints. Borglum described his desire to carve the four presidents down to their waists and

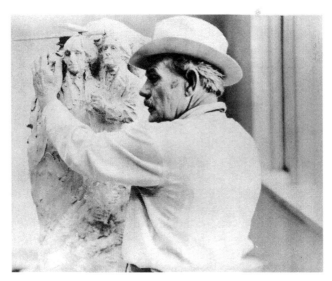

Figure 5.2 Gutzon Borglum, sculptor of Mount Rushmore, working on model, ca. 1920s (courtesy of Mount Rushmore National Memorial Archives, Mount Rushmore, SD)

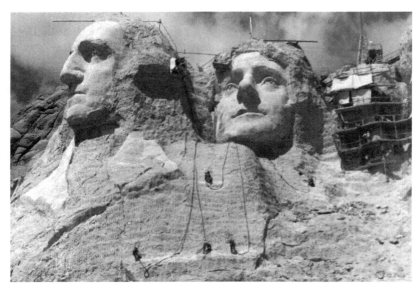

Figure 5.3 This construction photograph of Mount Rushmore illustrates that the Washington carving extended below his head and down to his chest, ca. 1930s. This amount of sculpting was not replicated in the Lincoln, Jefferson, and Roosevelt carvings (courtesy of Mount Rushmore National Memorial Archives, Mount Rushmore, SD)

to carve an entablature of U.S. history and to create a Hall of Records behind the presidents.[21] Ultimately, only the heads of the presidents were completed, and work on Mt. Rushmore was "finished" in 1941 by Gutzon Borglum's son, Lincoln. The entablature was never added to the site, and the Hall of Records that began under Gutzon Borglum was finished by the NPS on a much-reduced scale in 1998.

Borglum's definition of the memorial in 1925 was to commemorate "Empire Builders," and to "record the Revolution, the Louisiana Purchase, [and] the securing of Oregon, Texas, California, Alaska, and Panama."[22] Borglum's conception of an empire builder is most clear in his proposal for the entablature that was to be carved in the shape of the Louisiana Purchase and would include the eight events that Borglum considered as defining American history: "the Declaration of Independence, the framing of the Constitution, the Purchase of Louisiana, the admission of Texas, the settlement of the Oregon Boundary dispute, the admission of California, the conclusion of the Civil War, and the building of the Panama Canal."[23] According to Borglum, the presidents who best represented these events were George Washington, Thomas Jefferson, Abraham Lincoln, and Theodore Roosevelt.[24] Of these four, only Roosevelt engendered debate, mostly because he had not long been deceased.[25]

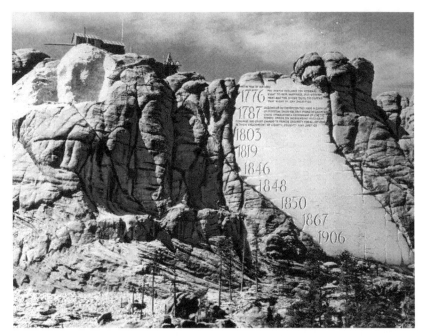

Figure 5.4 A rendering of Mount Rushmore sculptor Gutzon Borglum's plan for a carved entablature that was to have appeared next to the four presidents (courtesy of Mount Rushmore National Memorial Archives, Mount Rushmore, SD)

At the time of Mt. Rushmore's construction, Borglum's vision of this monument as a commemoration of U.S. expansionism *was* read as a monument to imperialism, yet there was little registered discordance with his "imperial view of history."[26] Prevailing political culture during the time of Mt. Rushmore's conception and construction provide some insight into the initial acceptance of Borglum's ideology. In the late 1920s, the United States was still in the shadow of World War I, and, as Michael Schudson explains, the "fear of anarchism, socialism, and bolshevism, plus concern about the need to Americanize immigrants, [were] reasons for a renewed interest in the Constitution and all things American in the 1920s and '30s."[27] There was no objection to building a U.S. memorial that Borglum portrayed as one "designated as a monument to a specific form of government"[28] that memorialized "the principles that underlie the form of our political philosophy, and determined our territorial dimensions."[29] For Borglum, there was no question that his carvings constituted a "memorial to the various incidents that have resulted in the organizing and completion of what is today the American Empire."[30] Just seven years after Borglum's death in 1941, President Calvin Coolidge described Mt. Rushmore as representing a "continuing allegiance to independence,

to self-government, to freedom, and to economic justice."[31] Borglum's incorporation of U.S. expansion into the definition of Mt. Rushmore quickly disappeared, and its absence in any of the interpretive materials is discussed in more detail later in this chapter.

"Patriotism, as a commodity, is hard to sell."[32]

Throughout the 1950s, the NPS continued to request funding for the construction of on-site exhibits that would define Mt. Rushmore: "The cost of the Visitor Center is an investment which will make the million dollars spent on the Sculptures pay additional dividends in patriotism."[33] The 1957 museum prospectus for a new visitor's center is one of the first NPS documents that provided NPS's explanation, distinct from Borglum's, for the selection of the four depicted presidents; it defined the presidents' contribution in terms of "Freedom."[34] This plan acknowledged that each of the presidents had individual memorials and that Mt. Rushmore need not offer a biographic approach but should focus on its patriotic significance.[35] By 1963, the NPS had moved away from referencing Borglum's expansionist reasoning in its interpretive materials, and Mt. Rushmore's first visitor center was to contain the following exhibits: "Why Are the Black Hills Black"; "Wildlife"; "Black Hills Map"; "Perspective Drawing of Mount Rushmore Area"; "Presidential Quotes"; "Rock of Mount Rushmore" (granite); "History and Administration of Mount Rushmore"; "Identification of the Four Presidents" (located on outside patio). This plan also stated that the Hall of Records exhibit "should be dropped permanently," because it would serve to "reawaken consideration" of why it was not completed.[36] Borglum's expansionist and imperialist theme for Mt. Rushmore was replaced with a focus on Gutzon Borglum himself as the definition of Mount Rushmore. The additional exhibits would include "World's Great Man-Made Memorials," "Sculptor's Inspiration," "The Sculptor," and "Doane Robinson Asks for Borglum." The 1963 prospectus states unequivocally that "we are honor bound to make manifest through the exhibits the initiative and patriotism of the Sculptor."[37] Even with the additional visitor center exhibits, NPS personnel still believed that the task of interpreting Mt. Rushmore had not been met and that more interpretive materials were needed.[38]

Mount Rushmore Orientation Film

To provide an improved Rushmore experience, on December 21, 1964, the Mount Rushmore National Memorial Society accepted Charles W. Nauman's script for Mt. Rushmore's first orientation film, entitled *Mount Rushmore*.[39] The total budget was $17,800, and the proposed running

time was twenty-eight minutes. When completed, the final running time was nineteen minutes. Nauman's proposal described the film's purpose as one that would "document and interpret the history and the ideals embodied at Mt. Rushmore Memorial."[40] Of particular interest is Nauman's initial description of the film's content and the ways in which it substantially differed from the final version. Nauman proposed two minutes on Mt. Rushmore's creator, Gutzon Borglum, and eleven minutes on the four presidents depicted on the face of the mountain.[41] However, in the final cut, the first six minutes are devoted exclusively to Borglum's history. The next ten minutes are a chronological description of the carving of Rushmore and the dedications for each of the four presidents, scenes during which Gutzon Borglum is never far from the screen. There is a one-minute description of Lincoln Borglum finishing Mt. Rushmore after his father's death, and the last minute of the film includes current images of Mt. Rushmore. In this film's interpretation, Gutzon Borglum *is* Mt. Rushmore.

In general, orientation films primarily function as an introduction and an invitation to learn about a significant site and its meaning. The Mt. Rushmore National Memorial administration employs its orientation film in precisely this manner. The layout of the visitors center encourages the viewing of the orientation film, and the main walkway feeds visitors directly to theaters. The NPS rangers advise tourists to include the orientation film during their visit, and the site's printed literature promotes viewing the film.

The orientation films at Mt. Rushmore have gone through three iterations, with the Mt. Rushmore Historical Society producing the first film and the National Park Service producing the next two. The original film, made in 1965, was entitled *Mt. Rushmore: A Monument Commemorating the Conception, Construction, Preservation, and Growth of the American Republic.*[42] It was replaced in 1973 by *Four Faces on a Mountain,* which gave way in 1986 to *The Shrine,* the film that was still showing at the memorial in 2012 with no immediate plans for its replacement.[43]

All three films use one of the most popular documentary forms—exposition—and all three orientation films use male narrators: Lowell Thomas for the first film, Burgess Meredith for the second, and Tom Brokaw for the third. The three orientation films also include archival footage, music scores, historic black and white still photographs, contemporary color images of Mt. Rushmore, and editing that "generally serve[s] to establish and maintain rhetorical continuity more than spatial or temporal continuity."[44]

In the first film, *Mount Rushmore,* the narrator, Lowell Thomas, provided a "voice-of-authority commentary," which was a "richly toned male voice of commentary that proved the hallmark of the expository mode."[45]

Additionally, Lowell Thomas was widely recognized as a preeminent
broadcast journalist, a renowned war reporter, and a "contemporary
and friend of the late Gutzon Borglum."[46] The importance of claim-
ing Borglum's friendship in order to establish Thomas's ethos as nar-
rator relies on understanding Gutzon Borglum's role in the creation of
Mt. Rushmore. This orientation film conflates Mt. Rushmore's symbolic
meaning with Borglum as an individual, and this blurring was fueled by
Borglum's conception of U.S. artistry.

Borglum's idea of creating distinctive U.S. art in form and con-
tent can be understood by taking into consideration the historical the-
ory of monumentalism. Monumentalism is a critical historical approach
to understanding U.S. landscapes as a source of nationalistic pride.
Environmental historian Alfred Runte describes monumentalism as the
reasoning behind the initial U.S. National Parks idea that "evolved to
fulfill cultural rather than environmental needs" and as an essential part
of "the search for a distinct national identity."[47] Runte argues that mid-
nineteenth century Americans lived under a European cultural shadow
and were accused "of having no pride in themselves or in their past."[48]
Furthermore, "the absence of reminders of the human past, including
castles, ancient ruins, and cathedrals on the landscape, further alienated
American intellectuals from a cultural identity."[49] With the opening of
the West during the late nineteenth century, Americans found landscapes
that began to fill the need for an identity that was different from Europe.
Yellowstone, Yosemite, Mt. Rainier, and the Cascade Range started to
satisfy this nationalist desire. According to Runte, "the natural marvels
of the West compensated for America's lack of old cities, [and] aristo-
cratic traditions."[50] The concept of national parks and their monumen-
tal scenery functioning as symbols of U.S. cultural nationalism intrigued
Gutzon Borglum. Like many artists of the time, Borglum had studied art
in Europe, but he returned to the United States determined to create an
American art that was as distinct from the European traditions as pos-
sible.[51] Borglum "believed that classical forms had no place in the art of
America and argued that it was foolish to tie American art to Europe."[52]

Borglum declared that "the amazing and expanding character of
[American] civilization clearly demand[s] an enlarged dimension—a new
scale. Ours will be called the Colossal Age."[53] He further predicted that
Mt. Rushmore "will be [the] most gigantic sculpturing enterprise ever
conceived."[54] Communication scholars Carole Blair and Neil Michel place
Borglum's ideas for carving Mt. Rushmore in "the culture of the corpo-
ration and giant public works projects," as well as in as the "skyscraper
competition."[55] While colossal projects certainly defined the scale of U.S.
architecture of the time, I would add that Borglum's decision to carve
four U.S. presidents on a Western mountain also incorporated his desire

Figure 5.5 Mount Rushmore before the carvings (courtesy of Bell Studio, Mount Rushmore National Memorial Archives, Mount Rushmore, SD)

to surpass Europe's landscapes filled with "the impress of the past."[56] Borglum's carvings on Mt. Rushmore would permanently impress the U.S. landscape with historical meaning and provide the United States with a site of national identity.

Borglum's definition of a U.S. identity that included expansionism and imperialism is seen in the entablature, in the choice of presidents, as well as in the selection of the monument's location. Arguably, according to the 1868 Fort Laramie Treaty, Native Americans still own the Black Hills.[57] This dispute continues as of this writing on account of the Lakota suit against the United States for the Black Hills, which "resulted in a Supreme Court decision in 1980 compensating them for an illegal taking of the Hills by the United States in 1877."[58] The amount of the award in 1980 for the Black Hills was approximately $106 million, and in 2009 with an adjustment for inflation, the figure was estimated at just over $900 million.[59] As of 2012, this settlement has been refused because "regaining the Black Hills was becoming a symbol of revived Lakota nationalism."[60]

In 1924, the selection of the Black Hills for a colossal carving was largely uncontested, and this reaction was mostly a result of the U.S. policies toward Native Americans, the intent of which Edward Lazarus describes as "to kill a culture."[61] It is interesting to note that while the Lakota court case moved at a glacial pace through the court system, the government moved "with alacrity to a different Black Hills initiative—the carving of Mt. Rushmore."[62] During the construction of Mt. Rushmore, there were no Native American protests, and Black Elk participated in several events at

the memorial in the hopes of accepting the "monument and the new world it represented, hoping to survive within it."[63] Native American protest of Mt. Rushmore did not materialize until the 1970s, when Native American groups occupied the monument, an event discussed in more detail later in this chapter. Permanent interpretive materials concerning Native Americans did not appear in the visitors center until the 2000s, with the hiring of the site's first Native American superintendent, Gerard Baker.[64]

The first visitor center and orientation film do not include any reference to Native American history in the Black Hills or any representation of the Lakota's current court case to regain ownership. The first orientation film, *Mt. Rushmore*, also avoids a discussion of Borglum's vision of the memorial as a tribute to imperialism and instead conflates the

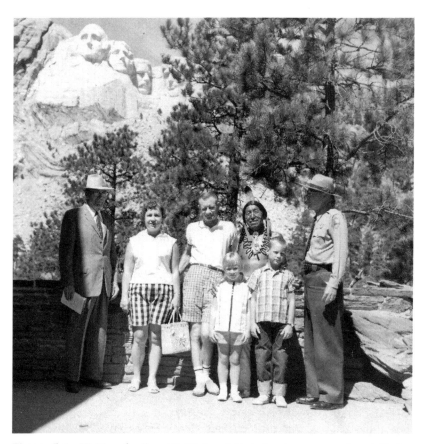

Figure 5.6 Visiting family with National Park Service personnel and Native American at Mount Rushmore National Memorial, ca. 1950s (courtesy of Bonita Cockran, Mount Rushmore National Memorial Archives, Mount Rushmore, SD)

symbolic meaning of Mt. Rushmore with a hagiographic representation of Borglum. The film begins with Borglum's first attempt at mountain carving on the Stone Mountain memorial in Georgia, which commemorates the Confederacy. Although there are fourteen shots of his work at Stone Mountain, there is no mention of his membership in the Ku Klux Klan or how badly this project ended.[65] During his work on Stone Mountain, Borglum joined the KKK in the hope of turning the organization "into a powerful political force strong enough to make national policy." [66] Following the Stone Mountain sequence are shots of Borglum at work in his studio and then a lengthy cataloguing of his other sculptures. The narration accompanying this section of the film is triumphant and describes Borglum's art as "purely and newly American" and Borglum as one of "America's foremost sculptors," who was "an intensely nationalistic and patriotic artist."

Gutzon Borglum is never far from the audience's eyes or ears in the ten-minute sequence covering the construction and dedication of each of the individual presidential carvings. This sequence uses archival footage that includes the dynamiting of the mountain as a prelude to the carving. In this sequence there are 194 different shots, 40 of which include Borglum. Although Bruce Nauman, the director, had indicated that the presidential sequence would be dedicated to the represented presidents themselves, this sequence instead presents *how* Borglum carved Mt. Rushmore and his emphasis on spectacle—not *why* he chose these specific presidents. For Washington, the narrator states that "Gutzon had spent much time lately going over the George Washington face refining it" and that Borglum's final touches "transformed the sculpture from colossal bulk to a portrait." For Thomas Jefferson, the narrator asserts that Borglum "spent one third of the time . . . in rethinking it or relocating it within the mountain itself." The narrator describes Lincoln as "a work of art, as a masterpiece of great sculpture. . . . we have been little more than able to indicate its fine possibilities." The Roosevelt dedication description postulates that "it was another Borglum performance with William S. Hart of motion picture fame and Sioux Indians attending."[67] Borglum's skill as a sculptor is highlighted in a two-minute segment explaining his pointing technique, which was a way to proportionally transfer the dimensions of the model in his studio onto the mountain for carving. There is a closing shot of Borglum in a fedora hat, cross-fading with the "finished" Mt. Rushmore that reinforces the film's hagiographic portrayal of Gutzon Borglum as Mt. Rushmore.

This film was well received at the time, and a National Park Service reviewer wrote: "It is top quality, shows deep appreciation of the purposes of the Memorial, and certainly stimulates understanding of the thorough research done, and the true creativeness of Gutzon Borglum."[68] There is no question that this film accomplishes an extended adulation of Borglum;

however, there is very little coverage of the "purposes" of the memorial. This approach is consistent with the "Great Man" theory of history that can skillfully focus the audience's attention away from larger cultural concerns. At the time of this film's production in 1964, the United States was in the midst of a growing civil rights movement that was based on recognizing and empowering those who had been left out of traditional historical representations. Historian Michael Sherry describes the political climate in 1964 as one that was increasingly unreceptive to any notion of U.S. imperialism, in which "leftist radicals trained their sights on 'the establishment'—the entrenched machinery of racism, imperialism, militarism, and corporate capitalism."[69] Historian Howard Zinn sees this change as a turning away from the approach to history where "the past is told from the point of view of governments, conquerors, diplomats, and leaders."[70]

The decision to focus the 1964 film on Gutzon Borglum conflates nation-state loyalties and individual predilection; that is, if Borglum is patriotic and nationalistic, then Mt. Rushmore is patriotic and nationalistic. This syllogism accomplishes two goals. It bridges the split between collective action and individual autonomy by placing national ideals in the man, and it limits a detailed version of U.S. history and patriotism to the imagination of one individual. One implication of this portrayal of U.S. history is that there was no national imperialism, just outstanding individuals.[71] Additionally, this depiction accomplishes the Foucaultian chore of masking national power, whereby "the aim was to render power sufficiently invisible and insidious for it to be impossible to grasp what it was doing or where it was."[72] Facing a rising tide of domestic challenges to U.S. imperialism, this orientation film chose to define Mt. Rushmore's national symbolism using a hagiographic depiction of Gutzon Borglum and to ignore his imperialist and expansionist definitions of Mt. Rushmore as well as his personal political affiliations.

Mt. Rushmore as Rhetorical Situation

The rhetorical situation at Mt. Rushmore changed considerably in the 1970s. Although there is no indication in the NPS planning documents for a substantial revision of their materials, political exigencies intruded. The Mt. Rushmore Memorial was the site of several Native American protests, some of which were peaceful and some of which were violent. Although there was no demand to change Mt. Rushmore's interpretive materials, the new orientation film reflected the changing rhetorical situation in the contemporary United States in general and at Mt. Rushmore in particular.

In 1973, the NPS replaced the *Mount Rushmore* orientation film with *Four Faces on a Mountain*. This new film was produced by the National

Park Service's interpretive branch in Harpers Ferry, West Virginia, and was funded by the Mount Rushmore National Memorial Society of the Black Hills, with a total budget of approximately $18,000–$20,000.[73] The change in form and content from the previous film is remarkable. *Four Faces on a Mountain* consisted of a one-minute opening of Black Hills' nature shots; one minute describing Doane Robinson and Senator Norbeck's involvement, as well as Borglum's contribution to Mt. Rushmore; seventeen minutes explaining the depicted presidents; and a one-minute conclusion.

This new textual mediation of Mt. Rushmore reflected a very different definition of the patriotic icon, and the most notable change was the elimination of Gutzon Borglum as a patriotic synecdoche. The focus shifted to explaining the choice of the four presidents. Borglum is not mentioned until three minutes into the film, there are no accompanying images of his previous artworks, and his artistic history is condensed to one line of narration: "Borglum had achieved some success as a sculptor, having executed a number of prize-winning works."[74] A Mt. Rushmore Superintendent's report succinctly described the change from the previous film. Whereas the first film had "depicted the engineering aspects and talents of Gutzon Borglum, the other film dwells more on the lives of the four Presidents selected to be carved into the mountain."[75] Another NPS memo takes a more direct approach and describes Borglum's role as "relegated to that of fabricator of the memorial." This memo further explains that "the overall theme is chiefly an explanation of why the mountain was carved, stressing the Nation's desire to commemorate the ideals of the four presidents depicted and the principles of democracy which they espoused . . . thus facilitating a large-scale reminder of concepts vital to American culture."[76] This substantial change in focus was not well received by the NPS. Harvey D. Wickware, the Acting Superintendent of Mount Rushmore in 1973, wrote: "The financial backers of the film are generally disappointed with it. They believe it lacks the 'zing' of the previous film and will not aid in inspiring the visitor. The staff agrees that the sound and voice is generally depressing rather than being spiritually uplifting."[77]

How did this new interpretive focus evoke such a dismal reaction? There are several elements that contribute to this substantial transformation in reception. In addition to losing the celebration of Borglum, the film uses a much less prominent narrator. The choice of Burgess Meredith as narrator is intriguing because he had not been a journalist and consequently did not have the "objective" ethos that a journalist brings to the role of narrator in an expository documentary. Meredith's body of work reveals no single film that would obviously qualify him to serve as narrator for Mt. Rushmore's orientation film.[78] Yet, his political activism may have played a role in his selection. He was "named an unfriendly

witness by the House Un-American Activities Committee in the early
1950s. . . . He was also an ardent environmentalist who believed pol-
lution one of the greatest tragedies of the time, and an opponent of the
Vietnam War."[79] His role as an environmentalist is noteworthy, because
a 1972 treatment of *Four Faces on a Mountain* describes the memorial
as a "harmony between the works of nature and man" that is "reborn
in the modern ecology movement."[80] Since 1957, NPS planning docu-
ments repeatedly included the natural beauty of the Black Hills as a minor
theme that should be included in its interpretive materials.[81] However,
the 1973 NPS memo criticized "the environmental and history lessons
worked into this film" and argued that these lessons were obstructions
to the film providing a spiritually uplifting message.[82] The first minute of
this orientation film contains no images of Mt. Rushmore. Instead, the
film's opening is devoted exclusively to stunning nature shots of the Black
Hills accompanied by soft melodic music. The portrayal of environmental
concerns and Meredith's role as narrator are two significant elements that
compose this new textual mediation of Mt. Rushmore. The third, and by
far the dominant element, that contributes to this film's bleak reception is
the presidential sequence.

The seventeen-minute presidential sequence is notable for its length
and unconventional version of the represented presidents' contribution
to building a national identity and sense of patriotism. Each presidential
section runs between two and four minutes, and each contains two major
themes. Instead of depicting the presidents as "Empire Builders," the
film portrays them as encountering profound national adversity during
their tenure in office and drawing on nature as a source of inspiration and
knowledge. The memorial's construction scenes are used to introduce
each president, rather than to highlight Borglum's achievement. The
dynamiting footage is used only once during the film, and the size of the
carvings is never mentioned.[83] The focus of this film is not to celebrate
Borglum's patriotism or his monumental achievement but instead to pro-
vide an explanation for why these presidents are represented.

The explanation offered for the choice of presidents is couched in
rhetoric that is particularly responsive to the tumultuous contemporary
political climate. "There were thousands of seeds and shoots of rebellion
all around . . . in this uncertain situation of the seventies,"[84] and Mount
Rushmore was one center of this rebellion. On August 24, 1970, sev-
eral Native American rights' groups targeted Mount Rushmore, declaring
that "this protest is part of [the] fight to awaken the U.S. government
to the fact that the Sioux Indians have been wronged. The government
illegally seized the Black Hills and has not paid for them."[85] This protest
lasted just under a month, but during the next year there was another
occupation that was primarily organized by members of the American

Indian Movement (AIM), who "had come specifically to take possession of the mountain." However, this protest lasted only ten hours because "National Guard troops and NPS rangers dragged most of the group off of the mountain." Fears of an occupation at Mt. Rushmore continued to escalate through the 1970s and eventually declined by the early 1980s. It was amid this rhetorical situation, when AIM leader Dennis Banks declared the memorial a "Hoax of Democracy," that the staff at the Harpers Ferry Center produced the second orientation film.[86]

Along with Native Americans challenging the ownership and validity of Mt. Rushmore, other U.S. constituencies opposed viewing the nation's history through a celebratory lens. There were extensive protests concerning civil rights, the Vietnam War, free speech, women's rights, the environment, gay rights, and Nixon's actions before his resignation. Historian Peter N. Carroll describes the mood of the time: "The crisis of the early seventies . . . added up to a spiritual crisis of major proportions,"[87] in which "Americans retreated to established ideals and old virtues."[88] During such a search for established ideals and virtue, Howard Zinn claims that "the supreme act of citizenship is to choose among saviors."[89] With Mt. Rushmore's continuing status as a symbol for U.S. patriotism and as potential site for additional protest, the decision to define the memorial in terms of the former presidents is understandable.[90]

The first president in this film's presidential sequence is Washington, and this sequence is as surprising for what it encompasses as for what it does not. The sequence does not begin with Washington's presidential election or battlefield victories but instead with Washington's farewell to his officers that "drew tears from many." This noncelebratory introduction of Washington sets the tone for the entire film. The sequence continues with a description of Washington as drawn away from the natural setting of Mt. Vernon on the Potomac River in order "to focus his country's attention on the awesome problems of internal harmony." The film then moves to Washington's farewell address, in which he admonishes the citizens to acknowledge the great wealth of the country and to recognize that they have a "fairer opportunity for political happiness than any other nation has ever been favored with." This section ends with the narrator declaring that Washington was "the steady hand that helped the young nation redirect itself after the destruction and turmoil of the Revolution."

Four Faces on a Mountain primarily defines Washington in terms of surviving national hardships. The focus is on the new country's problems and challenges during Washington's term instead of his successes and is clearly not "spiritually uplifting" or triumphant. This depiction reflects hard choices, conflicting interests, and deep discord in the country. The representation of Washington at the end of his career and not at the beginning spotlights the challenges facing a new nation and echoes

the contemporary political concerns of the 1970s. *Four Faces on a Mountain*'s Washington offers a definition of patriotism that is grounded in the notion of withstanding internal political unrest.

The theme of persevering through national adversity and maintaining a connection with nature continues in the Jefferson sequence. The film proclaims that the third president's appreciation of nature manifested itself in his Monticello home and was "like Washington's Mt. Vernon . . . where he maintained his connection with the land." The film then depicts Jefferson not only with the familiar quote from the Declaration of Independence ("We hold these truths to be self-evident, that all men are created equal") but also with the less familiar lines "that whenever any form of government becomes destructive of these ends it is the right of the people to alter or to abolish it, and to institute new government." The inclusion of this reference to the Founders' belief that it would be patriotic to challenge any government that becomes destructive offers a knottier version of patriotism. This depiction defines Jefferson as more concerned with internal governmental matters, as opposed to expansion. The sequence also includes Jefferson's presidential struggles concerning slavery and ends with his lament from a memorandum he wrote while reflecting on his time in office: "I have sometimes asked myself whether my country is the better for my having lived at all. I do not know that it is. I have been the instrument of doing things; but they would have been done by others, some of them, perhaps, a little better." Instead of highlighting the Louisiana Territory and territorial expansion (which Borglum indicated as his reasons for Jefferson's inclusion), this orientation film portrays a Jefferson who doubts his contributions to the country. Although the narration alludes to his founding of the University of Virginia and writing of the Declaration of Independence, this section ends with his regrets, thus highlighting a patriotism that is defined by surviving the challenges of the time and serious self-reflection.

The Lincoln sequence invokes the nature-as-knowledge theme and presents a remarkable representation of his endurance during a period of national adversity. Lincoln is first described as having "a new kind of wisdom, born of the frontier. . . . He was the epitome of this fresh approach, of country wisdom." However, the emotional center of Lincoln's sequence concerns holding the country together through the Civil War. Although Borglum considered the "conclusion of the Civil War" as one of the eight events that defined U.S. history, *Four Faces on a Mountain* does not focus on the war's conclusion but instead depicts a Lincoln mired in conflict and pain.[91] This sequence includes strikingly graphic photographic images of dead Civil War soldiers that draw the audience far away from Mt. Rushmore. Also included in this sequence are historical photos of Lincoln's physically changing face that "clearly reflected the scars and

trials of a country torn from within" during a time when "people hated and hunted neighbors." As in the previous two presidential depictions, the focus of the Lincoln sequence is also on enduring internal national conflict. Borglum does reappear in this sequence but only in terms of how he was able to carve Lincoln's face to reflect a "mixture of patience and faith which had given Lincoln the strength to endure." Lincoln's endurance in the face of the nation's greatest internal discord was the message for 1973 audiences who also faced internal national dissonance.

The main difference visually between the Roosevelt section and the previous presidential representations is the substantial use of film footage that is not of the depicted President but of contemporary society, including the urban poor, immigrants arriving in the United States, workers on bicycles, people in automobiles, and tourists in Yellowstone National Park. Continuing the theme of the presidents' connections to nature, Roosevelt is described as a "conservationist" who brought "a new level of consciousness in understanding Americans and their natural environment" and who laid "the cornerstone of the gateway to Yellowstone National Park." This section then portrays Roosevelt as confronting national adversity in the form of internal class warfare. His sequence begins with his refusal "to accept the crimes of those few rich who were exploiting the people of the United States." The Roosevelt sequence intertwines the two themes of nature and domestic struggles: "The preservation of the scenery, of the forest, of the wilderness life for the people as a whole . . . [should] not be confined to the very rich who can control private resources." The Roosevelt depiction offers the audience another portrayal of a former president who successfully confronts internal discord. There is no mention of his Panamanian exploits.

Four Faces on a Mountain's conclusion includes a quotation from Washington's farewell address in which he questions whether the American Revolution "must be considered as a blessing or a curse." Washington's ambivalence about the future of the country recurs in the final two lines of the film's narration: "Four faces on a mountain, each reflecting part of what America was and what it can become, if we are willing." This orientation film defines Mt. Rushmore's symbolism as more on the cusp of reaching Washington's ideals than as having attained them. In 1973, critical questions regarding the country's future were germane, and this orientation film depicts these presidents as the nation's saviors. This definition of Mt. Rushmore's symbolic patriotism was responsive to its contemporary rhetorical situation; however, thirteen years later, the cultural and political climate was very different, and the NPS responded to these changes.

During the time between 1973 and 1986, Mt. Rushmore was no longer a site of protest, and the main problem the site next encountered

was increasing visitation. In addition to beginning plans for a new visitor center with vastly increased parking capacity, management plans also reveal a need to work on the site's patriotic messages. Mt. Rushmore's 1981 Interpretive Plan describes the visitor center as creating a "somewhat patriotic mood" and that an interpretive goal should be to "foster appreciation and understanding of the sculpture, its method of construction and its value in commemorating our form of government."[92] By 1982, the NPS was unequivocal about the need for changing the interpretive materials: "The highest priority research need is for oral history to be recorded. Former workers and Lincoln Borglum (Gutzon's son) should be interviewed."[93] Although work on a new visitor center did not commence until 1993, the NPS staff debuted a new orientation film in 1986, which incorporated these new themes.

This next orientation film, *The Shrine*, lasts seventeen and half minutes, is narrated by Tom Brokaw, and received funding from both the National Park Service and the Mount Rushmore National Memorial Society of the Black Hills.[94] The producer and writer of this orientation film was Robert G. McBride of Earthrise Entertainment in New York. Visually, this film differs from the previous two by using more contemporary footage of Mt. Rushmore, including many aerial shots. The narrator, Tom Brokaw, brings not only his journalistic reputation to the film but also his identity as a native South Dakotan.[95] The film's positive reception is evidenced by the fact that it was still showing in 2012 and that there are no immediate plans for its replacement.[96]

Initially, *The Shrine* appears to fall ideologically between the two previous orientation films. *The Shrine* offers some definition of the presidential choices; however, its message is not wrapped up in the person of Gutzon Borglum or in the historical adversity facing each of the represented presidents. The major sequences include Doane Robinson's contribution; two and a half minutes on Gutzon Borglum, with no reference to his previous artistic work; a one-minute explanation for each of the presidents; the presidential dedications; and six and a half minutes on the construction of Mt. Rushmore. Much of the archival footage of Mt. Rushmore's construction is from the same footage in *Four Faces on a Mountain*. However, *The Shrine* adds dynamite-blasting sounds to the construction footage, and the sequence is not broken into small sections peppered throughout the film; instead, these scenes are edited together as one sequence. The actual dynamiting and jack-hammering, and the individual workers at Mt. Rushmore, receive the bulk of screen time.

The Shrine's overall message is a celebratory and progressivist version of U.S. history without depictions of economic exploitation, Civil War deaths, slavery, or Washingtonian regrets. In *The Shrine*, the presidents are not represented as mired in national adversity but are shown as

single-note great men. The abbreviated depictions portray only shining moments, and expansionism enters as an accomplishment.

Jefferson's depiction is first, and it sets the tenor for the next three presidential portraits. The familiar line from the Declaration of Independence is quoted: "We hold these truths to be self-evident, that all men are created equal", but Jefferson's call to abolish government if needed, as quoted in *Four Faces on a Mountain*, is gone. Jefferson is described as a "great nation builder," and one of his accomplishments is the "purchase of the Louisiana territory." George Washington follows and is described mostly in terms of his character and of his choosing to nurture "the sacred fire of liberty." Absent in this film are any laments or sorrowful presidential moments. Abraham Lincoln is the "great emancipator" who "lent a steadying hand" to guide the country through the Civil War. He "was the prophet of America's permanence and of liberty, tolerance, and social justice for all people." He is no longer depicted as emotionally damaged from the Civil War. A physically active Theodore Roosevelt extends "economic freedom" and "forg[es] new links between east and west with the Panama Canal."[97] This presidential sequence invokes Borglum's original expansionist reasoning for including these four national leaders; however, this brief presidential section is followed by an extended elucidation of the memorial's construction, which becomes the film's main focus.

The Shrine commemorates the men who worked on the mountain carving, as opposed to Borglum or the presidents. The narration catalogs the kinds of workers involved: "In addition to the pointers, the construction crew included powder men, winch men, blacksmiths, call boys [shouters of instructions], and as many drillers as the budget would allow." We see many black and white photos of the workers posed in front of Mt. Rushmore, but unlike the first orientation film, without images of Borglum. The final narration declares that Mt. Rushmore "is a monument no less to the men who, working together, transformed the lofty ideal into a colossal reality."

This change in Mt. Rushmore's textual mediation reflects a new slant in defining the memorial's patriotic symbolism. In 1986, the year of this film's production, there was a definite shift in the national political rhetorical situation. The protests of the 1970s had ended and President Reagan was in his second term; "despite notable successes [he] had failed to regenerate the nation's cultural foundations."[98] Michael Schudson describes a time when "civic life has collapsed. . . . [There was] the decline of parties; the fiscal impoverishment of cities strangled by suburbs; the dwindling of newspaper readership; disappearing trust in government and nearly all other major institutions; shrinking voter turnout; citizens' paltry knowledge of national and international affairs; the lack of substance in political campaigns."[99] By the late 1980s, as Michael Sherry observes, "the *fact* of cultural discord . . . was not new," but the civic response to it had changed.[100]

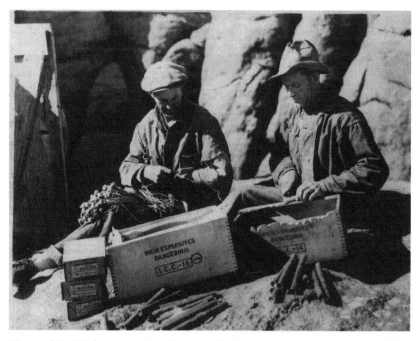

Figure 5.7 Workers preparing dynamite for Mount Rushmore carving, ca. 1930s (courtesy of Mount Rushmore National Memorial Archives, Mount Rushmore, SD)

In addition to the search for saviors during the ongoing cultural discord, a new reaction to the strife was the charge of revisionism: "In the 1980s and 1990s . . . a backlash emerged against the interpretive transformations wrought in the previous two decades." Mike Wallace argues that "powerful figures, garbed as populists, claimed that historians and curators (even theme park operators) had imposed their 'politically correct' views on an unwilling populace."[101] In an effort to respond to such charges of revisionism, *The Shrine* eliminates the "environmental and history lessons" of the previous film and instead focuses on the less controversial accomplishment of the physical carving and on the actual Mt. Rushmore workers.

This rhetorical move accomplished multiple goals. By highlighting the colossal physical aspects of the memorial, the film placed the audience in the position of admiring the feat of the carving without asking for reflection on (or an interpretation of) the nature of the country's history, its future, or *why* this memorial was created. Another implication of this shift in emphasis was that the visitors' experience at Mt. Rushmore became more of a recreational event, with *The Shrine* defining Mt. Rushmore as an amazing American spectacle.[102] This film extolled the work of individuals

in the name of a very narrowly defined collective action—that of carving Mt. Rushmore—not in terms of larger nation-state loyalties.

The Shrine can be read as a partial return to Doane Robinson's original intention for Mt. Rushmore that "every community . . . should have something to draw tourists."[103] *The Shrine* offers tourists an "exciting" rendition of Mt. Rushmore—one that is closer to a theme park experience than a contemplative site of national reflection.[104] Also embedded in this "fun" representation of Mt. Rushmore is an allusion to U.S. imperialism. In their work on Mt. Rushmore's ideological representation, Blair and Michel argue that the memorial itself "is an image of imperialist pride."[105] The inclusion of the imperialistic reasoning for the presidential choices can be seen as laying the groundwork for understanding the United States as empire and as an imperialistic power, even though the creators of *The Shrine* may well have intended to make the film more historically accurate.[106] Nevertheless, the memorial's message of imperialism is significantly muted because of the emphasis on the construction sequence and the workers' ability to create Mt. Rushmore. One result of this particular combination of scenes is that the audience is "wowed" by the dynamiting and uncritically accepts the depiction of U.S. imperialism. Reinforcing this message is the continued absence of any acknowledgment of contemporary Native American presence in the Black Hills or Lakota claims of ownership to the Black Hills. The first "permanent" exhibit concerning Native Americans does not arrive until 2007 as part of Heritage Village, which will be discussed in more detail later in this chapter.

When compared to *Four Faces on a Mountain* and the first orientation film, *Mt. Rushmore, The Shrine* is much more triumphalist about U.S. capabilities and portrays the workers' skills as the main component of Mt. Rushmore's patriotic symbolism. No longer is Mt. Rushmore the creation of a single man—Gutzon Borglum—it is now the triumph of myriad U.S. workers. *The Shrine* offers audiences a version of U.S. nation building in terms of individuals literally and metaphorically conquering a mountain. The film's narrative of patriotism is built on the premise that the U.S. can "blast" its way to success through skill and technological prowess. *The Shrine*'s patriotism is grounded in individual Americans' abilities and not in individual great men or its leaders.

The Shrine has been Mt. Rushmore's orientation film for more than twenty-six years. Its longevity speaks to its positive reception and adherence to dominant ideologies in the U.S.'s contemporary rhetorical situation. *The Shrine*'s emphasis on the individual in the name of a collective action is one that continues to resonate and offer a noncontroversial definition of patriotism. The film's focus on the Rushmore workers and their physical prowess delineates successful individual actions in the name of a national interest that is limited to the monument itself. The workers'

representation conveniently avoids identifying Mt. Rushmore's patriotic symbolism within the more contentious arenas of world affairs.[107]

"New" Visitor Center

The interpretation of Mt. Rushmore's patriotic meaning in terms of human physical achievement carried over into the redesigned visitor's center, which opened in 1998.[108] Plans for this visitor center called for an exhibit that simulated the exploding dynamite that created Mt. Rushmore. This exhibit has turned out to be one of the most popular exhibits: "Children scramble for position in front of a mock dynamite plunger," and during my repeated visits, I watched many adults enjoy this exhibit as well.[109] Plans to continue interpreting Mt. Rushmore in terms of somatic accomplishment are evident in the 1992 NPS Interpretive Prospectus in which three of the seven interpretive objectives were to "inform visitors about the various stages of construction, . . . encourage an understanding of the people who played a part in the creation of the carving," and to "enable visitors to understand the origin and nature of the carving medium—the granite."[110]

The 1998 visitor center consisted of 21 exhibits with over 400 historic photographs, two 125-seat theaters for screening the orientation film, an amphitheater with an additional 500 seats, and a Presidential hiking trail.[111] Former Mt. Rushmore Superintendent Dan Wenk described the 1998 visitor center as "a world-class experience."[112] A permanent exhibit dedicated to Native Americans would not appear until 2007; however, one of the "new" exhibits in 1998, "The Meaning of Rushmore," a mural depicting U.S. history in a timeline, does reference Native Americans, but only in the past tense in their relationship to the Black Hills.

"The Meaning of Rushmore" exhibit contains the following references to Native Americans: Sacajawea and Shahaka (Mandan chief) assisting the Lewis and Clark expedition; Andrew Jackson chasing raiding Seminoles; a description of the Trail of Tears; an explanation that during the Civil War, "the army moved Indians onto scattered reservations"; the Fort Laramie treaty; an Arapaho Camp and the Battle of Little Big Horn; and a 1934 description of U.S. policy concerning Native Americans. There are two entries on the historic timeline that broach Native Americans and their relationship to the Black Hills—the 1868 Fort Laramie treaty and the 1934 U.S. Indian Reorganization Act, which supported tribal self-government. These two timeline entries would have been the logical place to include reference to the ongoing dispute concerning Black Hills ownership. The Fort Laramie treaty explanation states that the army failed in an attempt to buy the Black Hills, and in 1876, Indians did not comply with the Commissioner of Indian Affairs order

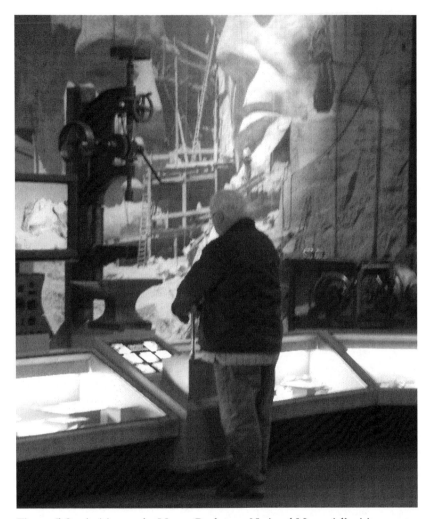

Figure 5.8 A visitor at the Mount Rushmore National Memorial's visitor center dynamite exhibit pushes down on the plunger in order to simulate the exploding dynamite that created the presidential carvings (photograph by the author, 2011)

to return to the reservation and were thus "treated as hostiles." The final timeline description of Native Americans begins with the observation that "with the buffalo herds virtually exterminated, the tribes were eventually starved into submission to the white man's will." This is followed by a reference to the 1934 Indian Reorganization Act, which would halt the division of "what remained of the ancestral lands" and the comment that "Native Americans now number some 1.5 million. They retain

diversity in 500 tribal groups speaking 250 languages."[113] Although the site's interpretive materials were vastly expanded, there was still no reference to the local Native American tribes and their relationship to the Black Hills. This omission would be addressed with the hiring of a new superintendent who escorted the arrival of shared historical authority to Mt. Rushmore.

A Top-Down Paradigm Shift

The three iterations of Mt. Rushmore's orientation films and changing interpretive exhibits responded to fluctuating national rhetorical situations but not necessarily to particular constituencies lobbying for change. This was unlike Chinese Americans at the CSRM, or Japanese Americans at the U.S.S. *Arizona*, or Mexican Americans at the Alamo, or the LGBTQ community and the Traditional Values Coalition at the Lincoln Memorial, where distinct constituencies lobbied regarding the interpretive exhibits. The first Native American Superintendent of Mt. Rushmore was Gerard Baker, and his arrival in 2004 initiated a profound shift in the local Native American tribes' relationship to Mt. Rushmore. Together with his staff, Baker actively sought their input by holding "listening sessions with the tribes of South Dakota . . . with tribal government elders and with community members to introduce himself and see what each reservation was interested in having in a relationship." Amy Bracewell, Mt. Rushmore's historian who worked with Baker, recalled that the key requests that emerged from these sessions were a desire to "incorporate Lakota language into the exhibits and programs and interpretive materials" and to add "American Indian history in the program," because Native Americans "didn't see their story here, they didn't have much of a presence."[114] Baker, who worked in the NPS for over thirty years before coming to Mt. Rushmore, described his motivation for these sessions: "Every national park was some Indians' territory at some point in time," and "as a government agency, one of our responsibilities is to look at all the stories."[115]

The result of Baker and his staff's outreach efforts appeared in 2007 in the form of a single tipi set up along the Presidential trail and in the audio tour.[116] The single tipi would become three tipis in 2008 and compose Heritage Village, or the Paha Sapa stop, on the Mt. Rushmore audio tour.[117] During the summer months, Native Americans work at Heritage Village, where they explain Native American culture, including the use of porcupine needles to decorate clothes, the traditional use of buffalo parts, the construction of the tipis, and Lakota religious beliefs.[118] As of 2012, the Mount Rushmore audio tour was available in four languages, English, Spanish, German, and Lakota. Baker's emphasis on incorporating the entire history of the Black Hills, including the time before the carving

Figure 5.9 National Park Service Ranger with visitors at Mount Rushmore National Memorial's Heritage Village, ca. 2008 (courtesy of Mount Rushmore National Memorial Archives, Mount Rushmore, SD)

of Mt. Rushmore, enacted an element of the 2000–2005 NPS strategic plan that called for "management decisions about resources and visitors [to be] based on scholarly and scientific information."[119] This goal is surprisingly similar to the Alamo's 2011 new guidelines for its interpretation under the State of Texas that enjoined the DRT to "provide education outreach that emphasizes historical accuracy."[120] However, emphasis on scholarly and scientific research is not always well received when it comes to the interpretation of national symbols.

"I wonder when Baker is going to get rid of this Indian shit."[121]

Gerard Baker not only went to the local Native American tribes in their communities to listen to their thoughts about Rushmore, but he also held a Native American elder summit at Mt. Rushmore.[122] The local South Dakotan community responded with mixed opinions to this outreach and incorporation of Native Americans into Mt. Rushmore. The *Rapid City Journal* reported that visitors complained that the "new Native history display doesn't fit with the 'theme' of Mount Rushmore" and that the exhibits "didn't belong" there.[123] Several writers to the local newspaper were also clear about where they felt Native American history should go: "Maybe they can move all the Native American stuff over to Crazy Horse

and restore Mount Rushmore to the way it used to be. I am sure that the people at Crazy Horse could find a place for all of Mr. Baker's display."[124] Nevertheless, there were those in the area who defended Baker and the installation of the Native American exhibits: "To those narrow-minded folks who think the teepee [*sic*] village should not have been at Mount Rushmore: Most tourists were delighted. Are you not aware of the history of South Dakota and the Native people?"[125] One letter writer specifically defended Baker as "intelligent, charismatic and capable" and "very proud of his work in highlighting the two cultures that care about the Black Hills, both the Natives who were here first and those who followed."[126]

Despite Baker's concerted efforts to involve the local Native American community with Mt. Rushmore, there is sense of fragility about this shift. The addition of Heritage Village and audio tour in Lakota probably would not have happened without Baker, and their tenure at Mt. Rushmore will be determined by others—perhaps those who were inspired by his work and vision or by others who are also interested in the history of the area before Gutzon Borglum. Baker left Mt. Rushmore in 2010, when he was named assistant director for American Indian relations for the NPS division of the U.S. Department of the Interior in Washington, D.C.[127] The Heritage Village and audio tour that includes the Lakota language were still at Mt. Rushmore in 2012, despite their mixed reception. The next challenge for Mt. Rushmore is whether the Native American interpretative exhibits can coexist with the other ongoing displays. For Baker, there is no question that "Indian tribes are never going to get the Black Hills back," and he envisions a coexistence in which Native Americans must "educate ourselves and take the jobs to be the ones to make the decisions." For Baker, taking back the Black Hills means that Native Americans should "start managing it ourselves" through the NPS.[128] For Kollette Medicine, a member of the Cheyenne River Sioux and one of the summer interpreters for Heritage Village, coexistence in the Black Hills is necessary because "it's sacred to us as citizens, as all brothers and sisters of the United States of America," and it is "balancing both the Lakota way of life with the European way of life."[129] As of 2012, Bracewell, Mt. Rushmore's historian, stated that "we're committed to keeping up the audio tour and the village."[130]

Mutable Meanings

The changing interpretive exhibits and orientation films at Mt. Rushmore offer an opportunity to understand not only how they contribute to what Roy Rosenzweig and David Thelen have observed as U.S. "historical amnesia," but also how the exhibits illuminate what Americans *do* "know and think" about Mt. Rushmore's symbolism.[131] As compared

to the four other historic sites studied in this book, Mt. Rushmore has experienced the most substantial change in its interpretive materials. As a historical location created to define patriotism, Mt. Rushmore, has also experienced the most varied articulation of its definition. The interpretive materials have not offered a unitary definition of patriotism, and their parameters have largely been determined by a selective representation of U.S. history that is also politically expedient. From defining Mt. Rushmore as Gutzon Borglum, to defining this patriotic icon through its presidents during times of crisis, to understanding Mt. Rushmore as the result of individual workers' abilities, to acknowledging Native Americans' historical presence in the Black Hills, these exhibits and films illustrate the changing nature of this icon's symbolism. As Hariman and Lucaites have argued, iconic patriotic images "operate as powerful resources within public culture, not because of their fixed meaning" but instead because they offer an interpretation of patriotism that is "open to continued and varied articulation."[132]

The implications of these mutable meanings of one of America's most iconic patriotic symbols warrant consideration. In the first orientation film, Gutzon Borglum is offered as the definition of Mt. Rushmore; however, no mention is made of his Ku Klux Klan affiliation or his belief in imperialist expansionism. The second orientation film concentrated on U.S. historical hardships and presidential reflections upon them. The

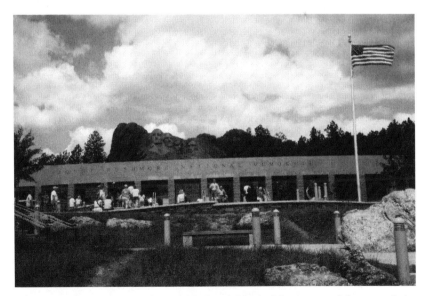

Figure 5.10 Mount Rushmore National Memorial entrance (photograph by the author, 2011)

third film reduces U.S. nationhood to the ability of individuals to blow up mountains, and the continued presence of Heritage Village and the audio tour in the Lakota language is fragile at best. In addition to this selective rendering of U.S. history, the interpretive materials reduce significant concepts regarding nation building and citizenship to individual concerns informed by political expediency, and these representations naturalize expansionism and imperialism in the name of patriotism.

There is the possibility of representing and remembering Mt. Rushmore's patriotic symbolism differently—that is, other than through a progressivist and privileged trajectory. The appearance of Heritage Village and the availability of the audio tour in the Lakota language begins to represent the more complicated and contested history of this site. And despite its shortcomings, the 1973 orientation film did focus on the harsh realities of U.S. political life and offered audiences a representation that incorporated challenges into a U.S. triumphalist historical narrative. An approach that incorporates the contested nature of Mt. Rushmore's ownership as well as addresses the evolutionary nature of patriotism and nationalism would continue these interpretive materials' role in addressing contemporary political exigencies and ensure greater historical accuracy. Constructing a national identity is complicated and consequential, and even though this particular patriotic icon is carved in stone, its orientation films and interpretive exhibits are not. As resources in the ongoing construction of public memory, these interpretive materials illustrate the mutability in defining this patriotic symbol, the significance of its seminal constituencies in sharing historical authority—and the possibility to redefine and represent its meaning.

Necessary Changes

Public memory sites and museums are generally held in high esteem as locations where cities, regions, and countries display narratives and exhibits commemorating their founders, significant accomplishments, and outstanding residents. A visit to a local, regional, or national public memory site has mostly meant a civic encounter with a sober discourse on past events deemed worthy of remembrance in a quiet atmosphere promoting reflection amid numerous reminders to NOT TOUCH any of the contents. In the late twentieth and early twenty-first centuries, a profound change took place in many museums and visitor centers in the United States. Not only were there controversies concerning particular

Exhibiting Patriotism: Creating and Contesting Interpretations of American Historic Sites by Teresa Bergman, 173–184 © 2013 Taylor & Francis. All rights reserved.

exhibits, but also many sites began to exhort visitors TO TOUCH, to listen, and to engage more critically with their contents. Staid discourses have been gradually replaced with display elements that promote learning, and sites of controversy acknowledged their mistakes and their need to expand interpretations by replacing, altering, or enlarging exhibits, which incorporated more engagement with their publics. These changes were the result of an array of fissures and cracks in the previous museological paradigm that had been acquisition- and collection-driven and that contained the attendant assumption that audiences would uniformly extend appreciation and understanding of a site's holdings. The ruptures in this museological approach to commemoration and public history came from many directions: the uniform public turned into multiple publics desiring inclusion, association, and accurate representation; academics provided new historical research challenging previous interpretations; sources of funding evaporated for public memory sites; and museums recognized the need to stay relevant to contemporary audiences in order for learning to take place. Each of these developments followed its own trajectories; however, their confluence contributed to a shift from an object-centric to a visitor-centric paradigm in exhibition development and display. The production of interpretive materials to meet these new parameters requires a profound reorienting of representations at public memory sites and an engagement with sharing historical authority.

The shift from a collection-centric exhibition to a visitor-centric exhibition paradigm in the late twentieth and early twenty-first centuries provides an excellent opportunity for a theoretical analysis of how this reorientation has been incorporated, as well as how interpretive messages may have changed as a result. The implications of redesigning interpretive exhibits in a manner that addresses contemporary visitors' lives involve revisiting traditional triumphalist historical narratives and incorporating those experiences and voices that have been marginalized, elided, or misrepresented.

Changes in interpretive materials at each of the sites studied in this book serve as illustrative texts for observing the evolution of the sites' messages and for understanding the prevailing forces at the time of their creation and revision. For each case study, the reasons for the controversies surrounding the interpretive materials were counterintuitive, and their resolutions required extended deliberative engagement between the memory sites' personnel and their multiple publics. It is intriguing to note that many of the tensions that contributed to the sites' paradigm shift can be traced to discussions concerning the original conception of the locations. At the initial Lincoln Memorial Commission meetings, sides were immediately drawn between representing the former president as emancipator or as savior of the Union. The California State Railroad Museum's

initial elision of the Chinese contribution reflected a resistance from its public to incorporating the railroad's negative social consequences. The slow response of the Daughters of the Republic of Texas to the Alamo's multiple publics led to the private organization's removal as the Alamo's sole custodians and its placement under the Texas State government. Mt. Rushmore's interpretive materials have experienced multiple iterations, but its history involving the local Native American tribes has only recently been incorporated. In the early discussions concerning the U.S.S. *Arizona*'s commemoration, there was division over whether the site should be a shrine to the dead or a monument proclaiming constant vigilance against the next attack on the United States. The fact that Admiral Nimitz regretted memorializing Pearl Harbor Day because it would celebrate a great U.S. loss speaks both to the need for distance when creating memorials and to the understanding that it is rare to achieve consensus about how to commemorate. Yet commemoration does take place, memorials and museums are built, and their changing interpretative materials denote persistent and necessary negotiations over their meanings.

The definitions of patriotism, citizenship, and nationalism have evolved at the five public memory sites studied in this book. The advantage of analyzing previous interpretive exhibits is that they illustrate normative assumptions during the time of their creation, which often includes stereotypes and complete absences. Comparing the interpretive exhibits at these popular memory sites also elucidates the use of dated or limited historical research and illustrates some of the lingering challenges of incorporating the multicultural past into iconic U.S. patriotic narratives. The various publics, who responded to the problematic interpretative materials at these five memory sites, did so at different times and for extremely different reasons. Their resolutions demanded participation from the museological triangle of museum personnel, academics, and museum visitors. This work of producing multicultural public memory exhibits is challenging and messy, and it resulted in the production of new interpretive materials. The evolution of the messages depicting citizenship, nationalism, and patriotism at sites of public memory depends on the incorporation of new historical research, the inclusion of learning opportunities in museums, and the assimilation of demands from multiple publics. Reflecting on his tenure in the National Park Service, which included enduring his share of controversies concerning public memory sites, Robert Stanton observed that "we're still a relatively young nation, trying to mature and deal with the truth and hopefully learn from the mistakes of others."[1] Each of the five sites in this book contains lessons on how a multicultural society incorporates difficult historical chapters into its nation-building narratives, as well as examples of how this work can be challenged at any time.

The U.S.S. *Arizona* Memorial is one of the public memory sites that receive a tremendous amount of comments on its interpretive materials, and it is a site that has demonstrated its ability to incorporate multiple publics' concerns into the site's development of its interpretive materials. The NPS personnel at the U.S.S. *Arizona* went to admirable lengths to include numerous voices from each part of the museological triangle in the development of the interpretive materials for the 2010 expanded visitor center. The NPS personnel conducted sustained outreach to the site's varied stakeholders and publics—renowned history professors, former NPS personnel, Pearl Harbor survivors, and representatives of Hawaiians with Japanese ancestry—to incorporate additional viewpoints in depicting the Pearl Harbor attack. The difference between the 1980 and the 2010 visitor center was the change from a narrowly interpreted site to one that locates the U.S.S. *Arizona* within the Pacific theater of WWII. One of the elements still missing from this broader interpretation is reference to the history of U.S. colonialism in the Pacific, which would disrupt a triumphalist narrative but is a crucial element in understanding the events of WWII in the Pacific and on Hawai'i in particular. The success of representing Japan and Americans of Japanese descent without relying on racist stereotypes and historical inaccuracies speaks to the ability for public sites of memory to create interpretive exhibits that depict complicated and not always positive historic events. Although Hawai'ians of Japanese descent experienced racism and their patriotism was challenged, they wanted to be positively associated with the story of Pearl Harbor. After years of outsider status in the memorial's administrative structure and in the culture at large, Japanese Americans and Hawai'ians of Japanese descent had come to view this memorial's representation as fixed. It took out-of-town visitors to alert James and Yoshi Tanabe to the problematic depiction and the need for such portrayals to be removed. Yoshi Tanabe's memorable description of the events is worth repeating—that this is "what our country is all about . . . you're going to correct it when it's wrong and support it when it's right."[2] The Tanabes participated in the development of the 2010 visitor center and were pleased with the resulting exhibits depicting Hawai'ians of Japanese descent, their contributions to WWII, and the clarification of their U.S. loyalty and patriotism. The paradigm shift at the U.S.S. *Arizona* into sharing historical authority in its exhibition development serves as an exemplar of the challenges and rewards that can result from publics demanding change at one of the most significant sites of commemoration in the United States.

The experience at the California State Railroad Museum bears similarities to the events at the U.S.S. *Arizona* Memorial in terms of the timing and the changes in how the representations of Chinese were read by Chinese Americans. The CSRM personnel recognized and attempted

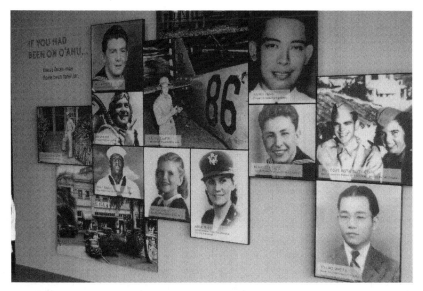

Figure C.1 "If You Had Been on Oa'hu" display exhibit in the 2010 visitor center in the World War II Valor in the Pacific National Monument (photograph by the author, 2011)

to incorporate the Chinese contribution to building California railroads into the museum but encountered resistance from the Chinese American community of the 1970s, which did not want displays of this dire episode of the Chinese in U.S. history. It took the next generation of Chinese Americans to demand that their experience with the railroads appear in the museum. The CSRM had multiple goals in its commemoration of railroads and its attendant social effects. The exhibits represented railroad technology as the definition of progress, and any messages about its negative social costs were absent. The challenge for the CSRM was to reconcile its uncritical representation of railroad technology with its human costs. The first orientation film in particular was indicative of a narrowly conceived and triumphalist interpretation of railroads' societal effects. Eventually, however, the challenge of creating exhibits that included the Chinese experience as coolie labor within a celebratory narrative of railroad history was met. Some of the lessons of inclusion that could be gathered from the museum's experience with the Chinese worker exhibit have yet to be applied to the depiction of other minority groups. The visitor-centric shift in exhibition development at the CSRM was limited and came about on account of outspoken Chinese Americans, support from locally elected officials, responsive CSRM personnel, and one particularly active Chinese American historian. One result of these events

is that Philip Choy, the Chinese historian who played the major role in these events, and the Chinese American CSRM board members now have a strong and positive connection to the museum. The CSRM's move into sharing historical authority resulted in the creation of the permanent Chinese exhibit and a new orientation film that are now sources of pride for CSRM personnel.

In some ways, pride was the ingredient that brought the visitor-centric paradigm shift in exhibition development and shared historical authority to the Alamo. The Daughters of the Republic of Texas had so successfully interpreted the Alamo as an iconic American narrative of liberation against foreign oppression that multiple publics wanted to be part of this story. The DRT's insistence on a primarily Anglo interpretation of this history excluded publics that rightly deserved inclusion. In particular, Tejanos resented their demonization, and instead wanted their historic participation positively associated with this liberation narrative. The DRT could take pride in creating and maintaining a world-class public memory site; however, their slow responsiveness to their multiple publics and resistance to change cost them exclusive control of the site. The Mexican American community in San Antonio had long lobbied for positive inclusion in the Alamo's narrative, and there had been some success in widening the Alamo's interpretation beyond the thirteen-day battle of 1836. However, consequential elements were still missing in on-site displays. The role of slavery in Texas history and in the Alamo remains practically nonexistent. Slavery is another painful chapter of U.S. history, which complicates the story of liberation at the Alamo, and its absence is inexcusable. The Alamo illustrates some of the problems of having a nongovernmental agency run a historical site of national and international interest. The future administration of this site under the auspices of the Texas Land Office, which supervises the DRT, appears to be a step in the right direction in creating an administrative structure that is able to respond in a more timely manner to the multiple publics of this extremely popular public memory site.

The shift into sharing historical authority at the Lincoln Memorial contains lessons in understanding this shift's evolution. The Lincoln Memorial experienced a visitor-centric change of its meaning with the African American civil rights demonstrations. The controversy that surrounded the Lincoln Memorial's interpretive materials was related to an outcome of that first shift in its meaning. African American civil rights organizers in the 1930s chose the Lincoln Memorial as the logical location for extending Lincoln's legacy of emancipation. This move was exceptionally successful, and in 1990 a group of high school students organized to have the representation of the civil rights movement included in the memorial. Robert Stanton remembers that the "students' views

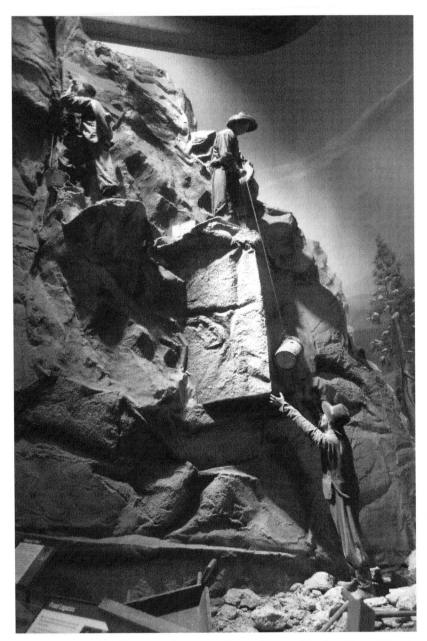

Figure C.2 The Chinese railroad worker exhibit with the Sierra Nevada background mural (photograph by the author, 2011)

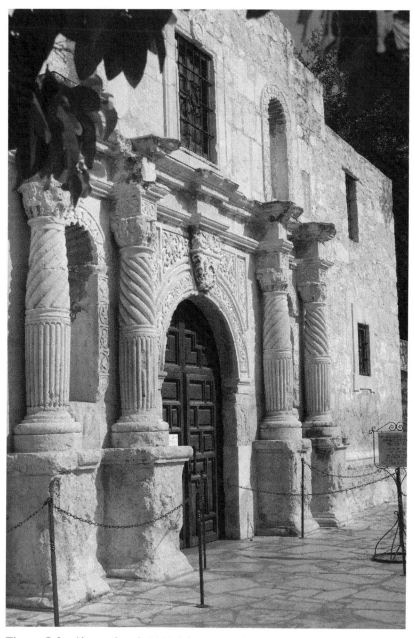

Figure C.3 Alamo chapel, 2001 (photograph by the author, 2011)

were more visionary than any of [ours]" in filling the need to interpret Lincoln's legacy to contemporary audiences.[3] The difficult lesson of shifting into sharing historical authority at the Lincoln Memorial regards the attempt to limit inclusivity by narrowly defining who deserves civil rights representation. Sharing historical and curatorial authority at the Lincoln Memorial involved multiple national publics, including civil rights groups, religious organizations, and GLBTQ communities, which illustrated the need for the continuous evaluation of visitor demands when changing interpretive materials at public memory sites.

One of the lessons to be learned from the controversy at the Lincoln Memorial is that even if administrative structures and qualified personnel are in place to address and assess requests for change, this process also needs to be transparent and open to public scrutiny. An abundance of caution must be taken with all requests and particularly those that try to limit or diminish inclusion in the development of interpretive exhibits. The events surrounding the interpretive film at the Lincoln Memorial are an example of the lofty goals of shared historical and curatorial authority encountering contemporary political pressures. This controversy at the Lincoln Memorial also illuminated issues concerning the volume of interpretive material needed at public memory sites. The Lincoln Memorial is an instance where the building, the inscriptions, the statue, and the murals are not enough for contemporary audiences to understand Lincoln's legacy. The site would benefit from additional interpretive materials to explain Henry Bacon's architectural rhetoric, Jules Guerin's murals, and Daniel Chester French's sculpture, and they would complement the *Lincoln's Legacy* exhibit. This additional interpretation would be tied to the core values of the site, which would make the memorial's meaning more accessible to contemporary audiences.

The Mount Rushmore National Memorial is the one site studied that was specifically conceived to represent nationalism, patriotism, and citizenship. Owing to Mt. Rushmore's conceptual nature, the meaning of this memorial has experienced the most variation of all five sites. The NPS realized fairly quickly that this memorial's intended patriotic meaning was dated and that interpretive materials were needed for contemporary visitors to understand the memorial's nationalistic messages. Each iteration of the site's interpretive materials reflected the changing rhetorical situations of the location as well as national political concerns. Even though Mt. Rushmore experienced the most revisions of its meaning in its interpretive materials, the local Native American tribes and their relationship to Mt. Rushmore and the Black Hills continued to be absent.

The unusual element of the shift to a visitor-centric paradigm concerning exhibition development at Mt. Rushmore was its appearance in the form of one individual rather than a community. As Mt. Rushmore's

Figure C.4 Image of a rally at the Lincoln Memorial ca. 1970s located in the *Lincoln's Legacy* exhibit, which includes a sign supporting the ERA (Equal Rights Amendment) (courtesy of the National Park Service)

first Native American supervisor, Gerard Baker instigated a set of top-down policies aimed at including local Native American tribes in the administration and interpretation of the memorial. The results included an audio tour offered in four languages, including Lakota, and the creation of Heritage Village located at the foot of Mt. Rushmore, which is staffed by Native Americans who educate visitors on Native American life in the Black Hills. Still missing from the interpretive materials is any reference to the ongoing Lakota lawsuit claiming Black Hills ownership. Although Baker believes that "Indian tribes are never going to get the Black Hills back," he does envision the need for Native Americans to gain education and to work within the NPS and thus "start managing it" themselves.[4] Baker's success in bringing a Native American representation to Mt. Rushmore is also tenuous. The local South Dakota community is divided over its appropriateness, while national and international visitors have indicated that Heritage Village provided needed historical explanation of Mt. Rushmore before Gutzon Borglum. The evolving interpretive materials at Mt. Rushmore demonstrate how the meaning of this iconic U.S. public history site continues to change, with the incorporation of its Native American public composing its latest shift. Sharing historical and curatorial authority at Mount Rushmore will require ongoing participation from its publics as well as from its NPS personnel.

Figure C.5 Aerial view of Mount Rushmore National Monument under construction, ca. 1930s (courtesy of Mount Rushmore National Memorial Archives, Mount Rushmore, SD)

Multiple publics gaining voice and representation in sites of public history will inevitably bring new tensions in the development of interpretive materials. These five case studies contain several lessons for the future of public memory sites. One lesson is that public participation *did* affect the interpretive exhibits and that messages concerning patriotism, citizenship, and nationalism *do* change. Three consequences of this lesson are, first, that public memory sites need administrative structures that ensure access and responsiveness in order to respond to their multiple publics; second, that this engagement can result in stronger ties between the sites and their publics; and third, that the interpretive materials that are more inclusive are not guaranteed to be permanent. Changes in the national political climate and funding for updates and improvements will continue to engender new interpretive directions. The definitions of patriotism, citizenship, and nationalism will also continue to evolve at public memory sites, because future visitors will be further removed from the historic events and will need new interpretive materials so they can connect "what they see, do, and feel with what they already know, understand

and acknowledge."[5] Sharing historical and curatorial authority in the development of new exhibits can help ensure the inclusion of multicultural histories, which add complexity and accuracy to U.S. narratives of liberation and triumphalism.

My hope is that the various administrations of public memory sites will recognize that challenges to their interpretive materials are necessary calls for negotiation with their publics. Successful mediation of the tensions in the museological triangle between museum personnel, museums' multiple publics, and academics will produce better interpretive materials. Institutional indifference or intransigence can be identified, and public memory site personnel can be prodded into action if communities stay involved and demand representation, and if the personnel remain responsive and possess adequate resources to respond. Historical research will continue, and new understandings of the United States' multicultural past will be written. Sites of public memory will remain dynamic locations where the definition of patriotism continues to be created and contested.

Notes

Introduction

1. In 2008, the U.S.S. *Arizona* was incorporated into the newly created NPS historical site, World War II Valor in the Pacific National Monument. For the purposes of this study, I analyze the U.S.S. *Arizona* Memorial and not the eight historic sites that are now part of this enlarged NPS site.

2. Tony Bennett, "Difference and the Logic of Culture," in *Museum Frictions*, Ivan Karp, Corrine A. Kratz, Lynn Szwaja, and Tomas Ybarro-Fausto (Eds.) (Durham, NC: Duke University Press, 2007), 67. My interest in discussing citizenship in this context primarily concerns the messages visitors encounter in their visits to these sites. I am not focusing on the legal definition of citizenship; rather I am concerned with the messages at these sites and how their changing contents inform this practice of citizenship.

3. David Lowenthal, *The Past Is a Foreign Country* (Cambridge: Cambridge University Press, 1985), 325.

4. Ivan Karp, "On Civil Society and Social Identity," in *Museums and Communities: The Politics of Public Culture*, Ivan Karp, Christine Mullen Kreamer, and Steven D. Lavine (Eds.) (Washington, D.C.: Smithsonian Institution Press, 1992), 4.

5. Another dimension of the museological paradigm shift concerns the idea of becoming a participatory museum, which Nina Simon defines as a participatory cultural institution where visitors contribute their own ideas, objects, and creative expression. These institutions encourage visitors to socialize with staff and other visitors about the evidence, objects, and ideas that are important to the institution. Nina Simon, *The Participatory Museum* (Santa Cruz,

185

CA: Museum 2.0, 2010), ii–iii. The five sites studied in this book have engaged with the paradigm shift of moving from a collection-centric to a visitor-centric orientation in terms of sharing historical and curatorial authority in the development and revision of exhibits and displays. The shift has been in a manner that both expands the historical record and addresses issues of racism, misogyny, and homophobia, but in a manner that both expands the historical record and addresses issues of racism, misogyny, and homophobia.

6. Gail Anderson, "Introduction: Reinventing the Museum," in *Reinventing the Museum: Historical and Contemporary Perspectives on the Paradigm Shift*, Gail Anderson (Ed.) (Lanham, MD: AltaMira Press, 2004), 1.

7. Stephen E. Weil, *Making Museums Matter* (Washington, D.C.: Smithsonian Books, 2002), 28–29.

8. Alan Singer, "Fairy Tale History at New York's (un)Historical Society," George Mason University's History News Network (2011), http://hnn.us/articles/fairy-tale-history-new-york%E2%80%99s-unhistorical-society.

9. Darlene Roth, "Consider This: Response to Alan Singer," HNet: Humanities and Social Science online, http://h-net.msu.edu/cgi-bin/logbrowse.pl?trx=vx&list=H-Public&month=1112&week=b&msg= iZ6k7pFtGdZeeTnZRuw8Zg.

10. George E. Hein, *Learning in the Museum* (New York: Routledge, 1998), 153.

11. John H. Falk, *Identity and the Museum Visitor Experience* (Walnut Creek, CA: Left Coast Press, 2009), 136.

12. Paul M. Johnson, "A Glossary of Political Economy Terms," www.auburn.edu/~johnspm/gloss/iron_triangles.

13. Hein, *Learning in the Museum*; Hilde Hein, *The Museum in Transition* (Washington, D.C.: Smithsonian Institution Press, 2000); Falk, *Identity and the Museum Visitor Experience*; John H. Falk and Lynn D. Dierking, *The Museum Experience* (Walnut Creek, CA: Left Coast Press, 2011); Robert R. Archibald, *A Place to Remember: Using History to Build Community* (Walnut Creek, CA: AltaMira Press, 1999); Archibald, "Community Choices, Museum Concerns," in *Museum Philosophy for the Twenty-First Century*, Hugh G. Genoways (Ed.) (Lanham, MD: AltaMira Press, 2006); Hilde Hein, *Public Art: Thinking Museums Differently* (Lanham, MD: AltaMira Press, 2006); Weil, *Making Museums Matter*; "Rethinking the Museum: An Emerging New Paradigm," in *Reinventing the Museum: Historical and Contemporary Perspectives on the Paradigm Shift*, Gail Anderson (Ed.) (Lanham, MD: AltaMira Press, 2004); Edward P. Alexander

and Mary Alexander, *Museums in Motion: An Introduction to the History and Functions of Museums* (Lanham, MD: AltaMira Press, 2008); Anderson, "Introduction: Reinventing the Museum", 1.

14. Anderson, "Introduction: Reinventing the Museum", 1.

15. Falk and Dierking, *The Museum Experience*, 154.

16. Carole Blair, Greg Dickinson, and Brian L. Ott, "Introduction: Rhetoric/Memory/Place," in *Places of Public Memory: The Rhetoric of Museums and Memorials*, Greg Dickinson, Carole Blair, and Brian L. Ott (Eds.) (Tuscaloosa: University of Alabama Press, 2010), 27. I rely on Aristotle's definition of rhetoric, which refers to recognizing the available means of persuasion.

17. Barbara Biesecker, "Rethinking the Rhetorical Situation from within the Thematic of Differànce," *Philosophy and Rhetoric* 22, no. 2 (1989); Richard E. Vatz, "The Myth of the Rhetorical Situation," *Philosophy and Rhetoric* 6, no. 3 (1973); Kathleen M. Hall Jamieson, "Generic Constraints and the Rhetorical Situation," *Philosophy and Rhetoric* 6, no. 3 (1973); Lloyd Bitzer, "The Rhetorical Situation," *Philosophy and Rhetoric* 1, no. 1 (1968).

18. Warren Leon and Roy Rosenzweig, "Introduction," in *History Museums in the United States: A Critical Assessment* (Chicago: University of Illinois Press, 1989), 17, 26.

19. One notable exception is the orientation film at North Cascades National Park, which employs a poetic format, a form of documentary "stress[ing] visual and acoustic rhythms, patterns." Bill Nichols, *Introduction to Documentary* (2nd ed.) (Bloomington: University of Indiana, 2010), 150.

20. Nichols, *Representing Reality* (Bloomington: Indiana University Press, 1991), 34. Documentary film has been a notoriously difficult area of film to define on account of its slippery relationship to issues of authenticity and objectivity. Many documentary theorists focus their research on articulating its components, analyzing its practice, and describing its effects and use in society.

21. I put the word "objectively" in quotation marks because I do not believe that any documentary form can represent its subject objectively on account of the myriad choices that documentrists have available when making films. Some of these choices include subject, narration, lighting, music, recreation, and editing. I find that the objective/subjective split is problematic because every representation is filtered through the filmmaker, and that a more beneficial approach to analyzing its messages is to abandon this artificial dichotomy. However, I use the term "objective" when critiquing documentaries because of their continuing popular perception as "objective" representations of the historic world.

22. Teresa Bergman, "Fashionably Objective: When the Politics of Epistemology Encounter Progressive Political Documentary Representation" (Ph.D. Dissertation, University of California, Davis, 2002). Although other forms of documentary incorporate elements of self-reflexivity, the expository format is not so oriented. Bill Nichols describes the additional forms of documentary as "poetic documentary which reassemble[s] fragments of the world poetically; observational documentary which eschew[s] commentary and reenactment [and] observe[s] things as they happen; participatory documentary [in which] the filmmaker interview[s] or interact[s] with subjects [and] uses archival footage to retrieve history; reflexive documentary [which] question[s] the documentary form [and] defamiliarize[s] the other modes; performative documentary [which] stress[es] the subjective aspects of a classically objective discourse." Bill Nichols, *Introduction to Documentary* (Indianapolis: Indiana University Press, 2001), 138.

23. Bruce Gronbeck, correspondence with author, September 14, 2009.

24. Robert Stanton, interview with author, April 6, 2011. Mr. Stanton served as Director of the NPS from 1997 to 2001.

25. Melissa Rachleff, "'The Fever Dream of the Amateur Historian': Ben Katchor's The Rosenbach Company: A Tragicomedy," in *Letting Go? Sharing Historical Authority in a User-Generated World*, Bill Adair, Benjamin Filene, and Laura Koloski (Eds.) (Philadelphia: Pew Center for Arts & Heritage, 2011), 260. Rachleff discusses the various roles of non-experts in the development of interpretive materials at history museums.

26. Lakota, Nakota, and Dakota Sioux compose the main local Native American tribes near the Mt. Rushmore National Memorial.

27. Gerard Baker left his position at Mt. Rushmore in 2010 to assume the position of Assistant Park Service Director for Native American Relations.

Chapter 1

1. Edwin Heathcote, *Monument Builders* (West Sussex: Academy Editions, 1999), 26.

2. Robert Hariman and John Louis Lucaites, *No Caption Needed: Iconic Photographs, Public Culture, and Liberal Democracy* (Chicago: University of Chicago Press, 2007), 10.

3. Scott Pawlowski, interview with author, Honolulu, HI, June 1, 2011.

4. AldrichPears Associates, "Visitor Center Development: USAR226 Interpretive Media Value Analysis" (National Park

Service, U.S. Department of the Interior, 2006), 4. The three NPS goals cited in order of importance for the new visitor center interpretive materials were (1) the December 7, 1941, attack on Oahu; (2) contemporary meaning making and relevance; (3) historical context. *Arizona* Memorial file, WWII-VPNM.

5. Pierre Nora, "Reasons for the Upsurge in Memory," in *The Collective Memory Reader*, Jeffrey K. Olick, Vered Vinitzky-Seroussi, and Daniel Levy (Eds.) (Oxford: Oxford University Press, 2011), 437.

6. Ibid.

7. Carole Blair, Greg Dickinson, and Brian L. Ott, "Introduction: Rhetoric/Memory/Place," in *Places of Public Memory: The Rhetoric of Museums and Memorials*, Greg Dickinson, Carole Blair, and Brian L. Ott (Eds.) (Tuscaloosa: University of Alabama Press, 2010), 18.

8. Ibid., 22.

9. Nora, "Reasons for the Upsurge in Memory," 439.

10. Robert R. Archibald, *A Place to Remember: Using History to Build Community* (Walnut Creek, CA: AltaMira Press, 1999), 171.

11. National Park Service, "Valor in the Pacific World War II Monument Brochure" (Honolulu: U.S. Department of the Interior).

12. Treena Shapiro, "*Arizona* Memorial Seen as a Dedication to Peace," *Honolulu Star-Bulletin*, A7. *Arizona* Memorial file, WWII-VPNM.

13. Unknown, "'Prisoner of War' Drew up Plans for *Arizona* Memorial," *Waikiki Beach Press*, November 30–December 3, 1981, A6. *Arizona* Memorial file, WWII-VPNM.

14. Office of Innovation and Improvement, U.S. Department of Education, "World War II Internment in Hawai'i," www.hawaii-internment.org/history-of-internment. Gail Sakurai observes that one reason for the smaller internment numbers in Hawai'i was economic considerations: "There was no mass relocation and internment in Hawai'i, where the population was one-third Japanese American. It would have been impossible to transport that many people to the mainland, and the Hawai'ian economy would have collapsed without Japanese-American workers." Gail Sakurai, *Japanese American Internment Camps*, Cornerstones of Freedom (New York: Scholastic, 2002), 17.

15. Ken Orr, "Construction of *Arizona* Memorial Begins" (1960), A1. *Arizona* Memorial file, WWII-VPNM.

16. Ibid., 1. *Arizona* Memorial file, WWII-VPNM.

17. R.V. Denenberg, "The New Visitor Center at Pearl Harbor," *The New York Times*, December 7, 1980, 19.

18. Burl Burlingame, "Battle to Keep History Alive," *Honolulu Star-Bulletin*, October 28, 2001.

19. "Pearl Harbor Tribute," *The Tuscaloosa News*, December 4, 1957. *Arizona* Memorial file, WWII-VPNM.

20. Burlingame, "Battle to Keep History Alive," *Arizona* Memorial file, WWII-VPNM.

21. Daniel Martinez, interview with author, Honolulu, HI, January 9, 2005.

22. Michael Slackman, *Remembering Pearl Harbor: The Story of the U.S.S.* Arizona *Memorial* (Honolulu: *Arizona* Memorial Museum Association, 1998), 57.

23. According to my interviews with bookstore employees in June 2011, the Elvis T-shirt is the best-selling T-shirt at the memorial.

24. Slackman, *Remembering Pearl Harbor: The Story of the U.S.S.* Arizona *Memorial*, 44.

25. National Park Service, "NPS Stats," U.S. Department of the Interior, www.nature.nps.gov/stats/viewReport.cfm.

26. Unknown, "House OKs Pearl Harbor Visitor Site," *Honolulu Star-Bulletin*, August 16, 1972. *Arizona* Memorial file, WWII-VPNM. Until 2001, visitors could hire local boats for a ride out to the memorial and a ride around Ford Island, which included views of the U.S.S. *Utah* and the U.S.S. *Missouri* Memorials. After the attacks of September 11, 2001, this activity was halted in Pearl Harbor.

27. Unknown, "*Arizona* Visitors Center Wins Award for Design," *Honolulu Star-Bulletin*, April 16, 1981, E-1.

28. John Burns went on to be the second elected governor of the state of Hawai'i and served three terms from 1962 to1974.

29. Slackman, *Remembering Pearl Harbor: The Story of the U.S.S.* Arizona *Memorial*, 58.

30. Ibid., 60.

31. Ibid.

32. Ibid., 70.

33. Denenberg, "The New Visitor Center at Pearl Harbor."

34. Lyle Nelson, "Improvements Planned for the *Arizona* Memorial," *Honolulu Star-Bulletin*, December 7, 1977.

35. The Navy harbor tugboat tour went to the U.S.S. *Arizona* Memorial and then completely around Ford Island. The talk given on the Navy tugboat was twenty-two typed double-spaced pages and included an explanation of the Navy hierarchy in Pearl Harbor, the background of World War II, a description of the attack on

each of the ships in battleship row, a description that pointed out that Japanese Americans did not spy for Japan but that Japanese nationals in Hawai'i did work as spies, comments on the possibility of future attacks, a list of the current Navy air carriers, the history of the U.S.S. *Utah* and the mothball fleet, a description of Ford Island Naval Station's history, a description of the Pearl Harbor Shipyard, a discussion of mistakes the Japanese made in their attack, and an explanation of the boat the passengers were aboard. Public Information Office Fourteenth Naval District (Pearl Harbor, Hawai'i, September 30, 1965). *Arizona* Memorial file, WWII-VPNM.

36. Daniel Martinez, interview with author, Honolulu, HI, August 3, 2011.

37. Undated document entitled "Existing Exhibits," *Arizona* Memorial file, WWII-VPNM.

38. The Navy Pearl Harbor tour talk states explicitly that "No part of the Japanese attack could be blamed upon any American-Japanese citizen." U.S. Navy, "Script of Navy Produced Film" (Honolulu: Department of Defense, United States Navy). *Arizona* Memorial file, WWII-VPNM.

39. Daniel Martinez, interview with author, Honolulu, HI, January 9, 2005.

40. "*Arizona* Memorial's New Visitor Center," *Honolulu Star-Bulletin*, December 11, 1980. *Arizona* Memorial file, WWII-VPNM.

41. W. E. Gustafson, "Pearl Harbor Center a Gem," *The Saginaw News*, September 14, 1980.

42. Gary Beito, "U.S.S. *Arizona* Memorial Museum Foundation–AMMF" (1978). *Arizona* Memorial file, WWII-VPNM.

43. Dave Forgang, "Scope of Collections for Pearl Harbor," Memorandum (Honolulu: U.S. Department of the Interior, 1978), 2. *Arizona* Memorial file, WWII-VPNM.

44. John D. Burlage, "New *Arizona* Memorial Center to Stress Quality over Quantity," *Hawai'i Navy News*, October 22, 1980. *Arizona* Memorial file, WWII-VPNM.

45. Script of Navy Produced Film, *Arizona* Memorial file, WWII-VPNM.

46. Lyle Nelson, "Pearl Harbor Movie Is Good, but Flawed," *Honolulu Star-Bulletin*, October 15, 1980, A 14.

47. Lyle Nelson, "A Better Film on Pearl Harbor," *Honolulu Star-Bulletin*, December 23, 1981.

48. Burl Burlingame, "New Dec. 7 Film Debuts at *Arizona*," *Honolulu Star-Bulletin*, December 3, 1992, A1.

49. Ibid.

50. Donald Magee, "Letter to Julie Parroni" (1990), 1. *Arizona* Memorial file, WWII-VPNM.
51. Geoffrey White, "Moving History: The Pearl Harbor Film(s)," *Positions: East Asia Cultures Critique* 5, no. 3 (1998), 724.
52. Quoted in ibid., 710.
53. Stu Glaberman, "Vets: Let's 'Remember Pearl Harbor'," *Honolulu Advertiser*, September 16, 1991.
54. Burlingame, "New Dec. 7 Film Debuts at *Arizona*," A1.
55. Associated Press, "New Pearl Harbor Film Leaves Somber Mood," *Honolulu Advertiser*, 1992, A8.
56. U.S. Navy, "Script of Navy Produced Film," *Arizona* Memorial file, WWII-VPNM.
57. Burlingame, "New Dec. 7 Film Debuts at *Arizona*," A1.
58. James and Yoshi Tanabe, "The *Arizona* Memorial Orientation Film" (Honolulu, 1999), 1.
59. Undated newspaper story. *Arizona* Memorial file, WWII-VPNM.
60. Transcribed from narration of the 1992 orientation film.
61. Geoffrey White and Jane Yi, "December 7th: Race and Nation in Wartime Documentary," in *Classic Whiteness: Race and the Hollywood Studio System*, D. Bernardi (Ed.) (Minneapolis: University of Minnesota Press, 2001), 301–38. Some of the films that John Ford directed include *Stagecoach, Grapes of Wrath, The Man Who Shot Liberty Valence*, and *The Searchers*.
62. Historic recreation has been used in documentary films since its inception. In the 1960s a group of filmmakers rejected its use and created what became known as cinéma vérité; however, other documentrists did continue using recreations in their films. Academy-award-winning documentary filmmaker Erroll Morris uses historic recreation in his films and has repeatedly defended its use in his highly acclaimed documentary, *Thin Blue Line*.
63. James and Yoshi Tanabe, December 6, 1999.
64. Gordon Prange, *At Dawn We Slept: The Untold Story of Pearl Harbor* (New York: Penguin Group, 1981), 76.
65. White and Yi, "December 7th: Race and Nation in Wartime Documentary," 334.
66. Daniel Martinez, "Review of Historical Data of Park Orientation Film" (Honolulu: National Park Service, U.S. Department of the Interior, 1998). *Arizona* Memorial file, WWII-VPNM.
67. The JACL questionnaire consisted of the following questions: "(1) What is your reaction to the film; (2) Prior to your viewing of this film, what was your understanding of the attitude of the American military toward Americans of Japanese ancestry during the war; (3) Has your understanding changed after viewing the

film; (4) Do you think the film should be modified? If so, how; (5) Were you in the military during the war; (6) Was your life directly impacted by the war (i.e., you or someone you [*sic*] or a family member served in the military during the war, you were in Hawai'i when Japan bombed Pearl Harbor, you know someone who died in the war)?" Japanese American Citizens League Honolulu Chapter, "Film Questionnaire" (Honolulu, 1999). *Arizona* Memorial file, WWII-VPNM.

68. Clayton C. Ikei, "Orientation Film U.S.S. *Arizona* Memorial" (Honolulu, 1999), 2.

69. Undated newspaper story. *Arizona* Memorial file, WWII-VPNM.

70. Ronald Takaki, August 17, 1999. *Arizona* Memorial file, WWII-VPNM.

71. Roger Daniels, "Superintendent Kathleen Billings" (Honolulu, 1999). *Arizona* Memorial file, WWII-VPNM.

72. Gail Lee Dubrow, September 30, 1999. *Arizona* Memorial file, WWII-VPNM.

73. Tanabe. U.S.S. *Arizona* Park Superintendent Kathleen Billings informed the Tanabes that it would take up to three months for the agreed-on changes to be made to the film and offered to have an NPS ranger read a disclaimer until the edited film arrived. Park historian Daniel Martinez drafted a disclaimer that read: "The film you are about to see raises the issue of possible saboteurs hidden amid Hawai'i's Japanese population. For the record, there were no acts of sabotage on December 7, 1941. The Japanese-American community remained loyal and went on to serve their country with distinction in World War II." Daniel Martinez, "Film Disclaimer" (Honolulu: National Park Service, U.S. Department of the Interior, 1999). *Arizona* Memorial file, WWII-VPNM.

74. Associated Press, "*Arizona* Memorial Film Changed after Japanese Americans Protest," *Honolulu Advertiser*, April 25, 2000. *Arizona* Memorial file, WWII-VPNM.

75. Lori Tighe, "Memorial to Correct Movie That Wrongs Japanese Americans," *Honolulu Sun Bulletin*, October 28, 1999. *Arizona* Memorial file, WWII-VPNM.

76. The three edits comprised adding the lines "The ship on which they served is now their tomb. The memorial, a shrine to their memory" and "That evening there was a band concert at Bloch Arena"; also, the number of men who died on the U.S.S. *Oklahoma* was changed from 415 to 429. U.S.S. *Arizona* Memorial Film Script provided by Daniel Martinez, *Arizona* Memorial file, WWII-VPNM.

77. White and Yi, "December 7th: Race and Nation in Wartime Documentary," 18.
78. Robert R. Archibald, "Community Choices, Museum Concerns," in *Museum Philosophy for the Twenty-First Century*, Hugh G. Genoways (Ed.) (Lanham, MD: AltaMira Press, 2006), 268.
79. Dan Nakaso, "Pearl Harbor Opens New Visitor Center for U.S.S. *Arizona*," *Honolulu Advertiser*, February 17, 2010.
80. A. Kam Napier, "Afterthoughts: War Stories, Visiting the U.S.S. *Arizona* Memorial's New Visitor Center," *Honolulu Magazine*, February 17, 2010.
81. John H. Falk and Lynn D. Dierking, *The Museum Experience* (Walnut Creek, CA: Left Coast Press, 2011), 137.
82. White, "Moving History: The Pearl Harbor Film(s)," 736.
83. The historians included Donald Goldstein (University of Pittsburg), Tetsuden Kashima (University of Washington), Paul Stillwell (naval historian), Jerry Greene (NPS historian), Harry Butowsky (NPS historian), DeSoto Brown (Bishop Museum), Ed Linenthal (Indiana University), James Horton (George Washington University), Dwight Pitcaithley (retired NPS chief historian), and Laura Hein (Northwestern University). The military reviewers included, Bob Cressman (Naval History Center), Burl Burlingame (submarine interpreter), Mike Wenger (author), Gary Miller (Hickam Air Force Base), Judy Bowman (Fort DeRussy), and Barbara Watanabe (*Go for Broke*—a non-profit group dedicated to preserving Japanese-American participation in World War II). Educators included Rosanna Fukuda (Social Studies K–12), Geoffrey White (University of Hawai'i), Yujin Yaguchi (University of Tokyo), Gary Mukai (Stanford University), Hasse Halley (Woodstock Union High School), and John Rosa (Kamehemeha High School). Pearl Harbor historic partners include the U.S.S. *Bowfin*, the U.S.S. *Missouri*, the Pacific Aviation Museum, and Tom Shaw (U.S.S. *Arizona* Memorial Museum Association). The stakeholders included Brian Niiya (Japanese American Cultural Center), Jane Kurahara (Japanese American Cultural Center), Jina and Yoshi Tanabe, Ed Ichiyama, Tom Coffman (producer/writer/director), Ted Tsukiyama (442nd, Military Intelligence Service), Jane Komeiji (local community historian), Jonathan Osorio (University of Hawai'i, Director Center for Hawai'ian Studies), John DeVirgilio (Pearl Harbor History Associates), Kerry Gershaneck (Press and Information Officer Pearl Harbor), Kendall McCreary (Hawai'i Conservation Alliance), Gary Cummins (retired NPS), Kent Bush, Dorinda Nicholson (children's author), Yoshitaka

Yamada (Consulate General of Japan), and Grace Helwen (Navy Community Relations Office).

84. Daniel Martinez, interview with author, Honolulu, HI, August 3, 2011.

85. Mike Wenger, "50% Graphics and Outline Text" (2007), 12. *Arizona* Memorial file, WWII-VPNM.

86. John W. Roberts, "USAR Exhibit" (2007). *Arizona* Memorial file, WWII-VPNM.

87. Tetsuden Kashima, "U.S.S. *Arizona* Draft 50% Design Development Package" (2007), 2. *Arizona* Memorial file, WWII-VPNM.

88. Laura Hein, "Evaluation of 'Story of the Attack on Pearl Harbor' Exhibit for the Pearl Harbor Memorial Museum" (2008). *Arizona* Memorial file, WWII-VPNM.

89. AldrichPears Associates, "USS *Arizona* Memorial Visitor Center 100% Design Development Graphics & Text Document" (National Park Service, U.S. Department of the Interior, 2008), 43. *Arizona* Memorial file, WWII-VPNM.

90. Ibid., 45.

91. Ibid., 81.

92. Ibid., 111.

93. Ibid., 155. Several of the outside reviewers had suggested including references to the heroic work of local Hawai'ians in the aftermath of the attack on Pearl Harbor.

94. Ibid., 160–62.

95. Ibid., 169. In the 1922 *Ogawa versus the United States* case, "the Supreme Court ruled that Japanese were not White and therefore could not be naturalized as U.S. citizens." Encyclopedia of Immigration, "*Ozawa v. United States* (1922)," http://immigration-online.org/225-ozawa-v-united-states-1922.html.

96. Daniel Martinez, interview with author, Honolulu, HI, August 3, 2011. The Valor in the Pacific World War II Monument exhibit describes the 442nd Regiment: "With the 100th Infantry Battalion, the 442nd Regimental Combat Team (also known as the Purple Heart Brigade) fought in Europe and became the most decorated unit of its size and length of service in U.S. Army history."

97. AldrichPears Associates, "U.S.S. *Arizona* Memorial Visitor Center 100% Design Development Graphics & Text Document," 170. Italics in the original. *Arizona* Memorial file, WWII-VPNM.

98. Ibid.

99. Hilde Hein, *Public Art: Thinking Museums Differently* (Lanham, MD: AltaMira Press, 2006), xx.

100. AldrichPears Associates, "U.S.S. *Arizona* Memorial Visitor Center 100% Design Development Graphics & Text Document," 66–70. *Arizona* Memorial file, WWII-VPNM.
101. Ibid., 106.
102. Ibid., 41.
103. Hein, "Evaluation of 'Story of the Attack on Pearl Harbor' Exhibit for the Pearl Harbor Memorial Museum."
104. Edward T. Linenthal, "Reviewer's Comments" (2008), 2.
105. White, "Moving History: The Pearl Harbor Film(s)," 738.
106. Heathcote, *Monument Builders*, 68.

Chapter 2

1. Sacramento Trust for Historical Preservation, Inc. "The California State Railroad Museum Recommendations for Planning and Development" (Sacramento, 1972), 11. Manuscript 102, CSRMDC.
2. John R. White, "The California State Railroad Museum: A Louvre for Locomotives," *Technology and Culture* 24, no. 4 (1983), 644.
3. Joseph J. Corn, "Tools, Technologies and Contexts: Interpreting the History of American Technics," in *History Museums in the United States: A Critical Assessment*, Warren Leon and Roy Rosenzweig (Eds.) (Urbana: University of Illinois Press, 1989), 255.
4. Michelle Giroux and Mark Smith, "The California State Railroad Museum," *Locomotive & Railway Preservation* (1987), 37.
5. "California State Railroad Museum: Museum of Railroad History Attendance." Manuscript 102, CSRMDC.
6. Sacramento Trust for Historical Preservation Inc., "The California State Railroad Museum Recommendations for Planning and Development" (Sacramento, 1972), 10. Manuscript 102, CSRMDC.
7. California Department of Parks and Recreation, "The Railroad Museum: An Interpretive Prospectus" (State of California Resource Agency, December, 1972), 6. Manuscript 102, CSRMDC.
8. Ibid. "The Railroad Museum: An Interpretive Prospectus [No. 2]," Manuscript 102, CSRMDC.
9. Ibid., 27. Manuscript 102, CSRMDC.
10. Sacramento Trust for Historical Preservation, "The California State Railroad Museum Recommendations for Planning and Development," 10. Manuscript 102, CSRMDC.
11. Ibid.

12. Philip P. Choy, interview with author, San Francisco, CA, February 1, 2011.

13. Sacramento Trust for Historical Preservation, "The California State Railroad Museum Recommendations for Planning and Development," 19. Manuscript 102, CSRMDC.

14. Ibid., 39.

15. Philip P. Choy, *Canton Footprints: Sacramento's Chinese Legacy* (Sacramento: Chinese Council of Sacramento, 2007), 19. Sacramento's historic Chinatown no longer exists at this location.

16. Barry Howard & Associates, Inc., "CSRM/History Building Historical and Thematic Outline: Second Revision" (1976), 16. Manuscript 102, CSRMDC.

17. Reginald Horsman, *Race and Manifest Destiny* (Cambridge: Harvard University Press, 1981), 220. "'Every portion of this continent, from the sunny south to the frozen north, will be, in a very few years, filled with industrious and thriving Anglo-Saxons,'" *Merchants' Magazine and Commercial Review*, 14 (May, 1846): 435–39, quoted in ibid., 222.

18. Theodore Judah was the individual who provided the original idea and plans for building the railroad through the Sierra Nevada mountains. He did not live long enough to see his plans come to fruition. The railroad's founders in California are often referred to as the Big Four. They were the financial backers who brought the transcontinental railroad to California: Collis Huntington, Leland Stanford, Charles Crocker, and Mark Hopkins.

19. According to my 2011 interview with Ellen Halteman, CSRM Archivist, the museum has been very successful in recent years in volunteer recruitment.

20. Mike Dunne, "Exhibit on the Track to Mend Historic Error," *The Sacramento Bee*, February 19, 1982.

21. National Park Service, "Golden Spike," National Park Service, U.S. Department of the Interior, www.nps.gov/gosp/history-culture/upload/Spikes.pdf.

22. Kathleen E. Davis, Betty J. Rivers, and Jeanette K. Schulz, "Museum of Railroad Technology. Phase 1: Historical Background" (Sacramento: California Department of Parks and Recreation, Resource Protection Division, Cultural Heritage Section, 1995), CSRMDC.

23. Philip Choy, interview with author, San Francisco, CA, February 1, 2011.

24. Wesley Yee, interview with author, January 21, 2011.

25. Philip Choy, interview with author, San Francisco, CA, February 1, 2011.

26. Chih-Chieh Chou, "Critique on the Notion of Model Minority: An Alternative Racism to Asian American?" *Asian Ethnicity* 9, no. 3 (2008), 219–20.

27. Keith Osajima, "Asian Americans as the Model Minority: An Analysis of the Popular Press Image in the 1960s and 1980s," in *A Companion to Asian American Studies*, Kent Ono (Ed.), *Companions in Cultural Studies* (Oxford: Blackwell Publishing, 2005), 217.

28. Choy, *Canton Footprints: Sacramento's Chinese Legacy*, 140.

29. Barry Howard and Associates, Inc., "CSRM/Museum of Railroad History Interpretive Narrative" (1977), 18. Manuscript 102, CSRMDC.

30. Marilyn Somerdorf, interview with author, February 2, 2011.

31. Philip Choy, interview with author, San Francisco, CA, February 1, 2011.

32. Marilyn Somerdorf, interview with author, February 2, 2011.

33. Michael Schudson, *The Good Citizen: A History of American Civic Life* (New York: The Free Press, 1998), 291.

34. Philip Choy, interview with author, San Francisco, CA, February 1, 2011.

35. California State Railroad Museum exhibits, Sacramento, CA, February 2011.

36. Philip Choy, interview with author, San Francisco, CA, February 1, 2011. The 2011 version of the Chinese exhibit was part of a 2005 NEH grant to upgrade several exhibits throughout the museum.

37. Wesley Yee, interview with author, January 21, 2011. Herbert Yee, interview with author, January 21, 2011.

38. Philip Choy, interview with author, San Francisco, CA, February 1, 2011.

39. Gary Kulik, "Designing the Past: History-Museum Exhibitions from Peale to the Present," in *History Museums in the United States: A Critical Assessment*, Warren Leon and Roy Rosenzweig (Eds.) (Urbana: University of Illinois Press, 1989), 17, 26.

40. California Department of Parks and Recreation, "The Railroad Museum: An Interpretive Prospectus," 3. Manuscript 102, CSRMDC.

41. Peterson Company, "Film Treatment of Orientation II" (1980), 7, CSRMDC.

42. Peterson Company, "Perspective for Readers" (November 3, 1978), 2. Manuscript 102, CSRMDC.

43. White, "The California State Railroad Museum: A Louvre for Locomotives," 645.

44. John H. White, Jr., quoted in Sacramento Trust for Historical Preservation, "The California State Railroad Museum Recommendations for Planning and Development," 107–8. CSRMDC.

45. Miles Orvell, *After the Machine: Visual Arts and the Erasing of Cultural Boundaries* (Jackson: University Press of Mississippi, 1995), 7.

46. Chris Miller-Marti quoted in Stephen E. Weil, "Rethinking the Museum: An Emerging New Paradigm," in *Reinventing the Museum: Historical and Contemporary Perspectives on the Paradigm Shift*, Gail Anderson (Ed.) (Lanham, MD: AltaMira Press, 2004), 76.

47. Peterson Company, "Film Treatment of Orientation II," 6. Manuscript 102, CSRMDC.

48. I use the previous screenplays for insights into the creators' ideological stances on this topic because these drafts provide "textual evidence that the speaker considered these factors when framing the message." Roderick P. Hart, *Modern Rhetorical Criticism* (2nd ed.) (Boston: Allyn & Bacon, 1997), 50.

49. A treatment is the prose description of a documentary. Treatments can become the main written document for documentaries because interviews are not scripted as they are in screenplays.

50. Peterson Company, "Film Treatment of Orientation II" (October 25, 1978), 10. Manuscript 102, CSRMDC.

51. Peterson Company, "Film Treatment of Orientation II" (1979), 14. Manuscript 102, CSRMDC.

52. Lawrence Grossberg, quoted in Carole Blair, Greg Dickinson, and Brian L. Ott, "Introduction: Rhetoric/Memory/Place," in *Places of Public Memory: The Rhetoric of Museums and Memorials*, Greg Dickinson, Carole Blair, and Brian L. Ott (Eds.) (Tuscaloosa: University of Alabama Press, 2010), 16.

53. Peterson Company, "Film Treatment of Orientation II" 3. Manuscript 102, CSRMDC.

54. Peterson Company, "Film Treatment of Orientation II" (1979), 9. Manuscript 102, CSRMDC.

55. Ibid., 7. Manuscript 102, CSRMDC.

56. Peterson Company, "Film Treatment of Orientation II" (April 10, 1979), 11, CSRMDC.

57. Stephen E. Drew, interview with author, Sacramento, CA, August 25, 2000.

58. The budget for the 1981 film was $112,500, and the budget for the 1991 film was $225,000. Senior Curator Stephen Drew adds that "we secured many donations or reduced fees for use

of props, costumes, trains operations, etc., etc., which materially expanded the onscreen value of both productions!" Stephen E. Drew, correspondence with author, August 25, 2000.

59. Michel de Certeau, *The Practice of Everyday Life* (Berkeley and Los Angeles: University of California Press, 1984), 113.

60. "Whitman's achievement was providing in his poetry and person a way of embracing that same civilization on an ideal plane where the self was not constrained by the new technologies but rather was enlarged," Miles Orvell, *The Real Thing: Imitation and Authenticity in American Culture 1880–1940* (Chapel Hill: University of North Carolina Press, 1989), 29.

61. California State Railroad Museum, "Request for Proposals for New Orientation Film" (Sacramento, CA: California State Railroad Museum, 1989), 1. Manuscript 102, CSRMDC.

62. Intrepid Productions, "Proposal for Orientation Film CSRRM" (1989), 5. Manuscript 102, CSRMDC.

63. Historic documentary photography and interviews are used in vignettes 3, 6, 9, 10, 13, 14, and 15.

64. The 1991 orientation film states that the "use of historic film footage and historic black and white stills will be permitted." California State Railroad Museum, "Request for Proposals for New Orientation Film," 4. Manuscript 102, CSRMDC.

65. Intrepid Productions, "Proposal for Orientation Film CSRRM," 2. Manuscript 102, CSRMDC.

66. According to Senior Museum Curator Stephen Drew, "the interviews with Leslie Selby and Bill Tatem were used in an attempt to bring the 1991 movie up to date. Selby had just been appointed the nation's first road foreman of engines. I understand she has since left Amtrack." Stephen E. Drew, personal communication with author, Sacramento, CA, August 25, 2000.

67. Intrepid Productions, "Evidence of a Dream Film Script," 28. Manuscript 102, CSRMDC.

68. Ibid., 15.

69. "In 1790 Congress adopted the first naturalization act, which restricted the right of citizenship to immigrant aliens who were 'free white person(s).' That statute remained essentially intact for eighty years, denying blacks, Asians, and Native Americans the right of citizenship through naturalization." James Harrison Cohen, "A Legal History of the Rights of Immigrant Aliens in the United States Under the Fourteenth Amendment to the Constitution 1870 to the Present" (Ph.D. Dissertation, New York University, 1991), 13.

70. Ibid., 18.

71. Ping Chiu, "Chinese Labor in California 1850–1880, An Economic Study" (Ph.D. Dissertation, University of Wisconsin, 1959), 166–77.

72. Ibid., 176.

73. Alexander Saxton, *The Indispensable Enemy: Labor and the Anti-Chinese Movement in California* (Berkeley and Los Angeles: University of California Press, 1971), 62.

74. Chiu, "Chinese Labor in California 1850–1880, An Economic Study," 179.

75. Saxton, *The Indispensable Enemy: Labor and the Anti-Chinese Movement in California*, 66.

76. Intrepid Productions, "Evidence of a Dream Film Script," 22. Manuscript 102, CSRMDC.

77. "In 1870 Congress amended the naturalization law to extend that right to aliens of African nativity and to persons of African descent." Cohen, "A Legal History of the Rights of Immigrant Aliens in the United States Under the Fourteenth Amendment to the Constitution 1870 to the Present," 13–14.

78. Joseph F. Wilson, *Tearing Down the Color Bar: A Documentary History and Analysis of the Brotherhood of Sleeping Car Porters* (New York: Columbia University Press, 1989), 16.

79. Ibid., 17–20.

80. Brailsford Reese Brazeal, "The Brotherhood of Sleeping Car Porters: Its Origin and Development" (Ph.D. Dissertation, Columbia University, 1946), 5.

81. Ibid., 1–2.

82. Intrepid Productions, "Film Treatment of Orientation II" (1990), 1. Manuscript 102, CSRMDC.

83. Thomas W. Benson and Carolyn Anderson, *Reality Fictions: The Films of Frederick Wiseman* (Carbondale: Southern Illinois University Press, 1989), 42.

84. Intrepid Productions, "Film Treatment of Orientation II," 21. Manuscript 102, CSRMDC.

85. Southern Pacific Company, "Company Betters Living Conditions for Employees on Desert Sections," in *The Bulletin* (November 1, 1915), 1.

86. Ibid.

87. Ivan Karp, "On Civil Society and Social Identity," in *Museums and Communities: The Politics of Public Culture*, Ivan Karp, Christine Mullen Kreamer, and Steven D. Lavine (Eds.) (Washington, D.C.: Smithsonian Institution Press, 1992), 15.

88. Intrepid Productions, "Film Treatment of Orientation II," 16. Manuscript 102, CSRMDC.

89. Michel Foucault, *Power/Knowledge: Selected Interviews &
 Other Writings 1972–1977*, Colin Gordon, Leo Marshall, John
 Mepham, and Kate Soper (Trans.) (New York: Pantheon Books,
 1972), 90.

Chapter 3

1. *Alamo—Providing for the Purchase, Care and Preservation of*,
 S.H. B. 1. DRTLA.
2. Scott Huddleston, "Alamo Contract Approved between DRT,
 Land Office," *San Antonio Express-News*, December 17, 2011.
3. In terms of visitation to NPS memorials and monuments, only
 the Korean War Veterans Memorial, Statue of Liberty, Vietnam
 Veterans Memorial, Lincoln Memorial, and the National World
 War II Memorial outrank the Alamo. National Park Service. "NPS
 Stats," June 27, 2007, www.nature.nps.gov/stats/park.cfm.
 According to the Governor's office, "the Alamo is the number
 one attraction in Texas," San Antonio Chamber of Commerce,
 "Visitor Information," June 27, 2007, http://sachamber.org/
 cwt/external/wcpages/index.aspx. Obtaining accurate num-
 bers of attendance is difficult because there is no fee or ticketing
 needed to enter the site. From 2000 through 2011, I have read
 that the number of tourists ranged from 2.5 million to 4 mil-
 lion annually. I use the 4 million estimate because, in 2010, both
 Senator Van de Putte and Alamo historian Bruce Winders used
 that number repeatedly in public statements.
4. Senator Leticia Van de Putte, interview with author, September
 6, 2011.
5. James McKinley, "Critics Accuse Group of a Serious Texas Sin:
 Forgetting the Alamo," *The New York Times*, December 4, 2010.
6. Randell G. Tarin, "The History of The Alamo & The Texas
 Revolution," DeWitt Museum, www.tamu.edu/faculty/ccbn/
 dewitt/adp/history/mission_period/valero/vframe.html. The
 Alamo was originally "a failed mission known as San Francisco
 Solano," and it "was relocated from Coahuila to the San
 Antonio River," where it was renamed Mission San Antonio de
 Valero. National Park Service, "San Antonio Missions–Their
 Beginnings," U.S. Department of the Interior, www.nps.gov/
 saan/historyculture/history2.htm.
7. National Park Service, "San Antonio Missions" (San Antonio:
 U.S. Department of the Interior, 2009).
8. Ibid.
9. Ibid.

10. Lester G. Bugbee, "Notes and Fragments," *The Quarterly of the Texas State Historical Association,* 2 (July, 1898–April, 1899), 246.

11. Randell G. Tarin, "Alamo de Parras," John Bryant Robert Durhan (Ed.), *The Second Flying Company of Alamo de Parras* (2007), www.tamu.edu/faculty/ccbn/dewitt/adp/history/hispanic_period/pframe.html.

12. Richard R. Flores, *Remembering the Alamo: Memory, Modernity and the Master Symbol* (Austin: University of Texas Press, 2002), 23.

13. Ibid., 31.

14. Daughters of the Republic of Texas, *The Wall of History* (San Antonio: Daughters of the Republic of Texas, 2001).

15. Adina de Zavala, "History and Legends of the Alamo and Other Missions in and around San Antonio," Richard Flores (Ed.) (Houston: Arte Publico Press, 1996), vii.

16. *Alamo—Providing for the Purchase, Care, and Preservation of* (January 25, 1905). DRTLA.

17. *The Story of the Alamo: Thirteen Fateful Days in 1836,* The Daughters of the Republic of Texas brochure, March, 2007.

18. *Alamo—Providing for the Purchase, Care and Preservation of.*

19. *Constitution and By-Laws of the Daughters of the Republic of Texas 1892.* Article VI, Section I, p. 7. DRTLA.

20. *Constitution and By-Laws of the DRT of Texas 1892,* Article II, Section I, pp. 3–4, DRTLA.

21. Madge Roberts, interview with author, San Antonio, TX, July 10, 2006.

22. During my research I found that the DRT was able to keep the Alamo open and running during the Depression without going into debt. Former DRT President Madge Roberts explained that "there was one time when there was not enough money to pay the salary of the custodian, and the DRT members stepped up.... They would bring their own gardeners in here to take care of the gardens. They would bring in their own maids to clean up." Madge Roberts, interview with author, San Antonio, TX, July 10, 2006.

23. Barbara J. Howe, "Women in Historic Preservation: The Legacy of Ann Pamela Cunningham," *The Public Historian* 12, no. 1 (1990), 32.

24. Ibid.

25. See Richard Flores' introduction in Adina de Zavala's *History and Legends of the Alamo and Other Missions in and around San Antonio,* pp. xii–xxv, for a description of Zavala's work to save

the Alamo grounds and her subsequent dismissal from the DRT when she tried to install herself as the administrator of the Alamo site.

26. Holly Beachley Brear, "We Run the Alamo, You Don't," in *Where These Memories Grow: History, Memory, and Southern Identity*, W. Fitzhugh Brundage (Ed.) (Chapel Hill: University of North Carolina Press, 2000), 301.

27. Madge Roberts, interview with author, San Antonio, TX, July 10, 2006.

28. *Alamo—Providing for the Purchase, Care, and Preservation of.* Bruce Winders defended the DRT's interpretation of the Alamo in a letter to the editor in the National Park Service's Cultural Resource Management publication. Richard Bruce Winders (Ed.), "A Response to 'The Alamo's Selected Past,'" National Park Service (2000), 31.

29. *Alamo—Providing for the Purchase, Care, and Preservation of.* DRTLA.

30. The Alamo's historian, Bruce Winders, described the mythic tale of the battle of the Alamo as the "traditional" narrative, which is a term I adopted for describing this particular rendition of the Alamo story. Bruce Winders, interview with author, San Antonio, TX, June 26, 2006.

31. Holly Beachley Brear, *Inherit the Alamo: Myth and Ritual at an American Shrine* (Austin: University of Texas Press, 1995), 23.

32. Ibid., 24–31.

33. Roland Barthes, *Mythologies* (New York: Hill and Wang, 1972), 25.

34. Lon Tinkle, *13 Days to Glory* (College Station: Texas A&M University Press, 1958), 69.

35. Pierre Nora, *Realms of Memory*, 3 vols., vol. 1 (New York: Columbia University Press, 1992), xvii.

36. Richard Bruce Winders, "The Alamo Audio Tour" (San Antonio, Texas).

37. Greg Thompson, "Alamo Buffs Gather Fascination Extends to Europeans," *San Antonio Express-News*, March 6, 1980. DRTLA.

38. Brear, *Inherit the Alamo: Myth and Ritual at an American Shrine*, 107.

39. Rudi Rodriguez, interview with author, San Antonio, TX, August 10, 2011. Alamo historian Bruce Winders provides this definition of Tejano: "The Spanish missionaries and soldiers were accompanied by Tlaxcalans, members of a band allied to the king since the time of Cortés. Intermarriage between the Spaniards, Tlaxcalans, and Coahuiltecans produced a regional

population called *Tejanos* (Spanish for person from Texas)."
Bruce Winders, *Sacrificed at the Alamo: Tragedy and Triumph
in the Texas Revolution* (Abilene, TX: McMurray University,
2004), 21–22.

40. Bruce Winders, interview with author, San Antonio, TX,
August 10, 2011. Curators at both the California State Railroad
Museum and the U.S.S. *Arizona* Memorial have warehouses full
of donated historical items and regularly turn down offers of
more donations on account of the lack of display and storage
space.

41. Most historical documentation refers to the "chapel" on the
Alamo mission site. The DRT literature refers to the chapel as
the "Shrine." I refer to this building as the chapel.

42. "City of San Antonio official website," City of San Antonio,
www.sanantonio.gov.

43. During my 2011 visit, the DRT had agreed to allow a commercial
photography firm to set up directly next to the chapel door. The
photographers aggressively offered to take visitors' pictures next
to the iconic building, which resulted in considerable confusion.
Many visitors mistook their offer as mandatory, not realizing that
it was an optional commercial enterprise that had nothing to do
with gaining entrance to the chapel.

44. Brear, *Inherit the Alamo: Myth and Ritual at an American
Shrine*, 23–44.

45. Madge Roberts, interview with the author, San Antonio, TX,
July 10, 2006.

46. Associated Press, "Discovery of Frescoes Delights Alamo
Historians," *Shreveport Times*, November 26, 2000. Historic
Sites: Alamo: Conservation and Restoration File, DRTLA.

47. Bruce Winders, interview with the author, San Antonio, TX,
August 10, 2011.

48. During my visit in May, 2011, there was a glass exhibition case
that contained a statue of Saint Francis near the front of the
chapel.

49. William G. Christ, Harry W. Haines, and Robert Huesca,
"Remember the Alamo: Late-Night Newscasts in San
Antonio, Texas," in *The Electronic Election: Perspectives on
the 1996 Campaign Communication*, Lynda Lee and Diane
Bystron (Eds.) (Mahway, NJ: Lawrence Erlbaum Associates,
1999), 43.

50. Donald R. Morris, "Alamo Disappointing to Visit: Silence Should
Replace Irrelevant Hodgepodge," *Houston Post*, 1973. Historic
Sites: San Antonio: Alamo Clippings 1970–1980, DRTLA.

51. During my visits to the Alamo, I did not notice the inlaid stones until a park docent pointed them out. After repeated visits to the Alamo, I found that I was best able to orient myself in terms of the battle and the mission's layout only after visiting the four other NPS Missions San Antonio, whose original footprints are largely intact.

52. Voluntary learning is also described as free-choice learning which is "nonlinear, is personally motivated, and involves considerable choice on the part of the learner as to what to learn, as well as where and when to participate in learning." John H. Falk, and Lynn D. Dierking, *Learning from Museums: Visitor Experiences and the Making of Meaning* (Lanham, MD: AltaMira Press, 2000), 13.

53. Morris, "Alamo Disappointing to Visit: Silence Should Replace Irrelevant Hodgepodge." DRTLA.

54. Ibid. Alamo Clippings 1970–1980, DRTLA.

55. "New Sound At Alamo—Bell to Peal," *San Antonio Light*, December 5, 1962, 41. Alamo Clippings: Alamo Bells, DRTLA.

56. "When's the Last Time YOU Visited the Alamo?" *San Antonio Express-News*, June 26, 1963. Historic Sites: San Antonio: Alamo Clippings 1960–1970, DRTLA.

57. Renwicke Cary, "Around the Plaza," *The Light*, 1964, 13. Historic Sites: Alamo Clippings 1960–1970, DRTLA.

58. The other objects in the case include an archeological exhibit of Mexican army artifacts that consists of an exploding shell cannonball and its wooden wick, Bowie knife, canister shot for cannon, metal buckle and musket parts; a collection of modern reproductions of Bowie knives, the buckskin coat belonging to Governor Reynolds (governor during 1857–1859), his pistol, and a primitive Bowie knife.

59. This film was a videotaped version of an audio-slide show that began screening at the Alamo in 1973. This slide show was written by T. R. Fehrenbach, who has numerous historical publications and is probably most known for his best-selling book, *Lone Star: A History of Texas and Texans*. Fehrenbach describes himself as a writer and not a historian, and he is also a member of the Texas Cavaliers. He remembers that he was brought onto the audio/slide project initially because, in his words, the DRT "had one of those ladies write it but it was awful," and he remembers the he did not get paid for it—"It was pro bono"—and he wrote only the one draft of the piece. Theodore R. Fehrenbach, interview with author, San Antonio, TX, June 29, 2006.

60. As of December 2011, 63.2% of the San Antonio's population identified as Hispanic. San Antonio Chamber of Commerce, December 27, 2011, www.sachamber.org/index_flash.php.

61. Flores, *Remembering the Alamo: Memory, Modernity, and the Master Symbol*; David Montejano, *Anglos and Mexicans in the Making of Texas, 1836–1986* (Austin: University of Texas Press, 1987); Brear, "We Run the Alamo, You Don't."

62. Mike Wallace, *Mickey Mouse History and Other Essays on American Memory* (Philadelphia: Temple University Press, 1996), 26.

63. Flores, *Remembering the Alamo: Memory, Modernity, and the Master Symbol*, 152.

64. T. R. Fehrenbach, the writer of the film, reinforces the significance of the Alamo as a place of liberation in the many public speeches he gives regarding the Alamo: "One need not be Texan or American to honor the cause of the Alamo, which was liberty, the liberty of free men who refused to bend the knee to tyranny, to stand with those who died in the Alamo." T. R. Fehrenbach, transcript of speech delivered in 1986, in possession of author.

65. All unidentified quotes are taken from the narration of the two orientation films.

66. Coahuiltecan Indians lived in the area of Texas currently known as San Antonio. Richard Bruce Winders, *Sacrificed at the Alamo: Tragedy and Triumph in the Texas Revolution* (Abilene, TX: McMurray University, 2004), 21.

67. Winthrop D. Jordan and Leon F. Litwack, *The United States* (2nd ed.) (Englewood Cliffs, NJ: Prentice Hall, 1991), 313–14.

68. Michael C. Meyer, William L. Sherman, and Susan Deeds, *The Course of Mexican History* (New York: Oxford University Press, 1995), 335, quoted in Flores, *Remembering the Alamo: Memory, Modernity, and the Master Symbol*, 22.

69. Will Fowler, *Santa Anna of Mexico* (Lincoln: University of Nebraska Press, 2007), 162.

70. Ibid., 163.

71. Winders, *Sacrificed at the Alamo: Tragedy and Triumph in the Texas Revolution*.

72. Winders, *Crisis in the Southwest: The United States, Mexico, and the Struggle over Texas* (Wilmington, DE: Scholarly Resources, Inc., 2002), 9.

73. Flores, *Remembering the Alamo: Memory, Modernity, and the Master Symbol*, 23. Bruce Winders also notes that there was a serious misunderstanding regarding land ownership between the American immigrants and the Mexican government. Americans

thought that the Mexican land was for sale, whereas Mexico was colonizing the land under *empresarios,* which was a legal relationship that defined land grants as the "right to occupy" the land and that "implied a close and continuing relationship between the state and the recipient," not as individual ownership. Winders, *Crisis in the Southwest: The United States, Mexico, and the Struggle over Texas,* 8.

74. Flores, *Remembering the Alamo: Memory, Modernity, and the Master Symbol,* 145.

75. Holly Beachley Brear, "The Alamo's Selected Past," National Park Service, crm.cr.nps.gov/archive/22-8/22-08-5.pdf.

76. Flores, *Remembering the Alamo: Memory, Modernity, and the Master Symbol;* Montejano, *Anglos, and Mexicans in the Making of Texas, 1836–1986.*

77. Lieutenant Commander David Nava, "Alamo Defenders," *The Stars and Stripes,* May 17, 1984.

78. Brear, "We Run the Alamo, You Don't," 310.

79. Daughters of the Republic of Texas, *The Wall of History,* 14.

80. Hispanic Heritage Center of Texas, "Legacy, Heritage, History," Hispanic Heritage Center of Texas (San Antonio).

81. Rudi Rodriguez, interview with author, San Antonio, TX, August 10, 2011.

82. Hispanic Heritage Center of Texas, "Interim Offices for The Hispanic Heritage Center of Texas" (San Antonio, Texas).

83. Scott Huddleston, "State Wants Alamo to Have Director," *San Antonio Express-News,* September 1, 2011.

84. Walter Rundell, Jr., "Alamo Day (March 6)," in *Holidays: Days of Significance for All Americans,* Trevor Nevitt Dupuy (Ed.) (New York: Franklin Watts, Inc., 1965), 38. Historic Sites: San Antonio: Alamo Clippings 1960–1970, DRTLA.

85. "Patriotism Theme of Rally," *San Antonio Light,* November 7, 1965. Historic Sites: San Antonio: Alamo Clippings 1960–1970, DRTLA.

86. "300 Rally at Alamo to Support War," *San Antonio Light,* May 21, 1969. Historic Sites: San Antonio: Alamo Clippings 1960–1970, DRTLA.

87. "Protestors March on Alamo," *San Antonio Light,* August 8, 1971. Historic Sites: San Antonio: Alamo Clippings 1970–1980, DRTLA.

88. Jim Michaels, "They Remembered MIAs at the Alamo," *San Antonio Light,* October 3, 1985. Historic Sites: San Antonio: Alamo Clippings 1980–1985, DRTLA.

89. Reed Harp, "Irish Remember the Alamo," *San Antonio News,* March 18, 1983. Historic Sites: San Antonio: Alamo Clippings 1980–1985, DRTLA.

90. Sir Knight Francis A. White, "Remember the Alamo!," *Knight Templar*, February 1981. Historic Sites: San Antonio: Alamo Clippings 1980–1985, DRTLA.

91. Amy Dorsett, "100 Years of Care: Renovated Long Barrack Will Reopen Today as Alamo's Custodians Mark the Occasion," *San Antonio Express-News*, October 5, 2005. Historic Sites: San Antonio: Long Barracks Museum, DRTLA.

92. Dora Guerra, "The Alamo: A Story Bigger Than Texas (review)," *The Southwest Historical Review* 110, no. 3 (2007), 438.

93. Richard Bruce Winders and Lonn Taylor, "The Alamo: A Story Bigger Than Texas Script for Long Barrack" (San Antonio, TX, 2005). Long Barrack planning documents provided to author by Bruce Winders, Alamo Historian, San Antonio, TX.

94. Ibid. Long Barrack planning document provided to author by Bruce Winders, Alamo Historian, San Antonio, TX.

95. Ibid. Long Barrack planning document provided to author by Bruce Winders, Alamo Historian, San Antonio, TX.

96. Mexico's laws regarding slavery in Tejas and Cohuila vacillated during the years of 1823 through 1830. After the Mexican revolution, slavery was ended, but the 1824 Mexican constitution did not prohibit slavery. In 1827, the Cohuila and Tejas state constitution again outlawed slavery, but in 1828 the governor allowed the practice of "peonage" whereby "human property [are] declared indentured servants." In 1829, President Vicente Guererro "announced the emancipation of all slaves" while he "exempted Texas from the emancipation decree." In 1830, Mexico passed another law ending the "further importation of slaves." Winders, *Crisis in the Southwest: The United States, Mexico, and the Struggle over Texas*, 79–81.

97. Winders and Taylor, "The Alamo: A Story Bigger Than Texas Script for Long Barrack."

98. Jan Jarboe Russell, "It's Time to Take Back the Alamo from the DRT," *San Antonio Express-News*, December 5, 2009.

99. Scott Huddleston, "State is Reassessing DRT's Role at Alamo: Hearing to Delve into Alamo's Condition, Challenges Ahead," *San Antonio Express-News*, March 4, 2011.

100. Jan Jarboe Russell, "Stage Set for the Next Battle for the Alamo," *San Antonio Express-News*, January 2, 2011.

101. Express-News Editorial Board, "Transparency Would Help DRT, Alamo," *San Antonio Express-News*, June 11, 2011.

102. Scott Huddleston, "Pact Could Be New Era for Alamo," *San Antonio Express-News*, December 16, 2011.

103. Ibid.

104. Ibid.

Chapter 4

1. In 1939, Marian Anderson was hired by the Daughters of the American Revolution to sing in their Constitution Hall in Washington, D.C., but when they discovered that Anderson was black, they refused to let her perform. Complaints were made to President and Eleanor Roosevelt, and Anderson's performance was moved to the steps of the Lincoln Memorial.

2. Scott A. Sandage, "A Marble House Divided: The Lincoln Memorial, the Civil Rights Movement, and the Politics of Memory, 1939–1963," *Journal of American History* 80, no. 1 (1993), 135–67; Kirk Savage, *Monument Wars: Washington, D.C., the National Mall, and the Transformation of the Memorial Landscape* (Berkeley and Los Angeles: University of California Press, 2009); Barry Schwartz, *Abraham Lincoln and the Forge of National Memory* (Chicago: University of Chicago Press, 2000).

3. The orientation film is discussed in detail later in the chapter.

4. In many national parks, orientation film screenings are high-lighted in brochures, park personnel suggest that visitors view the film, and the actual architecture directs foot traffic into the orientation film theater. (Mt. Rushmore National Memorial, U.S.S. *Arizona* Memorial, and Alcatraz Island are just a few of the national parks that employ these practices with their orientation films.) The NPS Lincoln Memorial brochure that is freely distributed on site contains no mention of this exhibit and refers to the basement only under the heading of "Visiting the Memorial," where it is described as: "For visitors with disabilities, restrooms and chamber access are in the lower level." National Park Service, "Lincoln Memorial" (Washington, D.C.: U.S. Department of the Interior, 2004).

5. Liza Porteus, "Conservative Groups Blast Lincoln Memorial Video," *Fox News*, February 7, 2003.

6. Ibid.

7. Undated two-page memorandum, "Report and Recommendations on Lincoln Memorial Film," addressed to Director from the Acting Associate Director, Cultural Resources. PEERF.

8. Ibid.

9. "Since 1971, Close Up has provided programs that are safe, fun, and known for their impact on student attitudes. Our programs are exciting for teachers and students alike, as we help them explore the inner workings of Washington, meet with elected officials, policy experts and media, and live and learn with peers from across the country. As our 650,000 alums attest, Close

Up is an experience of a lifetime." See Close Up website, www. closeup.org/Teachers/TeachersChoose.aspx, accessed June 10, 2009.

10. Marc Morano, "Controversial Lincoln Video Was Part of Student Project," *CNSNews.com*, February 11, 2003. PEERF.

11. "Letter to Robert Stanton, the Regional Director of the National Capitol Region," signed by twenty-four members of Congress, requesting an exhibit in the ground level of the Lincoln Memorial. The list of signatories to the letter includes Congressional members Bruce Vento, John Lewis, Cardiss Collins, Ronald Dellums, George Brown, Ben Nighthorse Campbell, John Miller, Jim Jontz, Morris Udall, Martin Frost, Charlie Rose, Frank Horton, Edolphus Towns, Stephen Solarz, Martin Lancaster, and Jim McDermott (1989). PEERF.

12. Hank Burchard, "Making Their Mark at the Memorial," *The Washington Post* 1994. The high school students were so enthusiastic about this project that they wanted to be part of the design team for the exhibit: "Next thing you knew, 17 students from all over the country—mobilized in a teacher-assisted networking campaign—were hunched over the drawing tables at the Park Service's national design center in Harpers Ferry, W. Va. The professionals handled the technical specifications and gave advice, but the design was essentially done by the youngsters over the course of four days." Ibid.

13. Undated two-page memorandum entitled "Report and Recommendations on Lincoln Memorial Film," addressed to Director, from the Acting Associate Director, Cultural Resources. PEERF.

14. Sandage, "A Marble House Divided: The Lincoln Memorial, the Civil Rights Movement, and the Politics of Memory, 1939–1963," 166.

15. "On August 22, 2003, the National Park Service will dedicate an inscription that commemorates the location where Dr. Martin Luther King, Jr., delivered the historically significant I Have A Dream Speech. . . . The commemorative work was authorized on October 27, 2000, in the 106th Congress with the enactment of Public Law 106–365, which provided that the Secretary of the Interior shall install in the area of the Lincoln Memorial in the District of Columbia a suitable plaque to commemorate the speech of Martin Luther King, Jr., known as the 'I Have a Dream Speech.'" The National Park Service, "Dedication Program," 2003, provided by Glenn DeMarr, National Capital Region Office, National Park Service.

16. V. William Balthrop, Carole Blair, and Neil Michel, "The Presence of the Present: Hijacking 'The Good War,'" *Western Journal of Communication*, no. 74 (2010), 170–207; David Lowenthal, *The Past Is a Foreign Country* (Cambridge: Cambridge University Press, 1985); Bernard J. Armada, "Memorial Agon: An Interpretive Tour of the National Civil Rights Museum," *Southern Communication Journal* 63 (1998), 235–43; Roy Rosenzweig and David Thelen, *The Presence of the Past: Popular Uses of History in American Life* (New York: Columbia Press University, 1998); M. Hasian, Jr., "Remembering and Forgetting the 'Final Solution'; A Rhetorical Pilgrimage through the U.S. Holocaust Museum," *Critical Studies in Media Communication*, no. 21 (2004), 64–92; Greg Dickinson, Brian Ott, and Eric Aoki, "Spaces of Remembering and Forgetting: The Reverent Eye/I at the Plains Indian Museum," *Communication and Critical/Cultural Studies* 3, no. 1 (2006), 27–47; Vicky Gallagher, "Memory and Reconciliation in the Birmingham Civil Rights Institute," *Rhetoric and Public Affairs* 2 (1999), 303–20; John Bodnar, *Remaking America: Public Memory, Commemoration, and Patriotism in the Twentieth Century* (Princeton, NJ: Princeton University Press, 1992); Barbara Biesecker, "Renovating the National Imaginary: A Prolegomenon on Contemporary Paregoric Rhetoric," in *Framing Public Memory*, Kendall R. Phillips (Ed.) (Tuscaloosa: University of Alabama Press, 2004), 212–47.

17. Communication scholars V. William Balthrop, Carole Blair, and Neil Michel cite the need to assess "the ethical and political legitimacy of particular renditions of the past in the present." Balthrop, Blair, and Michel, "The Presence of the Present: Hijacking 'The Good War,'" 3.

18. Hilde Hein, *Public Art: Thinking Museums Differently* (Lanham, MD: AltaMira Press, 2006), xx.

19. Bill Adair, Benjamin Filene, and Laura Koloski (Eds.), *Letting Go?* (Philadelphia: The Pew Center for the Arts & Heritage, 2011), 11.

20. Ibid., 12.

21. Robert R. Archibald, *A Place to Remember: Using History to Build Community* (Walnut Creek, CA: AltaMira Press, 1999), 170.

22. Ibid., 171.

23. D. H. Burnham, "The Lincoln Memorial Commission" (Washington, D.C., 1912), 3. Box 94, Record Group 42, Records of the Office of Public Buildings and Public Parks of the National Capital, Records of the Lincoln Memorial, File Folder 1921–1931. NARA.

24. Savage, *Monument Wars: Washington, D.C., the National Mall, and the Transformation of the Memorial Landscape*, 82.

25. Christopher A. Thomas, *The Lincoln Memorial & American Life* (Princeton, NJ: Princeton University Press, 2002), 92.

26. Savage, *Monument Wars: Washington, D.C., the National Mall, and the Transformation of the Memorial Landscape*, 218.

27. Lincoln Memorial Commission, "Outline of History of the Construction of the Lincoln Memorial with special reference to the engineer and construction features of that undertaking," (Lincoln Memorial Commission, n.d.). Box 2, Record Group 42, Records of the Office of Public Buildings and Public Parks of the National Capital, Records of the Lincoln Memorial, Miscellaneous Records 1911–1927. NARA.

28. Lincoln Monument Association, "Lincoln Monument Association" (1867). Box 2, Record Group 42, Records of the Office of Public Buildings and Public Parks of the National Capital, Records of the Lincoln Memorial, Miscellaneous Records 1911–1927. NARA.

29. Thomas, *The Lincoln Memorial & American Life*, 9. Professor Barry Schwartz observes how the challenge to represent Lincoln reflected the United States' changing role in international relations: "The burden of Lincoln's changing image was to help Americans express awareness of their new world role and necessity of their performing it within the limits of values transmitted from the past." Schwartz, *Abraham Lincoln and the Forge of National Memory*, 257.

30. Issues that caused controversy in the planning of the Lincoln Memorial included whether the National Mall should be extended by filling in the land up to the Potomac River; whether the use of Greek architecture would be perceived as too European; whether the choice of Yule marble from Colorado would be upsetting, because multiple states competed to supply the building materials; whether allegorical definitions of each species of dogwood trees, box bushes, English Elms should affect planting choices; and whether the reflecting pool should include a cruciform with cross arms. The Lincoln Memorial Commission, "Outline of History of the Construction of the Lincoln Memorial with special reference to the engineer and construction features of that undertaking" (Lincoln Memorial Commission, n.d.) Box 2, Record Group 42, Records of the Office of Public Buildings and Public Parks of the National Capital, Records of the Lincoln Memorial, Miscellaneous Records 1911–1927. NARA.

31. Shelby M. Cullom, "Letter to Henry Bacon" (1913). Special Collections & Archives, Henry Bacon Papers, 1866–1924, Box 4, File 1913. WUL.

32. Henry Bacon, "Letter to Shelby M. Cullom" (1912), 2. Special Collections & Archives, Henry Bacon Papers, 1866–1924, Box 4, File 1912. WUL.

33. Ibid., 3.

34. Savage, *Monument Wars: Washington, D.C., the National Mall, and the Transformation of the Memorial Landscape*, 223.

35. Shelby Cullom, "Letter to Henry Bacon" (1912). Special Collections & Archives, Henry Bacon Papers, 1866–1924, Box 4, File 1912. WUL.

36. Electus C. Litchfield, "Letter to Henry Bacon" (1921). Special Collections & Archives, Henry Bacon Papers, 1866–1924, Box 4, File 1921. WUL.

37. Royal Cortissoz, "The Architect," undated. Special Collections & Archives, Henry Bacon Papers, 1866–1924, Box 6, File Clippings & Other Minor Items. WUL.

38. Albert Boime, *The Unveiling of the National Icons: A Plea for Patriotic Iconoclasm in a Nationalist Era* (Cambridge: Cambridge University Press, 1998), 288.

39. Vincent Scully, *Architecture: The Natural and the Manmade* (New York: St. Martin's Press, 1991), 108–09.

40. In a letter to Senator Shelby Cullom, Bacon wrote: "I must go to Greece to study some of the Greek details which I have in mind before I make the final detail drawings for the contractors." Henry Bacon, "Letter to Senator Shelby Cullom" (1916). Special Collections & Archives, Henry Bacon Papers, 1866–1924, File 1916, Box 4. WUL.

41. Daniel Chester French, "Letter to Henry Bacon" (1922). Special Collections & Archives, Henry Bacon Papers, 1866–1924, Box 4, File 1922. WUL.

42. Royal Cortissoz, "Letter to Henry Bacon" (1919). Special Collections & Archives, Henry Bacon Papers, 1866–1924, File 1919, Box 4. WUL.

43. Royal Cortissoz, "Letter to Henry Bacon" (1922), 1. Special Collections & Archives, Henry Bacon Papers, 1866–1924, File 1922, Box 4. WUL. President Taft wanted to change the third line in the inscription about the Lincoln Statue from "For whom he saved the Union" to "For which he saved the Union." Cortissoz strongly disagreed with the suggested revision and successfully resisted Taft's suggested change for the inscription. Ibid.

44. "Jules Guerin's Mural Work for the Lincoln Memorial Ready," *The Sun*, February 16, 1919. Box 7, Record Group 42, Records of the Office of Public Buildings and Public Parks of the National Capital, Records of the Lincoln Memorial, Classified Records of the Executive and Disbursing Officer 1911–1924. File Folder D1, Entry 66. NARA.

45. Boime, *The Unveiling of the National Icons: A Plea for Patriotic Iconoclasm in a Nationalist Era*, 288.

46. National Park Service, "Lincoln Memorial Brochure" (Washington, D.C.: U.S. Department of the Interior, 2004).

47. "The Decorations by Jules Guerin in Lincoln Memorial," undated. Box 1, Record Group 42, Records of the Office of Public Buildings and Public Parks of the National Capital, Records of the Lincoln Memorial, Classified Records of the Executive and Disbursing Officer 1911–1924. File Folder A-1, General. NARA.

48. Carole Blair and Neil Michel, "The Rushmore Effect: Ethos and National Collective Identity," in *The Ethos of Rhetoric*, Michael Hyde (Ed.) (Colombia: University of South Carolina Press, 2004); Savage, *Monument Wars: Washington, D.C., the National Mall, and the Transformation of the Memorial Landscape*; Schwartz, *Abraham Lincoln and the Forge of National Memory*; Boime, *The Unveiling of the National Icons: A Plea for Patriotic Iconoclasm in a Nationalist Era*.

49. Rexford L. Holmes, "Dedicatory Exercises Incident to the Formal Dedication of the Lincoln Memorial" (Potomac Park, Washington, D.C., 1922). Box 3, Record Group 42, Records of the Office of Public Buildings and Public Parks of the National Capital, Records of the Lincoln Memorial, Miscellaneous Records 1911–1927. NARA.

50. Charles Moore, "The City of George Washington and Abraham Lincoln," *Daughters of the American Revolution Magazine*, April 1921, 182. Box 96, Record Group 42, Project Files 1910–1952, Misc. Publications and Clippings, PI 79, Entry 17. NARA.

51. Holmes, "Dedicatory Exercises Incident to the Formal Dedication of the Lincoln Memorial." Box 3, Record Group 42, Records of the Office of Public Buildings and Public Parks of the National Capital, Records of the Lincoln Memorial, Miscellaneous Records 1911–1927, Entry 372. NARA.

52. "Resolutions of Protest Adopted by the District of Columbia Branch of the N.A.A.C.P. Against the Segregation of Colored People at the Dedication of the Lincoln Memorial," undated. Box 2, Record Group 42, Records of the Office of Public

Buildings and Public Parks of the National Capital, Records of
the Lincoln Memorial, File Folder Race Segregation Lincoln
Memorial Dedication, Entry 366. NARA.

53. J. LeCount Chestnut, "Mock Ideal of Lincoln Memorial,"
Chicago Defender, June 10, 1922. Box 2, Record Group 42,
Records of the Office of Public Buildings and Public Parks of the
National Capital, Records of the Lincoln Memorial, File Folder
Race Segregation Lincoln Memorial Dedication, Entry 366.
NARA.

54. Thomas, *The Lincoln Memorial & American Life*, 158.

55. Sandage, "A Marble House Divided: The Lincoln Memorial,
the Civil Rights Movement, and the Politics of Memory, 1939–
1963," 143.

56. Ibid., 147. Oscar L. Chapman, Franklin D. Roosevelt's Assistant
Secretary of the Interior, claimed to have thought of using the
memorial, but black leaders were discussing the idea at least two
weeks before their first recorded meeting with Chapman. Quoted
in ibid., 144.

57. Boime, *The Unveiling of the National Icons: A Plea for Patriotic
Iconoclasm in a Nationalist Era*, 10.

58. Henry Bacon, "Letter to H. A. Vale" (October 14, 1913). Box
5, Record Group 42, Records of the Office of Public Buildings
and Public Parks of the National Capital, Records of the Lincoln
Memorial, 2/16/16–4/5/22. NARA.

59. The idea of adding a Lincoln museum to the memorial basement
has been discussed several times since 1956, and in 1992 Interior
Secretary Manuel Lujan endorsed the proposal of former Iowa
Congressman Fred Schwengel to create a Lincoln museum in
the memorial's basement. This plan did not receive congressional
support or funding. Tom Kentworthy, "Plan for Museum within
Memorial Has Backer in Lujan: [Final Edition]," *The Washington
Post*, February 17, 1992, 27.

60. Jo. C. S. Blackburn, "Letter to Lincoln Memorial Commission,"
(1918). Box 6, Record Group 42, Records of the Office of Public
Buildings and Public Parks of the National Capital, Records of
the Lincoln Memorial, Classified Records of the Executive and
Disbursing Officer 1911–1924. File Folder C-9, Commission
Special Resident Commissioner. NARA.

61. Jane Radford, interview with the author, April 5, 2011.

62. Burchard, "Making Their Mark at the Memorial."

63. Jane Radford, interview with author, April 1, 2011.

64. Burchard, "Making Their Mark at the Memorial."

65. Robert Stanton, interview with author, April 6, 2011.

66. Tim Radford, interview with author, April 5, 2011.

67. Ibid.

68. Burchard, "Making Their Mark at the Memorial."

69. Even though every event held at the memorial is not specifically identified in the film, there are clues in the images as to the time period and cause of each event—for example, posters, clothing, hairstyles, celebrities, and politicians.

70. Undated two-page memorandum entitled "Original shot list for LIME's 'Lincoln's Living Legacy'—2004," accessed at the Public Employees for Environmental Responsibility Files. PEERF.

71. Transcript of *Lincoln's Living Legacy*. PEERF.

72. Undated two-page memorandum entitled "Original shot list for LIME's 'Lincoln's Living Legacy'—2004." PEERF.

73. Marc Morano, "Controversial Lincoln Video as Part of Student Project" (CNSNews.com2003). PEERF.

74. "Lincoln Living Legacy Exhibit Rehab" (2004). The reason stated for this expenditure was that the "National Capital Parks-Central staff requested the assistance of Harpers Ferry Center to review the Lincoln's Living Legacy Exhibit." Unsigned memorandum, PEERF.

75. Gary Cummins, personal communication with author, April 2011.

76. Tim Radford, interview with author, April 5, 2011.

77. Tim Radford, interview with author, April 6, 2011.

78. Lou Chibbaro, "'Gay' scenes in or out at Lincoln Memorial? Park Service gives conflicting signals on gay footage in video," *Washingtonblade.com*, January 18, 2004, 1.

79. Halle Czechowski, "Who Shot Lincoln Videotape?" (People for the American Way, 2005). PEERF.

80. Gary Cummins, "HFC: All Employees: Lincoln Memorial Video Lawsuits" (National Park Service, Department of the Interior, 2005). PEERF.

81. Comment from an HFC employee who wished to remain anonymous in a phone conversation with the author in April 2011.

82. Chibbaro, "'Gay' scenes in or out at Lincoln Memorial? Park Service gives conflicting signals on gay footage in video," 1. PEERF.

83. Gary Cummins, personal correspondence with author, May 6, 2011.

84. Tim Radford, "Tim's Legacy" (National Park Service, Department of the Interior, 2003). PEERF.

85. In addition to purchasing images of politically conservative events at the Lincoln Memorial, the list also included a number of other

ceremonial images: "Memorial holiday week-end draws atten-tion to Gulf Veterans"; "US Afghans show support + interfaith vigil"; "Promise Keepers"; "Demo-Gulf War"; "Youth Rally for Life 1-4"; "'Stop the Crime Bill' rally; pro-gun activist delivers speech criticizing Waco, Janet Reno and assault weapons ban"; "'US Bikers, Rolling Thunder veterans', motorbike rally"; "31st Smithsonian Kite Festival"; "Flags in wind"; "Armed Forces on steps to LIME"; "Honor Guard marching in with flags"; "Pull back of memorial anti-gun rally"; "Start Seeing Iraqi Children" sign; "Pro-war protest prayer being lead." PEERF.

86. Gary Cummins, interview with author, May 12, 2011.
87. Gary Cummins, correspondence with author, May 6, 2011.
88. Tim Radford, interview with author, April 5, 2011.
89. Cullom, "Letter to Henry Bacon." WUL.
90. National Park Service, "National Mall & Memorial Parks, National Mall Plan: Summary November 2010" (Washington, D.C.: U.S. Department of the Interior, 2010), 22–23.
91. Boime, *The Unveiling of the National Icons: A Plea for Patriotic Iconoclasm in a Nationalist Era*, 8.

Chapter 5

1. Carole Blair and Neil Michel, "The Rushmore Effect: Ethos and National Collective Identity," in *The Ethos of Rhetoric*, Michael Hyde (Ed.) (Columbia: University of South Carolina Press, 2004), 156.
2. American identification with its landscape stands opposed to the European perspective that looks to their historic culture for a definition of their nationality and citizenship. Alfred Runte, *National Parks: The American Experience* (Lincoln: University of Nebraska Press, 1979), 16.
3. Recent critical works include Albert Boime, "Patriarchy Fixed in Stone," *American Art* 5 (1991); Leonard Crow Dog and Richard Erdoes, *Crow Dog: Four Generations of Sioux Medicine Men* (New York: HarperPerennial, 1995); Matthew Glass, "Alexanders All: Symbols of Conquest and Resistance at Mount Rushmore," in *American Sacred Space*, David Chidester and Edward T. Linenthal (Eds.) (Bloomington: Indiana University Press, 1995); Jesse Larner, *Mount Rushmore: An Icon Reconsidered* (New York: Thunder's Mouth Press/Nation Books, 2002); Edward Lazarus, *Black Hills White Justice* (New York: HarperCollins, 1991); Russell Means, *Where White Men Fear to Tread: The Autobiography of Russell Means* (New York: St. Martin's Press, 1995); Simon

Schama, *Landscape and Memory* (New York: Vintage Books, 1995); John Taliaferro, *Great White Fathers: The Story of the Obsessive Quest to Create Mt. Rushmore* (New York: PublicAffairs, 2002); Blair and Michel, "The Rushmore Effect: Ethos and National Collective Identity."

4. There are a substantial amount of critical essays concerning the rhetoric of place/monuments/landscape and of public memory; they include Carole Blair, "Contemporary U.S. Memorial Sites as Exemplars of Rhetoric's Materiality," in *Rhetorical Bodies*, Jack Selzer and Sharon Crowley (Eds.) (Madison: University of Wisconsin Press, 1999); Carole Blair and Neil Michel, "Reproducing Civil Rights Tactics: The Rhetorical Performances of the Civil Rights Memorial," *Rhetoric Society Quarterly* 30, no. 2 (2000); Gregory Clark, *Rhetorical Landscapes in America: Variations on a Theme from Kenneth Burke* (Columbia: University of South Carolina Press, 2004); Greg Dickinson, Brian Ott, and Eric Aoki, "Spaces of Remembering and Forgetting: The Reverent Eye/I at the Plains Indian Museum," *Communication and Critical/ Cultural Studies* 3, no. 1 (2006); Vicky Gallagher, "Memory and Reconciliation in the Birmingham Civil Rights Institute," *Rhetoric and Public Affairs* 2 (1999); Harry W. Haines, "What Kind of War?: An Analysis of the Vietnam Veterans Memorial," *Critical Studies in Mass Communication* 3 (1986); M. Hasian, Jr., "Remembering and Forgetting the 'Final Solution'; A Rhetorical Pilgrimage through the U.S. Holocaust Museum," *Critical Studies in Media Communication*, no. 21 (2004); Marita Sturken, *Tangled Memories: The Vietnam War, the AIDS Epidemic, and the Politics of Remembering* (Berkeley and Los Angeles: University of California Press, 1997); Barbie Zelizer, *Remembering to Forget: Holocaust Memory through the Camera's Eye* (Chicago: University of Chicago Press, 1998).

5. Roy Rosenzweig and David Thelen, *The Presence of the Past: Popular Uses of History in American Life* (New York: Columbia Press University, 1998), 3.

6. See U.S. National Park Service, "Visitation Database," Mt. Rushmore National Memorial www.nature.nps.gov/stats/ viewReport.cfm, May 4, 2012.

7. Robert Hariman and John Louis Lucaites, "Performing Civic Identity: The Iconic Photograph of the Flag Raising on Iwo Jima," *Quarterly Journal of Speech* 88, no. 4 (2002).

8. Barbara Biesecker, "Renovating the National Imaginary: A Prolegomenon on Contemporary Paregoric Rhetoric," in

Framing Public Memory, Kendall R. Phillips (Ed.) (Tuscaloosa: University of Alabama Press, 2004).

9. Russell A. Apple and Merrill J. Mattes, "Museum Prospectus for Mount Rushmore National Memorial" (Mt. Rushmore: National Park Service, U.S. Department of the Interior, 1957). MRNMA.

10. Cecelia Tichi, *Embodiment of a Nation: Human Form in American Places* (Cambridge, MA: Harvard University Press, 2001), 11.

11. On July 3, 1941, the Mount Rushmore National Memorial Association ceased to exist and transferred all responsibilities to the National Park Service with the first park Superintendent on October 1, 1941. David Wenk, "Mount Rushmore National Memorial South Dakota Statement for Management" (Mt. Rushmore: National Park Service, U.S. Department of the Interior, 1987). MRNMA.

12. Merrill J. Mattes, Ray H. Mattison, and Charles E. Humberger, "Outline for a Museum Prospectus for Mount Rushmore National Memorial" (Mt. Rushmore: National Park Service, U.S. Department of the Interior, 1956). MRNMA.

13. Ibid.

14. Ibid.

15. Gilbert C. Fite, *Mount Rushmore* (Norman: University of Oklahoma Press, 1952), 5.

16. Ibid., 5–6.

17. Ibid., 6.

18. The project was initially offered in December 1923 to Loredo Taft, who had to decline because of ill health.

19. "Borglum Plans Memorial to Matron," *The Free Press*, September 3, 1924. Box 102, Manuscript Division. GBLOC.

20. Howard Schaff and Audrey Karl Schaff, *Six Wars at a Time* (Darien, CT: Permelia Publishing, 1985), 227.

21. The entablature was to be 80 feet wide and 120 feet tall, engraved in three-feet letters covering Borglum's history of the U.S. The Hall of Records was to be 80 feet wide by 100 feet tall with an 800-feet granite stairway and was first proposed for Stone Mountain in Georgia. "This inscription, which Borglum called 'The Entablature,' was to become the source of bitter controversy and would never be carved." Rex Alan Smith, *The Carving of Mount Rushmore* (New York: Abbeville Press Publishers, 1985), 132. On August 9, 1998, the NPS decided to complete a portion of Borglum's grandiose plans by placing sixteen porcelain panels in a teakwood box in the unfinished Hall. These panels contained a variety of repre-

sentations including text, pictures, biographies of the four Rushmore presidents, Borglum's biography, the Constitution, and the Declaration of Independence. Paul Higbee, *Mount Rushmore's Hall of Records* (Keystone: Mount Rushmore History Association, 1999), 2–4.

22. Gutzon Borglum, "Letter to President Calvin Coolidge" (1925). Box 103, Manuscript Division. GBLOC.

23. Fite, *Mount Rushmore*, 101.

24. Although representation of Susan B. Anthony does not appear in any of the orientation films, the discussion surrounding her possible inclusion in the mountain carving illustrates Borglum's intent to make Mt. Rushmore a commemoration to U.S. imperialism. Rose Arnold Powell "campaigned for ten years to have Susan B. Anthony . . . up there on the granite with the four presidents." Schama, *Landscape and Memory*, 385. Borglum rebutted the many requests by stating that Anthony did not fit within his meaning for the memorial: "This memorial deals so definitely with the matter of territorial conception . . . that the introduction of any other names is not fitting." Gutzon Borglum, "Letter to Senator Arthur Capper" (1935). Box 103 and 104, Manuscript Division. GBLOC.

25. "The selection of Roosevelt was solely Mr. Borglum's . . . we discussed many times the hazards of immortalizing any man until he had been dead for at least fifty years." Doane Robinson, "Letter to Hon. Franklin B. Morgan" (1931). Box 170, Manuscript Division. GBLOC. Borglum also wrote that he wanted to salute the "country's expansion," and Theodore Roosevelt fulfilled that role with the building of the Panama Canal. Smith, *The Carving of Mount Rushmore*, 132.

26. Fite, *Mount Rushmore*, 101.

27. Michael Schudson, *The Good Citizen: A History of American Civic Life* (New York: The Free Press, 1998), 203.

28. Gutzon Borglum, "Letter to Mrs. Tueling" (1936). Box 170, Manuscript Division. GBLOC.

29. Gutzon Borglum, "Letter to William Mill Butler" (1935). Box 178, Manuscript Division. GBLOC.

30. Borglum, Gutzon. Letter to Peter Norbeck. August 28, 1925. Box 1, Peter Norbeck Papers, Folder 1B, Correspondence 1925. MRNMA.

31. Olaf Hagen, "Mount Rushmore Master Plan" (Mt. Rushmore April 19, 1948). MRNMA.

32. David D. Thompson, Jr., "The Construction Museum Prospectus: An Amendment and Addition to the Interpretive Prospectus,

Mount Rushmore National Memorial" (Mount Rushmore: Department of the Interior, March 25, 1963). MRNMA.

33. Apple and Mattes, "Museum Prospectus for Mount Rushmore National Memorial." MRNMA.

34. George Washington's subtitle is "Struggle for Freedom"; Thomas Jefferson's subtitle is "Philosophy of Freedom"; Abraham Lincoln's subtitle is "Unity in Freedom"; and Theodore Roosevelt's subtitle is "Responsibilities of Freedom." Ibid.

35. Ibid.

36. Thompson, "The Construction Museum Prospectus: An Amendment and Addition to the Interpretive Prospectus, Mount Rushmore National Memorial." MRNMA.

37. Ibid.

38. Ibid.

39. The Mount Rushmore National Memorial Society is "dedicated to the preservation, promotion, and enhancement of Mount Rushmore National Memorial and the values it represents through a partnership with the National Park Service. The Society has been supporting the Mount Rushmore National Memorial since work on the mountain first began. We are one of the nation's largest and oldest National Park Service friends organizations, raising millions for facility improvements and promotional events since 1930." Mount Rushmore Society, "About Us," www.mtrushmore.org/Content/122.htm.

40. Undated four-page proposal on Nauman Film's stationary. Box 20. MRNMA.

41. The balance of the proposal includes the following elements: President Coolidge handing Borglum the first drill bits, Doan Robinson and the early visionary phase, the construction period, present day shots of Mt. Rushmore, and a closing statement interpreting the American dream on this mountain. Charles Nauman, "Correspondence from Mt. Rushmore Historical Society to Nauman Films." Undated four-page proposal on Nauman Films stationary, Box 20. MRNMA.

42. I refer to this film hereafter as *Mt. Rushmore.*

43. Amy Bracewell, personal correspondence with author, January 9, 2012.

44. Bill Nichols, *Representing Reality* (Bloomington: Indiana University Press, 1991), 35. None of the three orientation films uses personal interviews.

45. Bill Nichols, *Introduction to Documentary* (Bloomington: Indiana University Press, 2001), 103.

46. All quotations without footnotes in this section are from the narration in the *Mount Rushmore* orientation film.
47. Runte, *National Parks: The American Experience*, xii.
48. Ibid., 7.
49. Ibid., 11.
50. Ibid., 22.
51. In 1890 Borglum studied at the École des Beaux-Arts in Paris, and in 1896 he opened a small studio in London. Fite, *Mount Rushmore*, 13–14.
52. Ibid., 16.
53. Taliaferro, *Great White Fathers: The Story of the Obsessive Quest to Create Mt. Rushmore*, 153.
54. "Borglum Plans Memorial to Matron." Box 102, Manuscript Division. GBLOC.
55. Blair and Michel, "The Rushmore Effect: Ethos and National Collective Identity," 17. Some large-scale public works projects of the era included Boulder Dam, the Tennessee Valley Authority's power plants, and the Brooklyn Bridge.
56. James Fenimore Cooper, "American and European Scenery Compared," as quoted in Runte, *National Parks: The American Experience*, 16.
57. Article Two of the 1868 Treaty of Fort Laramie provides for the "setting aside all of present-day South Dakota west of the Missouri River, including the reputedly gold-laden Black Hills, 'for the absolute and undisturbed use and occupancy of the Sioux.'" Lazarus, *Black Hills White Justice*, 48.
58. Glass, "Alexanders All: Symbols of Conquest and Resistance at Mount Rushmore," 168. The Supreme Court case, *The United States v. Sioux Nation of Indians, 448 U.S. 371 (1980),* offered a financial settlement and was argued by Arthur Lazarus.
59. *Rapid City Journal* Staff, "Government Wants Black Hills Settlement Claim Dismissed," *Rapid City Journal*, July 10, 2009.
60. Jeffrey Ostler, *The Lakotas and the Black Hills: The Struggle for Sacred Ground* (New York: Penguin Books, 2010), 174.
61. Lazarus, *Black Hills White Justice*, 43.
62. Ostler, *The Lakotas and the Black Hills: The Struggle for Sacred Ground*, 145.
63. Ibid., 147.
64. There have been several temporary exhibits concerning Native Americans, one of which included a small amount of text that referenced Sacajawea's involvement and the tribes to which she was connected during the Lewis & Clark Bicentennial. In 2008

and 2009, there was the temporary Indian Trade exhibit, which Zane Martin, Museum Specialist at Mt. Rushmore, created. Zane Martin, personal correspondence with author, January 9, 2012. Amy Bracewell, the Mt. Rushmore Historian, wrote: "We did have another temporary exhibit in 2009 and 2010 on Ben Black Elk. Besides that, I am not aware of any other exhibits. We have had several special events—musical performances, dance and music demonstrations, and two elders' summits, but no other museum exhibits." Amy Bracewell, personal correspondence with author, January 9, 2012.

65. "Gutzon had been fired because he '. . . neglected his work, . . . found time to deliver a series of lectures . . . and to launch a movement for a great Union Memorial in South Dakota,'" Schaff and Schaff, *Six Wars at a Time*, 214.

66. Ibid., 197.

67. Black Elk and other Lakota Sioux participated in several of the Mt. Rushmore dedications and "performed a pipe and healing ceremony and several dances." Ostler, *The Lakotas and the Black Hills: The Struggle for Sacred Ground*, 147.

68. Lemuel A. Garrison, "Letter to John Boland, Jr." (1965). Box 20. MRNMA. Garrison was the Regional Director for the Midwest region of the NPS.

69. Michael S. Sherry, *In the Shadow of War: The United States Since the 1930s* (New Haven, CT: Yale University Press, 1995), 273.

70. Howard Zinn, *The Twentieth Century: A People's History* (New York: Harper and Row, 1980), x.

71. Foucault observes that one theme of historical films is "that there's been no popular struggle in the 20th century." Michel Foucault, "Film and Popular Memory: An Interview with Michel Foucault," *Radical Philosophy* (1975), 25.

72. Ibid., 27.

73. Department of the Interior, National Park Service, "Briefing on Mount Rushmore Film," "Four Faces on the Mountain," May 16, 1983, Mt. Rushmore files. HFCA. The Harpers Ferry Center is part of the NPS and has produced "interpretive tools to assist NPS field interpreters" since 1970. See National Park Service, "Harpers Ferry Center," www.nps.gov/hfc/resources.cfm, July 16, 2003.

74. All quotes without footnotes in this section of the paper are from the narration in the *Four Faces on a Mountain* orientation film.

75. "Superintendent Reports: Interpretation and Resource Management" (1974), 2. Box 52. MRNMA.

76. Bill Sontag, "Briefing Statement on Mount Rushmore Film, *Four Faces on the Mountain*" (1983), 2. Mt. Rushmore Files, HFCA.

Bill Sontag was the Chief of the Division of Interpretation in the Rocky Mountain Regional Office of the NPS.

77. Harvey D. Wickware, "Memorandum: Review of Film, *Four Faces on a Mountain*" (1973), Box 52. MRNMA.

78. Meredith played President James Madison in the 1946 film, *Magnificent Doll.*

79. www.imbd.com/name/nm0580565/bio, June 29, 2004.

80. Harpers Ferry Center, "Mount Rushmore National Memorial Treatment" (Harpers Ferry, WV: National Park Service, U.S. Department of the Interior, 1972), 1. Box 52. MRNMA.

81. Apple and Mattes, "Museum Prospectus for Mount Rushmore National Memorial"; Mattes, Mattison, and Humberger, "Outline for a Museum Prospectus for Mount Rushmore National Memorial"; James B. Thompson, "Acting Regional Director," National Park Service, Department of the Interior (Mt. Rushmore, February 23, 1982). MRNMA.

82. Harvey D. Wickware, "Memorandum: Review of Film, *Four Faces on a Mountain*" (1973), 1. MRNMA.

83. The dynamiting footage is used to show that Jefferson had to be moved. The initial carving of Jefferson began to the left of Washington but had to be moved to his right when the rock on the left proved unusable for carving.

84. Zinn, *The Twentieth Century: A People's History*, 280–83.

85. This declaration was from a statement coauthored by Lehman Brightman, Dennis Banks, and Russell Means. "The protest began in the visitor's bookstore and amphitheater," and "as night fell . . . several dozen protesters climbed up to occupy the mountain, eventually camping in a small depression behind Roosevelt's head." Quoted in Larner, *Mount Rushmore: An Icon Reconsidered*, 280–84.

86. Quoted in ibid., 281.

87. Peter N. Carroll, *It Seemed Like Nothing Happened* (New Brunswick, NJ: Rutgers University Press, 1982), 135.

88. Ibid., 116.

89. Zinn, *The Twentieth Century: A People's History*, 281.

90. A bomb exploded on the terrace outside Mount Rushmore's visitor center on June 27, 1975. Larner, *Mount Rushmore: An Icon Reconsidered*, 289.

91. Fite, *Mount Rushmore*, 101.

92. Department of the Interior, National Park Service, "Mount Rushmore National Memorial Interpretive Plan" (Mt. Rushmore, 1981). MRNMA.

93. Ibid.

94. There are two versions of the 1986 orientation film, *The Shrine.* A thirteen-minute version was completed on August 8, 1985, and was shown for less than one year at the visitor center. The thirteen-minute film was well-received; however, the NPS wanted a longer version and entered into a contract with the Mount Rushmore National Memorial Society to extend the film. The NPS added four and a half minutes to the film using "extra footage shot for this film . . . and outtakes from *Four Faces on a Mountain.*" James C. Riggs, "Memorandum on Film Production Services" (1986), MRNMA. The NPS hired the same production company to expand the film, and the contract between the NPS and the Mount Rushmore National Memorial Society of the Black Hills guaranteed that each would have to approve the expanded film. I have decided to focus my analysis on the longer version of this film because the thirteen-minute script is not substantially changed, but expanded.

95. "Everyone in South Dakota seems pleased by the final film, and I of course am quite happy about that. Tom Brokaw is the narrator. As a South Dakotan, Brokaw was the first choice of the folks of the Mount Rushmore Society, and I think he does a decent job." Robert G. McBride, "Letter to NPS, Harpers Ferry Center" (1985). Rushmore files. HFCA.

96. Amy Bracewell, personal correspondence with author, January 17, 2012.

97. All quotes without footnotes in this section are from the narration in *The Shrine* orientation film.

98. Sherry, *In the Shadow of War: The United States Since the 1930s,* 427.

99. Schudson, *The Good Citizen: A History of American Civic Life,* 295.

100. Sherry, *In the Shadow of War: The United States Since the 1930s,* 429.

101. Mike Wallace, *Mickey Mouse History and Other Essays on American Memory* (Philadelphia: Temple University Press, 1996), xiii.

102. The Crazy Horse Monument, located only a few miles from Mt. Rushmore, also declares the capability to create a monument of colossal proportions as justification for its existence. The creator of the monument, Korczak Ziolkowski, and his family are not Native Americans and have offered varied reasons for the site's existence. However, their orientation film and literature convey the significance of the carving mostly in terms of the site's enormous dimensions: it is "bigger than" Mt. Rushmore. The Crazy Horse Gift shop has a list of "Top 10 Questions" asked about

Crazy Horse, and number 8 states: "What is the size comparison with Mt. Rushmore?" The answer is "The presidential faces are 60' high . . . Just Crazy Horse's face is 87'6" high (nine stories), and, overall, Crazy Horse will be 563' high, 641' long." "Souvenir Map" (Crazy Horse, SD: Crazy Horse Memorial Foundation, 2003). For a critique of the ideological messages of the Crazy Horse Monument see Blair and Michel, "The Rushmore Effect: Ethos and National Collective Identity," 174–75.

103. Doane Robinson, as quoted in Fite, *Mount Rushmore*, 9.

104. The interpretive center just outside the orientation film screening rooms contains an extremely popular exhibit that includes a plunger that, when pressed, simulates the dynamite explosions that created Mt. Rushmore.

105. Blair and Michel, "The Rushmore Effect: Ethos and National Collective Identity," 183.

106. References to declaring the U.S. as empire and to imperial power can be found throughout U.S. history, and one of the most influential pieces on this subject was by Henry Luce who declared the twentieth century to be the American Century. "It must be a sharing with all peoples our Bill of Rights, our Declaration of Independence, our Constitution, our magnificent industrial products, our technical skills." Henry R. Luce, "The American Century," *Life*, February 17, 1941, 64.

107. Contemporary versions of this definition of patriotism include invocations to support the troops but not the war in Iraq or Afghanistan, an approach that neatly avoids the ideological complexities of the U.S. invasion of these two countries.

108. Construction began in 1992, and the final dedication of the new center and museum took place in 1998.

109. Jen Sanderson, "Opening Week Brisk for New Visitor Center and Museum," *Rapid City Journal*, June 22, 1998. MRNMA.

110. The other four objectives in the 1992 Interpretive Prospectus were to: "acquaint visitors with the major achievements of the four presidents; place the monumental carving at Mt. Rushmore into an artistic framework; inspire visitors to draw strength from the achievement of goals in the face of great obstacles as exemplified by the presidents, by the creators of the carving and by the democratic institutions." Ronald E. Everhart, "Interpretive Prospectus Mount Rushmore National Memorial South Dakota" (Harpers Ferry, WV: Division of Interpretive Planning, Harpers Ferry Center, 1992). MRNMA.

111. The twenty-one exhibits included: (1–2) photo murals of Gutzon Borglum; (3) video of seasonal light changes on Rushmore; (4–9)

photos comparing Rushmore to other large structures, overviews of each president's achievements, Hall of Records explanation; (10) fundraising for memorial's redevelopment; (11) preservation efforts of the memorial; (12) Mt. Rushmore in popular culture; (13) twenty-eight foot long mural explaining U. S. history with an emphasis on the depicted presidents' achievements; (14) chronology of carving the memorial; (15) construction photographs; (16) a workers' exhibit; (17) more photos of workers and Borglum; (18) history of Borglum as sculptor; (19) 1930s site model; (20) photograph of 1941 memorial construction; (21) "carving exhibit" whose centerpiece will be an authentic explosives plunger, which visitors will push to trigger selected video displays of mountain blasts from 1927 through 1941. "Rushmore Redevelopment: Visitor Center/Museum Will Feature 21 Exhibits," *Rapid City Journal*, October 5, 1997. MRNMA.

112. Pat Dobbs, "Displays to Step into 'New Age': Hands-On Displays to Help Rushmore Visitors Understand," *Rapid City Journal*, April 29, 1996. MRNMA.

113. National Park Service, "Exhibit 13 The Meaning of Mount Rushmore" (Mt. Rushmore: U.S. Department of the Interior, 1996).

114. Amy Bracewell, interview with author, Mt. Rushmore, SD, May 18, 2011.

115. Gerard Baker, personal correspondence with author, January 3, 2012.

116. The Presidential Trail is a short, fully accessible trail that starts from the Visitor Center and goes to the base of the carvings.

117. This stop on the audio tour is described as the "Lakota, Nakota, and Dakota Heritage Village—Explore the history of the Black Hills and the American Indian tribes who have populated this land for thousands of years. Located along the first section of the Presidential Trail, this area highlights the customs and traditions of local American Indian communities." National Park Service, "Mt. Rushmore Guided Tours," U.S. Department of the Interior, www.nps.gov/moru/planyourvisit/guidedtours.htm.

118. Madeline Brand, "Mount Rushmore Now Offers Pre-Carving History," National Public Radio, www.npr.org/templates/transcript/transcript.php?storyId=92086614.

119. National Park Service, "Strategic Plan for Mount Rushmore National Monument Memorial October 1, 2000–September 30, 2005" (Mt. Rushmore: U.S. Department of the Interior). MRNMA.

120. Scott Huddleston, "Pact Could Be New Era for Alamo," *San Antonio Express-News*, December 16, 2011.

121. This is a comment Gerard Baker overheard during his tenure as Superintendent of Mt. Rushmore. Gerard Baker, interview with author, January 3, 2012.

122. Black Hills News Bureau, "Mount Rushmore National Memorial Welcomes American Indian Elders," http://blackhillsnewsbureau.com/news-stories/article/22-mount-rushmore-national-memorial-welcomes-american-indian-elders-.html.

123. Barbara Soderlin, "Does Native American Exhibit Belong at Mount Rushmore?" *Rapid City Journal*, August 25, 2008.

124. Two Cents, "Your Two Cents. In Two Sentences. On Page Too," *Rapid City Journal*, April 19, 2010.

125. Mailbag, "Narrow-Minded Comments Offensive," *Rapid City Journal*, 2010.

126. Opinion, "Hard to Read Hurtful Comments about Baker," *Rapid City Journal*, August 27, 2009.

127. Jesse Abernathy, "Legacy of Gerard Baker Lives on at Mount Rushmore," *The Buffalo Post*, September 23, 2011.

128. Gerard Baker, personal correspondence with author, January 3, 2012.

129. Jim Kent, "Dakota Digest," http://sdpb.sd.gov/newsite/shows.aspx?MediaID=57249&Parmtype=RADIO&ParmAccessLevel=sdpb-all.

130. Amy Bracewell, interview with author, Mount Rushmore, SD, May 18, 2011.

131. Rosenzweig and Thelen, *The Presence of the Past: Popular Uses of History in American Life*, 3.

132. Hariman and Lucaites, "Performing Civic Identity: The Iconic Photograph of the Flag Raising on Iwo Jima," 387.

Conclusion

1. Robert Stanton, interview with author, April 6, 2011.

2. Lori Tighe, "Memorial to Correct Movie That Wrongs Japanese Americans," *Honolulu Sun-Bulletin*, October 28, 1999. *Arizona Memorial file*, WWII-VPNM.

3. Robert Stanton, interview with author, April 6, 2011.

4. Gerard Baker, interview with author, January 3, 2012.

5. George E. Hein, *Learning in the Museum* (New York: Routledge, 1998), 153.

Bibliography

Abbreviations

CSRMDC	California State Railroad Museum Documents Collections, 111 "I" Street, Sacramento, CA
DRTLA	Daughters of the Republic of Texas Archives at the Alamo, San Antonio, TX
GBLOC	Gutzon Borglum Papers, Library of Congress, 101 Independence Ave. SE, Washington, D.C.
HFCA	Harpers Ferry Center Archives, 67 Mather Place, Harpers Ferry, WV
LOC	Library of Congress, Washington, D.C.
MRNMA	Mount Rushmore National Memorial Archives, Mt. Rushmore, SD
NARA	National Archives Records and Administration, 700 Pennsylvania Avenue NW, Washington, D.C.
PEERF	Public Employees for Environmental Responsibility Files, 2000 P Street NW, Suite 240, Washington, D.C.
WUL	Wesleyan University Library, Middletown, CT
WWII-VPNM	World War II Valor in the Pacific National Monument Archives, 1 *Arizona* Memorial Place, Honolulu, HI

Archives and Manuscript Collections

California State Railroad Museum Documents Collections, CSRMDC
Daughters of the Republic of Texas Archives at the Alamo, DRTLA
Harpers Ferry Center Archives, HFCA
 Mount Rushmore Files
Library of Congress, GBLOC
 Gutzon Borglum Papers
 Daniel Chester French Papers
Mount Rushmore National Memorial Archives, MRNMA
National Archives Records and Administration, NARA
Public Employees for Environmental Responsibility Files, PEERF

Wesleyan University Library, WUL
 Henry Bacon Papers
World War II Valor in the Pacific National Monument Archives, WWII-VPNM

Newspapers

The Buffalo Post (online)
Black Hills News Bureau (online)
Chicago Defender
CNSNews.com (online)
Dakota Digest (online)
Fox News (online)
Hawai'i Navy News
The Honolulu Advertiser
Honolulu Star-Bulletin
Honolulu Sun Bulletin
Houston Post
The San Antonio Light
The New York Times
Rapid City Journal
The Sacramento Bee
The Saginaw News
San Antonio Express-News
San Antonio Light
San Antonio News
Shreveport Times
Stars and Stripes
The Sun (Price, Utah)
Tuscaloosa News
The Waikiki Beach Press
Washingtonblade.com (online)
The Washington Post

Dissertations

Bergman, Teresa. "Fashionably Objective: When the Politics of Epistemology Encounter Progressive Political Documentary Representation." Ph.D. Dissertation, University of California, Davis, 2002.

Brazeal, Brailsford Reese. "The Brotherhood of Sleeping Car Porters: Its Origin and Development." Ph.D. Dissertation, Columbia University, 1946.

Chiu, Ping. "Chinese Labor in California 1850–1880, an Economic Study." Ph.D. Dissertation, University of Wisconsin, 1959.

Cohen, James Harrison. "A Legal History of the Rights of Immigrant Aliens in the United States under the Fourteenth Amendment to the Constitution 1870 to the Present." Ph.D. Dissertation, New York University, 1991.

Interviews

Denny S. Anspach, Board Member, California State Railroad Museum, January 26, 2011.
Gerard Baker, Former Superintendent, Mt. Rushmore National Memorial, January 3, 2012.
Amy Bracewell, Historian, Mt. Rushmore National Memorial, May 18, 2011.
Philip P. Choy, Former Historian, Chinese Historical Society, February 1, 2011.

Gary Cummins, Retired National Park Service, May 12, 2012.
Theodore R. Fehrenbach, Retired Texas Historian, July 11, 2006.
Ellen Halteman, Director of Collections, California State Railroad Museum, January 19, 2011.
Daniel Martinez, Historian, World War II: Valor in the Pacific National Monument, January 9, 2005 and August 3, 2011.
Scott Pawlowski, Chief Cultural and Natural Resources, World War II: Valor in the Pacific National Monument, June 1, 2011.
Jim Popovich, Former Director, California State Railroad Museum, June 27, 2003.
Jane Radford, Retired Harpers Ferry Center, April 5, 2011.
Tim Radford, Retired Harpers Ferry Center, April 5, 2011.
Madge Roberts, Former Chair, Daughters of the Republic of Texas Alamo Committee, July 10, 2006.
Rudi Rodriguez, President, Hispanic Heritage Center of Texas, August 10, 2011.
Marilyn Somerdorf, Curator, California State Railroad Museum, February 2, 2011.
Robert Stanton, Former National Park Service National Capital Region Director, April 6, 2011.
Leticia Van de Putte, Texas State Senator, September 6, 2011.
Bruce Winders, Historian, The Alamo, June 26, 2006 and August 10, 2011.
Herbert Yee, Board Member, California State Railroad Museum, January 21, 2011.
Wesley Yee, Board Member, California State Railroad Museum, January 21, 2011.

Government Documents

AldrichPears Associates. "U.S.S. *Arizona* Memorial Visitor Center 100% Design Development Graphics & Text Document." National Park Service, U.S. Department of the Interior, 2008.
———— "Visitor Center Development: USAR226 Interpretive Media Value Analysis." National Park Service, U.S. Department of the Interior, 2006.
Apple, Russell A., and Merrill J. Mattes. "Museum Prospectus for Mount Rushmore National Memorial." National Park Service, U.S. Department of the Interior, 1957.
Barry Howard & Associates, Inc. "CSRM/History Building Historical and Thematic Outline: Second Revision." 1–17, 1976.
———— "CSRM/Museum of Railroad History Interpretive Narrative." 1977.
Beito, Gary. "U.S.S. *Arizona* Memorial Museum Foundation–AMMF." 1978.
California Department of Parks and Recreation. "The Railroad Museum: An Interpretive Prospectus." State of California Resource Agency, December, 1972.
California State Railroad Museum. "Request for Proposals for New Orientation Film." Sacramento: California State Railroad Museum, 1989.
Davis, Kathleen E., Betty J. Rivers, and Jeanette K. Schulz. "Museum of Railroad Technology. Phase 1: Historical Background." Sacramento: California Department of Parks and Recreation, Resource Protection Division, Cultural Heritage Section, 1995.
Everhart, Ronald E. "Interpretive Prospectus Mount Rushmore National Memorial South Dakota." Harpers Ferry, WV: Division of Interpretive Planning, Harpers Ferry Center, 1992.
Forgang, Dave. "Scope of Collections for Pearl Harbor." 4. Honolulu: U.S. Department of the Interior, 1978.
Hagen, Olaf. "Mount Rushmore Master Plan." 2. Mt. Rushmore, April 19, 1948.
Harpers Ferry Center. "Mount Rushmore National Memorial Treatment." Harpers Ferry, WV: National Park Service, U.S. Department of the Interior, 1972.
Hein, Laura. "Evaluation of 'Story of the Attack on Pearl Harbor' Exhibit for the Pearl Harbor Memorial Museum." 19, 2008.
Intrepid Productions. "Evidence of a Dream Film Script."

——— "Film Treatment of Orientation II." 1990.

——— "Proposal for Orientation Film CSRRM." 1989.

Lincoln Monument Association. "Lincoln Monument Association." 1867.

Martinez, Daniel. "Film Disclaimer." Honolulu: National Park Service, U.S. Department of the Interior, 1999.

——— "Review of Historical Data of Park Orientation Film." Honolulu: National Park Service, U.S. Department of the Interior, 1998.

Mattes, Merrill J., Ray H. Mattison, and Charles E. Humberger. "Outline for a Museum Prospectus for Mount Rushmore National Memorial." Mt. Rushmore: National Park Service, U.S. Department of the Interior, 1956.

National Park Service. "Exhibit 13 the Meaning of Mount Rushmore." 24. Mt. Rushmore: U.S. Department of the Interior, 1996.

——— "Golden Spike." National Park Service, U.S. Department of the Interior, www.nps.gov/gosp/historyculture/upload/Spikes.pdf.

——— "Lincoln Memorial." Washington, D.C.: U.S. Department of the Interior, 2004.

——— "Lincoln Memorial Brochure." Washington, D.C.: U.S. Department of the Interior, 2004.

——— "Mt. Rushmore Guided Tours." U.S. Department of the Interior, www.nps.gov/moru/planyourvisit/guidedtours.htm.

——— "National Mall & Memorial Parks, National Mall Plan: Summary November 2010." Washington, D.C.: U.S. Department of the Interior, 2010.

——— "NPS Stats." U.S. Department of the Interior, www.nature.nps.gov/stats/viewReport cfm.

——— "San Antonio Missions." San Antonio: U.S. Department of the Interior, 2009.

——— "San Antonio Missions–Their Beginnings." U.S. Department of the Interior, www.nps.gov/saan/historyculture/history2.htm.

——— "Strategic Plan for Mount Rushmore National Monument Memorial October 1, 2000–September 30, 2005." Mt. Rushmore: U.S. Department of the Interior.

——— "Valor in the Pacific World War II Monument Brochure." Honolulu: U.S. Peterson Company. "Film Treatment of: Orientation II." 1979.

——— "Film Treatment of Orientation II." 1980.

——— "Film Treatment of Orientation II." April 10, 1979.

——— "Film Treatment of Orientation II." 1979.

——— "Film Treatment of Orientation II." October 25, 1978.

——— "Perspective for Readers." November 3, 1978.

Sontag, Bill. "Briefing Statement on Mount Rushmore Film, *Four Faces on the Mountain*." 1983.

Texas State Senate. *Alamo—Providing for the Purchase, Care, and Preservation Of.* S.H.B.1, January 25, 1905.

Thompson, David D., Jr. "The Construction Museum Prospectus: An Amendment and Addition to the Interpretive Prospectus, Mount Rushmore National Memorial." Mount Rushmore: Department of the Interior, March 25, 1963.

U.S. Department of Education, Office of Innovation and Improvement. "World War II Internment in Hawai'i," www.hawaiiinternment.org/history-of-internment.

U.S. Navy. "Script of Navy Produced Film." Honolulu: Department of Defense, United States Navy.

Wenk, David. "Mount Rushmore National Memorial South Dakota Statement for Management." Mt. Rushmore: National Park Service, U.S. Department of the Interior, 1987.

Wickware, Harvey D. "Memorandum: Review of Film, *Four Faces on a Mountain*." 1973.

Secondary Sources

Adair, Bill, Benjamin Filene, and Laura Koloski (Eds.). *Letting Go?* Philadelphia: The Pew Center for the Arts & Heritage, 2011.

Alexander, Edward P., and Mary Alexander. *Museums in Motion: An Introduction to the History and Functions of Museums*. Lanham, MD: AltaMira Press, 2008.

Anderson, Gail. "Introduction: Reinventing the Museum." In *Reinventing the Museum: Historical and Contemporary Perspectives on the Paradigm Shift*, Gail Anderson (Ed.), 1–7. Lanham, MD: AltaMira Press, 2004.

Archibald, Robert R. "Community Choices, Museum Concerns." In *Museum Philosophy for the Twenty-First Century*, Hugh G. Genoways (Ed.), 267–74. Lanham, MD: AltaMira Press, 2006.

———— *A Place to Remember: Using History to Build Community*. Walnut Creek, CA: AltaMira Press, 1999.

Armada, Bernard J. "Memorial Agon: An Interpretive Tour of the National Civil Rights Museum." *Southern Communication Journal* 63 (1998): 235–43.

Balthrop, V. William, Carole Blair, and Neil Michel. "The Presence of the Present: Hijacking 'the Good War.'" *Western Journal of Communication*, no. 74 (March–April 2010): 170–207.

Barthes, Roland. *Mythologies*. New York: Hill and Wang, 1972.

Bennett, Tony. "Difference and the Logic of Culture." In *Museum Frictions*, Corrine A. Kratz, Ivan Karp, Lynn Szwaja, and Tomas Ybarro-Fausto (Eds.), 46–69. Durham, NC: Duke University Press, 2007.

Benson, Thomas W., and Carolyn Anderson. *Reality Fictions: The Films of Frederick Wiseman*. Carbondale: Southern Illinois University Press, 1989.

Biesecker, Barbara. "Renovating the National Imaginary: A Prolegomenon on Contemporary Paregoric Rhetoric." In *Framing Public Memory*, Kendall R. Phillips (Ed.), 212–47. Tuscaloosa: University of Alabama Press, 2004.

———— "Rethinking the Rhetorical Situation from within the Thematic of Differánce." *Philosophy and Rhetoric* 22, no. 2 (1989): 110–30.

Bitzer, Lloyd. "The Rhetorical Situation." *Philosophy and Rhetoric* 1, no. 1 (1968): 1–14.

Blair, Carole. "Contemporary U.S. Memorial Sites as Exemplars of Rhetoric's Materiality." In *Rhetorical Bodies*, Jack Selzer and Sharon Crowley (Eds.), 16–57. Madison: University of Wisconsin Press, 1999.

Blair, Carole, Greg Dickinson, and Brian L. Ott. "Introduction: Rhetoric/Memory/Place." In *Places of Public Memory: The Rhetoric of Museums and Memorials*, Greg Dickinson, Carole Blair, and Brian L. Ott (Eds.), 1–54. Tuscaloosa: University of Alabama Press, 2010.

Blair, Carole, and Neil Michel. "Reproducing Civil Rights Tactics: The Rhetorical Performances of the Civil Rights Memorial." *Rhetoric Society Quarterly* 30, no. 2 (Spring 2000): 31–55.

———— "The Rushmore Effect: Ethos and National Collective Identity." In *The Ethos of Rhetoric*, Michael Hyde (Ed.), 156–98. Columbia: University of South Carolina Press, 2004.

Bodnar, John. *Remaking America: Public Memory, Commemoration, and Patriotism in the Twentieth Century*. Princeton, NJ: Princeton University Press, 1992.

Boime, Albert. "Patriarchy Fixed in Stone." *American Art* 5 (January/February 1991): 143–67.

———— *The Unveiling of the National Icons: A Plea for Patriotic Iconoclasm in a Nationalist Era*. Cambridge: Cambridge University Press, 1998.

Brand, Madeline. "Mount Rushmore Now Offers Pre-Carving History." National Public Radio, www.npr.org/templates/transcript/transcript.php?storyId=92086614.

Brear, Holly Beachley. "The Alamo's Selected Past." National Park Service, crm.cr.nps.gov/archive/22-8/22-08-5.pdf.

———— *Inherit the Alamo: Myth and Ritual at an American Shrine*. Austin: University of Texas Press, 1995.

———— "We Run the Alamo, You Don't." In *Where These Memories Grow: History, Memory, and Southern Identity*, W. Fitzhugh Brundage (Ed.), 299–317. Chapel Hill: University of North Carolina Press, 2000.

Bugbee, Lester G. "Notes and Fragments." *The Quarterly of the Texas State Historical Association*, 2 (July 1898–April 1899) 246–47.

Carroll, Peter N. *It Seemed Like Nothing Happened*. New Brunswick, NJ: Rutgers University Press, 1982.

Certeau, Michel de. *The Practice of Everyday Life*. Berkeley and Los Angeles: University of California Press, 1984.

Chou, Chih-Chieh. "Critique on the Notion of Model Minority: An Alternative Racism to Asian American?" *Asian Ethnicity* 9, no. 3 (October 2008): 219–29.

Choy, Philip P. *Canton Footprints: Sacramento's Chinese Legacy*. Sacramento: Chinese Council of Sacramento, 2007.

Christ, William G., Harry W. Haines, and Robert Huesca. "Remember the Alamo: Late-Night Newscasts in San Antonio, Texas." In *The Electronic Campaign Election: Perspectives on the 1996 Campaign Communication*, Lynda Lee and Diane Bystron (Eds.), 29–50. Mahway, NJ: Lawrence Erlbaum Associates, 1999.

Clark, Gregory. *Rhetorical Landscapes in America: Variations on a Theme from Kenneth Burke*. Columbia: University of South Carolina Press, 2004.

Corn, Joseph J. "Tools, Technologies and Contexts: Interpreting the History of American Technics." In *History Museums in the United States: A Critical Assessment*, Warren Leon and Roy Rosenzweig (Eds.), 237–61. Urbana: University of Illinois Press, 1989.

Daughters of the Republic of Texas. "The Wall of History." San Antonio: Daughters of the Republic of Texas, 2001.

Dickinson, Greg, Brian Ott, and Eric Aoki. "Spaces of Remembering and Forgetting: The Reverent Eye/I at the Plains Indian Museum." *Communication and Critical/Cultural Studies* 3, no. 1 (2006): 27–47.

Dog, Leonard Crow, and Richard Erdoes. *Crow Dog: Four Generations of Sioux Medicine Men*. New York: HarperPerennial, 1995.

Falk, John H. *Identity and the Museum Visitor Experience*. Walnut Creek, CA: Left Coast Press, 2009.

Falk, John H., and Lynn D. Dierking. *The Museum Experience*. Walnut Creek, CA: Left Coast Press, 2011.

Fite, Gilbert C. *Mount Rushmore*. Norman: University of Oklahoma Press, 1952.

Flores, Richard R. *Remembering the Alamo: Memory, Modernity and the Master Symbol*. Austin: University of Texas Press, 2002.

Foucault, Michel. "Film and Popular Memory: An Interview with Michel Foucault." *Radical Philosophy* (1975): 24–29.

―――― *Power/Knowledge: Selected Interviews & Other Writings 1972–1977*. Colin Gordon, Leo Marshall, John Mepham, and Kate Soper (Trans.). New York: Pantheon Books, 1972.

Fowler, Will. *Santa Anna of Mexico*. Lincoln: University of Nebraska Press, 2007.

Gallagher, Vicky. "Memory and Reconciliation in the Birmingham Civil Rights Institute." *Rhetoric and Public Affairs* 2 (1999): 303–20.

Giroux, Michelle, and Mark Smith. "The California State Railroad Museum." *Locomotive & Railway Preservation* (March–April 1987): 22–46.

Glass, Matthew. "Alexanders All: Symbols of Conquest and Resistance at Mount Rushmore." In *American Sacred Space*, David Chidester and Edward T. Linenthal (Eds.), 152–86. Bloomington: Indiana University Press, 1995.

Guerra, Dora. "The Alamo: A Story Bigger Than Texas" (Review). *The Southwest Historical Review* 110, no. 3 (2007): 436–38.

Haines, Harry W. "What Kind of War?: An Analysis of the Vietnam Veterans Memorial." *Critical Studies in Mass Communication* 3 (1986): 1–20.

Hariman, Robert, and John Louis Lucaites. *No Caption Needed: Iconic Photographs, Public Culture, and Liberal Democracy*. Chicago: University of Chicago Press, 2007.

―――― "Performing Civic Identity: The Iconic Photograph of the Flag Raising on Iwo Jima." *Quarterly Journal of Speech* 88, no. 4 (November 2002): 363–92.

Hart, Roderick P. *Modern Rhetorical Criticism* (2nd ed.). Boston: Allyn and Bacon, 1997.

Hasian, M., Jr. "Remembering and Forgetting the 'Final Solution': A Rhetorical Pilgrimage through the U.S. Holocaust Museum." *Critical Studies in Media Communication*, no. 21 (2004): 64–92.

Heathcote, Edwin. *Monument Builders.* West Sussex: Academy Editions, 1999.

Hein, George E. *Learning in the Museum.* New York: Routledge, 1998.

Hein, Hilde. *The Museum in Transition.* Washington, D.C.: Smithsonian Institution Press, 2000.

——— *Public Art: Thinking Museums Differently.* Lanham, MD: AltaMira Press, 2006.

Higbee, Paul. *Mount Rushmore's Hall of Records.* Keystone: Mount Rushmore History Association, 1999.

Hispanic Heritage Center of Texas. "Interim Offices for the Hispanic Heritage Center of Texas." San Antonio, Texas.

——— "Legacy, Heritage, History." Hispanic Heritage Center of Texas. San Antonio.

Horsman, Reginald. *Race and Manifest Destiny.* Cambridge: Harvard University Press, 1981.

Howe, Barbara J. "Women in Historic Preservation: The Legacy of Ann Pamela Cunningham." *The Public Historian* 12, no. 1 (Winter 1990): 31–61.

Jamieson, Kathleen M. Hall. "Generic Constraints and the Rhetorical Situation." *Philosophy and Rhetoric* 6, no. 3 (1973): 162–70.

Karp, Ivan. "On Civil Society and Social Identity." In *Museums and Communities: The Politics of Public Culture*, Ivan Karp, Christine Mullen Kreamer, and Steven D. Lavine (Eds.), 1–17. Washington, D.C.: Smithsonian Institution Press, 1992.

Kulik, Gary. "Designing the Past: History-Museum Exhibitions from Peale to the Present." In *History Museums in the United States: A Critical Assessment*, Warren Leon and Roy Rosenzweig (Eds.), 3–37. Urbana: University of Illinois Press, 1989.

Larner, Jesse. *Mount Rushmore: An Icon Reconsidered.* New York: Thunder's Mouth Press/ Nation Books, 2002.

Lazarus, Edward. *Black Hills White Justice.* New York: HarperCollins, 1991.

Leon, Warren, and Roy Rosenzweig. "Introduction." In *History Museums in the United States: A Critical Assessment*, xi–xxvi. Chicago: University of Illinois Press, 1989.

Lowenthal, David. *The Past Is a Foreign Country.* Cambridge: Cambridge University Press, 1985.

Luce, Henry R. "The American Century." *Life*, February 17, 1941, 61–65.

Means, Russell. *Where White Men Fear to Tread: The Autobiography of Russell Means.* New York: St. Martin's Press, 1995.

Montejano, David. *Anglos and Mexicans in the Making of Texas, 1836–1986.* Austin: University of Texas Press, 1987.

Moore, Charles. "The City of George Washington and Abraham Lincoln." *Daughters of the American Revolution Magazine*, April 1921, 171–82.

Napier, A. Kam. "Afterthoughts: War Stories, Visiting the U.S.S. *Arizona* Memorial's New Visitor Center." *Honolulu Magazine*, February 17, 2010.

Nichols, Bill. *Introduction to Documentary.* Second ed. Bloomington: University of Indiana, 2010.

——— *Introduction to Documentary.* Indianapolis: Indiana University Press, 2001.

——— *Representing Reality.* Bloomington: Indiana University Press, 1991.

Nora, Pierre. *Realms of Memory.* 3 vols. Vol. 1. New York: Columbia University Press, 1992.

——— "Reasons for the Upsurge in Memory." In *The Collective Memory Reader*, Jeffrey K. Olick, Vered Vinitzky-Seroussi, and Daniel Levy (Eds.), 437–45. Oxford: Oxford University Press, 2011.

Orvell, Miles. *After the Machine: Visual Arts and the Erasing of Cultural Boundaries.* Jackson: University Press of Mississippi, 1995.

——— *The Real Thing: Imitation and Authenticity in American Culture 1880–1940.* Chapel Hill: University of North Carolina Press, 1989.

Osajima, Keith. "Asian Americans as the Model Minority: An Analysis of the Popular Press Image in the 1960s and 1980s." In *A Companion to Asian American Studies*, Kent Ono (Ed.). *Companions in Cultural Studies*, 215–25. Oxford: Blackwell Publishing, 2005.

Ostler, Jeffrey. *The Lakotas and the Black Hills: The Struggle for Sacred Ground*. New York: Penguin Books, 2010.

Prange, Gordon. *At Dawn We Slept: The Untold Story of Pearl Harbor*. New York: Penguin Group, 1981.

Rachleff, Melissa. "'The Fever Dream of the Amateur Historian': Ben Katchor's the Rosenbach Company: A Tragicomedy." In *Letting Go? Sharing Historical Authority in a User-Generated World*, Bill Adair, Benjamin Filene, and Laura Koloski (Eds.). Philadelphia: Pew Center for Arts & Heritage, 2011.

Rosenzweig, Roy, and David Thelen. *The Presence of the Past: Popular Uses of History in American Life*. New York: Columbia Press University, 1998.

Roth, Darlene. "Consider This: Response to Alan Singer." In HNet: Humanities and Social Science online, December 14, 2011, http://h-net.msu.edu/cgi-bin/logbrowse. pl?trx=vx&list=H-Public&month=1112&week=b&msg=iZ6k7pFtGdZeeTnZRuw8Zg.

Rundell, Walter, Jr. "Alamo Day (March 6)." In *Holidays: Days of Significance for All Americans*, Trevor Nevitt Dupuy (Ed.), 38–42. New York: Franklin Watts, Inc., 1965.

Runte, Alfred. *National Parks: The American Experience*. Lincoln: University of Nebraska Press, 1979.

Sacramento Trust for Historical Preservation, Inc. "The California State Railroad Museum Recommendations for Planning and Development." Sacramento, 1972.

Sakurai, Gail. *Japanese American Internment Camps*. Cornerstones of Freedom. New York: Scholastic, 2002.

Sandage, Scott A. "A Marble House Divided: The Lincoln Memorial, the Civil Rights Movement, and the Politics of Memory, 1939–1963." *Journal of American History* 80, no. 1 (June 1993): 135–67.

Savage, Kirk. *Monument Wars: Washington, D.C., the National Mall, and the Transformation of the Memorial Landscape*. Berkeley and Los Angeles: University of California Press, 2009.

Saxton, Alexander. *The Indispensable Enemy: Labor and the Anti-Chinese Movement in California*. Berkeley and Los Angeles: University of California Press, 1971.

Schaff, Howard, and Audrey Karl Schaff. *Six Wars at a Time*. Darien, CT: Permelia Publishing, 1985.

Schama, Simon. *Landscape and Memory*. New York: Vintage Books, 1995.

Schudson, Michael. *The Good Citizen: A History of American Civic Life*. New York: The Free Press, 1998.

Schwartz, Barry. *Abraham Lincoln and the Forge of National Memory*. Chicago: University of Chicago Press, 2000.

Scully, Vincent. *Architecture: The Natural and the Manmade*. New York: St. Martin's Press, 1991.

Sherry, Michael S. *In the Shadow of War: The United States Since the 1930s*. New Haven, CT: Yale University Press, 1995.

Simon, Nina. *The Participatory Museum*. Santa Cruz, CA: Museum 2.0, 2010.

Singer, Alan. "Fairy Tale History at New York's (Un)Historical Society." In George Mason University's History News Network, December 5, 2011, http://hnn.us/articles/fairy-tale-history-new-york%E2%80%99s-unhistorical-society.

Slackman, Michael. *Remembering Pearl Harbor: The Story of the U.S.S. Arizona Memorial*. Honolulu: *Arizona* Memorial Museum Association, 1998.

Smith, Rex Alan. *The Carving of Mount Rushmore*. New York: Abbeville Press Publishers, 1985.

Southern Pacific Company. "Company Betters Living Conditions for Employees on Desert Sections." *The Bulletin*, November 1, 1915.

Sturken, Marita. *Tangled Memories: The Vietnam War, the Aids Epidemic, and the Politics of Remembering*. Berkeley and Los Angeles: University of California Press, 1997.

Taliaferro, John. *Great White Fathers: The Story of the Obsessive Quest to Create Mt. Rushmore*. New York: PublicAffairs, 2002.

Tarin, Randell G. "Alamo De Parras." In *The Second Flying Company of Alamo de Parras*, John Bryant Robert Durhan (Ed.), 2007, www.tamu.edu/faculty/ccbn/dewitt/adp/history/hispanic_period/pframe.html.

——— "The History of the Alamo & the Texas Revolution." DeWitt Museum, www.tamu.edu/faculty/ccbn/dewitt/adp/history/mission_period/valero/vframe.html.

Thomas, Christopher A. *The Lincoln Memorial & American Life*. Princeton, NJ: Princeton University Press, 2002.

Tichi, Cecelia. *Embodiment of a Nation: Human Form in American Places*. Cambridge, MA: Harvard University Press, 2001.

Tinkle, Lon. *13 Days to Glory*. College Station: Texas A&M University Press, 1958.

Vatz, Richard E. "The Myth of the Rhetorical Situation." *Philosophy and Rhetoric* 6, no. 3 (1973): 154–61.

Wallace, Mike. *Mickey Mouse History and Other Essays on American Memory*. Philadelphia: Temple University Press, 1996.

Weil, Stephen E. *Making Museums Matter*. Washington, D.C.: Smithsonian Books, 2002.

——— "Rethinking the Museum: An Emerging New Paradigm." In *Reinventing the Museum: Historical and Contemporary Perspectives on the Paradigm Shift*, Gail Anderson (Ed.), 74–79. Lanham, MD: AltaMira Press, 2004.

White, Geoffrey. "Moving History: The Pearl Harbor Film(s)." *Positions: East Asia Cultures Critique* 5, no. 3 (1998): 709–44.

White, Geoffrey, and Jane Yi. "December 7th: Race and Nation in Wartime Documentary." In *Classic Whiteness: Race and the Hollywood Studio System*, D. Bernardi (Ed.), 301–38. Minneapolis: University of Minnesota Press, 2001.

White, John R. "The California State Railroad Museum: A Louvre for Locomotives." *Technology and Culture* 24, no. 4 (October 1983): 644–54.

White, Sir Knight Francis A. "Remember the Alamo!" *Knight Templar*, February 1981, 4.

Wilson, Joseph F. *Tearing Down the Color Bar: A Documentary History and Analysis of the Brotherhood of Sleeping Car Porters*. New York: Columbia University Press, 1989.

Winders, Richard Bruce. "The Alamo Audio Tour." San Antonio, Texas.

——— *Crisis in the Southwest: The United States, Mexico, and the Struggle over Texas*. Wilmington, DE: Scholarly Resources, Inc., 2002.

——— "A Response to 'the Alamo's Selected Past'." National Park Service, 31, 2000.

——— *Sacrificed at the Alamo: Tragedy and Triumph in the Texas Revolution*. Abilene, TX: McMurray University, 2004.

Winders, Richard Bruce, and Lonn Taylor. "The Alamo: A Story Bigger Than Texas Script for Long Barracks." San Antonio, TX, 2005.

Zavala, Adina de. "History and Legends of the Alamo and Other Missions in and around San Antonio." Richard Flores (Ed.). Houston: Arte Publico Press, 1996.

Zelizer, Barbie. *Remembering to Forget: Holocaust Memory through the Camera's Eye*. Chicago: University of Chicago Press, 1998.

Zinn, Howard. *The Twentieth Century: A People's History*. New York: Harper and Row, 1980.

Index

Note: Italicized page numbers indicate figures.

academic disciplines, tensions between theory and practice, 18–19

African Americans
representation of, in *Evidence of a Dream*, 84–85
use of Lincoln Memorial for civil rights gatherings, 26, 117–18, 130–31, 136
See also slavery

Agnos, Art, 73

Alamo, The
overview and summary, 25–26, 178
appropriation of symbolic meaning of, 109–10
buildings and site of, 95–96, 101, *102*
as case study, 114–15
chapel, *90–91, 95,* 101, *180*
Convento Courtyard, *99,* 108–9
before 1836, 92–97
1836 Battle of the Alamo (1982 film), 103–4
framed as place of liberation, 105, 107–8
gift shop, 103, *104*
historical accuracy, 114, 169
interpretive materials, 26, 98–103, 110–14, 206n58, 206n59

Long Barrack, 103, 110–13, *111*
as Mission San Antonio de Valero, 92
orientation films, 100, 103–8
slavery supported by defenders of, 107–8
traditional narrative, defined, 204n30
use by U.S. and Confederate armies, 95
visitation numbers, 90, 202n3
visitor-centric paradigm shift, 91–92, 108–10
visitor experience, *23,* 100–101
See also Daughters of the Republic of Texas

Alamo, The (1995 film), 104

Alamo Day, 109

Alamo de Parras, 93. *See also* Alamo, The Alamo Lore and Myth Organization (ALAMO), 99

AldrichPears Associates, 52–53

American Federation of Teachers, 120

American Indian Movement (AIM), 158–59

Anderson, Gail, 21

Anderson, Marian, 26, 117, 130–31, *132,* 209–10n1

Anthony, Susan B., 221n24

Archdiocese of San Antonio, 92

Archibald, Robert R., 49, 121–22, 139–40
archival footage. *See* historic footage in documentary films
Arizona high school students, and Lincoln Memorial, 119–20, 133, 139
Austin, Stephen F., 113

Bacon, Henry, 124–26, 131–32, 140
Baker, Gerard, 27, 154, 168–70, 181–82
Banks, Dennis, 159
Barry Howard & Associates Inc., 63–64
Battle of Nagashino, 99
Beachley Brear, Holly, 99, 108
Billings, Kathleen, 47, 193n73
Bird, Lance, 43–49
Black Elk, 153–54
Black Hills
 in Mount Rushmore interpretive materials, 158, 168–69
 Native American tribes' relationship to, 27, 145–46, 153, 158–59, 181–82
 ownership rights to, 153, 170
 selection of, for colossal carving, 153–54
Blair, Carole, 22, 152
Boime, Albert, 126
Borglum, Gutzon
 background, 223n51
 in interpretive materials for Mount Rushmore, 150, 152, 157, 161–62, 171
 and model, 147
 Mount Rushmore plans, 147–49
 Stone Mountain project, 155
 U.S. identity as defined by, 152–53
Borglum, Lincoln, 148, 151
Bowie, James, 99, 106
Bracewell, Amy, 168, 170
Brazeal, Brailsford Reese, 85
Burchard, Hank, 133, 135
Burnham, D. H., 122

Burns, John, 39, 190n28

California State Railroad Museum (CSRM), 22, 60, 65
 overview and summary, 25, 176–78
 African American workers, 67, 69, 85
 approach to railroad history, 60–61, 64–65, 77–79
 as case study, 61
 Chinese railroad workers: artifacts of, 76; discrimination against, 84; in exhibits of, 25, 69–74, 74, 75, 79–80, 179
 criticism of, 74, 77
 as exemplar for technology museums, 59–61
 female railroad engineer mannequin, 83
 format of, 76–77
 gift shop, 68–69
 goals of, 63–64, 76
 Hispanic mannequins, 65, 68
 hobo vignette, 77–78
 interpretive focus, 63–64
 lessons from, 88
 Old Sacramento and, 62–63
 orientation films, 74–87, 200n64
 "People Gallery" exhibit, 69, 71
 Pullman porter mannequin, 67, 69
 railroad station recreation, 67
 rail stock: *C. P. Huntington* locomotive, 67; *Empire* locomotive, 67, 70; "Gold Coast" rail car, 65; *Gov. Stanford* locomotive, 64, 66
 rail workers vignette, 72–73, 78–79
 visitor-centric paradigm shift, 61–62, 86–88
Calvin, John, 120, 133
Camp Tule Lake, California, 36
Carroll, Peter N., 159
case studies

interpretive materials, 24, 174–75
lessons from, 27–28, 88, 183–84
significance of, 23
See also Alamo, The; California State Railroad Museum; Lincoln Memorial; Mount Rushmore National Memorial; U.S.S. *Arizona* Memorial
Chestnut, J. LeCount, 130
Chinese Americans, 25, 71–73
Chinese railroad workers. *See* California State Railroad Museum
Chinn, Thomas, 63, 71–72
Choy, Philip, 63, 69–71, 72–73
Chun, Richard, 54
citizenship
definitions of, 16–17, 32, 175
denial of, for Asian immigrants, 84
practice of, 34, 185n2
Civil Liberties Act (1988), 55
civil rights movement
and inclusion of Chinese mannequins in CSRM exhibit, 72–73
Lincoln Memorial and, 26, 117–18, 130–31, 136
in *Lincoln's Legacy* exhibits, 20, 119, 133
March on Washington (1963), 117
Civil War, Southern monuments to, 124
Close Up Foundation, 120, 210n9
Cohuila y Tejas, U.S. immigration into, 95
Colonial Dames of America, 98
communication, 24, 78, 112, 145, 152
Concerned Women of America, 119, 136–37
Coolidge, Calvin, 149–50
Copeland, Aaron, 135
Corn, Joseph, 60

Cortissoz, Royal, 125–27, 140, 214n43
Crazy Horse Monument, 226n102
Crocker, Charles, 73, 84
Crockett, David, 99, 106
CSRM. *See* California State Railroad Museum (CSRM)
Cullom, Shelby M., 125, 140
Cummins, Gary, 41, 137

Daniels, Roger, 47
Daughters of the American Revolution, 98, 209–10n1
Daughters of the Republic of Texas (DRT)
Alamo organizational structure and, 114–15
controversy in tenure of, 90–91, 98
custodianship of Alamo complex, 25–26, 96–98, 203n22
end of tenure as custodians of Alamo, 89–90, 113–14
interpretive materials, 100, 104, 108–9, 114
investigation of, by Texas state attorney's office, 114
membership requirements, structure, and purpose, 97
orientation films, 103–8
Texas Education Agency and, 97–98
December 7th (film), 45–46
Dickinson, Greg, 22
Dierking, Lynn, 51, 57
documentary films
definition difficulties, 187n20
expository format, 24
forms of, 188n22
historic recreation in, 83, 192n62
objective/subjective split, 187n21
See also names of specific films; individual case studies
Drew, Stephen, 80
Driscoll, Clara, 98
DRT. *See* Daughters of the Republic of Texas
Dubrow, Gail Lee, 47

1836 Battle of the Alamo (film), 103–4
Esparza, Enrique, 109
Esparza, Gregorio, 106–7
Evidence of a Dream (film)
 content changes, 82–87
 ideological functions, 86–87
 Orientation Program compared to, 80–81
 representation of ethnic minorities in, 82–86
 vignettes, 81–82
Executive Order 9066, 54–55

Falk, John, 19, 51, 57
Fanfare for the Common Man (Copeland), 135
Fannin, James Walker, 106
Fehrenbach, T. R., 206n59, 207n64
Flores, Richard, 105, 108
Ford, John, 45, 192n61
Fort Laramie Treaty (1868), 153, 166, 223n57
Four Faces on a Mountain (film)
 form and content of, 151, 157
 mutable meanings in, 171–72
 national mood at the time of production, 159
 NPS and, 156–58
 presidential sequence, 158–61
 reception of, 157–58
 themes of, 160–61
Franciscan friars, 92
free-choice learning, 102, 206n52
freedom of information act (FOIA) request, 137–38
Free Press, The, 147
French, Daniel Chester, 124, 126, *127*

Gandy Dancers, 86
gay rights, in *Lincoln's Living Legacy,* 136–37
Gettysburg Address, in Lincoln Memorial, 125–26
Goda, Harry, 54
Gratz, Tucker, 37, 39
"Great Man" theory of history, 156

Grossberg, Lawrence, 78–79
Guerin, Jules, 124–25, 127–29, *129,* 140

Harada, Yoshio, 46
Harding, Warren G., 129
Hariman, Robert, 145, 171
Harpers Ferry Interpretive Center, NPS, 52–53, 133, 134, 137
Hawai'i, 46, 55–56
Hawai'ian Japanese Americans
 in *December 7th* film, 45
 internment of, compared to all Japanese Americans, 36
 JACL, 46–47, 192–93n67
 U.S.S. *Arizona* Memorial and, 25, 34, 52
Heathcote, Edwin, 31–32, 57
Hein, George, 19
Hein, Hilde, 121
Hein, Laura, 52, 56–57
Hill,Thomas, 67–68
Hispanic worker mannequins, CSRM, 22
historical accuracy, 23, 28, 35, 48, 52, 57, 62, 114, 133, 172
historical and technology museums, in 1980s, 75–76
historical authority, shared
 CSRM and, 87
 Lincoln Memorial, 121–22, 139
 Mount Rushmore National Memorial, 144–45
 painful periods in U.S. history and, 24–25
 at sites of public memory, 21
 U.S.S. *Arizona* Memorial, 52–56
historical scholarship, tension between museum interpretive exhibits and, 19
historic footage in documentary films
 in CSRM 1991 orientation film, 200
 in *Evidence of a Dream* film, 80, 82
 in *Four Faces on a Mountain,* 225n83

in *How Shall We Remember Them,* 43
in *Lincoln's Living Legacy,* 121, 135–39
in *Mount Rushmore* film, 155
in Mount Rushmore orientation films, 151, 158
in *The Shrine,* 162
historic preservation, women's participation in, 98
historic recreation/reenactment in documentary films
in *December 7th,* 45
in documentary films, 192n62
in *Evidence of a Dream,* 81–83
in *Orientation Program,* 76–77
Honolulu Star Bulletin, 44
Houston, Sam, 105
How Shall We Remember Them (film), 43–49

Ienaga, Saburō, 55–56
"If You Had Been on Oa'hu" exhibit, *177*
"I Have a Dream" speech (King), 26, 211n15
indigenous Indians of San Antonio, in Alamo orientation films, 105–6
internment of Japanese Americans, 36, 54, 189n14
interpretation guidelines, 122, 139–40
interviews, contemporary, in documentary films, 81–82
Intrepid Productions, 81
iron triangle, 19–20

Japanese American Citizens League (JACL), 46–47, 192–93n67
Japanese Americans, 25, 34, 36, 45, 52–55, 189n14
Japanese nationals, 46
Jefferson, Thomas, 155, 160, 163
Jefferson Memorial, 136
Judah, Theodore, 197n18

Karotko, Bob, 138
Kashinma, Tetsuden, 52

King, Martin Luther, Jr., 26, 120–21, 133, 211n15
Kinzler, Robert, 47
Ku Klux Klan (KKK), 155

Last Spike, The (painting), 67–68
learning, in museums, 19, 206n52
Light of Liberty (film), 136
Lincoln, Abraham
in *Four Faces on a Mountain,* 160–61
French's statue of, 125–26
Mount Rushmore National Memorial and, 155
national symbolism of, competing ideologies, 124, 127–30
Second Inaugural Address, 125–26
in *The Shrine,* 163
Lincoln Memorial, *118*
overview and summary, 26, 178–81
Marian Anderson and, 26, 117, 130–31, *132,* 209–10n1
Arizona High School students and, 119–21, 133, 136, 139
as case study, 140
civil rights movement and, 117–18, 130–31, 136
under construction, *29, 123*
controversies: attempt to manipulate meaning of, 136–39; over core values, 122, 124, 131, 133, 136, 138–39, 141; over design and placement of, 124–26; in planning of, 213n30
dedication of, 124, 129–30, *131*
Equal Rights Amendment rally, *182*
features of, 124–26, *127,* 127–29, *129,* 140
goals for, 122–24
interpretive materials: demands for changes in, 118–19; *Lincoln's Legacy* exhibits, *20,* 119, *119, 120,* 133, *134,*

182, 210n4; location of,
 131–33
King's "I Have a Dream" speech
 commemoration, 211n15
orientation film, 119–21,
 135–36, 138
shared historical authority,
 121–22, 139–41
as site for contemplation and
 inspiration, 129–30
under-interpretation of, 140
visitor-centric paradigm shift,
 26, 121
visitor experience, 118–19,
 132–33
Lincoln Memorial Commission,
 124–25
Lincoln Monument Association, 124
Lincoln's Legacy exhibits, *20,* 119,
 119, 120, 133, *134, 182,* 210n4
Lincoln's Living Legacy (film),
 119–21, 134–36, 138
Linenthal, Ed, 57
Litchfield, Electucs C., 125
Locomotive & Railway Preservation
 magazine, 60
Lucaites, John Louis, 145, 171

Magee, Don, 42
manifest destiny, railroads and, 64
March on Washington (1963), 117
Martinez, Daniel, 41, 46–47,
 193n73
Matsunaga, Spark M., 37–38
Medicine, Kollette, 170
memorials, traditional, 122
memory studies research, 22–23. *See
 also* public memory, construction of
Meredith, Burgess, 157–58
Mexican Americans, in San Antonio,
 104
Mexican revolution, in Long Barrack
 exhibit, 112
Mexicans, in Alamo orientation films,
 107
Mexico

Alamo de Parras and, 94–95
American settlement in, 107
battle for independence from
 Spain, 84, 98, 107, 111–12
illegal U.S. immigration into, 95
land ownership
 misunderstanding between
 American immigrants and
 government of, 207n73
slavery prohibition in, 107,
 209n96
Texas's battle for independence
 from, 95
Michel, Neil, 152
Mikuma, John, 46
Miners' Strike (1869-1871), 84
Mission Concepción, San Antonio,
 Texas, 92, *93*
Mission Espada, San Antonio, Texas,
 92, *94*
Mission San Antonio de Valero. *See
 also* Alamo, The
Mission San José, San Antonio,
 Texas, 92, *93*
Mission San Juan, San Antonio,
 Texas, 92, *94*
missions built by Franciscan friars
 along San Antonio River, 92, *93, 94*
"model minority" stereotype, Chinese
 Americans and, 71
monumentalism, historical theory of,
 152
monuments to the Civil War,
 Southern, 124
Moore, Charles, 129
Morris, Erroll, 192n62
Moton, Robert R., 130, *131*
Mount Rushmore (film), 150–56, 171
Mount Rushmore National Memorial
 overview and summary, 26–27,
 181–84
 Gerard Baker and, 27, 154,
 168–70, 181–82
 Borglum's plan for carved
 entablature, *149,* 220n21
 as case study, 143–44

under construction, *148, 183*
entrance, *171*
Hall of Records, 148, 150
Heritage Village (Paha Sapa stop), 168, *169,* 170, 172
historical accuracy, 172
interpretive materials: audio tour, 168–70, 172; changes in, 170–71; exhibits, *164, 166–67, 167,* 227–28n111; history of, 145–46; objectives for, 166; plans for, 162
as memorial to U.S. expansionism and imperialism, 149, 221n24–221n25
model of, and sculptor Borglum, *147*
Native American with NPS ranger, *17*
orientation films, 151–52, 154–56, 162, 171
original concept for, 146–47
paradigm shifts: shared historical authority, 144–45; top-down, 168–70
patriotic symbolism of, 163, 172
from Peter Norbeck Scenic Byway, *144*
political culture at time of conception and construction, 149–50
pre-construction, *153*
Presidential Trail, 168, 228n116–17
presidents chosen for, 148, 150
rhetorical situation, 144, 156, 159, 161, 163, 165, 168
visitor centers, 150, 166–68; first, 150
visitors' experience, 145–46, 164–65
See also Native Americans
Mount Rushmore National Memorial Society of the Black Hills, 150–51, 157, 162, 222n39

museological, as term, 21
museological paradigm shifts, 18, 21, 185–86n5. *See also* paradigm shifts
museological triangle, 19–21
museum exhibit development, 19, 121
museum visitor experience research, 21

N.A.A.C.P., 130
national historic sites
attendance as performance of civic virtue, 34
controversies at, 15–16
necessary tensions in interpretations and depictions of history, 27
"official" designations, 17
opportunity for reflection, 34
orientation films, 104
suppositions concerning representation at, 16–18
nationalism, 16–17, 152, 175
National Park Service (NPS)
Four Faces on a Mountain and, 156–58
Harpers Ferry Interpretive Center, 52–53, 133, 134, 137
Lincoln Memorial and, 119–20, *120,* 132, 133, 137, 210n4
Mount Rushmore National Memorial and, *17,* 146, 150, 155–56, 162, 166
National Mall Plan recommendations, 140
San Antonio missions and, 92
U.S.S. *Arizona* Memorial and, 37–38, 41–43, 48, 188–89n4
Native Americans
in Alamo interpretive materials, 105–6, 111–12
Gerard Baker and, 27, 154, 168–70, 181–82
in *Evidence of a Dream,* 85
Lakota, Nakota, and Dakota, 144–45
Lakota language, 168, 170, 172

Lakota lawsuit for ownership of Mt. Rushmore, 153–54, 165
at Mount Rushmore National Memorial, 17, 154
Mount Rushmore National Memorial interpretive materials and, 166–70, 223–24n64
protests at Mount Rushmore National Memorial, 154, 156, 158–59
relationship to Black Hills and Mt. Rushmore, 27, 144–45, 153, 158–59, 170, 181–82
Naturalization Act (1790), 200n69
Naturalization Act (1870), 84, 201n77
Nauman, Bruce, 155
Nauman, Charles W., 150–51
Nava, David, 108
Navarro, Jose Antonio, 109
Neasham, Aubrey, 62
Nelson, Lyle, 42
New York Historical Society, 19
New York Times, 90–91
Nichols, Bill, 188n22
Nora, Pierre, 34
Norbeck, Peter, 147
North Cascades National Park orientation film, 187n19
nostalgia, as interpretive approach, 77
Novarro, Jose Antonio, 112–13
NPS. *See* National Park Service

Ogawa v. the United States, 195n95
Old Sacramento, 62–63, 63
orientation films
The Alamo, 100, 103–8
California State Railroad Museum, 74–87
form and function of, 151
goal and format of, 24
Lincoln Memorial, 119–21, 135–36, 138
Mount Rushmore National Memorial, 151–52, 154–66, 171–72, 225–26n94

in national parks, 210n4
North Cascades National Park, 187n19
U.S.S. *Arizona* Memorial, 34, 41–42, 43–49, 192–93n67
Orientation Program (film), 74–81
Osajima, Keith, 71
Ott, Brian, 22

Pacific Fleet, 56–57
Pacific Railroad fever, 64
Pacific War Memorial Commission, 37
Pang, Harry Tuck Lee, 54, 56
paradigm shifts
in 20th century academic disciplines, 18
The Alamo and, 91–92, 108–10
from collection-driven to visitor-centered, 21, 24–25, 174
CSRM and, 61–62, 86–88
Lincoln Memorial and, 26, 121
Mount Rushmore National Memorial and, 27, 144–45, 168–70
museological, 18, 21, 185–86n5
U.S.S. *Arizona* Memorial and, 51–56
patriotism
as commodity, 150–56
definitions of, 16–17, 175
evolution in interpretation of, 28
Mount Rushmore symbolism, 163, 172
narrative of, in *The Shrine,* 165–66
national historic site attendance as performance of, 34
Pearl Harbor, colonial history of, 57
Pearl Harbor attack, 34, 37, 56–57
Pearl Harbor Survivors Association (PHSA), 47, 52
Pearl Harbor tour, U.S. Navy, 190–91n35, 191n38
People for the American Way, 137
Peterson Company, 77
Powell, Rose Arnold, 221n24

Prange, Gordon, 46
Preis, Alfred, 36, 49, *50*
Presley, Elvis, 37, 190n23
Public Employees for Environmental
 Responsibility (PEER), 137
public memory, construction of, 27,
 35
public memory, sites of, 16, 21–23.
 See also national historic sites
Pullman, George, 85
Pullman Porters' Union, 85

racism
 Marian Anderson and, 26, 117,
 130–31, *132*, 209–10n1
 Chinese Americans and, 72–73
 Chinese railroad workers and, 84
 in *Evidence of a Dream*, 83–84
 Japanese Americans and, 53–54
 in orientation film for U.S.S.
 Arizona Memorial, 34
 railroad workers and, 84
Radford, Jane, 132, 133, 135
Radford, Tim, 135, 137–39
railroads
 Big Four, 197n18
 labor unions, 84–85
 as nation builder, 63–69
 nostalgic interpretations of
 history of, 77
 symbolism of, 64
 See also California State Railroad
 Museum
Railway Labor Act (1926), 85
Railway & Locomotive Historical
 Society, Pacific Coast chapter, *59*
Rapid City Journal, 169–70
"Revolution! The Atlantic World
 Reborn" exhibit, 19
Roberts, John W., 52
Roberts, Madge, 98
Robinson, Doane, 146–47, 162, 165
Rodriguez, Rudi, 99–100, 109
Roosevelt, Theodore, 54, 155, 161,
 163
Ruiz, Jose Francisco, 109, 112
Rundell, Walter, 109

Runte, Alfred, 152
Russell, A. J., 68
Russell, Jan Jarboe, 113–14

Sacramento Trust for Historic
 Preservation, 63
Safeway, 62
San Antonio, Texas, 96, 104. *See also*
 Alamo, The
San Antonio Express-News, 114
Sand Island internments, 36
Santa Anna, Antonio Lopez de, 99,
 105, 107
Savage, Kirk, 122–24, 125
Schudson, Michael, 72, 149–50, 163
Selby, Leslie, 82, 200n66
Sequin, Juan, 109
Sheldon, Louis, 119, 136–37
Sherrill, Clarence O., 130
Sherry, Michael, 156, 163
Shiga, Shigetaka, 99
Short (Lieutenant General), 53
Shrine, The (film), 151, 162–66, 172,
 225–26n94
Shriver, Robert, 46
Singer, Alan, 19
sites of public memory, 16, 21–23.
 See also national historic sites
slavery
 Lincoln Memorial and message
 against, 127–29
 in Long Barrack exhibit, 112,
 113
 New York Historical Society's
 installation on, 19
 prohibition against, in Mexico,
 107, 209n96
 support of, by Alamo defenders,
 107–8
Somerdorf, Marilyn, 72
Southwestern Historical Quarterly,
 110–11
Spanish military, and Alamo de
 Parras, 92–94
Stanton, Robert, 24, 133, 175,
 178–81
"State of Mind: America" exhibit, 55

"State of Mind: Japan" exhibit, 55
Stone Mountain, 124, 155

Takaki, Ronald, 47
Tanabe, James and Yoshi, 44–49, 176
Tatem, Bill, 82
Tejanos, 99–100, 105–10, 112–13,
 204n39
Texas
 battle for independence from
 Mexico, 95
 birth of republic, in Alamo
 orientation films, 107
 Education Agency, 97–98
 General Land Office, 25–26,
 89–90, 113
 mythic narrative of, 98–100
 slavery in, 107
Thomas, Lowell, 151–52
Tiahrt, Todd, 137
Tinkle, Lon, 99
Toland, Greg, 45
torpedoes, opposite Preis's "Tree of
 Life," 51
tourism, historically oriented, 145
Travis, William Barrett, 99, 106
treatment, defined, 199n49
"Tree of Life" (Preis), 49, 50
Tule Lake Segregation Center,
 California, 36

U.S. expansionism and imperialism,
 56–57, 149, 156, 165
U.S. Indian Reorganization Act
 (1934), 166–67
U.S. Navy
 Pearl Harbor tour, 41, 190–
 91n35, 191n38
 U.S.S. Arizona battleship
 commemorations, 37–38
 U.S.S. Arizona Memorial
 orientation film (1980), 42,
 43–44
U.S.S. Arizona battleship, 33, 36–38,
 37, 38
U.S.S. Arizona Memorial

overview and summary, 25, 176
 Asian Americans and, 47, 54
 citizenship defined in exhibits
 of, 32
 under construction, 28
 emotional impact of, 31–32
 exterior (2005), 32
 ideological concerns regarding
 commemoration, 39
 interpretive materials: absences
 in, 54, 56–57; exhibits, 41,
 50–51, 177; historically
 inaccurate and racist
 representations, 25; paradigm
 shift into sharing historical
 authority, 52–57; tension in
 development of, 32
 JACL, 46–47, 192–93n67
 Japanese Americans and, 15, 25,
 35–36, 44–47, 52–53, 55
 NPS and, 189n4
 O'ahu Courtyard, 55–56
 orientation films, 34, 41–42,
 43–49, 192–93n67
 Shrine Room, 44
 sign, 18
 U.S. Navy orientation and
 tugboat tour, 41
 visitor centers, 40; (1980):
 completion and replacement
 of, 38–39; guidelines for
 collections, 41; interpretive
 materials, 54; (2010):
 changes at, 35; configuration
 of, 49; dedication of, 39;
 goals for, 33; interpretive
 exhibits, 50–51, 53; physical
 connection with U.S.S. Bowfin
 site, 49–50; planning and
 design for, 52–53
U.S.S. Bowfin site, 49
U.S. War Department, morale film
 series, 45

Van Cleave, Virginia, 110
Van de Putte, Leticia, 89–90

voluntary learning, 19, 206n52

Wallace, Michael, 104–5, 164
Wall of History exhibit (The Alamo), 108–9
Washington, George, 155, 159–60, 163
Weil, Stephen, 18
Wenger, Mike, 52
Wenk, Dan, 166
White, Geoffrey, 46, 48, 52, 57
White, John R., 60, 77
Whitman, Walt, 81
Wickware, Harvey D., 157
Wilson, Joseph F., 85
Winders, Bruce, 98, 100, 108, 207–8n73
Winthrop, Robert C., 64
women's rights, in *Lincoln's Living Legacy*, 136–37
World War II Valor in the Pacific National Monument

entrance sign, *34*
442nd Regimental Combat Team description, 195n96
historic sites in, 36
"If You Had Been on Oa'hu" exhibit, *177*
"Tree of Life" replica, *50*
U.S.S. *Arizona* Memorial sign, *18*
U.S.S. *Arizona* Memorial under construction, *28*
visitor center, *48*
See also U.S.S. *Arizona* Memorial

Yamamoto (Admiral), 42
Yee, Herbert, 73
Yee, Wesley, 69–71, 73
Yoshikawa, Takeo, 46, 53

Zavala, Adina de, *95–96*, 98
Zavala, Lorenzo de, 96
Ziolkowski, Korczak, 226–27n102

About the Author

Teresa Bergman is Associate Professor in Communication and Film Studies at the University of the Pacific and a former documentary film-maker. She teaches courses in the rhetoric and production of documentary film, communication criticism, and qualitative research methodologies. Her articles on documentary film and orientation films have appeared in *Text and Performance Quarterly*, the *Western Journal of Communication*, and in several anthologies.